PIERO'S LIGHT

PIERO'S LIGHT

In Search of Piero della Francesca:
A Renaissance Painter and the Revolution
in Art, Science, and Religion

LARRY WITHAM

PEGASUS BOOKS
NEW YORK LONDON

PIERO'S LIGHT

Pegasus Books LLC
80 Broad Street, 5th Floor
New York, NY 10004

First Pegasus Books cloth edition January 2014

Interior design by Maria Fernandez

ISBN: 978-1-60598-494-0

10 9 8 7 6 5 4 3 2 1

Printed in the United States of America

Distributed by W. W. Norton & Company, Inc.

Contents

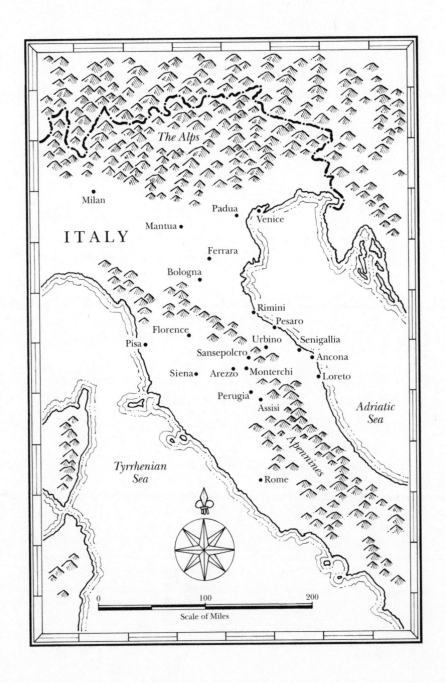

The Alps

Milan

ITALY

Padua

Mantua

Venice

Ferrara

Bologna

Rimini

Pesaro

Florence

Urbino

Senigallia

Pisa

Sansepolcro

Ancona

Siena

Arezzo

Monterchi

Loreto

Perugia

Assisi

Adriatic
Sea

Tyrrhenian
Sea

Apennines

Rome

0 100 200

Scale of Miles

PIERO'S
LIGHT

Preface

Piero della Francesca first crossed my path when I was a college art student in the early 1970s. Like a Michelangelo, Raphael, or Leonardo, "Piero" was presented on a first-name basis. He was clearly not as famous as the big three. Among the Renaissance painters, though, Piero stood apart. His imagery looked strangely ancient and modern at the same time. More recently, Piero attracted my attention once again. After two decades of writing on the topics of religion, science, and philosophy, it occurred to me that the life of Piero offers a window on a broader topic: the roles of art, religion, and science in how we perceive the world.

As a rule, individual artists do not change the course of human history. Only with the rise of mass media in the twentieth century have artists of the past appeared to be such titanic figures, shaking the world in their own time (when they actually did not). Nevertheless, artists have held a special place in our imagination as markers along the road of great cultural transitions. As a child of the Renaissance, Piero is such a figure. A painter of religious topics, he was also the "painter-mathematician and the scientific artist par excellence" of his time, says one historian of mathematics.[1] Transcending his time in history, Piero's legacy allows us to understand the precipitous change in art, religion, and science that

began to take place during the Renaissance and has affected the Western world ever since.

Piero's story begins in the early Quattrocento, the 1400s on the Italian peninsula. It was a time when there actually was no modern Italy, but rather a mosaic of city-states, from Florence and Milan to Venice, Perugia, and Rome. In Piero's day, many of the barriers we have now erected between art, religion, and science did not exist. This was the so-called "medieval synthesis," and as a painter and craftsman, Piero was in its artistic stream. Such a happy synthesis of culture continues to have a great allure in the West, according to the Italian historian Umberto Eco. For people of the Middle Ages, "Life appeared to them as something wholly integrated," he writes in his essay *Art and Beauty in the Middle Ages*. "Nowadays, perhaps, it may even be possible to recover the positive aspects of their vision, especially as the need for integration in human life is a central preoccupation in contemporary philosophy."[2]

With one foot in the medieval synthesis, Piero ultimately became a kind of bridge figure, taking a step into the early modern world. During his lifetime, the synthesis of the Middle Ages was being added to by the Renaissance's revival of the classical past: the arts and letters of Greece and Rome. Art returned to an imitation of nature. Religion revived Platonist thought. And in science, there was a growing fascination with mathematics, optics, linear perspective, and the physical structure of the heavens. Having been caught up in these cultural changes, Piero was required to take the best of the medieval synthesis, embrace the innovations of the Renaissance, and move into the future with new ways to integrate the aesthetic, spiritual, and intellectual aspects of life. This has made Piero a multi-dimensional figure, and for our contemporary minds, an adept guide for exploring the meaning of the Renaissance.

To assist in that exploration, a second theme of this book will be that one of the revivals of the Italian Renaissance—namely, the philosophy of Platonism—had provided an integrating framework for Piero and others. Piero lived and worked within a Christian Platonist tradition that was maturing during the Italian Renaissance. It was an intellectual subculture that was attempting to reconcile Greek philosophy and science with Christian belief. He was introduced to the Platonist revival by the religious movements and humanist scholars around him, and, while not university-trained, Piero

had ample opportunity to absorb the new thinking. In his own right, he edited, transcribed, or illustrated at least eight physical manuscripts on mathematical topics, some of which reflected the Platonist interest in ideal shapes and numerical proportions.[3]

It was the early-Renaissance enthusiasm for antiquity that prompted Italian book hunters to collect and translate many Greek texts. Among these were the writings of Plato. Eighteen centuries earlier, in Greece, Plato had been the student of Socrates and the teacher of Aristotle. To speak of Platonism, however, is to speak of the Western world's first wide-ranging debate about the nature of things. In his twenty-five dialogical texts, Plato does not necessarily declare his own view; rather, through the many dialogues, he reveals the intellectual duels among Greek philosophers. At bottom, though, one Platonist doctrine comes through more strongly than all others: reality is dualistic, made up of a physical realm and a transcendent realm, a world of physical perception (the *sensible*) and one of mental transcendence (the *intelligible*).[4]

Although the Platonic dialogues explain how difficult, even impossible, it is to perfectly apprehend either the physical or transcendent worlds, Platonism presents both pursuits as worthwhile and basic to human life. The transcendent world offers ideals or essences that are deemed worthy of contemplation and explication. In turn, the physical world is in constant flux, vast and elusive and yet knowable by a process of critical thinking and reflective experience. And as Platonists have consistently argued, this world of flux mysteriously yields to the power of mathematics.

Piero was not the originator of such mathematical concerns during this transition from the Middle Ages through the Renaissance, but he applied mathematics to his art, innovated in arithmetic and geometry, and wrote extensively on these topics. The mathematical features of Platonist thought would eventually contribute to the Scientific Revolution, and Piero was an important benchmark on the way there. Going further, it could be argued that even the artistic innovations of the Italian Renaissance helped shape a new scientific view of the world.

Platonism is not the only big idea that emerged from the Renaissance. That period in history perpetuated a number of philosophies that are still with us: individualism, humanism, skepticism, Epicureanism, scientism,

political cynicism, the occultism of the perennial New Age, and certainly the striving for fame, wealth, and glory. Yet amid these many streams of thought, Platonism has proved to have much broader implications about the nature of reality and human perception, and thus an enduring ability to integrate the ideas of visual beauty, spiritual or mental transcendentalism, and scientific progress. Accordingly, the second part of this book, which follows Piero's legacy down to the present, will also explore the Platonist legacy.

Because art and religion are both forms of human perception, they finally are based on our understanding of the human brain and the powers of the mind. It is no surprise, therefore, that the final science to challenge the transcendent nature of aesthetic and spiritual experience is neuroscience, which presents the case that all human experience can be reduced to neurons and modules in the brain. In this book, Platonism and neuroscience will meet in surprising ways. But in the end, the jury will still be out on whether brain science can fulfill its claim to "explain away" transcendental experiences such as God, beauty, or the desire for Platonist essences in a world of change.[5]

The jury is still out on the nature of the Italian Renaissance itself, too, surprisingly enough, and this further complicates any story about Piero and his significance in history. Some historians view the Renaissance as no more than an extension of the late medieval world, rejecting the idea that it was the chief moment of European "rebirth." Even more skeptical of its existence, other historians have called the Italian Renaissance a fiction created by later generations, a kind of romantic hindsight.[6] At any rate, for our purposes, this book takes the conventional view that the Italian Renaissance was a distinct period of change. It was by no means an idyllic time, to be sure. "Good and evil lie strangely mixed together in the Italian States of the fifteenth century," the Swiss historian Jacob Burckhardt wrote accurately enough.[7] Still, Burckhardt pegged the Italian Renaissance as a turning point, a period that "must be called the leader of modern ages."[8] In making this claim, Burckhardt was astute enough to acknowledge that he was presenting a very personal "picture" of the Renaissance based on his own modes of research and analysis.

This book shares Burckhardt's basic confession that any broad interpretation of a trend in human history and thought must be simply a picture

for readers to consider, nothing more. When it comes to Piero's life in particular, many approaches could be taken.[9]

Biographies of Piero virtually require an interpretive viewpoint to fill in so many empty spaces and missing pieces. Given the paucity of documented dates in Piero's life, one art historian has concluded: "With Piero the essential truth must, in the end, be elicited from the [art] works themselves," of which about sixteen survive.[10] Piero's works also include his three treatises on arithmetic and visual geometry, revealing his thoughts in page upon page of procedural explanations and mind-numbing numerical notations. Yet as another Piero scholar says, with nearly perfect accuracy, "In the hundreds of pages of his own writings there is not one remark of a personal nature" (though he does, in fact, show a bit of piety or wry humor here and there).[11] In summary, "Nothing involving Piero is simple or straightforward," says James R. Banker, a Piero scholar who should know, having been in pursuit of him for two decades.[12] Thanks to Banker's research in Italy, where he has lived in Piero's home town, something like an alternative consensus has emerged on dating Piero's life. Its central feature is to give Piero an earlier birthdate of 1412, a rejoinder to the often-used date of 1420. This book will adopt the early-dating approach, which offers a significantly altered view of Piero.[13]

Despite Piero's elusive presence in history, it is a testimony to his acclaim that his story has extended far beyond his lifetime: this has been called the "search for Piero." Following his death, his memory was briefly chronicled. Then he was virtually forgotten until the nineteenth century, when there was a kind of Piero revival in Europe, bringing him to the attention of the English-speaking world. The universal quality of Piero was recognized again in the twentieth century. This was the century not only of modern art, which in itself put a new lens on Piero, but of the era when physics and biology provided a firm foundation for the mechanistic sciences. These included neuroscience, and thus a final challenge to belief in the transcendent Platonist ideals of the Renaissance.

In the following pages, Piero's life and legacy will be explored across these three epochs, following the twists and turns of art history, science, and religion—and their indebtedness to Platonism—down to the present. For our modern day, the nearly-forgotten Piero della Francesca was "discovered" in the 1850s, and the mood on the Italian peninsula, as our story begins, was one of revolution.

Discovering Piero

The great European insurrection was widespread but brief. What historians call the Revolutions of 1848 first erupted in Sicily against the imperial rule of the French empire. Soon Paris itself was up in arms. Like falling dominos, street uprisings against monarchic regimes swept across fifty countries in Europe and Latin America. Then, after several months and several thousand dead, the rebellions collapsed, leaving the monarchies of the day still in firm control. On the Italian peninsula, however, the rumblings for liberation continued, especially in Florence.

In that fabled city of the Renaissance, the brewing political changes of the 1850s became the backdrop for two very different men—an Italian and an Englishman—to achieve one common goal. Amid those tumultuous days, they recovered the memory of a long-lost Renaissance painter: Piero della Francesca.

The Italian was Gaetano Milanesi, a linguist by training.[1] Milanesi was a native of Siena, about forty miles south of Florence, and he frequently visited Florence for his archival research on art history. Milanesi was there in 1855 as the Austrian troops, sent by the Habsburg Empire to restore order in the Grand Duchy of Tuscany, were pulling back from their occupation of the city. Many Italians were calling for independence. The slogan in the streets was *risorgimento*, or resurgence. The goal was a unified modern Italy.

For Milanesi, recovering Italy's art history was an equally patriotic pursuit. At age forty-two, he was an expert in interpreting antique Italian language, deeds, and contracts. He had studied law, but his love of art redirected him into research on Siena's rich pictorial history. He and his friends had founded the Fine Arts Society. The society had published a new commentary on the single most important source on Renaissance art history, Giorgio Vasari's second edition of his *Lives of the Artists* (1568). With precocious zeal, Milanesi and his cohorts corrected many of the mistakes in Vasari's massive work, which chronicled 124 Italian artists over 250 years, including a somewhat vague entry on Piero della Francesca.

By 1855, Milanesi's full attention had turned to new developments in Florence. Despite the political tumult of the decade, the Habsburg-appointed Duke of Tuscany had decreed that the historic Uffizi Palace be turned into an art museum and a vast state archive; it was Tuscany's first centralized repository of historical documents. In a year, Milanesi would be hired as a staff member at the State Archives. Until then, he was casting his research net widely. This included the archives of one of Florence's famous establishments, the Hospital of Santa Maria Nuova, a great monastery complex that had been a Renaissance pioneer in medical services and in patronage of the arts.

To reach Santa Maria Nuova, Milanesi traversed the narrow cobblestone streets of Florence, avoiding soldiers and pamphleteers at every turn. From the center of the city, with its great Renaissance cathedral and tower, he crossed several more city blocks to find the hospital, known by its ornate classical façade. Despite the Grand Duke's call to centralize Florence's historic documents, the hospital had kept its own small archives, made up mostly of leather-bound account books—a type of Renaissance artifact that had survived in abundance. During the Renaissance, Italy had been an economic power, a bookkeeping nation. No less a person than Petrarch, an early humanist literatus, noted that the young talents of that day "employed themselves in preparing such papers as might be useful to themselves or their friends, relating to family affairs, business, or the wordy din of the courts."[2]

The Hospital of Santa Maria Nuova, too, had had its share of bookkeepers. During the Renaissance, the business of the hospital was not only religion and medicine, but also to seek funding from businesses, guilds, or wealthy patrons for decorative and devotional artworks in its buildings. On arriving at Santa

Maria Nuova, what Milanesi found were the Renaissance-era ledgers that recorded the contracts for these artworks. They were the doorway to much lost art history, for the contracts provided names, dates, descriptions, and amounts of money. They suggested the rank of the artist, or how large a project had been.

On this particular day, Milanesi continued his probing through the ledgers. From the cramped shelves of the hospital archive, he took down one of many volumes dated 1439, a significant year in Florentine history. It was the year of the great Council of Florence, the last great effort of the Latin and Byzantine (Greek) churches to overcome their differences and unite as one Christendom. For much of 1439, the council had submerged Florence in ceremonial pageants and lavish spending. Milanesi surmised correctly that it had been a year of many local art commissions as well. From the archive shelf, Milanesi chose volume forty from that year and, after setting it on the table before him, he leafed through it page by page. Only an expert could read the archaic, often obscure hand-written notations, and Milanesi had the patience and an eye for such detail.

After reviewing page ninety-four, he turned to its reverse side. In the last entry at the top of the page, a date leaped out: September 7, 1439. On that date, Santa Maria Nuova had paid the painter Domenico Veneziano to produce a series of frescos for the hospital. Resembling an afterthought, the entry also said: "Pietro di Benedetto from Borgo a San Sepolchro is with him."[3] In the calm manner of a bibliophile, Milanesi felt the thrill of discovering something not known before. The ledger proved that Piero, son of Benedetto, had traveled from his home town of Sansepolcro to Florence, the center of the artistic revolution.

Here was the most significant document yet found on Piero della Francesca. The scribbled note provided the earliest date known for Piero's career. The discovery was a small revolution toward understanding that enigmatic Renaissance figure.[4]

The other man who walked the streets of Florence in that decade of Italian revolutions was a visiting Englishman, John Charles Robinson, a frequent visitor to Florence around this time. As Milanesi was documenting Piero's

life, and the Grand Duke of Tuscany was opening the Uffizi archive, Robinson was among the elite band of British buyers and collectors on the prowl in Italy for Renaissance antiquities.

Robinson traveled Spain and Italy as an art hunter extraordinaire. Trained as a graphic artist, he had put that aside to work on building England's collections of historical art. In his early thirties now, he was the head of art collections for the South Kensington Museum, which had been opened in 1851 in the aftermath of England's Great Exhibition of crafts and manufactures. Europeans had long beaten a path to Italy for its scenery and history—but, in this decade especially, also to buy antiquities.

In Robinson's era, the English had developed a sudden taste for early-Renaissance art, a style that was being put under the umbrella term "pre-Raphaelite," so-called "primitive" works done before Raphael and before the High Renaissance. One British dealer in Florence, writing home, noted that his gallery of hundreds of Italian works was amply stocked with "the sort of [p]re-Raphaelite paintings now so much sought after."[5] At the time, Piero della Francesca was just becoming known in England—sufficiently so, in fact, that shady dealers and auctioneers were palming off anything remotely looking Pieroesque as "a Piero." But for all practical purposes, the historical Piero was known only to a few elite connoisseurs and collectors. To everyone else, he was just one more Italian painter who had come before Raphael.

Quite by accident, Robinson helped Piero emerge from the crowd. This came in early 1859, when he returned to Italy on another buying spree. It was a time when Tuscany's break from the Austrian Empire was in full swing. "The country was in a state of war and revolution," Robinson recalled. Dealers and church officials were not letting their antiquities go cheap, it seemed, but they were eager to do business for cash. "The unsettlements of things in general afforded unusual facility for my purpose," said Robinson in a delightful case of English understatement.[6]

Indeed, buyers were acting so quickly before the Italian political situation exploded that "Florence has not had such a raking out as this within the memory of man," Robinson wrote home at the time.[7] Although the Grand Duchy of Tuscany, backed by Austria, had been easy enough on export permits for art, things would be different very soon when the patriotic,

revolutionary Italian government seized control of the peninsula. "There will be no more organ lofts or altar-pieces to be had," Robinson surmised. "The new government of Italy will preserve all these things most jealously."

Between 1858 and 1859, Robinson was nevertheless able to purchase and ship to England about fifty pieces of antique Italian sculpture, a significant addition to England's art collections from the Renaissance period. He had several ways of learning about the good deals in artifacts. One was the Monte di Pietá, a local bartering institution found in many towns, part of what he called a "national pawnbroking establishment of the papal government." He received tips about art objects here and there, some in Florentine churches, others in Pisa, and he would eventually go to Rome as well. By one Robinson account, he obtained an elaborately sculpted marble cantoria, a choir box. Having been alerted to some construction activity in Florence, he dashed to the demolition site, "obtained admission to the church, and succeeded in purchasing the *cantoria* for the Museum as it lay disjointed on the ground."[8]

Through contacts with the local dealers, the best of whom had amicable ties to the Grand Duchy, Robinson got word that a painting by Piero della Francesca, *The Baptism of Christ*, had been put on the market. On his trips to Italy, his primary goal had been to buy sculpture. So, on learning of the Piero, he wrote officers at the National Gallery in London to see if they were interested in a quick purchase. Receiving no reply, Robinson then inquired of a collector friend in England, who approved Robinson's efforts to obtain the work.

Robinson had been touring the Tiber Valley, visiting churches and convents in search of antique sculpture, and this finally led him to Sansepolcro, Piero's home town. The cathedral was replacing some of its old altar lamps, and the antique discards were just the kind of sculptures that perked Robinson's interest. The cathedral had been desperate for funds, so it had also put Piero's *Baptism of Christ* on the market. At first, the cathedral had tried to sell it to the Tuscan government as a piece of cultural heritage. That had failed, so other buyers were welcome.

When Robinson arrived in Sansepolcro, he found the ancient cathedral gutted, its furnishings shunted aside. "In spite of troubled times and universal penury, the ecclesiastical authorities of the place were bent on

'restoring' (in reality, desecrating with cheap [neo-baroque] bedizenment) the interior," he said.[9] He looked at the sculptural objects and was also shown the *Baptism of Christ*, for which he offered four hundred pounds, a goodly sum, since prices had been rising in Italy in these years of ferment. To hear the local fine-arts assessor, the *Baptism* panel painting—measuring four by six feet—was neither special nor valuable, so the cathedral had "a really good piece of luck" to sell it off.[10]

Once the government approved the sale, Robinson had the painting removed from its medieval-looking frame, and he prepared it for shipping back to London. By this time, another painting purportedly by Piero (and now deemed authentic) had already reached England, acquired by a couple traveling in Italy in 1837 for their private collection.[11] But the *Baptism* would be the first undisputed Piero original to reach Great Britain, and it would be the first for public viewing in the English-speaking world.

Its arrival on British shores was a very close-run thing.

The sale to Robinson took place in April 1859, the same month that Grand Duke Leopold II, in a bloodless coup, fled his Florence capital and an Italian contingent of Sardinian soldiers began to occupy Tuscany. Robinson's purchase and shipment of Piero's *Baptism* had been "concluded just in the nick of time,"[12] he wrote, dashing off another letter to England.

His own swift departure from Italy was the next pressing matter. Robinson and others had tried to depart by the sea route, but the chaos was already descending. Ocean travel was "all but cut off for passengers as the boats have been reduced in number by being taken off to carry troops and these that remain are so crowded that it requires a week or two's application beforehand to get a berth."[13] So his party took the land route due west to Pisa, and then apparently found the northerly Turin passage out of Italy open. From there, all roads led back to England. Of course, the inveterate art buyer Robinson was back in Italy again in the fall of 1860. But, as he had predicted, and as his traveling associate wrote home, "The exodus of works of art from Italy is to be and indeed is stopped" (though it was never stanched entirely, of course).[14]

In two years, after exchanging hands and going on the auction block at Christie's, the *Baptism* was hanging in London's National Gallery, an antique work that now reposed elegantly in a gold Renaissance-style frame.

It was as if Piero himself had escaped the revolution in Italy and, though strictly a regional painter in his day, had been resurrected onto an international stage.

Traditionally, such events as the Milanesi discovery and the National Gallery debut have marked the rediscovery of Piero della Francesca. His artistic works—altarpieces, frescos, and portraits—began to take a more central place in interpretations of the Italian Renaissance. Before long, he was being acknowledged as among the world's greatest painters (a phenomenon in human art appreciation that happens frequently, with Vermeer, Rembrandt, and Van Gogh as just a few examples of unknowns who suddenly became famous). And as befits great paintings, Piero's works would evoke a search for hidden meanings behind the painter's hand. His life became emblematic of a new kind of Renaissance craftsman. Piero was the artist as a Christian humanist who bridged the sciences with the arts and religion, and thus has become a figure who would seem relevant to many such encounters of art, religion, and science down through the centuries.

All such elevated visions of Piero, of course, inevitably must be wrapped in the messy, ambiguous, and contentious world of human affairs. In the artistic confusion of the 1850s, Queen Victoria herself plunked down eighty-four pounds at a Christie's auction to buy a pre-Raphaelite portrait painting she liked very much, barely noticing that it was by someone named "Piero della Francesca" (though, as with other not-quite-Piero paintings on the art market in that period, the Queen's picture was later found to actually have been done by the Flemish artist Justus of Ghent, a contemporary of Piero's).[15]

This was the same decade when Gaetano Milanesi and John Charles Robinson recovered aspects of the true Piero by entering, in one case, the dusty, arcane world of Renaissance archives and, in the other, the shifty and speculative world of a wartime antiquities trade. By luck and persistence, they pioneered a wider search for Piero by bringing new facts and art objects to light. After this, they went on to make significant marks on their fields: Milanesi became known as the founder of modern Italian art history; and

back in London, Robinson rose to be Surveyor of the Queen's Pictures, which he achieved by a brilliance born of worldly-wise enterprising, despite being "a difficult man, who plunged headlong into a series of violent controversies," and who eventually lost his South Kensington Museum job because, as his superiors reported, "whilst traveling at the public expense he had sometimes purchased works of art for himself and for his friends."[16]

After the 1850s, Piero himself gained increasing notoriety, and, for those who took an interest, it was almost always bright and admiring.[17] He would become one of the surprising stories of art history. He has become a unique window on the revolutions under way at the dawn of the Italian Renaissance, and on the transition between high medieval approaches to art and culture and Renaissance ways of thinking. Piero was a true offspring of that age, beginning with his artisan apprenticeship in the town where he was born.

PART I

CHAPTER 1

The Renaissance's Apprentice

On a hot Tuscan day in June 1431, nineteen-year-old Piero della Francesca stood in the dusty streets of his native Sansepolcro and admired his handiwork, a painted candle holder that was passing by in a religious procession. The candle was a small job, even insignificant. It nonetheless marked Piero's passage from novice to artisan, a painter who would be duly paid for his skills.

For one day every year, the procession of the Corpus Christi festival dominated the walled city of Sansepolcro, which had a population of more than four thousand. With a priest at its head, the parade was a sea of banners on poles, movable shrines, small statues, and candles, all carried by the townsfolk. At other times, these objects were permanent decorations in churches and chapels—a testimony to the dexterity of local artisans. Citizens in the parade also bore the emblems of Sansepolcro's guilds and the city's lay religious groups, called confraternities.

Piero had painted the candle for the Confraternity of Maria della Notte. In time, other account books in Sansepolcro would begin to list payments to Piero as a "painter."[1] During most of the Italian Renaissance, there was no

such thing as an "artist." There was only the carpenter, goldsmith, sculptor, or painter. Usually the painter was no higher than a baker or a mason, although some, called a "master" (*maestro*), were enterprising businessmen with street-side workshops (*bottegas*). High or low, the painters made their living by the support of patrons, the people who would commission, or buy on the spot, their various crafts.

As Piero would learn soon enough, patronage followed the general hierarchy of the late-medieval social order. At the top were the aristocrats and leading merchants, a relatively small number and, for the most part, the wealthier segment of the population that also organized the important confraternities in the cities. Then came the Roman Catholic Church with its many priests, monks, and nuns and its large public following that, while not excluding the elite, ranged mostly from workers to peasants. A senior painter, the maestro, received his commissions for altarpieces, wall paintings (frescos), and palatial decorations from the more elevated patrons, of course: princes, guilds, city councils, bishops, and confraternities. The average painter was more likely to have been decorating household objects for ordinary citizens. The social level best known by Piero was the growing class of ordinary merchants, tradesmen, and farmers; and, with the rise in prosperity, many of them bought terra cotta madonnas, decorated wooden trays, chests with scenes painted on their surfaces, family coats of arms, and small religious diptychs for their homes.

The toil, creativity, and exchange of money and goods among all of these classes produced in Quattrocento Italy a vibrant market-style economy yet unknown in Europe. The Italian peninsula became relatively rich. Its location on the Mediterranean Sea also made it a prospering crossroads of trade; a city like Florence became the banking house for Europe and for the papacy as well. The widespread homage to Christianity went without saying, for if the church was active anywhere on the Continent, it was on the Italian peninsula, home to the papacy and record numbers of clergy, lay groups, and designated saints. Nevertheless, a society counting its financial successes was beginning to demand more secular excellence. Society was changing in the Quattrocento, and so were the expectations in what a painter could, or should, do.

The skill of the painter, especially in attempts at realistic representation, was now being measured against what patrons saw in the commercial

marketplace: the new applications of mathematics and geometry. Standing on street corners, merchants divided investment percentages and estimated volumes in barrels of goods or piles of grain. As if by magic, builders turned square ground plans into octagonal structures, and surveyors measured plots of land by triangular calculations found in the principles of Euclid, the ancient Greek mathematician. Painters who could demonstrate such skills—painting the perfect illusion of geometric objects—were bound to be equally impressive to potential patrons.[2] To succeed in his mercantile society, Piero would need to learn a wide range of geometric skills, and his challenge was to merge these with his society's traditional tastes in religious paintings and decorations.

For all the merchant activity in Sansepolcro, Piero's town was by no means a bustling city like the relatively nearby Florence (about seventy miles by road). But for a country town, it was fairly cosmopolitan. In religion and in trade, Sansepolcro was a busy crossroad in the Upper Tiber Valley. It stood along small pilgrimage routes from the Adriatic. It boasted its own famous relic, a piece of rock from Jesus' tomb brought from the Holy Land (and the basis for the name Sansepolcro, or "holy sepulcher"). It was also an agricultural center for the cultivation and sale of the plant that produced indigo dye. The valley itself was worth visiting for its beauty, an arena surrounded by mountains, bisected by streams, paved with pale earth, and richly green in its native flora.

In Piero's family, the ancestral plot of land and house had been at the top of the Via Borgo Nuova in Sansepolcro since the mid-1300s. The house was inside the walls of the town, which, like so many Quattrocento boroughs, was a postcard picture of orange-tiled roofs and flat-topped lookout towers (campaniles). It was in Sansepolcro that Benedetto and Francesca, Piero's father and mother, reared a family of six children (counting two who died young). Benedetto had elevated the family from the farming to the merchant class. Formerly a tanner of rough animal hides, he had moved up to finer leather products, buying and selling land, trading in plant dyes, making architectural repairs around town, collecting taxes, and even making loans. In a town like Sansepolcro, family connections of both a religious and commercial nature were important. To the benefit of his sons, Benedetto had done well in this respect.

Piero's two youngest brothers became merchants. His closest sibling became a monk in the regional Camaldolese order, an influential religious movement alongside the Franciscans—both of which would provide social advantages for Piero's painting career. Being a merchant, Benedetto probably took his sons on business journeys south, to Perugia, or over the mountains to the east, where coastal towns such as Rimini and Ancona were friendly to Sansepolcrans.

As a parent, Benedetto had done his children one other great favor: he fathered them in wedlock. The Italian Renaissance, especially in higher social classes, was full of illegitimate children. These sullied offspring often had to be legitimized by special decree, from a pope or other authority, if the child was to eventually pursue the honors of a high-profile profession, become a ruler, or seek holy orders. In return for Benedetto's decency, the sons honored his good name by choosing respectable occupations. The exception, perhaps, was the dubious choice of Piero—as his eldest son—to be a painter, not a merchant or an educated cleric. This doubtless worried Benedetto, but Piero persisted. One day his name would honor Sansepolcro more than any other.

In the overall sweep of things, the local cacophony of the Corpus Christi procession in Sansepolcro was small compared to the shifting political fates of Piero's homeland. The Italian peninsula had set itself apart from the rest of medieval Europe. It was a world of small city-states, often defined by mountains or valleys in a rugged, partitioned landscape. It had preserved the Roman Empire's tradition of towns and legal courts, not the kind of feudal fiefdoms seen everywhere else in medieval Europe. By the 1400s, Italy's cities and the accompanying civil structure had replaced most of the old dynastic families who had once ruled the countryside. Filled with local pride, the cities waxed and waned. More often than not, it seemed that they were at war with each other over trade routes, land, and other resources.

Within this fractious type of culture, a unified Italian identity still tried to assert itself, and perhaps the most unifying cultural force of all was still religion. The Italian people had long had the pride of the papacy; but in

the early Renaissance, it was popular faith that had unified the landscape. The Franciscan and Dominican orders vied for popularity and influence in urban centers across Europe, but in Italy in particular they had brought about a peak in popular preaching. A new kind of large church to hold crowds had, in consequence, stimulated the need for more painters to decorate their vast walls and many side chapels.

All this church construction would have an impact on Piero's vocation, but so would the tenor of the religion of his day. Religious groups were trying to reform themselves from within, giving rise to stricter "observant" movements that espoused a return to the original precepts that had founded Christian monasticism. Such sources included the teachings of the early church fathers (who were drawn to Christian Platonist mysticism) and the legalistic Rule of St. Benedict, a pithy guide to monastic life and Christian charity dating back to the sixth century.[3] These spurred both the religious orders and confraternities to acts of piety, simplicity, and charity and public displays of flagellation, all of which were no doubt characterized in the Corpus Christi parade in Piero's home town. Piero's fate would be bound up with the confraternities for the simple fact of their strength in Sansepolcro. This prominence grew from two sources. As a small town, Sansepolcro was historically lorded over by other powers, from princes to popes, and con-fraternities were a local method to organize in a somewhat independent spirit. Just as important, the leading religious order in Sansepolcro was the Camaldolese, with its allied confraternities. Together they resisted the encroachment of the closest papal authority, the bishop of Città di Castello, who was constantly trying (but failing) to establish his clergy and a parish system in Piero's home town.[4]

Quite apart from these religious forces, there was another intellectual movement—and a distinct one for the Renaissance—that was coming to the aid of a stronger Italian identity: this was the revival of the literature, philosophy, architecture, and sculpture of the Greco-Roman past. Roman ruins that had been ignored for centuries now became objects of fascination to an emerging group of learned Italians, and the same applied to piles of manuscripts—medieval Latin copies of Roman originals—that had man-aged to survive, and yet were mostly forgotten, in the old monasteries that dotted Europe. On visiting the ruins of Rome around the time Piero was

born, the Florentine sculptor Lorenzo Ghiberti saw a statue unearthed from a sewer, proclaiming that "Our tongues cannot express the skill, the art, the mastery, the perfection with which it was done. . . . The head was missing, but the rest was complete."[5] Clerks in the papal court took up the hobby of searching out reported caches of old manuscripts. They jealously collected them and produced more copies as a kind of cottage industry. All of this recovery of pride in ancient Rome became a new esprit in Italian cities.

With eyes on both antiquity and the scriptoriums of modern book-keeping, the Italian Renaissance produced a unique literary industry. Before the Renaissance, the independent (and often isolated) monasteries had invented a medieval book industry, or actually the art of hand-copied and bound manuscripts, which had been amassed in monastery vaults for centuries. But a shift was in the making. Its primary sponsor was the centralizing papacy, which was now creating the largest bureaucracy of literate clerks yet known.

Although the traveling poet and courtier Francesco Petrarca, better known as Petrarch, pioneered the elegant Latin of the Renaissance humanists, there were many other aspiring scribes in his wake who, part monk and part scholar and secretary, filled the growing papal bureaucracy—indeed, the papal civil service. These growing bands would also master quality Latin, and later Greek. Apart from the revival of fine Latin, they would also transform the Tuscan dialect into modern Italian. And like the precedents set by Petrarch, they also unearthed, collected, translated, and multiplied the lost writings from the Greek and Roman past. The clerks who mastered these materials were to be called the "humanists," for they had trained in the new, though still informal, curriculum of ancient literature called the *studia humanitatis.*[6]

A third unifying force that worked against the natural fractiousness of the Italian people and their landscape was political in nature. It was the way that cities and old landed families would pledge loyalty to either the papacy or the emperor in Germany (now only a shadow of his days as Holy Roman Emperor). If at some points in medieval history this loyalty to the emperor or pope produced real political consequences, by the time of the Renaissance the effects had largely become symbolic. Old families, local princes, and the new town councils initiated by the growing merchant class were

the real power brokers. "Every city has its own king, and there are as many princes as there are households," Pope Pius II lamented in his memoirs. "We regard 'pope' and 'emperor' only as empty titles and figureheads."[7]

Such local powers had one obvious limitation, however, and that was the lack of a local army. Whether a city was an autocracy under a prince or a "commune" under a town council, they all needed a military protector. This necessity gave rise to one of the most colorful and dynamic figures of the Italian Quattrocento, the *condottiere*. He was a mercenary who commanded a roving army-for-hire, and, mounted on their horses, these soldiers became models for the equestrian statues and paintings of the Renaissance. The *condottieri*, too, were a kind of unifying feature in Italian culture, if only because they were everywhere, capturing the public imagination. These soldiers of fortune commanded armies for the emperor and the pope. Their leadership was an art form of bravado, in effect, because the actual "battles" of the time were mostly bloodless, carried out like maneuvers on a game board. Losers retreated, and winners took prisoners and spoils.[8] A good reputation in this kind of battlefield success could help a condottiere rise to fame and become a local prince.

Such had been the state of things in the Upper Tiber Valley where Piero lived. For a century, it had been part of an area that extended east to the Adriatic coast and was governed by one condottieri clan, the Malatesta in Rimini. Various popes, exiled from Italy, had commissioned the Malatesta to oversee these parts of the Papal States. From the 1370s onward, the Malatesta had "owned" Sansepolcro. They built the fortified walls around the town, and they oversaw the city up through the time that Piero painted the candle shafts for the Corpus Christi parade.

When it came to styles of painting in Quattrocento Italy, the fractiousness of the national character still seemed to apply. Pope Pius II may well have added that every city, to only slightly exaggerate, had its own artistic look as well. All Italian painting had added its own peculiar touches to a broad medieval milieu that had mixed the traits of Byzantine and French Gothic art, and now each city was going its own way. In Florence, which had imported a number of styles from across the peninsula, the newest was the imitation of Greek and Roman statuary and architecture, thus suggesting that Florentine art had a kind of classical and rational look. For its part,

Sansepolcro had a political affinity with Siena, which had indeed supplied Piero's town with a Resurrection altarpiece for its abbey (later to be the cathedral). The Sienese painters had developed a Byzantine-derived mystical look to their imagery, and that is what Piero saw in the main religious objects as he was coming of age.

A single style did not necessarily dominate a single city, of course, and Siena was a case in point. The painters of Siena had both a traditional and a "modern" approach, the latter of which tended to decorate its civic buildings. Siena had adopted the communal tradition of a town council and, accordingly, it had commissioned great wall paintings in the Palazzo Pubblico, or city hall, to express this governing ideal. Those ideals, and the style of painting, changed somewhat, as would be seen in the great murals that decorated the inner Palazzo. Around the 1320s, the painter Simone Martini painted both a condottiere who had saved the town and the *Maestà*, the enthroned Madonna, who effectively saved the citizens spiritually. Then, in 1339, the Sienese painter Ambrogio Lorenzetti completed a radically new kind of mural, a panorama of six frescos known as The Allegory of Good and Bad Government. For this project Lorenzetti pioneered a new naturalism in painting, unifying his landscape with an informal perspective not seen in the late-Gothic murals.

Piero may have seen Lorenzetti's modern approach in Siena. Just as likely, he might have seen innovations in painting on the trade routes as far south as Perugia, a journey of just more than forty miles, or even Assisi, where frescos revealed early experiments in perspective.[9] The essential Piero, however, was shaped by what he learned in Sansepolcro.

Italians had developed a variety of ways to educate their youth. While the wealthier families turned to church schools and Latin schools, the general population relied on an entrepreneurial phenomenon rising from the grass roots, the vernacular grammar school. Anchored on a local or traveling teacher, these schools met in homes or available buildings. Meanwhile, the commercial culture had brought another kind of teacher and school to the fore: the abacus school. It taught boys commercial mathematics.

Sansepolcro did not have a permanent abacus teacher, so it probably relied upon an itinerant.[10] Being the son of a merchant, Piero probably had two sources of learning: an abacus teacher; and the town market, where he saw buyers and sellers using calculation tables. He may well have honed his skills by doing his father's account books, but, as one historian of medieval mathematical arts has lamented, "We do not know when and where Piero learned mathematics."[11]

Piero's Italian roots certainly paved the way for such learning. In all of Europe, Italy had taken the lead in advancing the mathematical arts. At the start of the thirteenth century, Leonardo of Pisa (also called Fibonacci) returned from North Africa, where he had learned the mathematical notations of the Arabs. He translated this knowledge into the vernacular and produced the first handbook on mathematics, *Liber Abaci* (1202). At the heart of Fibonacci's work was the more ancient tradition of Euclid, the Greek geometer, and together their legacy in geometry (Euclid) and arithmetical calculation (Fibonacci) increased that learning in Europe.

The most available Italian version of Euclid's *Elements*, the translation by Companus of Novara from the middle of the thirteenth century (still used for lectures at Italian universities), eventually fell into Piero's hands (for his late-life writings cite Companus twice).[12] Much later in life as well, Piero would gain access to a rare copy of the collected works of Archimedes, the Greek geometer who had come after Euclid; Piero would become fascinated—even obsessed—with Archimedean calculations and the ways to draw the many-sided shapes called polyhedra.[13]

Alongside Plato, Euclid had built on the mystical Pythagorean tradition, which viewed numbers as the essence of the world. In Greek theology, such as it was, the gods made the world by number. "Number is the ruler of forms and ideas, and the cause of gods and daemons," said Pythagoras, the early Greek mystic and mathematician.[14] Plato was more specific: the Creator used ratios (such as 1 to 1.6, now called the "golden ratio") to organize the material world. The elements of the world were made of perfect solid shapes composed of geometrical units, such as perfect squares and triangles, with a given number of faces (such as a tetrahedron, which has four triangular faces, or a dodecahedron, which has twelve pentagonal faces). The Creator, Plato said in his *Timaeus*, organized life to move "in all the six directions

of motion, wandering backward and forward, and right and left, and up and down."[15]

While such ideas had a mystical side, they also proved eminently practical. One example is the Pythagorean theorem regarding the sides of right triangles (if you know the length of two sides and one angle, you can calculate the length of the third side). The theorem was logically proved by Euclid, who, as part of the Greek critical tradition, believed that demonstrable reasons must justify basic claims about reality.[16] In Sansepolcro, Piero surely witnessed how surveyors used the tools of Pythagoras and Euclid to measure his father's cultivated acreage, cementing for him how the math and geometry of the ancients could be applied in everyday life, to a world beyond matters theological and metaphysical.

Like many Renaissance figures, Piero would nevertheless combine his wonderment toward numbers with his Christian beliefs. From the thirteenth century, the Franciscan intellectuals of Europe had made mathematics no less than a divine science. In this, the monks were not shy about giving Pythagoras, Plato, and Euclid credit for finding in Greek science that which was also testified to in the Bible and the doctrines of the church.[17] This mingling of antiquity with Christianity would continue through the Renaissance. It was a way to universalize the Christian claim that the God of the Hebrew Bible was working in the hearts and minds of people everywhere, even apart from the biblical figures. As an intellectual venture, this overlapping of Greek thought and Christianity, typified by attempts to reconcile Plato's *Timaeus* with the biblical Genesis, was still mostly a topic for the monastery or university. In the backwater of Piero's upbringing, however, the undercurrents of Platonism still had some impact.

Such a Greek/Christian synthesis reached Sansepolcro by way of the Platonist-minded religious orders, beginning with the Franciscans. The Franciscans had a strong presence in Sansepolcro and Tuscany. Their great mother church was just fifty miles south in Assisi. Just as Aristotle was the pagan patron saint of the Dominican order, Plato served that philosophical role for Franciscan thinkers. This alignment was more due to historical accident than to any particular theological difference between Dominicans and Franciscans. The leading Dominican thinker of his age, Thomas Aquinas, was a friend of a leading translator of Aristotle's lost

works, and in them he found a wide range of philosophical categories on which to expand Christian theology. In turn, while the Franciscans were perhaps more mystically inclined than the Dominicans, a few of their leading thinkers in the Middle Ages believed that mathematics was the key to earthly science, and it was Plato alone (and his late-Roman expositor Boethius) who gave a fulsome treatment to mathematics alongside arguments for a Creator and the human soul.

Piero's early encounter with Platonism probably came from a source that was even more Platonist in spirit than were the ordinary Franciscans. This was the local Camaldolese order in Sansepolcro. The Camaldolese drew upon a desert monastic tradition that had adopted Platonist mysticism. And when it came to setting a spiritual tone in Sansepolcro, the supreme religious authority was the Camaldolese abbot, leader of the town abbey. The head of the entire Camaldolese order in Piero's lifetime was Ambrogio Traversari. A scholar of Greek and of Plato, Traversari was a leading humanist in Florence, where he convened great gatherings of the Italian men of letters. Piero's family had Camaldolese affiliations and, not least, his brother pursued his religious calling in that group.[18]

Too young to be a thoroughgoing Platonist himself, of course, Piero completed his grammar education (and presumably some abacus) around the age of fifteen. Then he began to meld his knowledge of math with craftsmanship, probably as an apprentice in a merchant's shop. Renaissance merchants were jacks-of-all-trades. They bought and sold. Their shops made and repaired things. Working with wood, plaster, stone, and cloth, these shops produced everything from the heavy scaffolds used by builders to delicate frames for artwork in churches. In this setting, Piero met the people who—short of being career painters—did a good deal of preparatory or repair work on the city's decorations: large altarpieces, sundry flags and banners, and stage settings for religious theater or visiting dignitaries.

Sansepolcro was not a large enough town to have an artisans' guild for painters, which often was the guild of pharmacists, with their chemicals and pigments. But there were at least two goldsmiths in town, and Piero surely had the opportunity to see an array of aesthetic objects. Judging by his future works of art, four particular objects made a lasting impression on Piero. By far the largest in any medieval town would have been the

great altarpiece, often with gold surfaces, pointy spires, and richly painted panels. These rose like alternative realities. Next would be religious statues of wood or clay, which Piero encountered in great number, as if human figures frozen in time, their faces and their robes painted brightly. Piero's eyes were also treated to the great city banners, with their bright, clear shapes, like posters. Finally, there was the town marketplace itself. In its precincts for wealthier shoppers, Piero viewed opulent new fabrics, shiny metals, jewelry, and leather goods. One day, Piero would draw upon all these visual memories and paint them with an unusual vividness.

Once Piero's father accepted that his son might end up being a painter, he had to look for a master painter and workshop to ensure that Piero received the best training. Where Piero actually studied is unknown, but it was most likely along familiar roads of commerce. The two adjacent territories were Umbria, with its main city of Perugia, and the Marches, which included mountain towns such as Urbino and the far busier coastal ports of Rimini and Ancona. Wherever it was that Piero found a master, the emphasis was on the master's authority. Like a brass stamp on wax, master painters of the Quattrocento impressed their methods and styles on apprentices. The apprentice could certainly be "fired . . . with ambition," said painter Cennino Cennini in *The Craftsman's Handbook* (c. 1400). Even so, he advised, "Submit yourself to the direction of a master for instruction as early as you can; and do not leave the master until you have to."[19]

Some masters became veritable celebrities as bearers of a new style, and this was the case with the Marches-born traveling painter Gentile da Fabriano.[20] Gentile's renown gave him wings. From Venice to Brescia and Mantua, he produced works for the most prestigious courts. In Florence he was welcomed into the painters' guild. At the end of his life, Gentile worked for the papacy as it began to restore decorative art to Rome. By all accounts, Gentile dressed like a humanist/nobleman—with rolled-up sleeves on his frock—not like a dour craftsman.

Gentile was the apostle of a style that would later be called International Gothic, which he brought to a peak. His use of rich, dark colors was a quite noticeable departure from the subdued tones of Byzantine and Gothic paintings. To this he also added glittering ornamentation and an almost literal description of nature, objects, and human characters. He further led

a revolution against using too much gold in the backgrounds of pictures, which had amplified the flattened look of the medieval Byzantine style. In its place, he painted vivid scenery with flora, fauna, and urban vistas. These backdrops were crammed with crowds and buildings and, still not using perfect perspective, odd and enchanting viewing angles.

Gentile would die in 1427, just as Piero began his apprenticeship. But his busy and decorative style had set the stage for newcomers. Even in his absence, Gentile might have been significant in shaping Piero as a painter, since some of Gentile's best students would be known to work with Piero after he left Sansepolcro. In ways such as this, Gentile would become the last strong influence in Italian painting before the rise of a new kind of visual revolution in painting—the use of linear perspective, with its emphasis on the geometrical forms underlying the visual world.

The use of linear perspective as an illusion for depth had ancient roots, and in this sense it has Roman origins. In 1414, for example, when Piero was around two years old, the humanists had recovered the ancient Roman work *De architectura*, written by Vitruvius Pollio before 27 B.C.E. From this, it was clear that illusionist perspective had been used in ancient times. Vitruvius marveled at the artistic "deception" in Roman theater scenery: "Though all is drawn on a vertical flat façade, some parts may seem to be withdrawing into the background, and others to be standing out in front."[21]

Before a work like the one by Vitruvius was uncovered, Italian painters had derived their sense of perspective by looking at samples in ancient art. In Florence, this kind of observation was pioneered by Giotto. Rounding his figures with light and dark, and using a more correct optical geometry, he revived a pictorial realism in early Renaissance painting. The same had been happening among a select group of painters in Rome. When Giotto's followers and the Rome painters converged in Assisi to paint inside the great Franciscan church, for the first time in centuries a true and correct geometrical perspective began to emerge. In all, from Giotto to Gentile, and passing through the Lorenzetti workshop in Siena, painters were attempting to create visual naturalism.

This combination of Gentile's brightness, Giotto's solidity, and ancient Roman perspective was hard to resist for a young painter like Piero, who probably was getting secondhand accounts of the new trends during his

apprenticeship. Wherever that training had taken place, it would have followed the kind of priorities put down a generation earlier in Cennini's *Handbook*, which taught that "the basis of the profession, the very beginning of all these manual operations, is drawing and painting."[22] Much remained to be mastered, as the *Handbook* further outlined: the application and sanding of gesso, tooling with stamps and punches, working with cloth, applying gold leaf, and transferring drawings to a surface. The painter's life was a highly material world, requiring knowledge of egg tempera for wooden panels, charcoal and ink for drawings and underpaintings, oils for binding paints, and flakes of gold for gilding. There was a whole range of pigments, many problematic or unstable, and some that were extremely expensive, such as the royal blue produced from crushed lapis lazuli stone. The most complex and heavy-duty task was making frescos. This required putting up wet plaster, rapidly applying watery paint, and then touching up after the plaster has dried.

When Piero returned to Sansepolcro, presumably with many of these skills under his belt, he still had to start out small. He painted the candle for the confraternity in 1341, and perhaps for the first time was paid as a painter. In that decade, however, the painting business in Sansepolcro—thanks to a new culture of patronage among a burgeoning middle class of bankers and merchants—was in for a surprising boom time.

In the previous few centuries in Italy, the lay people who donated money to religious orders, monasteries, and churches had typically designated it for the poor. That was changing in Piero's century. The patrons of his day were more likely to leave bequests to build chapels and tombs, decorated with art, after their deaths. In Sansepolcro after the 1420s, bequests such as these allowed the religious orders and the lay confraternities to generate major art commissions.

One such case brought Piero's life to a fortuitous crossroads. In Sansepolcro, the Franciscans had received a donation hefty enough to hire a carpenter to make a large wooden altarpiece. The structure had several panels (known today as a polyptych) that needed to be painted. After that,

it would be placed in the Church of San Francesco, a block from the town square. The Franciscans liked the late Gothic style already known in Sansepolcro, so they were in search of a master painter with "knowledge, art, and industry" in that milieu, someone skilled enough to paint "figures and narrations as it seems and are pleasing to said Friars."[23] Sansepolcro had no master painter. So when they looked beyond the town, they found a painter named Antonio Anghiari.[24]

As his name suggested, Antonio was from Anghiari, a smaller city just five miles to the south on the road to Florence. He arrived in Sansepolcro in 1430, bringing with him a large family. It could be said that Antonio made the shortest possible journey to Sansepolcro because, in fact, the flat valley road that connects the two towns is virtually a straight line. Antonio immediately found enough work to borrow money, acquire two houses, and open a workshop on a narrow street. As fate would have it, Antonio had arrived when the political turmoil of the region (in addition to local patronage) was generating a host of new projects. Most of the political turmoil was an extension of the big changes taking place in Rome, a city about a hundred and forty miles south.

When Piero was about eight years old—around 1420—the papacy had returned to Rome after more than a century of being elsewhere. For most of that period, from 1309 to 1377, the popes had been Frenchmen, prompting them to keep the papal court in Avignon, France, a stretch of time that has become popularly known as the "papal exile." After that exile ended, furthermore, the Great Schism (1378–1417) was thrust upon the papacy, a time when three popes claimed leadership. A single heir to St. Peter's throne would finally take up residence in Rome with the election of Martin V. His rule coincided with the death of the head of the Malatesta clan in Rimini, and therefore the governance of Sansepolcro was relinquished by the condottieri, coming back into direct papal jurisdiction. Now Piero, and Antonio Anghiari, would see a small bit of history in the making.

On April 1, 1430, the regional bishop arrived in Piero's town, and the first order of business was visual. He paid to have Pope Martin V's coat of arms painted on the four gates of Sansepolcro.[25] This was a job for Antonio. And as Antonio's workshop became busier, the talented young Piero was drawn into its orbit. When, in September 1431, Sansepolcro held its annual

festival, complete with horse race and civic pomp, Antonio painted the flags and banners; Piero is on record as fastening the horse-race flags to wooden poles.

By the end of his first year in Sansepolcro, Antonio had clearly taken on more projects than he could handle. The commission that seemed to never get done, in fact, was the very altarpiece for which the Franciscans had recruited him. As his loyal assistant, Piero had done the preparatory work. Once the carpenter had built the polyptych, a solid but rough wooden structure, Piero coated it with layers fit to receive paint. The enemy of all paintings—on panels or walls—was moisture that soaked through the backing. Painters used everything from reeds to old tablecloths as insulation under coats of gesso, a durable white medium of lime mixed with glue that provided the final surface.

In this task, Piero used a coat of charcoal—a carbon barrier—as the insulation against moisture. The charcoal coating had been standard in religious statuary, and Piero may have worked on such sculpted objects, both wooden and terra cotta, putting a layer of carbon on them and then painting the faces and colorful garb.

It was in late 1431 that Piero had probably begun to prepare, with charcoal and gesso, the Franciscans' altarpiece to be painted by Antonio. About this time, many of the town confraternities also began to show up at Antonio's workshop door. First off, the Confraternity of San Bartolomeo hired Antonio to paint a "seven labors of mercy" mural on the façade of its building on the public square. Then the Confraternity of Sant Antonio, whose men practiced flagellation, recruited him to decorate their chapel at the south end of town. As requested, Antonio topped it with a lovely blue sky, a difficult enough task, since blue paint reacts to the lime in wet fresco plaster (gradually turning greenish). So Antonio may have painted the blue on dried plaster, which made it more susceptible to peeling off over the years. At any rate, Piero watched and learned. To follow was the Confraternity of Santa Maria dell Notte. After seeing Antonio's work on the piazza, this group contracted to have paintings done on the façade of its Palazzo Laudi, a building next to the abbey. When Antonio put up frescos in its interior chapel, Piero worked at his side.[26]

Although Antonio was the designer of these projects, and he painted the dominant figures, Piero was beginning to show his hand. On this occasion,

he probably painted a good deal of the background and some auxiliary figures. As a person adept at geometry and observant of town life, Piero began to think how he would design his own paintings. The day would come, in fact, when he would begin to change the look of his home town, filling it with his art, a type of local influence unusual for notable Renaissance painters. Piero would paint at least three major altarpieces for Sansepolcro, and while it was hard to depart too radically from the medieval tradition, he always seemed to add an innovative feature. By one interpretation, he translated his vision of so much religious statuary in the town into a pictorial realism of statue-like figures in his paintings. And over time his use of rectangular pictures with half-circle lunettes—like great windows on the world—would alter the aesthetics of his tradition-bound city.[27]

For the time being, as an apprentice in the early 1430s, he could not veer from Antonio's style or direction. By the same token, Antonio could not veer from the tastes of his patrons who commissioned such projects. The contracts were drawn up in excruciating detail, setting sizes, fees, and dates. There was always room, though, for a patron to say something about wanting a "beautiful" end product.

For centuries, beauty had been defined by the classical and Christian philosophers as "proportion and brilliance."[28] The knowing of beauty, moreover, was presumed to be an innate power of the human mind, for, as the medieval philosopher Thomas Aquinas said, "A thing is not beautiful because we love it; rather we love it because it is beautiful."[29] With the help of a Platonist tradition that defined Beauty as a transcendent essence, Christian thinkers had combined theological views with classical ideas, and the end result was a Renaissance belief that beauty is a quality that is rational, objective, and based in metaphysics.[30] Such medieval writing on beauty was a rich body of material; but, granted, it was all in Latin and typically ensconced in the monasteries, universities, or wealthy courts that collected ancient books. Piero learned about beauty by observation and intuition.

For their part, the patron class of merchants and church leaders saw beauty in practical terms. For them, beauty was the use of royal blue pigment and gold leaf. Although Piero had to follow the tastes of his patrons, workshops of artists like himself had some written sources to stimulate ideas. These were the popular devotional works, some of which implied

descriptions of what is beautiful in the sayings of St. Francis on the Cre-
ation, for example, in the *Meditationes de Vita Christi*, a devotional hand-
book in which painters found descriptive stories they could try to paint.

The most scientific approach to beauty in the Middle Ages had arisen
in the attention to physical "optics," including the nature of the biological
eye. Such writings on optics had begun to circulate in humanist circles in
Piero's time, and much later in life he would write down his own barely
scientific version of what he had read, such as: "[The] eye, I say, is round
and from the intersection of two little nerves which cross one another the
visual force comes to the center of the crystalline humor, and from that
the rays depart and extend in straight lines."[31]

Such Pieroesque optics was for another day, however, so, as he worked
in Sansepolcro with Antonio, Piero's earliest musings must have been
theological in nature; he was wondering at how beauty was perceived by the
soul. Whatever beauty was, in painting it seemed to be evoked by optical
effects, and the most obvious of these caught Piero's attention. The seeing
soul, for instance, was taken by strong contrasts of color and brightness.
Some color combinations, moreover, were pleasing beyond words. Others
followed a law of opposition—such as the power of yellow and blue on a
banner, or green and red in a garment. We can only imagine what Piero
made of afterimages (when, after the eye sees bright light, it then sees dark,
or upon looking at red a long while, it sees green). Piero also found that
certain proportions among shapes were unusually satisfying, and, with his
aptitude for mathematics and geometry, he began to think that exacting
numbers were behind this kind of aesthetic power. All of this prepared him
for the day, perhaps, when he would be exposed to the doctrines of beauty
and proportion that filled the Latin texts of the classical and Christian
philosophers.

For the time being, though, Piero first had to focus on the more mate-
rial demands of his career, which meant sufficiently mastering the effect
of beauty in paint, for to please a patron was to acquire a reputation and
gain more interesting and profitable work. Pleasing patrons also required
knowing the popular theology of the day, to which most of them subscribed.
The painter's daily bread was the rendering of biblical stories, theological
themes, and the holy figures that were known to the public, or that the

public needed to learn about. Every successful painter thus became a quick study in religious iconography: the signs, symbols, and colors that stood for personages and beliefs of the Christian faith.

Every city, in turn, had favorite saints. Each had a history and symbol. The citizens of Ferrara would expect to see the patron St. George in their murals; in Ravenna, St. Apollinaire. Anthony of Padua could be known by his lilies or bread, St. Agnes by her repose with a lamb, and Bernardino of Siena by the three bishop's miters at his feet. Blue was the color of heaven, and it was always the color of the Virgin Mary's robes, whereas touches of yellow (hope), red (the martyrs), and brown (humility) were variously used along with many others. In Piero's Sansepolcro, the pilgrim founders Arcanus and Aegidius and their favored patron, St. Leonard, were a perennial topic, as was St. John the Baptist, patron saint of Sansepolcro, Florence, and not a few other cities.

Italy had become a veritable land of saints. Between 1200 and the mid-1500s, more than two hundred Italian saints would be canonized, twice the number from lands such as France and Spain and elsewhere combined.[32] Patrons were quite particular about the treatment of such figures, both local and historical. A guild of bakers who worshipped at Santa Barbara Church in Siena, for instance, required that its painter produce an altarpiece with two flying angels, "showing that they are holding the crown over the head of St. Barbara."[33]

Behind such amicable religious concerns, the entire world of Quattrocento patronage was actually a theological controversy in itself. This was because of usury, a lending of money for profit that the church deemed a sin. Merchants, bankers, and civic leaders profited under such a system, as did Piero's father in his own small way. The Renaissance offered an unspoken solution: paying for art in the church was suitable penance. The Florentine wool merchant and banker Giovanni Rucellai said that he commissioned paintings "because they serve the glory of God, the honor of the city, and the commemoration of myself."[34] He was also assuaging guilt. Patronage of the arts in Florence was particularly robust in this respect.

The day would come when Piero would look for patrons like Rucellai. To make the best of his career, he had to seek commissions from the courts of the great and the wealthy. As Antonio and Piero were painting small-time

banners and chapels, the great and wealthy were meeting up in Florence, where the papacy had just arrived in a cloud of political turmoil. It had arrived in the person of Pope Eugenius IV. The events around his sixteen-year reign (1431–47) would have an impact on the next stage of Piero's life in Sansepolcro, and on the development of his art and his way of thinking as he began to travel beyond his native surroundings.

CHAPTER 2

Florentine Crossroads

F lorence was not just the largest city near Piero's home town: it was one of the largest cities in Europe, and its traditional alliance with the papacy would be a great benefit to Eugenius IV, the new pope. The 1431 papal conclave that elected Eugenius had taken place in Rome, a sign that the Italian papacy had truly returned. And as ever, a new papacy had a domino effect on the peninsula.

In Sansepolcro, the city directed Antonio, its master painter, to change the papal insignia, a friendly-enough switch from red to blue on the papal chevron. In Rome, however, Eugenius's welcome was quite the opposite. The old families, such as the Colonna, could not stomach a pope born in Venice, so in 1434 they led an armed insurrection. Disguised as a Benedictine monk, Eugenius IV fled the city. He took a rowboat down the Tiber and eventually was met by a vessel from friendly Florence.

Safe in Florence, Eugenius still had to worry about Milan, which continued its bid to be the dominant power in the north. Milan's condottieri had been harassing northern towns that showed papal loyalty. In the most recent foray, these Milanese had penetrated the Upper Tiber and taken control of Sansepolcro, no doubt stripping away the papal insignias as part of the insult. Eugenius took his time, but, backed by his Florentine allies, he

finally mustered his own army. In early 1436, it expelled the Milanese and brought Piero's town back into papal jurisdiction. It was decreed that the city should again paint the papal emblem "above the four gates." Antonio was back on the job. He was paid to also make "six banners placed upon the fortified towers of the walls."[1]

When Eugenius had originally arrived in Florence, there was far more to see than a few colorful banners. He witnessed Florence's revival of classical architecture, sculpture, and painting. It had been in full swing for a few decades, and its first phase had been in the most public of art forms, architecture. At the start of the Quattrocento, Florence held a great competition to design new bronze doors for the octagonal Florence Baptistery, one of Florence's oldest buildings, erected in the eleventh century in the Romanesque style. In the final two-man runoff, both designs incorporated the new naturalism. Both employed shallow sculptural relief, realistic human figures, and a semblance of linear perspective. Lorenzo Ghiberti won this competition, but his rival, Filippo Brunelleschi, went on to still greater things: he won the competition to build a massive red-brick dome on the cathedral, one of the great architectural feats of all time.

As illustrated in the bronze doors, and in many free-standing statues, it was the sculptors who had introduced naturalism to the Renaissance painters by imitating Greek and Roman works. Outside Italy, to the north in Burgundy, realism in sculpture had also reached a peak.[2] Based on the work of such predecessors, the artisan Donatello brought this kind of sculpture to perfection in Florence. He and Brunelleschi had traveled to Rome to view the sculptures of old and—in Brunelleschi's case—measure the ancient ruins to understand Roman buildings and architecture, realizing that there was a geometrical element that contributed to what made these ruins so thrilling to behold. The painter who was most attentive to this new sculptural realism was Masaccio, a hulking young man who had arrived in Florence from the provinces. Masaccio revived the kind of earthy realism that Giotto's painting had shown a century earlier, and then he added a new visual dimension: the accuracy of geometrical perspective.

Neither Martin V nor Eugenius IV had been a great patron of the arts. Martin at least formed a committee to restore the basilicas in Rome, and painters did start arriving in that city in his wake. Eugenius made his first

cultural mark in north Italy. Coincident with his nine-year exile from Rome, he threw his support behind the humanist agenda at the University of Bologna, a city to which he moved for a time.

Eugenius's real preoccupation was the consolidation of papal authority in Christendom—and, naturally enough, a bit of Florentine politics as well. The year before Eugenius arrived, the aristocratic Albizzi family of Florence had persuaded the town council (the Signoria) and one of the key municipal officials (a *gonfaloniere*) to expel from the city its most powerful banker, Cosimo de' Medici, an Albizzi rival who had become a kind of economic prince in his own right. Under its communal system, though, the Signoria changed regularly. In a year, it was again leaning in Cosimo's favor, and he soon beat a triumphal return. On the day that Eugenius and Cosimo met up in Florence, they were two men who knew the sting of exile; they would soon be in business together.

Even before the exile of 1433, Cosimo was renowned as a patron of the arts in Florence. The most skilled craftsmen sought his financial support, as did the humanists, who aspired to collect and translate ancient texts, a task that required financial resources. Of humanists in Florence, there were two kinds: those who tended toward the secular, and those who embraced the religious. The exemplars were the secular Leonardo Bruni, at times a chancellor of Florence, and the monk Ambrogio Traversari, a leader of the Camaldolese religious order. Both were skilled translators of Greek. For more than a generation by this point, the Florentine government had been inviting Greek scholars to teach in the city. Bruni and Traversari had been among their most avid students. These two Florentines, however, were driven by different motives. Skeptical of popular piety, Bruni was interested in secular learning, patronage, and literary fame. If Bruni put the Greek speeches of Demosthenes and the political works of Aristotle into Latin, Traversari went in another direction, interested especially in Latinizing all the writings of the Greek Church's fathers. He wanted to claim the rich Greek heritage for the Church, and his skills in Greek translation easily matched those of Bruni.

In either case, the Church still set the agenda in scholastic and literary matters, and while Traversari was fairly safe with the impeccable credentials of a cleric, Bruni had to walk softly to avoid offending the religion of his day. Having been a papal secretary, he knew how to work Church circles for its patronage. When he translated Plato for one pope, he said it was to strengthen Christianity, while in reality he was trying to secure more funding for humanist projects. "Although Christian doctrine needs no help in this matter," Bruni advised this pope, the translation of Plato "will bring no small increase to the true faith if they [people] see that the most subtle and wise of pagan philosophers held the same belief about the soul as we hold."[3] In another case, Bruni translated St. Basil of Caesarea's "Letter to Young Men" for one obvious reason: the ancient churchman's Greek epistle encouraged the study of great pagan literature. Bruni's dissembling contrasted with Traversari, who truly believed that the ancient Greeks were precursors of the Christian faith. Though a worldly banker, Cosimo had no grudge against the strict religious groups, and he often gave them patronage.[4] When he wanted a set of Plato's writings translated into Latin for his personal library—a compendium called the *Vitae philosophorum*—Cosimo turned to Traversari for the task.

Like Bruni, Traversari moved easily in the city's intellectual circles. From the early 1420s, he had convened leading humanists at S. Maria degli Angeli, the headquarters church of the Camaldolese. When, in 1433, he completed his translation of the *Vitae philosophorum*, Traversari gave Latin Christendom its first accessible book on Plato's original works and on the works of his late Roman interpreters, the Neoplatonists. Traversari also gave Plato an honored place in the Church: his introduction said that Plato is "largely in agreement with Christian truth."[5] Two years before, Traversari had been made head (prior general) of the Camaldolese order, and now he was poised to usher in an even greater Christian openness to Platonism.

In his flight from Rome, Pope Eugenius would bring his own Platonist to Florence in the person of Leon Battista Alberti, a learned clerk and secular priest in the papal Curia.[6] When Alberti wrote his own autobiography, he presented himself as the quintessential Renaissance man, interested in everything, comfortable with fame, and very much at home in the world. Displaced by the Colonna revolt in Rome, Alberti and many of the other

clerks had made their way up the peninsula to rejoin the pope. Alberti had been educated at Padua and Bologna, and he traced his ancestry to Florence, from which his family, too, had been exiled. He had visited once briefly to see the new artistic revival. Now, as part of Eugenius's entourage, he became a kind of honorary Florentine (though he traveled a good deal with the papacy, and finally spent most of his career in Rome). Awash in the arts of the city, Alberti almost immediately produced a small treatise that one day would probably inspire Piero. It was titled *On Painting* (1435).

In marveling at the success of Florentine painting, typified by the naturalism of Masaccio, Alberti naturally gave credit to sculpture as its precursor. *On Painting* opens with praise for the "genius" of Brunelleschi and Donatello. For the time being, Alberti gave genius status to only one painter, Masaccio, whose Florentine frescos on St. Paul in the Brancacci Chapel and the *Trinity* in Santa Maria Novella Church employed realistic modeling and geometrical perspective. *On Painting* went well beyond the kind of how-to *Handbook* produced by Cennini three decades earlier. A refined humanist, Alberti had the rhetorical skill necessary to improve the social status of painters. For the first time in Italian literature, he put them in the company of men of letters instead of confining them to the status of tradesmen. He described painting as having religious-like powers—"a truly divine power," Alberti said—and he encouraged painters to see themselves as part of a new cultural class.[7]

As Alberti wrote *On Painting*, Antonio and young Piero were still two rough-hewn craftsmen stacking up commissions in Sansepolcro. In one of them, a set of frescos for a new chapel in the town's Santa Maria dell Pieve Church, Piero showed off his prowess in the painting of human figures: Antonio did the principal characters, but Piero did two of the three saints, Santa Fiora and Santa Lucilla. Centuries later, viewers of his two female saints described them as among Piero's "most beautiful and praised works."[8]

In his mid-twenties now, Piero was ready to work on his own. His family connections, and the misfortunes of Antonio, opened the way. Antonio's

contract obligations were not going well. Six years earlier, the Franciscans had paid him for their altarpiece, and yet the naked structure still sat in their church. Antonio had simply been overwhelmed by too many projects, or at least that has seemed the most plausible reason for his troubles. Accordingly, the Franciscans revoked his contract, and the old painter left for nearby Arezzo, five miles away, to eke out a living for his large family. Piero had learned a great deal from Antonio, but the hour had come to claim his role as Sansepolcro's native talent.[9]

About this time, the church of Benedetto's affiliation, San Giovanni Battista, was also embarking on a large decorative project. One of the church's members had left money to build a wooden altarpiece. Another church family, the wealthy Graziani, had meanwhile offered to pay for a painter, receiving in return the honor of having the Graziani coat of arms appear on the finished work. Now viewed as a young maestro, Piero was chosen to do the painting; it apparently would be his first major commission.[10] Since the church's patron saint was John the Baptist, Piero had to compose an image that featured him prominently. Thus was conceived the painting to be known as the *Baptism of Christ*. Not only would it make John the most dynamic figure in a story about Christ, it would mark a small revolution in the visual culture of the Renaissance.

Already, Italian painters had begun to tell biblical stories in contemporary settings. For a baptism story, Piero needed a Jordan River scene, so he used the Tiber River headwaters of his own valley as a worthy substitute. In first-century Roman times, the imperial magistrate Pliny the Younger had described the view on Piero's valley from the mountains as "looking not at the landscape but at some painting of a scene of extraordinary beauty."[11] Pliny was suggesting that even nature could be idealized, enhanced, or abstracted into an "extraordinary beauty" in the proper hands. Mindful of this potential in painting, as if penetrating the normal world to discover its spiritual, or Platonic, essences, Piero combined both nature and something more in the *Baptism*, an early hint of where his lifetime oeuvre was heading.

The altarpiece structure allowed for a painting six feet tall and four feet wide at its center. Piero would give the panel a semicircular top. To make this painting's support, Piero obtained two wide planks of poplar. He joined and smoothed them and applied layers of gesso. Piero may have

done sketches for his composition; but rather than stencil them on the gessoed surface, he composed his drawing directly. Then he prepared his egg tempera paints. His first color was a green underpainting, a technique preferred as a base for skin tones. Such a project required a painter's environment, a space both organized and messy. At the time, Piero was probably renting workshop space along with his brothers on a street in Sansepolcro.[12]

The years of the *Baptism* project, beginning in 1438, remain a mystery. During that time, Piero made a trip to Florence. It was there especially that he would learn more about the great debate over artists using perspective to imitate nature. In Florence, he may have heard of *On Painting*, and probably found himself agreeing with the premise that the painter was someone more than a mere craftsman. In Florence's busy streets, workshops, or humanist gatherings, Piero may have met Alberti himself, who was only eight years his senior.[13]

Despite their common interest in the visual crafts, there was nothing obviously in common between two men like Alberti and Piero, especially looking at their educational backgrounds. The difference could be illustrated by one Latin word: *perspectiva*.[14] During his life around merchants, or among painters, Piero may have heard this Latin term dropped amid the Tuscan vernacular. To his ears, it simply meant, broadly speaking, "seeing." By contrast, Alberti had learned Latin at the northern universities and had read entire treatises titled *Perspectiva* (even though, for some unknown reason, Alberti would not use the term in his two writings on the practice of drawing in perspective, whereas Piero would enthusiastically adopt the term late in life in his own work, *On Perspective*).[15] This seemingly simple concept would, in hindsight, become one of the most contested and debated in the history of art. Its roots were fairly ancient, and the start of its actual application as a technique in painting was a bit obscure. In other words, who "invented" the perspective that is said to characterize the Italian Renaissance?

By the time of Alberti and Piero, the search to understand what the ancient Greek geometer Euclid had called "optics"—in his treatise

Optics—had been under way for several centuries. Using what remained of Euclid's lost works, the Christian statesman Boethius, in the late Roman period of the sixth century, translated the term "optics" into Latin as *perspective*, and the word would come to mean all aspects of sight: physical, geometrical, mental, and metaphysical.

The full recovery of Euclid's *Optics* was achieved by the Arabs, who came into the possession of Greek manuscripts that had survived the Western dark ages by being carried to the East. The Arabs made advancements on Euclid by studying how light behaved geometrically and emanated in all directions from objects. In his book *De aspectibus*, the Arab polymath Alhacen refined this emanation theory. He proposed that rays of light radiated from *points* on objects and arrived at corresponding points in the eye, a basic idea that has been confirmed by modern physics and biology.

In Europe, a group of learned Franciscans absorbed these Greek and Arab insights. They produced a new geometry and physics that was steeped in theology and that viewed light as the originating source of the universe. All of this was summarized in the work of the English Franciscan Roger Bacon's *Perspectiva*, which set an agenda for the Latin natural philosophers (scientists), and indeed would be known as "Franciscan optics," so influential were members of the order in exploring the topic. When Alberti entered university in north Italy, he would be reading textbook treatments in the Bacon tradition by two later writers, Erasmus Witelo, a Polish cleric in central Italy, and the English Franciscan John Pecham, who worked in Paris and whose text *Perspectiva Communis* was especially influential in the Quattrocento.[16]

None of this optical science could escape the religious and metaphysical context of medieval culture. In its early development, the optics of the Arabs and Christians easily mixed with such Platonist concepts as the divine nature of light, its role in creation, its procession by emanation, and the geometrical nature of the universe. St. Augustine, a sophisticated Roman philosopher, popularized the idea that physical light was a perfect analogy for the mind's seeing spiritual light. During the Quattrocento, the orders of preachers were especially eager to draw upon the new optical science. It was the last great century of popular preaching in Italy, even in its cities, and as perspective-style painting emerged, sermons pointed to it as an example of

how humans can see the world as God sees it—clearly, geometrically, and in perspective.[17] Florence had its champion of these ideas in the Dominican Antonino Pierozzi, a theologian and orator "of marvelous eloquence."[18] Soon to be archbishop of Florence, he preached divine optics, he moralized vision, and he discussed these finer points with the city's artisans as they produced altarpieces and frescos.

At the start of the Quattrocento, therefore, the idea of perspective was caught up in several driving cultural forces, from religion and geometry to experiments in architecture. The surviving records of the time, unfortunately, do not reveal exactly how technical perspective was rediscovered and promulgated in the arts. The logical place to start has rightly been with the Florentine architect Brunelleschi. As early as 1413, Brunelleschi was being spoken of as "an ingenious perspective man."[19] This may simply have meant that he was interested in the theological and geometric topics that were suggested in the *Perspectiva* manuscripts owned by humanists or were heard about in sermons. Whatever the timeline, Brunelleschi's knowledge of practical perspective surely had grown. As perhaps the world's first "paper architect" (since others used wooden models), he very likely had been an early user of technical methods to draw in linear perspective.

At some point, Brunelleschi conducted two visual experiments in his neighborhood. This was the precinct that included the Florence Baptistery, with its surrounding piazza. Famously—yet known by only one account—Brunelleschi had positioned himself across from the Florence Baptistery and, somehow using a mirror, drew and painted the Baptistery building in accurate linear perspective. On a second occasion, he drew another picture, the angled view of a building across the street from the Baptistery, which was also an illusionist success.

What Brunelleschi had done in his drawing method was apparently something entirely new. According to his biographer, he had discovered a "regola" for perspective, a term used for a method that solved a mathematical problem.[20] In other words, he had found a geometrical principle for drawing anything in correct perspective, via a formula of visual points, lines, and angles. Brunelleschi may have stumbled upon this formula quite by accident. He could simply have been drawing the Baptistery for

a neighborhood banner when the geometrical properties of painting in perspective leaped out at him.[21]

Although perspectiva, or "real perspective," had been around for a long time, Brunelleschi had invented what would be called "artificial perspective," a drawing technique that would revolutionize Western painting. When Alberti dedicated *On Painting* to Brunelleschi and called him a genius as well, he may have been referring to the latter's invention of a new technique for drawing; however, Alberti did not say so. *On Painting* presents Alberti's rules and methods as if he were the inventor himself. Years later, Brunelleschi's biographer, Antonio di Tuccio Manetti, felt it necessary to proclaim his friend's priority—"through industry and intelligence he either rediscovered or invented it"—probably because the circulation of *On Painting* seemed to give Alberti pride of place.[22]

As a humanist scribe, Alberti had avoided making *On Painting* a technical treatise. He wanted to make his work readable. For most of it, he waxes eloquent, adding references to antique writers, myths, and literary sources. Behind it was an Albertian view of the cosmos that was both Pythagorean and Platonist, viewing perception and nature as having roots in the divine laws of number, proportion, and harmony. Having done a little painting himself, Alberti infused *On Painting* with enough methodology to make it the first-ever instruction book on perspective.

On Painting begins with a Euclid-style description of what makes forms—points, lines, and surfaces. Then Alberti takes Euclid's idea of vision being like a triangle, with its apex at the eye, and expands the visual concept to a pyramid. Adhering to Euclid, he explains that objects become smaller in the distance because the angles of the visual rays in the eye become smaller. He then presents a pyramid of vision made up of one central ray and countless peripheral rays (prescient, since modern science would make the biological distinction between a tiny spot of central vision and a larger peripheral vision). For Alberti's purposes, the central ray locates the "centric point"—a point on the horizon directly across from the viewer. The centric point was the key feature in what became known as the "Alberti diagram" for drawing perspective. All perspective lines met in the point, and, by the same token, the viewer's distance from that point established additional "distance points" to draw with optical accuracy the lines that went crosswise.

Alberti's emphasis on rhetorical eloquence meant that *On Painting* did not exactly spell out a step-by-step method for drawing perspective, leading to confusion even today on what precisely he was saying. Less known, he also wrote a smaller work, a two-thousand-word tract titled *Elements of Painting*, which provided the kind of clarifying diagrams that were lacking in *On Painting*.[23] Nevertheless, *On Painting* presented a simple enough starting point for most people to understand: the starting point was Alberti's vision of the earth's surface as receding like the lines and squares on a checkerboard. To visualize this, he speaks in terms of floor tiles, something relevant to painters, showing how they decrease in size and angle as the floor spreads into the distance. With this, he corrected a few erroneous practices by painters, who had simply claimed that each tile shrank by a third as the floor receded.

Alberti's most practical suggestion, though, was for the painter to think of his flat painting surface as if it was a window being looked through. The visual rays for seeing an object have an "intersection" point with the window, and this allows the painter to draw "the external lines of the painting" based on a "recording of the outlines" of objects that are seen.[24] It is a method later to be called Alberti's "legitimate construction," though it may have been used first by Brunelleschi to draw the Florence Baptistery. It was a practical optical method that would be built upon by Piero, Leonardo da Vinci, and the German artist Albrecht Dürer.

Based on this points-on-a-window concept, Alberti further recommended that painters create a handheld grid (made of threads) to hold up and visually transfer objects to their exact places on the checkerboard scheme in the painting. Already, painters were using stencils or other methods to transfer a shape or drawing onto a wall or panel. With a grid method, though, Alberti was offering a tool that was both practical and theoretical (since it presumed a geometrical theory about visual rays intersecting a plane). Without using such a visual grid, he claimed, it was impossible to correctly draw the figures, objects, and buildings precisely as they are seen in the visual field. A generation later, Leonardo da Vinci would state the concept using a different see-through medium: "Perspective is nothing else than the seeing of a place behind a sheet of glass . . . on the surface of which all things may be marked that are behind the glass."[25]

Alberti dedicated the rest of his brief treatise to citing the ancients, talking about the good use of color, and encouraging painters to tell great stories with action and emotion (*historia*)—and, in their own lives, to be exemplary persons. Alas, he decided to skip the debates on biology, "the functions of the eye in relation to vision," as he said. "This is not the place to argue whether sight rests at the juncture of the inner nerve of the eye, or whether images are represented on the surface of the eye."[26] The biology of vision would be a frontier of discovery delayed for another few centuries. For now, Alberti made the idea of looking through a window a classic Renaissance definition of a painting.

Over in Sansepolcro, meanwhile, Piero's painting of the *Baptism of Christ* was shaping up very much like a great window, and even like walking through a door into the scenery itself. He was also producing a historia painting with all the marks of the new Renaissance naturalism. In color, form, and perspective, the painting told the tale of the coming of the Messiah. As that project got under way, another story of historic proportions was reaching a dramatic crescendo, driven by a desperate effort of Christendom to unite its disparate parts against the expanding empire of the Ottoman Turks.

For a half century, the Byzantine Empire, home of the Greek Church, had already been in rapid decline. It had been losing territory to the Muslim Turks from the edges and was simultaneously suffering internal decline from a lack of revivals in the Church and a dysfunctional royal dynasty. The Byzantine emperor, John Palaeologus VIII, would do anything to save his capital, Constantinople, from Turkish conquest. But before the Latin Church could talk seriously with the Greeks about a military defense of the East, or political unity of Christendom, it had to put its own papal house in order.

Around the time that Brunelleschi had done his Baptistery experiments with perspective, the cardinals of the Catholic Church had resolved the Great Schism, with its three rival popes, by agreeing to a single pope in Rome. This decision, made in 1417 at the Council of Constance, came with

a major caveat: the pope had to hold regular councils with the cardinals (from many countries) to share power. An autocratic papacy was naturally reluctant to concede, but shrewdly went along. The multi-year council sessions continued, taking on new names each time, now in Constance, now in Basel, now in Ferrara.

At the outset of his own reign, Pope Eugenius IV realized that the Council of Basel, as it was going, would undermine his power. So he negotiated with Cosimo de' Medici to move the Council to Florence.[27] Around the time that Alberti unveiled his *On Painting*, the city of Florence voted to fund preparations for the great council. Some Latin clergy, in fact, started sending personal luggage there. Then Eugenius switched: with the Milanese condottieri controlling the roads between Basel and Florence, he decided that Ferrara was a safer choice. It was an elegant city, fortified with walls and surrounded by a fruitful countryside. Most important of all, Ferrara was near Venice. It made for an easier journey for the Greeks to come to Italy to continue talks about the unification of Christendom under the papacy.

This assertion of papal authority was bold and risky, and Eugenius needed all the allies he could summon. For such a project with the Greeks, it was not surprising that three of his most stalwart supporters were Hellenists, scholars of the Greek heritage. Two of them were Latin churchmen. Abrogio Traversari of Florence was widely known, of course. The second was a young, up-and-coming German theologian, Nicholas of Cusa (Cusanus in Latin), who, as a scholar of the Greek language and Platonist thought, had been appointed as a chief negotiator with the Greeks. Eugenius's third ally was on the Greek side, the scholarly priest Basilius Bessarion of Nicea. In preparation for the Council of Ferrara, Cusanus and Bessarion would travel much, and, when the council commenced, Traversari and Bessarion were drafting its decrees in the Latin and Greek languages.

To make the council a success, Pope Eugenius was also willing to empty the papal coffers. The expenses were massive, beginning with a fleet of ships to collect the Greeks (and a small army the pope paid for to protect Constantinople while the Byzantine leadership was in Italy). Embarking from Constantinople, the fleet carried seven hundred Greek delegates on their long, delayed journey: first to Venice, then by river or horseback to Ferrara. Cusanus was the Latin diplomat on deck during the storms and tedium of

the ocean journey, there to shepherd the Greek flotilla to its destiny. When the council finally convened, the chief authorities were Pope Eugenius IV for the West and, for the East, Byzantine Emperor John VIII and the Greek Church's Patriarch Joseph. Hundreds of others were constantly at work, including an exhausted Traversari. "It is I who do all this business of the Greeks, translating from Greek into Latin and from Latin into Greek all that is said or written," he said.[28]

The policy sessions began in spring 1438, but a rise of the plague that summer—in Ferrara, Bologna, and Florence—put the entire council in doubt. Slowed by precautions, the council also ran out of money. A now-hesitant pope (who first eyed Venice as a plague-free place to move the council with the Greeks) looked to Florence for help. The Medici and the town council were already reaching out. They offered to pay for a continuation of the council in Florence. Once Eugenius persuaded the reluctant Greeks, promising a four-month cap on the proceedings, the separate entourages of the pope, emperor, and patriarch began to reach the gates of Florence in January 1439.

The pope and emperor were received with great pomp—the emperor arrived on Carnival day. It was a visual feast, by all accounts. Florentines already dressed brightly. The ornate white garb of the Latin clergy was quite elaborate as well. To the Italians, the secular Byzantine officials and higher Greek clergy were an equally marvelous sight. Clerics wore copes of blue with white and purple stripes. Statesmen donned ankle-length robes with great sashes. Their drooping hats were of gray felt and red silk. Perhaps more than these, the Florentines gawked at the general clerical garb of somber black, topped by Greek stovepipe hats with black veils. In the clean-shaven times of Quattrocento Italy, the Greek beards also were wondrous to see—a feature still universally painted on Christ but, in real-life Italy, a taste of something exotic.

On the Greek arrival, Florence was not only in full bloom with its new artistic commissions, but with the humanist enthusiasm for Greek literature. The city chancellor was the literary wit Leonardo Aretino. He addressed the Greeks twice in their native tongue. In the months that followed, the booming voice of Bessarion made an array of official statements. The Greek emperor with his pointed beard wore, by turns, a tall hat with

a great jewel or a hat with a long beak-like point. There was plenty more spectacle and drama. At the height of the council, the aged Greek patriarch died (as would Traversari unexpectedly, though it was not until shortly after the council, a time of retreat at a Camaldolese monastery). In Florence, festivities always went ahead. At the end of June, on the Feast of St. John the Baptist, patron saint of the city, a few thousand council delegates jostled through two days of raucous street festivity: processions, displays of wealth, music, banners, effigies, and street theater.

Florence celebrated another great holiday on July 6. Businesses closed and the population flocked to the cathedral piazza, where the pope and emperor, under Brunelleschi's dome, decreed a union that ended 437 years of division—in word, at least. The emperor stayed another month. Then he was escorted under a canopy in a regal procession to the city gates, beginning the long journey, by way of Venice, back to Constantinople.

Six days before the emperor's ship left Venice (departing on September 13), the Hospital of Santa Maria Nuova paid the painter Domenico Veneziano for his work on frescos in the choir of Sant' Egidio Church in the hospital complex. And as the records show, Piero was "with him."[29] Piero had seen plenty of festivals back in Sansepolcro. Bright banners and costumes were nothing new. Even so, Florence must have been visually stunning. His visit would have an impact on his future paintings, where he would feature oriental-style costumes and, as interpreters would suggest, symbolize the tribulations of the Latin and Greek churches.

A year before the Council of Florence, Domenico Veneziano had been in Perugia, having traveled there from his Florence base for a painting commission. From Perugia he was trying to reach a traveling member of the Medici household, Piero de' Medici, in hopes of securing a painting commission back in Florence. Domenico assured his Medici patron that he could produce "marvelous things."[30] When Domenico returned to Florence, he would instead be employed by the hospital, which wanted a large fresco. Domenico probably began that project, a series on the life of the Virgin Mary, at the start of 1439, meaning that the fresco was going

up as the Greek and Latin delegations swarmed into the city. For some art historians, though not all, the notation about Piero della Francesca being "with" Domenico in Florence, and by implication working alongside him on the hospital frescos, provided an image of Piero as being established in Florence as a teenage apprentice, a view that is now in serious doubt (as this book suggests).[31]

Being "with" Domenico is probably more pertinent to Piero's evolving style than to where he did his apprenticeship. Domenico was apparently a very animated figure. Born in Venice, he had been trained as a painter in Rome and Florence, the city in which he finally settled. His bold use of color and light had been nurtured by working under the late-Gothic colorist Gentile da Fabriano. Along the way, Domenico had also learned of the new classical look, with architectural perspective and realism in human figures. His style would eventually become a benchmark in vivid, solid painting, as evidenced in his (one day to be famous) *St. Lucy Altarpiece* in Florence. The picture is a tableau of sunlit color. The figures of the Virgin, child, and saints occupy a Renaissance loggia, its tiled floors, arches, and columns all in perspective. The painting represented a Domenico style that, according to art historians, seems to be a precursor of the mature style that Piero would develop.

By an early dating of Piero's birth, Piero may have been just two years younger than Domenico.[32] While not having the prestige of Domenico's Roman training and Florentine connections, Piero may have worked with him as a peer, and certainly not as an apprentice. Therefore, in the Florence of 1439, Piero could well have been standing in as an able painter helping with Domenico's large commission. The chronicler Vasari would alternatively report that the two had actually painted together on the east coast of Italy and in Loreto, where they had fled the plague. This period after Florence may have been the time in which Piero absorbed some of Domenico's style.

Whatever the actual relationship and chronology, there is documentary evidence that Piero had been in Florence in 1439. Like anyone who visited, he was struck by the city's artistic developments, which may have included seeing Alberti's *On Painting*. Alberti had written a version in the Tuscan vernacular, but it was probably only in very limited circulation. It would

have been hard for Piero to obtain and read a copy, but the message of *On Painting* was no doubt circulating among the Florentine humanists whom Piero would meet. Not only had Alberti extolled the "virtues of painting," he had asked society to elevate the status of painters who achieved excellence in the use of perspective, color, form, and historia,[33] a sentiment that Piero and Domenico would have only found pleasing to their ears.

During Piero's unspecified time in Florence, the theological dimensions of the Council were surely not lost on him either. He could be excused if some of the theological subtleties escaped his attention: the council debated the bread used in the Eucharist, the Holy Spirit's procession (from Father or Son), the Latin doctrine of the existence of Purgatory, and the authority of the papacy as heir to St. Peter, the first bishop of Rome. Regardless, in the context of the council, Piero could not have missed the enthusiasm for all things Greek, including the strong doses of Platonism that pervaded humanist and artistic circles.

Greek thought had arrived in Italy in waves. Depending on the era, it came as mere ripples or with tidal force. The lost works of Aristotle arrived first. When a friend of Thomas Aquinas began translating Aristotle from the Greek and Arab sources, Aquinas produced his *Summa Theologiae* (1268–73). It was an entirely new system of Christian thought based on Aristotle's categories. For Aquinas and theologians before him, four categories of Aristotle were particularly helpful: the idea of an ultimate cause; the distinctions between substance and accident; the relationship of potentiality and actuality; and Aristotle's view that each kind of existence has a "form" that determines its purpose and direction. Such ideas began to underpin Church doctrine. For instance, the Church explained the supernatural power of Eucharistic bread by saying Christ is its substance while the wheat flour is its accident (appearance). Similarly, God as Creator is not only the first cause (falling under Aristotle's category of "final" cause), but also absolute actuality. By contrast, Creation merely exists in various degrees of potentiality (finally actualized by their inherent forms or by divine intervention).

By the time Dante died in 1321, Aristotle and Thomism had become the somewhat official philosophy of the Catholic Church. Soon after Dante was gone, the young Petrarch—who was about seventeen when

Dante died—came to loathe the Aristotelian hegemony in the universities and schools, with its dry, logic-chopping approach. Unable to read Greek, he was nevertheless inspired by Plato's "divine torrent of eloquence" in Latin translations. He also found Plato implicit in the teachings of Augustine, who had said "There are none who come nearer to us [Christians] than the Platonists."[34]

With the Quattrocento, the Greek language barrier was finally being broken in Italy. The crumbling Byzantine Empire jettisoned caches of Greek manuscripts in the direction of Italian courts and libraries. In Florence, the scholarly Byzantine ambassador Manuel Chrysoloras taught Greek. Linguistic adventurers such as Giovanni Aurispa were on manuscript-buying sprees in Constantinople, and he, too, at the invitation of Traversari, became a language teacher in Florence.[35]

Platonism had its greatest secular—that is, pagan—advocate in Gemistos Plethon, a native of Greece who had also arrived in Italy. Soon to be a kind of celebrity around Florence, Plethon vociferously rejected the way Christian theologians often mixed Plato and Aristotle. When he lectured during the great council, he emphasized their irreconcilable differences. For the attentive Christian mind, the important difference between Plato and Aristotle was probably this: although Aristotle had gods as movers, and he had "forms" that were actualized in things as their inherent natures, he rejected his teacher Plato's ideas about pre-existing essences (Ideas) and eternal souls. Plato also spoke of a creator as an artificer that used number, while for Aristotle mathematics bore little interest. Plethon's lectures in Florence do not survive. But it is said that Cosimo de' Medici was so impressed (hearing a simultaneous translation, probably, from Traversari), that he envisioned a Platonist revival under his own patronage. In all, 1439 marked a major wave of Platonist influence in Italy.

Being a young painter in the hinterlands, Piero was not immediately aware of these cultural migrations. His taste for Platonism probably began locally, derived from his enchantment with Greek mathematics, the intellectual Franciscans whom he painted for, and the spirituality of the Camaldolese

circles that his family moved within. When he began painting *The Baptism of Christ*, his artistic influences had been regional, the strongest probably being Siena's styles, although Florentine artists who traveled the countryside may also have passed something on to Piero. To be a revolutionary in his own setting, it was enough for him to depart from the late-Gothic look that still dominated Italy.

Piero may have taken two years to paint the *Baptism*. He may well have been in Florence with Domenico during a break in the middle of the *Baptism* project. It was only a trip of a day or two to Florence, and Piero was as good a horseman as any merchant's son. Much of his life was spent coming and going between nearby towns. A methodical enough artist, Piero could keep projects going for years, leaving them in suspended animation for months, and then picking up where he had left off. And so it may have been with the *Baptism*. If, by this time, Piero was well established as a painter, he could have had assistants working with him on the *Baptism*, even in his absence. Such accounts, of course, must enter the realm of pure speculation.[36] There is absolutely no evidence, such as diary entries or secondhand testimonies, of how Piero proceeded on any of his paintings. For the sake of argument, however, we can easily imagine that once Piero had done a good deal of work on the *Baptism*, he stopped, stored it safely in his workshop, and then, jumping on a horse, traveled to Florence to see what all the excitement was about.

In this scenario, Piero completed much of the *Baptism* before he left. Applying his undercoat came first. According to future chemical analysis of the painting, Piero next put in the background, laying down the landscape before the figures.[37] This Tuscan countryside, stretching under a blue sky with strange skittering clouds, had a barren look. Piero made the hills brown and dry. With gray paint, he revealed some of the cement-like deposits of the region. Then he dappled this terrain with vineyards and olive groves in summer greens. Nestled in those hills, Piero next painted the distant town of Sansepolcro, a city with towers. A mountain stream widens into the foreground and passes by a large walnut tree. Everything is bathed in morning sunlight, it seems, pouring in from the east.

From time immemorial, the chronicles of Sansepolcro had spoken of its landscape, a land of thick woods and giant walnut trees, later cleared

to make fertile fields. In his career, Piero used this idealized Tuscan style of landscape extensively. He had seen landscapes of late medieval masters: those by Gentile or even the Lorenzetti murals in Siena. Presuming that the *Baptism* was Piero's earliest work, it established a kind of signature countryside. It appears in Piero's small paintings of St. Jerome (both around 1450). Those works may have spread Piero's Tuscan naturalism to painters in the north, to Ferrara, and then beyond. With his liking for crystal clarity, though, what Piero would not use until late in his career was aerial perspective—innovated by Flemish artists—which put haze in the air and softened distant horizons with blue.[38]

On top of the landscape in the *Baptism*, Piero began filling in his human figures. In the foreground, these are Jesus, John the Baptist, and three angels. Back in the middle distance, he also placed various men at the riverside. His techniques included the line underdrawing, some pouncing from a cartoon (at least on one angel's robe), and a fine crosshatching in some of the brush strokes, which is a way to model the gradations of shapes with egg tempera. Although the *Baptism* is a complex picture, Piero had simplified its essence: he created the shapes and volumes by light and color, not by strong lines. He also employed more than a little geometry. Using the standard Renaissance measure of the "braccio" (length of the "forearm," or nearly two feet), on a two-braccio-wide panel he made Christ 1.5 braccia tall. The spaces on either side of him are one third of his height. Furthermore, in composing the picture, Piero conceptualizes an equilateral triangle to frame Jesus' position, having his joined hands mark the place where the triangle's bisecting lines would intersect. If Piero had seen any manuscript copies of Euclid's *Elements* by this time, he may have used Euclid's diagram of a pentagon superimposed on a triangle as a further guide, or as deeper meaning, behind the proportions in the picture.[39]

In this sort of painting, with no major architecture, there was little surface geometry to produce the effect of perspective. Every object in the *Baptism* is organic. By his modeling under a coherent and unifying light, Piero created the depth and atmosphere he needed. His objects, according to perspective, were all the right size, and if distant things were rendered in a more informal brush stroke, things in the foreground were done in

crisp detail: the hairs on Jesus' head, ripples in the water, and the sprigs of buttercup, licorice, and clover in the soil.

In its finished form, the *Baptism* bears one significant clue that it was completed after Piero returned from Florence. Amid the extravagance of the great council season, what apparently caught Piero's eye was the dress and hats of the Byzantines. In the *Baptism*, Piero inaugurated one of his signature hats, a tall flaring cylinder, which he apparently invented after seeing the Greek stovepipe headgear. The *Baptism* featured this flamboyant hat on one of the four bearded men who stood on the distant riverbank, men who represented the priestly officials who went to the Jordan to assess John the Baptist's claims. Piero turned the four men into stylized Greeks, giving them Eastern beards and cloaking them in red, yellow, and blue, their hats various and rakish. Throughout the Renaissance, it was only Piero who used such a fabulous cylindrical hat. For years to come, stovepipe hats and pointy beards would become his common devices.

Piero may have garnered other ideas in Florence for his final work on the *Baptism*, including the nonconformist way he presents the three angels. Piero does not pose the angels in Gothic veneration. Instead, he shows them clasping each other's hands, as in a pagan allegory of friendship. With wreaths on their blond heads, they look very much like the classical Roman "three graces," Christianized with wings. He may have had time to study the architecture in Florence. But if he did, those features—such as fluted columns—would not show up in his paintings for well over a decade.

In the *Baptism*, though, Piero did grapple with an important optical problem: How would he show Jesus' feet in the water?[40] The Bible said he was "in" the water, being the very nature of baptism. Water has unique optical effects. It reflects like a mirror but also refracts (bends) images. This double contortion had been studied for centuries, but in painting it was a relatively new problem. The puzzle was compounded in a theological painting such as the *Baptism*. The water would both reflect and refract Jesus' feet, appendages that were both human and divine.

Piero's apparent solution was this: to avoid distorting Jesus' feet, and also to avoid an awkward reflection of the divine ankles, Piero painted the stream as if it ended right where Jesus was standing. He painted small ripples around his ankles, yet retained handsome feet as if seen straight

through clear water. Thusly, Piero put a perfect divine figure in a world of natural phenomena, a mystery at the root of Christianity and Platonism. Beyond Jesus' feet, Piero's portrayal of water returns to complete naturalism in the landscape. Shining like a mirror, the river reflects the sky, the trees, the mountains, and the men in hats.

Most noteworthy of all was how, at a time when the ethereal look of late-Gothic painting still dominated, Piero had created a visual world that was precise and solid, and yet equally strange in its beauty. The substance, light, and gravity of nature pointed to something theological beyond. There was no need to paint theological items into the script. There was no God the Father in the sky, no angels in gold. At the same time, the *Baptism* was like a tight puzzle of abstract shapes. In an era when religion was speaking of the *devotio moderna*, and scholasticism the *via moderna*, Piero had done something similar in painting: he made an age-old biblical story look modern.

The splendors that Piero had seen in Florence in 1439 would not be a harbinger of good fortune in Sansepolcro. The pope had chosen Ferrara as the location for his council because he wanted to avoid a possible attack by condottieri who worked for Milan. After the Council of Florence, the Milanese aggression went unabated. In 1440, Milanese forces arrived in the Upper Tiber Valley. The Milanese passed through Sansepolcro as part of their plan for a surprise attack on the combined Florentine and papal forces near the hilltop town of Anghiari. No friend of Florence, and long unhappy with papal rule of their city, the disgruntled Sansepolcrans volunteered hundreds of men. On that hot summer day, June 22, 1440, the Milanese army finally headed across the valley, Anghiari in its sights. The dust it raised on the road, however, ruined the element of surprise, and when the forces clashed, the hapless Milanese were routed.

The Battle of Anghiari, which became a legendary memory of Florentine triumph over Milan, would one day be painted in Florence's city hall by Leonardo da Vinci. Preceding Leonardo, Piero also would paint a number of battle scenes. It has always been tempting to imagine what Piero might have seen of this (presumably bloodless) clash of armies in the fields below

Anghiari, with their armored legions on horseback, banners and trumpets, and lances piercing the air.

After the battle, Sansepolcro was viewed darkly by Florence and even by the pope. Most of the town's men were political prisoners for a time, only gradually released to go back to their families and work. The city once again became a pawn on the Quattrocento chessboard. Florence's expenses for hosting the Council of Florence had been so great that in 1441 the pope "sold" Sansepolcro to Florence as compensation. Here again, the Italian bookkeepers would not disappoint later historians in search of details: the amount owed to Florence was duly recorded as 2,500 ducats—not a king's ransom, but impressive enough. For the indefinite future, Piero's home town was a vassal of the Florentine city-state. Adding to this humiliation, the 1440s would be a time of commercial decline in Sansepolcro, at least compared to the relative prosperity of the 1430s, when Piero had gotten his start. The city council had to turn to Cosimo de' Medici for loans to buy grain.[41]

As the local economy soured, and hardship seemed at every turn, Piero took stock of his ability. His family was well connected, so work as a painter would not be too hard to find. Yet he must have craved some adventure, as well as intellectual and emotional stimulation; for, in the next ten or fifteen years, Piero was mostly away from his home town. He took his ability into the Quattrocento marketplace of north-central Italy.

CHAPTER 3

A Platonic Painter of Light

Piero's Tuscany fell under the bleaching summer sunlight of the Mediterranean. This sunlight may be one reason why Italian landscape painting is known to be so clear and vivid. Piero adopted this brightness as a matter of course, and if this central Italian environment had infused Piero's work with a regional charm and manner, he was now taking it east and north, in the opposite direction from Florence. In one small painting of this period, known as *Jerome in Penitence*, Piero signed it "the work of Peter of Borgo, 1450," showing that he knew well how to leave a business card around his itinerant circuit.[1]

As a successful son of Benedetto, Piero apparently had enough reputation to build a career in his home town, which, admittedly, was still shaken by the failed Battle of Anghiari. During that aftermath, Piero was listed as eligible for the town council. He may have been known for his big-city experience in Florence as well. Although none of this would keep him at home, a young man from the provinces like himself could not completely escape his roots. This was especially so with the kind of strong, devoted, and probably controlling father he had in Benedetto.

So while Piero may have been on the road physically, his family helped secure him another large painting commission in his home town, doubtless

a familial attempt to keep him connected to his native soil. For this contract, Piero had presumably returned to Sansepolcro in 1445. The project was an altarpiece, a "polyptych" of several panels, and he signed the agreement with the Confraternity of Santa Maria della Misericordia. This was the confraternity to which his family had close ties, and to which Piero himself may have belonged.

In hindsight, this polyptych—to be known as the Misericordia Altarpiece—would be a major accomplishment by Piero.[2] At the time, though, he may have had mixed feelings. In painting the *Baptism*, he had apparently had a degree of freedom to innovate. The Misericordia Altarpiece was the result of a stricter agreement. The contract dictated that the painting must have "the images, figures, and adornment which will be expressly detailed by the above Prior and council." It was to be "gilded and colored with fine colors, especially ultramarine azure." Piero had three years to complete it. He also had to maintain it for ten years, fixing anything that deteriorated. Most importantly, the contract informed Piero that "no other painter can put his hand to the brush except the said painter himself," just in case Piero was tempted to ask a talented assistant to do some important passages in the work, which was the occasional practice of busy master painters.[3]

The confraternity's desire to control the artist was understandable. It was a male religious community made up of wealthier merchants, and it had seen nothing but trouble for a quarter century in trying to obtain a spectacular altarpiece for its chapel. Now that Piero, a native son, had become a master painter, he seemed a dream come true. They paid him a master's fee as well, an extremely generous 150 florins. As it would turn out, the project ended up haunting Piero much as Antonio had been dogged by the massive altarpiece he had failed to produce. At one point, the primary donors on the Misericordia project, the Pichi family, sued Piero. They demanded (in 1455) that he return and "sit down in Borgo [Sansepolcro] and work on the panel during the entire upcoming Lent."[4] In the end, Piero delivered, of course, but it seems to have taken him fifteen years. There is really no saying when he actually began painting the work.[5] He apparently tackled it in two stages, as modern-day analysis would suggest.[6]

In the first stage, Piero completed the most important parts: the large central painting with a monumental Madonna surrounded by eight donors

in the confraternity; a small crucifixion scene at the peak of the polyptych; and two of the four saints on either side of the central Madonna. This grouping—Madonna and saints—is so solid, weighty, and colorful that Piero may have been thinking of the large amount of religious sculpture that he had grown up with in Sansepolcro. The altarpiece was to be a veritable wall in size. Standing nearly nine feet high and more than ten feet wide, it had nineteen separate panels and, at its sides, vertical buttresses to bear its considerable weight.[7] Because of its size, the "hand to the brush" of Piero finally applied only to the most important panels; his workshop assistants painted some panels as well. In the end, Piero would paint the main sixteen human figures, out of some forty total.

The Misericordia Altarpiece revealed a choice Piero was making about his own signature style. His painting of the crucifixion above, and the Madonna at the center, could not have been more different. The crucifixion was Piero's most emotion-laden experiment in painting human figures. It looks very much like a crucifixion that the Florentine painter Masaccio (one of Alberti's men of "genius") had painted in Pisa, a day's trip from Florence—a trip that Piero may have taken. Below, however, is Piero's Madonna. She has the cool, monumental look that finally would characterize all Piero's paintings. In a panel to her right, Piero painted St. Sebastian, a favorite saint to protect against the plague, since Sebastian himself was a survivor of extreme wounding. Shot through with arrows, the tortured Sebastian of Piero's imagination, like the Madonna, reposes in classical calm. In the *Baptism*, Piero had painted a partly naked Jesus in the river, but his Sebastian is perhaps the first almost entirely naked, anatomically sophisticated, and thoroughly realistic figure in a Renaissance religious painting.

Despite its many conventions, the altarpiece showed Piero's innovations. Mary projects modesty, yet she also has the stylish shaved forehead of the city girl. Piero applied the gold leaf in a lighter pattern than usual, and he managed to produce the striking effect of strongly realistic human forms living inside a golden mist. Despite the gold, the saints on either side of Mary occupy real space in a uniform light. They are like great statues that, having coiled springs inside, seem ready to come to life. The painting in the Misericordia Altarpiece does not feature any architecture, and so at

this stage Piero's fascination with mathematics, geometry, and perspective was held in abeyance. He was waiting for the right time and place to express this knowledge and skill more fully.

If the account of the late-Renaissance chronicler Giorgio Vasari is true, Piero's early travels as a painter may have pulled him eastward, toward the Adriatic, at the outset. He may have painted in the coastal town of Ancona, doing a "marriage of the Virgin" fresco and perhaps the *Jerome* calling-card painting. He may have worked in Pesaro, another coastal borough, this one ruled by Alessandro Sforza of the Milan dynasty. Then there was Loreto, an inland pilgrimage city, where Vasari says that Piero and Domenico Veneziano decorated a cathedral sacristy.[8]

By around 1448, all of Piero's known commissions had come from churches or, perhaps, leading families, but there was nothing yet that had risen to the level of aristocratic recognition. That would change around this time, when he was summoned to the House of Este in Ferrara. Piero may have been recommended to the Ferrara court by the Camaldolese or humanist circles of the late Traversari, or by the very much alive Bessarion, who was known to travel on occasion through Sansepolcro.[9] Whichever human channel had spread Piero's name, it was the rulers of small courts around Italy—Mantua, Padua, Rimini, Urbino, and Ferrara—that seemed most eager to commission the arts and humanities to enhance their own renown and glory.[10]

Ferrara had experienced a brief moment of fame for hosting the Council of Ferrara in 1438. Since then, its ability to attract humanists and artists had only increased. It had a humanist school for the children of princes. The manuscript collector Giovanni Aurispa was a teacher of Greek and the Platonist heritage in the city. Ferrara had a university, but just as important, Padua, the great intellectual center, was just a day's journey north. Roman ruins surrounded Padua, so it produced a Renaissance humanism that especially valued classical architecture.[11] Ferrara's love of fine buildings was seen in its city planning and wide streets with fine urban vistas. Its palaces were small but thoughtfully designed and executed, and these worthy structures needed to be decorated and painted.

When Piero resided in Ferrara sometime between 1448 and 1450, the Este House was in transition, so his precise patron is not clear.[12] Nevertheless, this was the city where Piero encountered the Flemish oil painting style that had recently come down into Italy, and it was the city to which Piero carried his own light-filled central Italian style, which would push against the remaining Byzantine influences in the north, derived especially from Venice, which had looked to the Orient for a century. More precisely, art historians have argued that Venice was late in adopting Renaissance classicism because of the later influence of the "Flamboyant Gothic figurative culture" of Gentile da Fabriano, who had otherwise departed from the full Byzantine look by developing the International Gothic style.[13]

As Piero would learn in Ferrara, it was not a long boat trip from that city to Venice, which was a storied maritime republic. Venice may have been part of his itinerary during the late 1440s, and it does seem a logical opportunity for him to take enthusiastically. Otherwise, there is only one surviving piece of physical evidence that hints at a Venice sojourn. This is Piero's small painting *Girolamo Amadi Kneeling before Saint Jerome*, which has ended up in Venice, and therefore may have been painted in that city of canals and watery light.[14]

The sparse available evidence also suggests that Piero's name was getting around in the fertile northern plains that bordered the Alps. It was in northerly Milan, for instance, that the humanist Antonio Filarete, writing in the 1460s a fictional dialogue about creating an ideal city—titled *Treatise on Architecture*—cited Piero as among the "most satisfactory" painters of the age.[15] There is no evidence that Piero's style would produce influential followers in Florence, but the opposite seemed to be true in the north, where future frescos and other pictorials took on the monumental, geometrical, and light-filled classicism of the mature Piero.[16]

On arrival in Ferrara, Piero's knowledge of geometry and perspective also seems to have rubbed off on a group of craftsmen who specialized in inlaid wood, called intarsia. These craftsmen began to take on new experiments, creating entire three-dimensional and illusionist scenes. More broadly, and in several Italian courts, intarsia would be used to imitate entire landscapes. In time, this form of wall decoration was illustrating domestic scenes with ornate tables, open cabinets, lutes, faceted cups, astrolabes, and piled-up devices.

Alongside intarsia, Piero would have also met the new phenomenon of Flemish oil painting. The arrival of the oil technique in Italy during the Quattrocento, as one expert opinion summarizes, "will never be fully understood" because of the historical loss of evidence.[17] By the middle of the fifteenth century, the Flemish achievement was showing up in places scattered from Naples and southern France to Austria, Switzerland, and Spain. Piero's most important encounter with oil painting must surely have been in the north, and in Ferrara in particular, which had become host to Flemish artists from guilds in the Netherlands. One of these artists was Rogier van der Weyden, whose oils adorned the Este court by the end of the 1440s; Piero probably had met him in that city. Some have speculated that, since truly learning oil painting required an apprenticeship—not simply a hard look at a finished product—Piero may have traveled farther north at some point to experience a Flemish workshop.[18]

Such speculation aside, on his arrival in Ferrara, Piero and his Flemish counterparts would have begun to analyze the differences in their native styles. This would have marked a key moment in the evolution of all Renaissance art. The Flemish style was characterized by the brilliance of oil paint, modeling by glazes, minute detail, lush landscaping, a peculiar northern light, and a type of homely portrait. The Italians, characterized by Piero, brought a more stark southern light, a simpler classical and monumental look derived from statuary, and the more cerebral approach to linear perspective.

Just as with the Italians, Flemish art was not uniform. Rogier worked in a simpler style, whereas the older Jan van Eyck was a master of detail and complex glazing. The impact on the Italians was singular nevertheless: the brilliance of oil was a marvel to behold, since the egg tempera that they used—adding pigment to egg yolk, not to oil—could not match the glossier luminous effects. Italian painters began to use oil in the 1450s and 1460s. Piero was very early in this development, and there is evidence that he began using oil on the finishing stages of the Misericordia Altarpiece.[19]

Through his travels north, Piero's name began to mix with others of renown in Renaissance history. After presumably meeting Rogier in Ferrara, Piero saw paintings by Jan van Eyck years later, presumably in Urbino, where van Eyck was popular. Also during his time in the north, Piero very

likely studied works of the painter Pisanello (1395–c. 1455), a native of Pisa born about two decades before Piero. Pisanello had worked alongside Gentile da Fabriano in the International Gothic style. Importantly, Piero may have seen how he handled battle scenes he painted for the House of Gonzaga in Mantua. An all-around craftsman, Pisanello invented the bronze portrait medal, which became a popular item for Renaissance nobility to have struck in their own image. To these medallions, too, Piero could have turned to distill his own concepts about formal side-view portraits.

In Ferrara, Piero would have been equally impressed by a new literary trend afoot in Italy. This was the revival of pre-Gothic heroic storytelling (Carolingian and Arthurian chivalry). Painters would follow suit, and in time they were inserting patrons into such visual epics, with Sandro Botticelli's inclusion of the Medici at the birth of Christ not atypical (*Adoration of the Magi*, 1475). Renaissance dynasties were also mingled with Greek and Roman mythology. Applied as large frescos in palaces or churches, these epic stories—whether biblical, mythological, or legendary—would be called cycles, a kind of epitome of Renaissance art (and something that Piero would eventually undertake).

What Piero had brought to the northerners, and even the Flemish, was his linear perspective and classically statuesque figures.[20] But he also brought a new sense of light. He saw the bright light of the Mediterranean, not the darker, moodier light of northern Europe. Piero's treatment of light had a kind of trademark coloration that tended toward paler and cooler tones. From his *Baptism of Christ* forward, he would also show a mastery of the visual representation of light operating on reflective surfaces and through media such as water, air, and glass. In the *Baptism*, Piero offered his solution to refracted light (in regard to Jesus' feet in the water), but he also revealed his taste for painting watery surfaces with the stillness of a mirror (seen again in later paintings, from his *Battle of Constantine* river scene in the Arezzo frescos to boats on a lake in a diptych for the Duke of Urbino).

At the time, some writings on the effects of light were available to painters who could read Latin. The most available work was John Pecham's *Perspectiva Communis*, a book on optics which discussed the scientific behavior of light. Piero may have combined the reading of such material with his own concentrated research into how light worked. Before his career

was over, he would excel in such virtuoso effects as the perfect reflection of light on metallic armor, the simulation of a crystal jar, a beam of light revealing itself through dust particles, reflected light bouncing around curved interiors, the hazy light of a distant landscape, and the subtle backlighting on the perfect ovoid shape of an egg.[21]

Most of these accomplishments in painting light are proved by Piero's surviving works, but the story of his activity in Ferrara and the north would not be so fortunate in terms of documentation. Nothing from his northern enterprise has survived except a few sparse written accounts and a good deal of stylistic interpretation of his lasting influence. On these grounds, it is believed that he painted at least two battle scenes in the private rooms of one of the Este brothers. Given the humanist setting of Ferrara, Piero must surely have painted secular as well as religious topics. He could see that even as a painter, his work was compelled to navigate the new encounter between Christianity and classical learning. Whichever topics he mingled, Piero's classic style was distinctive enough, according to some scholars, to have influenced a future Ferrara school of painters, which in the sixteenth century carried out great campaigns of mural painting. Many of these murals would be of Greco-Roman myths (such as the triumphs of Minerva, Venus, and Apollo), stories of the twelve astrological months, or the heroic life of the Este clan. Later still, a large illustrated Bible seemed to mimic Piero's clarity of human and architectural forms.

At this point in Piero's life, the question of his relationship to Leon Battista Alberti, the reigning art theorist of the day, has become intriguing. By the time of his work in Ferrara, Piero may surely have read something by the great humanist and architect for the papacy, or even engaged in conversation with him. The historically documented opportunities for Piero to cross paths with Alberti were actually few: they arose only in Florence in 1439 and then, possibly, in Urbino around 1470. History has provided no conclusive evidence either way, but it seems that Piero and Alberti (in no particular order) tended to follow in each other's footsteps around Italy.

They may have met up in Ferrara. In the 1440s, Alberti lived in that city. He was a friend of the new head of the Este household, Lionello, and it was Lionello who commissioned him to write a single architectural treatise (its chapters called "books" in those days). Begun in 1442, his *On the Art*

of Building in Ten Books (*De re aedificatoria*) was completed a decade later, modeled on Vitruvius, the sole surviving Roman source on architecture and related topics. Alberti frequently cites Plato, and although the citations are mostly about ancient architectural features and city planning, Alberti is clearly a partisan of the Platonic vision of numerical essences and ideal proportions.[22]

Based on Alberti's *On Painting*, and perhaps on his writing on architecture, a growing number of painters in Italy presumably adopted the Albertian outlook. He told them that viewing a painting should be like looking through a window. He expounded on how objects occupy space and are defined by color. "The representation in painting of this [color] aspect, since it receives all its variations from light, will aptly here be termed the reception of light," he said in *On Painting*.[23] Alberti also advocated a geometrical perception of nature, saying "that a painted thing can never appear truthful where there is not a definite distance for seeing it."[24] He famously criticized the medieval look in which figures were crammed into small spaces, as if dollhouses. These are pictures in which men are "painted in a building as if they were shut in a box in which they can hardly fit sitting down and rolled up in a ball."[25]

Alberti was advocating real architectural space in painting. Already well attuned to light, space, and color, Piero at some point began to take the painting of architecture seriously as well. He had seen its innovations in Florence, but, at least from what survives of his works, architecture did not come to the fore in his painting until he departed Ferrara. In his travels so far, Piero had seen a good sampling of new and old architecture, from the sundry Roman ruins around Tuscany, to the dominant Gothic and Romanesque styles of a Perugia or Ferrara, to the classical innovations of Brunelleschi in Florence. His imagination was most captured, though, by the motifs seen in authentic Roman remains. He did not seem to be reading treatises on architecture; instead, he was observing practical examples, which included how builders were making renovations that imitated antiquity.

Over the next few decades, Piero tended to favor three architectural objects: columns, marble surfaces on walls, and decorative floor tiles.[26] He looked for how it had been done in antiquity, then adapted that to

his own innovations, such as when he put a Renaissance-style loggia in a religious painting. Sometimes he painted architecture as if it was actually load-bearing; other times, he put things together as a matter of composition, not true to engineering. Piero seems to have "stored [architectural] images in his mind over long periods," said one art historian. "Things seen many years earlier proved relevant to the work at hand."[27] To take just one example, Piero no doubt saw Corinthian columns early in his life, and later saw the ancient Roman star pattern in a palace or church floor. In his early *Baptism*, he includes no architecture; but years later, Corinthian columns and elaborate floor tiles begin to appear, applied prominently in one of his earliest known paintings to use a complex architectural scene, *The Flagellation of Christ*. More generally, Piero's paintings would over time use the fluted columns he saw in Florence, the roundels viewed in Rimini or Venice, and the variegated marble, piers, and barrel vaults witnessed in Rome or Rimini.

In all of this, Piero apparently did not need tutorials from Alberti, who, ghostlike, nevertheless haunted the same places in Italy that Piero traveled through. Indeed, Piero's next set of projects would come in Rimini, a place where Alberti would make a significant mark in the history of architecture. Situated in Rome for the rest of his career, Alberti would send designs to Rimini to give its old Gothic buildings a new classical look. As usual, Piero would learn to paint the new architectonics simply by observing the construction projects. In Rimini, he would leave behind his first serious rendition of classical architecture.

At mid-century, the small courts of Italy were prospering and in search of painters to decorate their growing estates. One of these was the court of Sigismondo Malatesta in Rimini, the household that had once ruled Sansepolcro. Buoyed by a military victory in 1447, Sigismondo had returned to Rimini full of self-confidence and a plan to renovate his holdings in the image of Rome's classical past. For this he needed a painter, of course. After inquiries, the Medici had recommended Fra Filippo Lippi, a popular painter in Florence (who turned out to be too busy).

At this point, Piero's name came up. Commensurate with the growing coherence of his style, with its statuesque figures and geometrical clarity, Piero had become an identifiable brand. Even princes wanted to know in advance what kind of paintings they would be getting, and Piero had passed enough tests to be deemed reliable—a kind of Renaissance Seal of Good Housekeeping—for an important commission. His name may have been floated at the court of Rimini by recommendation of the Este, who were Malatesta relatives, or by an old Sansepolcro connection, an in-law of sorts. One of Malatesta's advisers was the humanist scholar Jacopo degli Anastagi, a Sansepolcro native whose relative had recently married Piero's brother.[28] The ultimate outcome was that around 1450, Piero packed his bags and headed for the town of Rimini.

Rimini had prestige as an ancient Roman port. It boasted a forum and was a link on the Via Flaminia, a road from Rome. Where the route reached Rimini, the Emperor Augustus had erected a great arch in his own honor. Sigismondo was feeling a bit like a local caesar himself, so he began to refit his fortress and church, San Francesco, with a Roman classical look.

Sigismondo had been lord of Rimini for twenty years, and, although a tyrant (Malatesta unfortunately meant "bad head"), he had served his people well enough to be popular. Probably born near Milan, the illegitimate Sigismondo had been reared in a humanist and military household. He is said to have led a military charge, such as it was, at age thirteen against a papal army. When he rose to power in Rimini, he nurtured his taste for the arts and antiquity. And he definitely took Alberti's words to heart in regard to the role of a Renaissance prince: "It is possible to achieve fame and power by using wealth with generosity and *magnificentia* for important and noble purposes."[29]

Being within the Papal States, Sigismondo needed Vatican approval to alter the San Francesco church, and this was received in 1448. The church was a great Gothic barn-like structure, a Latin cross in floor plan, built to hold the crowds gathered by Franciscan preachers. It was remodeled by putting up a classical façade, like a new skin, around its exterior. The design was produced by Alberti in Rome. Then it was sent to Rimini for the local architects and builders to carry out. Though a great dome in the design was never erected, the building, with its antique façade and Platonic

proportions, would be the most purely classical building of fifteenth-century Italy.

In form, Sigismondo was Christian, but his heart was more in the pagan revival. The church became known as the Malatesta temple. Inside, the imagery likened Sigismondo to Apollo and Jupiter, his wife Isotta to Diana, and Rimini to the mythical lands of antiquity. Greek inscriptions declared him a "bringer of victory" in war; his temple was a thank-offering "for God Immortal and the City."[30] The Malatesta temple was to be an echo of the triumphal arch left behind by the age of Augustus. On the exterior, Alberti had designed the front façade with three triumphal arches and each side with seven; it was Sigismondo's dreamy plan that he and Isotta be entombed in the front, and great figures in the side niches. As part of his program to stock his court with living and breathing humanists, he offered Rimini as a final home to the Hellenist scholar Plethon. Although the Greek declined, Sigismondo would later, when fighting the Turks in Mistra, Greece, exhume Plethon's remains and spirit them off to Rimini nevertheless.

Before any of the exterior work got under way, Sigismondo began transforming the interior of the old San Francesco church. When Piero arrived, he was tasked with producing a large fresco of Sigismondo himself in one of the three new chapel spaces. In an earlier St. Jerome painting, Piero had shown a prince kneeling in front of a rustic saint in what seems a forest. In the Sigismondo fresco—today known as *Sigismondo Malatesta before Saint Sigismondo*—Piero enlarged that supplicant-prince motif. Now the scene is a great throne room. Sigismondo kneels in front of a seated St. Sigismondo, his patron saint. And this was no small painting: the fresco was a long horizontal that measures just more than eleven feet by eight feet.

Piero pulled out his full toolbox of skills and knowledge for this new work. Once painted, the Rimini fresco would be like a window on an imaginary world, infused with Christian and classical iconography and using every painterly effect: perspective, architecture, proportion, color, light, and landscape. One can only imagine how such skill impressed Sigismondo, who hailed from a different world than Piero's. The prince, though five years younger than Piero, had been a ruler since age fifteen. By Piero's contacts with the court, he may well have conversed with his subject about the fresco. Indeed, he completed a separate profile portrait

of Sigismondo, which suggests that he may have studied his human topic closely and thoroughly.

Quite naturally, in the fresco design, Piero placed Sigismondo Malatesta at the exact center, a position usually reserved for a saint (or a caesar). Sigismondo's head is the vanishing point for the perspective lines, an approach that had otherwise been reserved for religious painting that made a theological point: Mary or Jesus, for example, are at the visual center. With Sigismondo at the locus, Piero organized the space around him in precise proportions. He used two consistent units of measure throughout, adding them together to create a third unit of measure.[31] Charming illusions fill the scene. Piero paints a round window that looks out on a landscape, which prominently features the skyline of Sigismondo's fortress.

There are exotic touches as well. On a great chair sits the solemn and elderly St. Sigismondo, looking very much the foreign ruler. Piero may have derived his costume from what he had seen of Greek robes, hats, and pointed beards (or what he had seen of the contemporary hat and beard of the real-life Emperor Sigismund, a Hungarian just enthroned and traveling around Italy). Piero presents only one bit of Christian symbolism, and this is Sigismondo Malatesta's praying hands; otherwise, Piero's brush has dictated that Roman symbols dominate the items within the fresco composition. A garland hangs from the ceiling. Decorative cornucopias and roses are carved on the stone walls. Two sleek greyhounds, one white and one black, sit languidly behind their master, suggesting a household of sport, good taste, and wealth.

In Sansepolcro, Piero had developed a love of the bright banners made everywhere in his city, often by stencils, and almost always with a simple heraldic look in bold colors. In the Rimini fresco, that heraldic aspect comes through. Its objects seem emblematic, even like Egyptian hieroglyphics. With this heraldic inspiration, the entire scheme could have looked flat, and yet Piero presents it in a rounded realism, showing his increasingly refined technique. He combines architectural symmetry and proportion with a completely irregular rhythm of natural shapes, a trait of his future works.

The Malatesta wall painting is the earliest surviving work to be done by Piero in fresco, and, indeed, it was done in the arduous wet-plaster method of "true" fresco. Putting up fresco paintings was not for the faint-hearted.

It required fast work, heavy lifting, and the dangers that attended maneuvering on a scaffold often built high above the floor. With experience under his belt from Sansepolcro, perhaps Florence, and in Ferrara, Piero moved ahead on the traditional process. His masonry assistant put up a first layer of plaster (the *arriccio*). Upon this, Piero incised a few major perspective lines to guide his drawing. Then he painted in some of the major markers of the composition with brush strokes of sepia-colored paint, a method called sinopia (named after a red chalk produced in the Black Sea city of Sinope). That laborious sinopia was soon to disappear under a final layer of plaster.

The final layer (the *intonaco*) was the actual painting surface. The mason troweled it up in small sections, each one for a day's work to match the drying time. The daily patch of fresco was so routine that it was called a *giornata*, a standard measure of progress. In a day, simpler fresco images could be painted in a large swath of intonaco, since it took less time to put in a large patch of blue sky, for instance, or the unadorned robes on human figures. When Piero came to the more complex parts—a face or the detailed lineaments in the architecture—the plaster was put up in smaller patches. For any fresco painter, it was always a race against the drying plaster. One Florentine frescoist reported the piecemeal process in his diary. "On Thursday I painted those two arms." The next day he did a head next to a rock. "On Saturday I did the trunk of the tree, the rock, and the hand."[32] And so forth. The routine was quick but notoriously careful. A badly done passage, locked into the fast-drying plaster, could be a minor calamity.

Some of Piero's brushwork on the Malatesta fresco was freehand, quickly judged and painted by eye alone. In the more exquisite areas, he tightened up and used the special tools of a draftsman. He had made preliminary drawings for some parts of the scheme. These are called "cartoons" after the Italian *cartone*, a heavy paper. He pricked holes in the paper so charcoal dust could seep through at the outlines on the drawing. After a patch of wet intonaco was applied, Piero (or an assistant) placed his cartoon upon it, "pouncing" the holes with a porous bag of dusty charcoal. This transferred the image to the wall. Then, before the plaster dried, Piero commenced a day's worth of serious painting. With the Rimini frescos, he was already applying the two basic methods of perspective that he would later write about. The first was to incise perspective lines in the wet plaster to

create the general, accurate spatial reality of the scene, especially its architecture. After that, Piero would use the cartoons and pouncing to put in the more complex human and organic objects, cartoons that he may have drawn using the "window" pane method seen in Alberti's *On Painting*, and for which Piero would develop his own mathematical approach.[33]

Piero's use of two perspective methods may have been novel, but the use of fresco was already age-old when he came on the scene. The sturdiest form was true wet fresco, into which the paint colors fused chemically and permanently. However, true fresco had long been augmented with painted details or glazes after the plaster dried (or after it was kept sufficiently damp by the covering of a wet cloth). Applied on a perfectly dry surface, this type of painting was untrue fresco *secco* (for "dry").

The need for such detailing on dried surfaces may have generated some of the first use of oil paint in Italy—and, indeed, oil does play such a role in the Rimini frescos. This would be Piero's first use of oil that can be dated (though some believe he used "a little oil" as early as the *Baptism*, did likewise in finishing the Misericordia Altarpiece, and may have tried oil in Ferrara and the north, none of which has survived).[34] Despite such ambiguity, Piero is clearly an early Italian practitioner (and innovative, since the oil-inventing Flemish used it only on wood panels). Sigismondo may have rushed Piero on the fresco, not allowing time for immaculate detail in the more durable true fresco. Piero's use of oil made some of his rich finishes less permanent, as time would prove. But in the moment, it allowed the harried painter to add more precision, color, and highlights.

As was the custom, Piero added a final inscription in praise of Malatesta at the bottom. He also added his name and the date 1451—a rare bona fide date on which modern scholars could reconstruct Piero's biography. The fresco must have been stunning to contemporary eyes. Word seemed to spread of the unique abilities of this painter from Sansepolcro. Thanks to Piero, whatever Sigismondo's real-life fortunes, at least two portrait images of him survived for posterity.[35] Sigismondo had several medallions designed bearing images of himself and his wife. But it was Piero's two pictures, like the proverbial two thousand words, that enhanced his chances of becoming a historical figure.

❈

The completion of the Malatesta fresco marked the start of Piero's mid-career, a year shy of forty. In the next decade, he would produce, or begin, some of his most remarkable works in skill, imagination, and scale. After Rimini, he would also reveal himself to be a thinking man, notably in the tradition of abacus mathematics.

One day, a person of importance, as Piero recounts, asked him to write a book on practical mathematics, presumably as used by merchants and builders. This request makes it obvious that Piero had a public reputation for his interest and ability in the mathematical arts, even though it had only come to light so far in how he designed his paintings. No literary figure himself, and far from the university world, Piero nevertheless decided to take the leap into what typically was the exclusive domain of the humanists. He set his mind to writing a treatise, which is now known by the homely title of *Abacus Treatise* (*Trattato d'abaco*), and it would be the first written work by Piero's hand. As he said in the text, it would be primarily concerned with the arithmetic "necessary to merchants."[36]

On all sides, Piero had seen the humanists writing treatises, mostly in Latin. He could at least boast a fine penmanship in the Tuscan vernacular, and indeed his handwriting—with an "e" that looks like a "z," an angular "a," his peculiar "et," and his "g" with a large circular tail—would become clues in tracking Piero's role in producing Renaissance manuscripts. In addition to being a fine draftsman, Piero was something of a systematic thinker as well, and had to be, taking readers of his *Abacus Treatise* through fractions, the nature of calculations, and starting each of hundreds of problems with pithy anecdotes such as "Two men are bartering, one has cinnamon and the other saffron," or "There is a fountain with two basins, one above and one below. And each has three spouts."[37] Such colorful examples, however, could not fully mitigate the essential mathematical tedium of such texts. If Piero's geometrical paintings could be called "dry," as Vasari would say later on, the same would have to be said of his *Abacus Treatise*. Surely, in his heart and mind, Piero must have felt something transcendent, even romantic, about numbers and, in the Platonic sense, their cosmic roles and mysteries.[38] Piero opens the *Abacus Treatise* by saying that with God's

help, he hopes to do a good job. Yet after that, such piety is put aside: he is all business, revealing a surprising aptitude for the mathematical logic and demonstrations invented by the ancient Greeks. "The divisor is always similar to the thing one wants to know [about]," he says with that sharp edge of Greek logic.[39]

The date of the *Abacus Treatise*'s composition is uncertain.[40] Piero may have spent many years on the project: first in study, then in drafting various parts, and then in producing a final version. Like all Renaissance men, he was racing against time, if not a new season of plague. Fifty percent of the people born during the Renaissance died at birth or during the first year of life. Considering that Piero would reach the remarkable age of eighty, he was a rare case indeed of good health and good luck. But at mid-career there was no guarantee that he would live beyond the average life span (of those who had survived their first year; perhaps the fifties), and this put projects such as the *Abacus Treatise*, not to mention his painting commissions, always on the cusp between success and failure.

To begin with, Piero's schoolday training in abacus was long gone, so he must have brushed up considerably. If Piero had conceived of the abacus project at an earlier time in his career—in the 1450s—he would have been entering his forties. At that time, he would still have had the Misericordia Altarpiece deadline hanging over his head. Just as pressing, in nearby Arezzo, a Franciscan church with hundreds of square feet of wall was appealing to Piero to fill it with elaborate—and time-consuming—frescos. Despite the unhappy outcome he had observed in the ill-fated procrastination of his old mentor in Sansepolcro, the painter Antonio, Piero must have had the stamina to keep his composure under pressure and stay on track.

How was he able to balance it all? One way to penetrate the complexities of Piero's enigmatic life is to recognize his ability to get about. Tuscany, for example, is the size of New Hampshire, and adjacent Umbria about a third that size. Despite their rugged Apennine landscape, they were manageable regions for frequent travel. At his age, Piero the able horseman could have moved between towns and courts in a matter of a day or two. He could have several projects going on in different places, with his Sansepolcro workshop as the hub, a not-unusual circumstance for that smaller segment of Renaissance painters who traveled extensively to find work. In Piero's

case, small panel paintings, or a part of an altarpiece, could be done in a workshop anywhere and then carried to their final home. Thus, Piero may have written the *Abacus Treatise* in Sansepolcro, returning to this literary project every time he was back in town.

At any rate, Piero had now entered the world of treatise patronage in addition to the world of painting patronage. During the Quattrocento, the primary audience for any treatise was a patron, secular or religious. They paid the scholar and copyists to duplicate ancient works or replicate contemporary materials, sometimes with a commentary to provide scholarly cohesion to the mysteries or contortions of ancient phraseology and thought.[41] This was how the papal scribes, from Bruni to Alberti, made a living. Fortunately, Piero had precedents for how to write his kind of arithmetical treatise. This was simply to mimic other abacus manuscripts or excerpts, and he may have had some of these around his home from his school days. The standard was the work by Italy's great thirteenth-century mathematician, Leonardo of Pisa (Fibonacci).

With effort, Piero could also have found a copy of Euclid's *Elements*, which was primarily about plane geometry, though his final sections (if available to Piero) covered what Euclid called "solids," which have "length, breadth, and depth"—cubes, pyramids, polyhedra, spheres, and cylinders.[42] As time went on in his writing career, Piero would be citing Euclid's name in one form or another more frequently (beginning with the twelve times in the *Abacus Treatise*).[43] Piero by now had also come upon some medieval source that summarized Archimedes, the ancient Greek geometer of three-dimensional shapes, since Piero cites his name in the *Abacus Treatise* in regard to the surfaces of spheres.[44]

From the start, Piero faced two constraints.[45] First, there was really not much pure, speculative, or theoretical mathematics going on in Italian society, at least outside the universities, where Piero had no obvious reason to ambulate. At those centers of academia, humanists related geometry to astronomy. They applied arithmetic to the harmonic scales in music. For medicine, mathematics was about astrology, since the movement of heavenly bodies was believed to affect illness and health. And in theology, still the queen of sciences, the mathematical concerns were focused on the nature of the universe and numerology in the Bible.

The second constraint on Piero was the lack of the notations we now call algebra (such as $a+b=b+a$, or $4x+1=13$). Arithmetic had not yet been applied to geometry. Everything was written out in long numbers and in verbal explanation, almost as if in computer code (do this, then do this, then do this). Indeed, the entire Greek tradition of geometry up to Piero's era had been to state matters in sentences, not in numbers. And so it was that Piero's *Abacus Treatise* was verbal. He calls his readers "tu" (you) as he gives step-by-step instructions. If Alberti had penned *On Painting* in Latin and in the spirit of Roman essayists such as Cicero and Quintilian, Piero was the no-nonsense abacus teacher.

After opening with exercises in fractions, Piero turns to the popular marketplace "rule of three," a means of calculating the relations of disparate objects and values. This is a math problem such as: "There is a fish that weighs 60 pounds; the head weighs ⅗ of the body, and the tail weighs ⅓ of the head. I ask how much the body weighs."[46] In the *Abacus Treatise*, Piero also drew upon the surveying tradition, one that used triangles to calculate distances. One of his examples is the calculation of the distance between two towers in the landscape.

Where Piero surpasses other abacus books of his day, however, is in his survey of geometric problem-solving. Of about five hundred problems in the *Abacus Treatise*, Piero made 147 of them about geometry. In this, he does a lot with triangles. Then he gives shorter examples with squares, rectangles, and higher polygons. A typical problem might be: "There is a triangle ABC in which the side AB is 14, BC 15, AC 13; in which I want to put the two largest circles that are possible. I ask what will be their diameters."[47] Most of these problems originated in Euclid's *Elements*, as Piero notes. But as an artisan, Piero is doing something new, and this is to combine Greek science with the mind of the workshop artisan. Such a merger of these two Renaissance cultures—the humanist and the artistic—has been most celebrated by history in a figure such as Leonardo da Vinci, but Piero got it started.[48] Dry as his *Abacus Treatise* may have been, it suggested the first hint of a new kind of literature that bridged art and science.

When it came to the mysteries of mathematics and number, however, Piero was mute. Speaking somewhat conventionally, he said that "with God's help" he hoped to assist merchants in their mathematics, and he

perhaps betrayed a bit more of his philosophical outlook when he said he would even venture into algebra, "if it please God."[49] As to the theology of number, however, there are no such effusions, traditional or solemn. When Piero uses the triangular mathematics of the Pythagorean theorem, for instance, he says nothing about the mystical Pythagoras, a figure at the center of a secretive religious fraternity, and yet an inventor of the practical method of calculating triangles.

What Piero's *Abacus Treatise* reveals is perhaps a different kind of philosophical interest, and that is the aesthetics of proportion: perhaps divine, but certainly practical and visual. Piero's extensive use of the rule of three, for example, is a constant demonstration of relating parts and quantities one to another. Medieval and Renaissance definitions of art were heavily weighted toward proportion as the essential element of beauty. Piero fused this aesthetic and mathematical concept into his goals as a painter. He was not unique in this interest, but clearly he would master proportion in ways that led to remarkably beautiful paintings and, late in his life, a unique ability to work with complex visual geometry, such as the so-called Archimedean polyhedra.

Piero's interest in proportion was further revealed in the ways he handled some of the most famous formulas of ancient geometry, though here again he offered no speculation. His *Abacus Treatise*, for example, drew upon what would be called the "golden ratio" and "divine proportion" by later writers. Euclid called this mathematical law the "mean and extreme ratio," and long before him Plato had identified it in his *Timaeus* creation story as the ratio, or proportion, by which the world was made.[50] What Plato and Euclid meant was that any line segment could be divided so that the shorter part's ratio to the longer is the same ratio as the longer to the entire segment. This is a ratio of 1 to 1.61803 . . . , which introduces an irrational number (that goes on infinitely) into the proportion.[51] As geometers would note across the ages, this ratio could be found in a remarkably large number of geometrical shapes, suggesting that this number—now called *phi*—was fundamental to nature and even of divine origins.[52]

Rather than elaborate on a divine ratio, Piero's *Abacus Treatise* reveals his interest in the so-called Platonic shapes, to which he dedicates the final 22 pages of his *Abacus Treatise* (which is 170 pages long). Plato's dialogue

on the natural world, *Timaeus*, most famously described these shapes, and thus they have been called Platonic. They were later called the "five regular solids" as well. Plato viewed them as the building blocks of the Creation. The shapes are so simple, fundamental, and perfect that they were hypothesized to be the constituent substances of both the world and the ether of the heavens: 1. tetrahedron (fire); 2. cube (earth); 3. octahedron (air); 4. dodecahedron (ether); and 5. icosahedron (water).

Euclid also analyzed the shapes, minus any mystical implications. And then after him the Greek mathematician Archimedes expanded their number, going beyond the five "regular polyhedra" to produce thirteen complex polyhedra. These complex solids have more than one kind of face, typically some combination of triangles, squares, and hexagons. Most of these could be created by trimming off the corners of the five Platonic solids, a visual process to be called "truncating."[53]

In Piero's day, the thirteen complex polyhedra of Archimedes had been essentially lost to history and would not be mapped and named until 1619, when Johannes Kepler inscribed them in one of his works. Between Euclid and Kepler, Piero actually made a small contribution in his *Abacus Treatise*. By truncating some Platonic solids, he illustrated two of the "lost" thirteen Archimedean polyhedra. And following the Archimedean tradition (of trying to fit solids inside one another based on mathematical calculations), Piero tried his hand in at least two cases in the *Abacus Treatise*. He showed how his two Archimedean polyhedra fit tightly into a sphere, the two being, as Piero said, "a body with 8 faces, 4 triangular and 4 hexagons," and then a body with fourteen faces, six square and eight triangular.

That last body was something new in Renaissance geometry until Kepler gave it an exact name: the cuboctahedron. By the end of his career, Piero would mathematically figure out and draw six of the polyhedra that Archimedes had originally formulated, but which had essentially disappeared from history with the inexorable loss and destruction of ancient Greek sources (preserved for a time in later Greco-Roman manuscript copies). Piero would also show his debt to Plato and Euclid by applying the golden ratio to some of his analyses of polyhedra.[54] For the time being, the *Abacus Treatise* was probably helpful to merchants and students and to future mathematicians, as would be seen in the notorious case of

one Piero follower, the mathematician Luca Pacioli (of which much more later). But the treatise had little to offer painters. Its obvious forte was to present far more plane and solid geometry than were seen in any other abacus text of Piero's period.

History would not be especially kind to Piero's little opus, either; without his name firmly attached to the manuscript, apparently, his authorship would be forgotten. It would thereafter be anonymously cited, copied, or quoted from for centuries. Not until the twentieth century (around 1917, to be precise) would anyone prove that the miraculously surviving *Abacus Treatise* had been done in the hand of Piero, giving him full credit once and for all.[55]

Piero's gift with mathematics would prompt future generations to look back at his works, from the *Baptism of Christ* onward, to find secret geometries, golden sections, or other such clues. The first painting of Piero that truly lends itself to mathematical analysis, however, is the one that is clearly the most complex geometrically of his (surviving) works. This painting's *historia* would also stir expansive debate on what cryptic "story" Piero was trying to tell. The work has been known as *The Flagellation of Christ*, a small rectangular panel that is just two feet tall.[56] It may have been part of an altar or even the decorative side of a wooden chest, called a cassone.

In painting the *Flagellation*, and probably doing so in Urbino, Piero would have made one of the most arduous journeys in middle Italy. Urbino sits atop the high crest of a mountain range. It is surrounded not just by grassy hills and fertile pockets of valley, but by something akin to a harsh lunar landscape, volcanic in origin. From Sansepolcro, Piero might have gone northwest over the treacherous Rocca Trabaria, a three-thousand-foot elevation of stratified rock and trees on the border between Umbria and the Marches. If traveling from Rimini on the Adriatic coast, Piero could take a road inland at Pesaro, winding through ever-rising rugged hills, finally reaching two steep hills on which Urbino sat like an eagle's nest.

In these years of Piero's travels, Urbino had received a new ruler, the soldier and patron Federico da Montefeltro, who was no less than the arch-rival

of Sigismondo Malatesta of Rimini.[57] A little younger than Sigismondo, Federico was just as ambitious militarily and just as proud of his humanist training and his spending on the arts. Their provinces shared a border and their families some marriage ties. But they were inveterate enemies. In the form of the mock battles that typified Quattrocento warfare, the two princes promoted border skirmishes to control land and trading routes. They sparred under their dynastic symbols: for Federico the eagle, and for Sigismondo the elephant.

Urbino had recently become a dukedom, elevated to that rank by Pope Eugenius IV, and its first leader was the legitimate heir, the young Oddantonio Montefeltro. A year later, in 1444, Oddantonio was assassinated and his brother Federico—born illegitimate but, like Sigismondo, declared legitimate by Pope Martin V—took control. Piero may have had occasion to visit Urbino earlier in his life, but his painting of the *Flagellation of Christ* (probably) in Urbino is his first known connection. If he once had worked with the House of Malatesta in Rimini, in the long run Piero would forge a stronger and longer bond of patronage with the House of Montefeltro.

The *Flagellation of Christ* received its name because of its literal imagery of a Jesus-like figure being whipped. Based on the biblical story, it was not an uncommon image for a late-Gothic work, though Piero was able to present a far more naturalistic rendering and modern setting than seen in the medieval paintings. Federico does not appear as a character in the painting, so he was not its patron. Piero may have done the work for a humanist official in Urbino, or he may have done the small panel—with its exacting mathematical calculations—as a kind of experiment and meditation.[58] Whichever was the case, Piero had taken a conventional story and seemingly added mystery upon mystery, both in narrative and mathematically.

Piero's portrayal of a flagellation story unfolds in two halves. The left side shows a background scene of a man tied to a column. He is being whipped as a royal figure looks on. These are presumably Pontius Pilate and Christ. In the foreground on the right, three other men are posed. They look like real people Piero had in mind, and the dress is both strange and specific, as if Piero had seen it in courts or on the street. One of them wears a dark silk garment emblazoned with the so-called pineapple decoration.

This was chic Italian fashion, and it may have passed before Piero's very eyes. Then again, he could have observed it in a painting by the Flemish master Jan van Eyck, whose works with elaborate costumes were then appearing in Italian courts.

More perplexing, the three men in the foreground seem to be, by one logic at least, discussing the flagellation event taking place behind them. The bearded man is speaking, gesturing to a listening companion. In between them is a youth with blond hair, his eyes strangely lit. No one is looking directly at the viewer, as does one angel in Piero's *Baptism* painting, but the *Flagellation*'s blond youth has virtually the same face as another angel in the *Baptism*. So, is he, too, supposed to be an angel? As the questions mount up, the plot thickens.

Given the panel's reasonable size, one can imagine how Piero proceeded in his work. He first did a plan-and-elevation drawing of the picture's open-air portico, the colonnades, and the receding buildings. He used his compass and straightedge to put in the perspective lines, and in one case he used a cartoon and pouncing to outline a turban on a figure in the foreground.

Like few other paintings in the Renaissance, the *Flagellation* is the robust work of a mathematician.[59] According to the linear perspective Piero uses, the picture represents an outdoor space extending back 250 feet.[60] A black stone tile in the foreground seems to be Piero's unit of measure. The picture is ten by seven of these units. The viewer, in turn, is way off center. From a low vantage point, the beholder looks across an array of complex floor tiles, walls, and façades. The scene incorporates stone and marble in white, purple, red, and pink, and it has two sources of light—and so on, a jungle of detailed visual patterns and special effects for the art sleuth willing to make the effort. Despite its odd angles and cross-cutting lines, the *Flagellation* is a remarkable work of illusion, an airy outdoor/indoor scene unified by light and color.

For any painter attempting complex perspective, there were calculations to be made. As an illusion, linear perspective works best when the viewer of a painting stands in exactly the right spot, and the early Renaissance seemed to have arrived at a rule of thumb on this matter. Painters drew their perspective lines so that the ideal viewing distance was equal to somewhere between the width of the painting and one and a half times the width. A

perspective painting five feet across, for instance, would be the most visually accurate for viewers five to eight feet away.[61] For the *Flagellation*, Piero bucked the trend. His perspective lines put the ideal onlooker much farther away, a viewing distance of two and a half times the width of the picture. Why he did this can only beg more speculation. Perhaps it was because of its original location, or simply because Piero enjoyed a challenging experiment in perspective—or because it simply looked good to him, which is probably the core motive behind most artworks, all things being equal.

Ideal distances notwithstanding, an insatiable curiosity remained: What was the painting about? By this time in his life, Piero was doubtless a circumspect philosopher and a keen observer of the political tumult of his age, from the warring Italian city-states to the continued strife with the Turkish Empire around the Mediterranean. For many future interpreters of Piero, the experience of seeing the ebullient hopes of the Council of Florence (1439), and then the Turkish conquest of Constantinople (1453), must have been something that any artist with a conscience would be compelled to paint about. In the years when Piero mulled or even painted the *Flagellation*, Pope Pius II had called a special Council of Mantua (1459) to try to launch a crusade against the Turks.

According to one popular view, Piero had all this geopolitical drama in mind while painting the *Flagellation*: the Turkish infidels had scourged Byzantium as Pontius Pilate had lashed Christ. In the foreground, three key personalities of the day—mystery men, to be sure—may have been political figures close to the events. Over the centuries, there would be thirty-five distinct interpretations of Piero's *historia*, either biblical, based on local headlines of the day, or symbolic of international events.[62] The most longstanding local tradition had said that Christ's tribulation symbolized the assassination of Oddantonio, and some of the personalities of Oddantonio's short reign stood in the front, sad or perplexed. To others, the *Flagellation* would be an analogy of the conflict of the Latin and Greek Christians with the Turks.

But something else entirely could be at play, if one looks at the work with a totally contrarian interpretation. It might not be the story of Christ at all. More people than Christ had been lashed in the saga of man's inhumanity to man. Such a lashing was dreamed of by St. Jerome and vividly

written down. That story of Jerome had been painted before. His dream relives his intellectual struggle. He is brought before the throne of heaven and whipped for the sin of loving pagan literature more than the Bible.[63] The transgression is true, he writes:

> I could not do without the library which I had collected for myself at Rome by great care and effort. And so, poor wretch that I was, I used to fast and then read Cicero. After frequent night vigils, after shedding tears which the remembrance of past sins brought forth from my inmost heart, I would take in my hands a volume of [Roman playwright and humorist] Plautus. When I came to myself and began to read a prophet again, I rebelled at the [prophet's] uncouth style. . . .[64]

For this backsliding, Jerome had been called before the judgment seat, and God rebuked him, saying: "Thou liest; thou art a Ciceronian, not a Christian. For where thy treasure is, there will thy heart be also."

If Piero had been painting the "Flagellation of St. Jerome," then the topic being discussed by the figures in the foreground could well have been the merits of classical versus biblical or patristic literature, and perhaps the struggle that any Renaissance Christian humanist—like Piero—faced in such an age of intellectual ferment, and this in a culture that still emphasized piety. In the courts where Piero had visited, not only were the Aristotelians and Platonists confronting each other. The topic of the hour was how to Christianize the Greco-Roman past, the recovery of which was turning out to be a central birthright of the Renaissance, for the encounter of antiquity and Christianity was now far exceeding anything seen in the Middle Ages.

In the *Flagellation*, Piero may have been meditating on his own Jerome-like struggle. He may have been presenting his viewers their own choice between the Bible and the classics. This flagellation story—biblical or otherwise—is, after all, presented by Piero as taking place in a Mediterranean court in classical times. One early Christian theologian, at war with his pagan rivals, had already posed the dilemma: "What has Athens to do with Jerusalem?" The incompatibility of the two was further suggested in the sixth century, when the Christian Emperor Justinian apparently closed

the great academy in Athens that carried on in the tradition of Plato and Aristotle. For those familiar with these concerns, Piero's painting probably roiled with such tension. It was a visual debate over how much the art, literature, mathematics, and philosophy of antiquity could be integrated with Christianity. A small painting, the *Flagellation* would prove to be one of the biggest, and most beloved, enigmas in the history of art.

Like most of Piero's paintings, the *Flagellation* also evoked the question—both Christian and classical—on the experience of visual beauty. Well past the Renaissance, the classical and Christian views of beauty had been remarkably the same, in essence identical. Plato had put the ideals of Beauty and the Good in a transcendent realm, and thus viewed artisans as finally unable to imitate such intellectual perfection. Despite this Platonist skepticism, the Greek tradition nevertheless twinned Plato's universal Beauty with particular beauties.[65] Beauty is known by the pleasure it brings, said the Greeks, but in Plato and Aristotle that experience was defined differently. For Plato it was mental pleasure, while for Aristotle it was "catharsis," or a physical and emotional release. This physical emphasis was taken further by the pleasure-loving Epicureans. Neither Plato nor Aristotle would ever see the day, of course, when today's brain science also would use the baseline of pleasure as the effect of visual beauty. Neuroscience, however, would look for this pleasure in something that is happening among the brain's neurons.

For Christianity, the Good and Beautiful of Plato were transferred to the nature of the Hebrew God, who became the Good and in whose mind exists the Beautiful. The early Christian definitions of beauty came gradually, and one of the most influential works finally was written by a Neoplatonist to be known as Dionysius the Areopagite. A murky figure, Dionysius was probably a Syrian mystic from the fifth century C.E., although for a thousand years his text was believed to have come from the hand of Dionysius of Athens, St. Paul's famous convert. Nevertheless, this text (now called pseudo-Dionysius) convinced a millennium of Christianity that "We call beautiful the thing which participates in [Platonic] beautifulness, because

from it is imparted to all reality the beauty appropriate to every thing, and also because it is the cause of proportion and brilliance."[66]

Thomas Aquinas came much later, and he too wrote on beauty. Following a more Aristotelian approach, he preferred to define the elements of beauty in the concrete: "The first is integrity, or perfection, of the thing, for what is defective is, in consequence, ugly; the second is proper proportion, or harmony; and the third is clarity—thus things which have glowing color are said to be beautiful."[67] The Renaissance strongly believed in the mind's capacity to recognize beauty in created works, for, to hear Alberti, artistic perfection "excites the mind and is immediately recognized by it." Alberti would have received no protest when he told his public "When you make judgments on beauty, you do not follow mere fancy, but the workings of a reasoning faculty that is inborn in the mind."[68]

Closely related to this Christian and classical agreement about the mind's innate judgment of beauty was the belief that beauty was bound up with light, both as a spiritual and physical quality. Biblical texts used light as a symbol of origins and truth. Plato was enamored of the Sun, and latter-day Platonism described light as an emanation that created the world. Early Franciscan science took the same stance, eager to find how light and geometry were primordial to the existence of all things. Theologically and scientifically, there was ultimate light (lux) and its secondary sources (lumen). The natural philosophers of the Renaissance could hardly yet imagine the biological complexity of the human visual system—or the origin of color—but the painters among them began to codify various effects that still prove valid in modern visual neuroscience.

It was Aristotle who first openly wrestled with color. At the dawn of the Renaissance, Cennini's *Handbook* (c. 1400) spoke of Aristotle's "seven natural colors," a mapping that even Leonardo da Vinci would not improve upon.[69] Instinctively, the best artists who worked with color picked up on its two essential features. First of all, color had primaries and contrasts. Second, it is a carrier of luminosity (a degree of brightness). This became known to Renaissance artisans as *chiaroscuro*, Italian for "bright/dark."

Piero presumably understood both of these qualities; his challenge was to exploit them. When he painted the *Baptism of Christ*, the clothes on the three men in the background are in red, yellow, and blue, the three primary

colors. In his day, the humanist Lorenzo Valla criticized those who imbued color with too much meaning, saying "It is stupid to lay down laws about the dignity of colors."[70] Piero was clearly more in line with Alberti's irenic discourse on the harmonic "sympathy" of certain color combinations.

It was Alberti who also put a good deal of emphasis on luminosity, although that term is modern and technical. Visual luminosity is about dark and light, which Alberti placed higher than particular colors. "In the nature of things there are only two true colors, white and black, and all the rest arise from the mixture of these two," he said (as if turning nature into a black-and-white photograph, and thus revealing its most perfect and beautiful form). "Light and shade make it apparent where surfaces become convex or concave," achieving for the artist what he "must above all desire: that the things he paints should appear in maximum relief."[71] Piero achieved this in obvious ways, but of this Leonardo da Vinci, with his stronger chiaroscuro, became master in the Renaissance.

Leonardo actually disliked brightly colored paintings with hard-edged imagery and sunny details. His alternative was to create shadowy atmospheres, now called *sfumato*. In this, his paintings often showed the widest range of natural luminosity.[72] Piero was a luminist of a different kind. While he did use a sharp dark/light chiaroscuro on occasion, his taste was in a sunlit, pale, and cool range of color.[73] His work as a frescoist probably influenced this bright aesthetic, whereas Leonardo was slow and used layer upon layer of paint (though, later in his career, Piero, too, would employ the richer glazing effects; and Leonardo would lighten up in his *Last Supper* fresco). Over Piero's life as a painter, he otherwise stayed with a distinctive coloration—bright, cool, still, and clear.

Renaissance painters no doubt wondered about the nature of light, and probably turned to the theological explanations of the day: it was an ethereal substance made by God. Science was still centuries away from understanding such entirely alien concepts as electromagnetism. Early scientists, meanwhile, knew little more than the painters. A century after Piero, Johannes Kepler, a Platonist who used geometry to solve problems in astronomy, viewed light as being colorless and noncorporeal, a higher substance known only to God. For his part, Piero put his light and color into practice, whatever theory he may have subscribed to. As a default

philosophy, the Platonist and Christian views of light, color, and beauty were natural enough to adopt. In Piero's time, it was a short step from beauty to religion. People wanted to see God and miracles in their paintings. It was no different back in Sansepolcro, where Piero brought about another visual marvel, a painting of the Resurrection.

Some Italian towns boasted ancient Roman origins. For Sansepolcro, the origins story was distinctly religious. The name meant "holy sepulcher," the tomb from which Christ had risen from the dead. A stone from Christ's grave was said to have been brought back from the Holy Land by saints Arcano and Aegidius and to have marked the original Sansepolcro settlement.

A large and powerful city such as nearby Siena had shown what a commune could do to celebrate its origins in visual imagery, both sacred and secular. At Siena's city hall, the Palazzo Pubblico, Simon Martini's great fresco of the enthroned Madonna, the *Maestà*, radiated its theological message opposite the wall that featured Ambrogio Lorenzetti's sprawling story of civic life, Good and Bad Government. A smaller town such as Sansepolcro felt no less civic pride. When expressed, though, it was more exclusively religious by comparison. This was evident when Sansepolcro's city fathers commissioned Piero to adorn an improved city hall with a painting of Christ rising from the dead, a fresco seven feet square.[74] Placed directly inside the entrance room to this public building, the picture made no bones about the secular and the sacred: Christ was like the mayor of the town, the judge of right and wrong.

As usual, Piero tried to do something new in the *Resurrection*, which otherwise was well defined in the conventions of medieval painting. Presenting Christ as a nearly life-size figure, he fills the picture with a peculiar quality of cool, gray light and morning stillness. Paintings of the Resurrection had a few typical formats, including Christ floating in the air. Instead, Piero has him emerging from the sarcophagus, his foot on its edge. Some art historians point to the *Resurrection* to suggest that medieval Siena had the strongest influence on Piero's lifetime work in general, and not Florence (as pro-Florentines have argued), and not least, in this case, because

a prominent Sienese painting of the risen Christ already existed in Piero's home town.[75] Typical of most such paintings, the sleeping soldiers assigned to guard the tomb are also shown, and in Piero's treatment, they almost seem to be dreaming up the event at hand. In the dawn light, Christ looks ashen, as might any man who has survived crucifixion and the grave, his dark, circled eyes sleepless and hypnotic. He has the rough visage of a Tuscan farmer. Yet he is framed by fluted columns and he bears a heraldic banner, as if simultaneously a prince on the field of battle.

Although the *Resurrection* is one of Piero's simpler compositions in a painting, it is not without a good deal of complex thought and rendering. It mixes two perspectives, for instance. From a viewpoint below, the viewer sees how one sleeping soldier's head is thrown back; the architectural frame and sarcophagus are painted in a similar from-below viewpoint. However, Christ is rendered as if seen straight on. He is defying earthly optics. With his figure as the anchor, the rest of the picture is filled with irregular, dynamic patterns. The sleeping soldiers create angles. Their clothes alternate between dark green, brown, and red, making the pale Christ and his pink garment luminescent.

In the background, Piero has painted two different kinds of landscapes, although they both have the Tuscan feel that he is known for. On the right side of the painting, the trees are slim and in full bloom, and they lead down the hill to a village in the distance. On the left, the tree trunks are thick and the branches barren. These trees lead up a steep, rocky slope.

Piero was hardly the first medieval painter to moralize a landscape, if that was indeed his intent. An older tradition viewed such visual dichotomies as a contrast between the Old Testament and the New. Piero had doubtless heard sermons about the Christian choice of two paths in life, and it would have enriched his painting to infuse that kind of duality into the countryside: the lush, rich landscape of those who believe in a risen Christ, and the barren wasteland of those who did not welcome his teachings. And yet was this really Piero's symbolic intention, whether by his own design or at the behest of his religious patrons?

The other possibility is that modern interpreters have misread Piero's painting for an embarrassingly mundane reason: old paint often falls off fresco surfaces over the centuries, especially if inept cleanings are conducted on the work. It has been suggested that Piero had painted both sets of trees

in the *Resurrection* with leaves, but those on the left were not painted in true fresco, and thus had abraded away, revealing only the leafless, wintry branches.[76] (In fact, at one point in later centuries, the *Resurrection* was whitewashed by uninterested parties, and it would be one of the miracles of antique restoration that Piero's fresco was so well restored once again, perhaps minus some green leaves.)

Such caution over finding too much "green and dry" symbolism in Piero's paintings may also apply to his *Death of Adam* scene in his great frescos at Arezzo; while it has been said that "the dead tree in the Adam panel echoes the death content of the scene in contrast with the new tree which Seth plants," it may not have been a dead tree at all back when Piero painted it. His green foliage, applied by a brush, may have simply sloughed off over the centuries, leaving only the barren branches.[77]

Through all of this interpretive hindsight, Piero—like his *Resurrection* painting—seems to have survived with a repose of confident indifference. He left behind no record of his personal symbolic intentions in any of his works. Nor is there evidence of whom he may have used as models for various human faces, such as the sleeping soldiers in the case of the *Resurrection*. Nevertheless, some enterprising local would soon pass on a tradition that survived long after Piero's death: it says that Piero painted himself as the sleeping soldier with his head thrown back—a head done in exacting perspective, of course.

Up to this point, Piero had conceived two paintings with a monumental figure dominating all else. The first was the larger-than-life Madonna in the Misericordia Altarpiece. The *Resurrection* was his second painting with an outsized divine figure. His future paintings would be filled with many more outstanding human images, but none so enormous in their centrality as these two: Mary lifting her protective cope and Christ bearing his triumphant banner. By adorning the town hall, the *Resurrection* may have been the more civic of these works, but even with that political connotation, it would pale next to the politically explosive frescos that Piero would begin in nearby Arezzo. They would be the largest project of his life.

Strange Legends in Fresco

On his travels, Piero had probably visited Arezzo before. Located on a hilltop overlooking the Arno River, it was a mere twenty-mile journey west across the mountains from Sansepolcro, and was known for its picturesque assemblage of medieval towers and walls along the main route to Florence. Now the little town, with its Franciscan presence and big "Aretine" pride, would dominate a good part of his life. As the 1450s began, Piero would embark on a massive fresco at Arezzo's central Franciscan church, adorning two thousand square feet of wall with one of the most alluring tales in medieval Christianity, the story of the true cross.

Arezzo had a taste for grand narratives of all kinds. It had produced a number of influential figures in Italian cultural life. They began with Petrarch and passed through Leonardo Bruni, the longtime chancellor of Florence. The city was also mindful of the political events of the day, the most shocking at about this time being the fall of Constantinople to the Turks in 1453. Islam seemed to be sweeping the East, knocking at the door of the Baltics and Italy. This was of dire concern to the Arezzo Franciscans. The papacy had designated the Franciscan order as the preachers of popular causes and as keepers of the Holy Land. In the past, they had been

at the forefront of crusade preaching, and the new Turkish threat made a similar demand.

Piero's series of storytelling frescos at the Franciscan church would one day be known in their entirety as The Legend of the True Cross. But for the Aretines and Franciscans who commissioned them, they may well have been a running commentary on the perennial Christian troubles with the Holy Land and the East.

The Franciscans had already set a high standard for fresco cycles. The premier exemplar was their Assisi mother church, where the life of St. Francis was painted in twenty-eight stories, like a film strip, across the vast walls.[1] The true-cross story had been painted in at least two other Italian churches, but the Arezzo Franciscans aspired to have it told with the splendor of an Assisi, especially given the Arezzo church's storied heritage.[2] On the outside, San Francesco was nothing special: it was the typical Gothic barn, large and simple to suit popular preaching. Its origins had a taste of the supernatural, however, for the church was said to have been established after St. Francis had a vision on the outskirts of the city.

A project of this scale was going to take both good theology and a good deal of money, and so it was that the Franciscan friars and one of the wealthiest families in Arezzo, the Bacci clan, tried to work out the proper arrangements. The Bacci were well-connected spice merchants and apothecaries.[3] About the time of Piero's birth, the family had promised the Franciscans that they would fund frescos for San Francesco. After decades during which no money was forthcoming, the Franciscans pressed for fulfillment. The results began to come in the 1440s.

As paying patrons, the Bacci probably had some say in how the Legend of the True Cross frescos would tell that story. The Bacci hand may explain why the frescos ended up with more than just theology: they would feature a set of worldly sagas, two battle scenes from the true-cross legend. One of these featured Emperor Constantine. Aretines, as it happened, claimed that their city had been the first to convert when Constantine made Christianity the state religion in 325 C.E. The other battle scene would show Heraclius against the Persians, a reminder, of course, that Christians at that hour were still contending with the East, now personified in the Ottoman Turkish Empire.

To recruit a seasoned painter, the Aretines turned to Florence, and there they found the elderly Bicci di Lorenzo, a Quattrocento veteran who had both rebuilt and painted churches. When Bicci arrived, the Arezzo church was not a blank slate: the interior was dotted with late-Gothic imagery, including allusions to the Franciscan founding and Arezzo's favorite saints. The new frescos were to go up on three towering walls. Each was three stories high at the very front of the church, an enclosure called the choir, the large space around the altar where the priests and monks sit during the Mass. When Bicci di Lorenzo began his work in the late 1440s, he brought to the project his Florentine experience with frescos, but also his conventional style.

No sooner had the project begun to make progress than Bicci fell seriously ill. This was 1448, when he and his assistants had probably completed the imagery around the arched entrance to the choir: the four evangelists, some fathers of the church, and a last-judgment scene. Then Bicci died in 1452. At some time between Bicci's illness and death, Piero was hired as a replacement master painter.

The painterly task that now faced Piero was a Herculean case of problem-solving: geometrical calculations, the rendering of large-scale human figures, and the painting of scores of organic and architectural images. Taking the baton from Bicci, however, Piero might not have viewed the Arezzo fresco as one of his most important artistic undertakings. As evidence of this, he would interrupt his work at Arezzo for other ventures that, perhaps, were more interesting, prestigious, or profitable. Anyway, whatever Piero's immediate attitude, the Arezzo frescos would stand the test of time. Over the centuries they would become known as Piero's monumental masterpiece.

The frescos would also speak to the popular imagination. They told the true-cross story, but they also reminded people of the most popular written work of the Middle Ages, a medieval anthology of saint biographies called the *Golden Legend* (*Legenda Aurea*). This collection, from which every grammar-school student learned to read (even in hand-copied manuscripts prior to the invention of printing), was the source for the episodes in the true-cross story that Piero was about to paint.

The *Golden Legend* was compiled by the thirteenth-century Dominican friar Jacobus de Voragine. He collected every version of the saint stories he

could find. When he compiled these according to feast days, they could be read or meditated upon on various dates. Piero had no doubt read from the *Golden Legend* as a schoolboy, and when he painted his St. Jerome panels, he may have referred to that saint's story in this text. The extensiveness of the Arezzo project invariably sent him back to the *Golden Legend* to brush up on the true-cross legend, told in two feast-day entries. It went like this:

At Adam's death, his son Seth, his third child after the death of Abel at the hands of his brother Cain, took a sprout given to him by an angel and planted it on his father's grave. It would grow and endure as a great tree on the hills of Lebanon. There, Solomon discovered it and brought the tree to his Temple. When the Queen of Sheba visited his temple, she sensed the wood's prophetic qualities. Feeling threatened, Solomon disposed of the tree, but it was unearthed again by the Jews when they dug a water pit. The wood was later used for the cross on which Jesus was crucified.

The wood surfaced again in the Christian era, an epoch opened by the Roman Emperor Constantine (after 325 C.E.). He Christianized the empire after he won his battle against the rival emperor Maxentius. The victory, in turn, had followed Constantine's nocturnal vision of the sign of the cross. His Christian mother, Helena, then gathered the wise men of Jerusalem to discover the whereabouts of the true cross. This was known by a reluctant Jew, who was thrown into a pit until he finally divulged the location. Helena took pieces of the cross back to Rome. Other pieces were exalted in Jerusalem.

Then in 615, the Persian king Chosroes II conquered Jerusalem, taking its remnant of the cross back to his palace to put among the pagan artifacts of his conquests. The Byzantine emperor Heraclius responded by defeating the Persians in a battle and duly returned the true-cross fragment to Jerusalem, where its veneration would continue. Over the many centuries of this adventure, the cross produced several marvels and made converts of non-believers. One line in the story says "The virtue of the cross is declared to us by many miracles."[4]

To squeeze this complex story onto the church walls, Piero and his patrons had to utilize only some of the events, omitting others. The Franciscans and the Bacci family had probably chosen many of these by the time Piero arrived. Even so, he surely had some power to arrange the

composition and add or subtract events. For example, Piero may have added the picture of an Annunciation, the story of Mary visited by an angel with news of her divine pregnancy; this was not mentioned in the true-cross narrative. But whoever had the final word, the genius of Piero was to arrange one entire, knit-together scheme.

Italian mural painting had already existed for a thousand years. Its advocates had used a variety of solutions to arrange a linear story across church walls, many of those walls irregular or extended into domes, vaults, and niches. Piero had a fairly square room to fill, even with its pointed arches at the top of the three walls. He adopted one of the earliest-used church formats. The story began at the top of the right wall, went downward, jumped to the bottom of the opposite wall, then continued up to the top, a direction quite opposite to reading a Western manuscript.

Whatever the order, most worshippers would know the big events in the true-cross story and pick them out. Adam comes first in time, then Solomon of the Old Testament, then the Annunciation of the New Testament, and later still Constantine of Christian history. Finally, the cross returns to Jerusalem. The *Golden Legend* provided churches with dates for feast days. In May and September, the Franciscans celebrated two specific events in the true-cross saga, now known in Piero's painted scenes as the *Discovery and Proving of the True Cross* and *Exaltation of the Cross*. He might have painted those two scenes first to accommodate the ongoing life of the congregation, which carried on actively, celebrating their feast days and skirting around his painter's encampment.[5]

To arrange his mural stories, Piero divided the side walls of the choir (left and right) into three tiers. The top tiers are in a pointed lunette shape. Below are two rectangular spaces, one above the other, each about 11 feet tall by 24 feet wide—giving him six large areas, as if giant canvases on which to paint. On the front wall, facing northeast and dominated by a window, he divided up small spaces for cameo stories. In the six large side areas, Piero used a common format. He painted a continuous background of landscape and architecture, and then in the foreground he featured two or three different stories. All six scenes have a low horizon line and a big sky. Against this depth, Piero did not place his human figures deeply. The characters line the wall as if in an Egyptian or Roman frieze at the visual forefront.

Piero also echoed themes from one picture to another. On the front wall, he painted two cameos of angels making announcements: the *Annunciation* and the *Dream of Constantine*. In the latter of these, Piero mastered a night-time chiaroscuro well before Leonardo, Caravaggio, or Rembrandt. The side walls are similarly harmonized. The top lunettes convey the start and end of the great story. The middle tiers both show queens recognizing the Christian faith as true, and the bottom tiers contain battle scenes.

One other effect seems to unify everything. The frescos are a world of frozen human action, all of it suspended in an atmosphere of cool, pale colors. The stillness presents a distinct optical effect, and this is particularly evident in the battle scenes. Their action is frozen into more detail than the eye could possibly see in a real human event. As neuroscience would suggest in the future, the brain associates action with flux and glimpses, not perfect stillness, and this is why the brain finds something unusual—either counterintuitive or transcendental—in the kind of stop-action imagery that Piero was putting up in the Arezzo choir.[6] In Piero's time, all that could be said was that his paintings created a strange, idealized imagery. His images brought unchanging things into worldly, physical forms, revealing their higher Platonic essences in geometric qualities and harmonious proportions.

An experienced fresco painter by now, Piero must have employed a large team. They built the scaffolding on which Piero stood, prepared the wet plaster, and did some of the painting as well. There are three theories on how the project unfolded, and, depending on which one you care to believe, Piero finished the project in a few years or over more than a decade.[7] Fresco was done top-down, since its watery elements dripped. By this same logic, the scaffolding was erected to do the uppermost areas first. Then it was built downward. In the simplest theory, this was Piero's procedure: he worked top-down and completed the project over a few concentrated years. A noticeable difference in Piero's painting styles would have been normal over such a period, perhaps stiffer at the top but, as he warmed up, working downward, the scenes became more integrated, the modeling rounder, and the color more sophisticated. The work of assistants around Piero, moreover, could explain a certain unevenness of quality everywhere in the murals.

A second theory views Piero as having worked down one side with the scaffolding, taking a long break, and then returning to do the other side. Thus he set up the scaffolding twice. This view may explain the difference in colors on the two sides. The first side is cooler and, to one discriminating eye, "more exquisite and more personal."[8] In this view, Piero did the second side later, giving it a warmer cast and sharper architectural images. The presumption is that Piero took a major break in the fresco to travel to Rome between 1458 and the cusp of 1460, having been invited to paint for the papacy.

The third theory is a combination: Piero took up the frescos even as the elderly Bicci fell ill, and he began painting at the top on both sides. Then, along the way, Piero departed Arezzo frequently for other projects. His style thus changed under different outlying events and inspirations. For example, his top lunette on the death of Adam is organic; it is about individuals and their emotions. Right below that, the gears switch: a geometric look prevails as Piero presents the emotionless elegance of a royal court with the Queen of Sheba. Later, when he did the battle scenes, he focused on portraiture. This theory also acknowledges Piero's trip to Rome as a crucial break. By implication, he returned with a better knowledge of painting architecture, not to mention a deeper affection for idealized Platonist shapes.

How much the contents of the narrative story on the walls changed in the time Piero painted them—a process of five years or fifteen years—is not certain. Additional theories say that the influential Aretines, knowing the mural's potential for propaganda, persuaded Piero to alter scenes, put in special faces, or massage other elements as religious and political events of the day evolved.[9] Still, the core narrative must have been in place from the start. The first thing Piero painted, it seems, was the end of the story—the return of the cross to Jerusalem. In this scene he included many of his famous tall, flaring hats. With that personal touch, he began the monumental project.

<center>⊰◇⊱</center>

During the Arezzo project, the papacy had summoned Piero to paint in Rome (of which more later). His stay would be brief, however, lasting from

1458 to 1459 and ending when his mother died and he chose to return to Sansepolcro. After this sojourn at home, Piero would undertake two major altarpiece projects, and their unique qualities would reveal the latest developments in his work.

In 1454 in his home town, Piero was commissioned to paint a polyptych that, as it turned out, would be his largest altarpiece done for Sansepolcro. It was for the monastery church of St. Augustine, and thus the name of the work as it comes down to us today: the Saint Augustine Altarpiece. Despite its size, the altarpiece had all the conventional limitations of a medieval design. Piero's challenge was, once again, to turn the commonplace into something extraordinary.

The commission originated with local resident Angiolo Giovanni Simone Angeli, who ran a prosperous mule business. At the time, the monastery church of St. Augustine, located at the west of the walled town, was busy with improvements. Like all the church buildings of such mendicant orders, this one, too, was like a great auditorium. Spiritually, the Augustinian monks were just as Platonist in their piety as the Camaldolese and the Franciscans, in effect following Augustine's motto that, when it came to the philosophical side of faith, including God's creation by Ideas and the existence of the soul, "There are none who come nearer to us [Christians] than the Platonists."[10] Quite apart from such intellectual matters, town residents supported the religious mission of the monks and the church by paying to decorate it with banners, frescos, chapels, tombs, and shrines. The church had probably erected a screen with icon pictures that bisected the great open space of the sanctuary. A stained-glass window had just been installed. All that was missing was a great altarpiece.

Accordingly, Piero was duly hired "for painting and decorating and gilding [the altarpiece] with those images, figures, pictures, and ornaments" that suited the patrons. They were especially eager to have gold and silvery colors, after the medieval fashion.[11] Piero's payment came not only in florins, but also in a piece of cultivated land.

Large altarpieces were not common in Sansepolcro, and the story of the St. Augustine project illustrated how materials—such as altarpiece structures—often were saved, revised, or reused. In this case, the Augustinians had acquired from the Franciscans the still-barren wooden altarpiece

structure that Piero had prepared for Antonio many years before, but which Antonio had failed to begin. Piero had prepared that structure to be painted on the front and back. Now he would use just one side—which still bore some twenty-six images—since the polyptych would thankfully stand against the wall behind the altar.

The center of the Saint Augustine Altarpiece inescapably featured a madonna and child (a panel now missing). No less striking were the four large saints arrayed on either side of the Virgin. The saints were among the most solid and voluminous of Piero's human figures, like great weighty statues. They seemed to echo the painted statuary that Piero had seen around town his entire life. Each saint stood in his own tall panel with a semicircle top: St. Augustine, Michael the Archangel, John the Evangelist, and a friar-looking figure said to be St. Nicholas of Tolentino, an Augustinian made a saint in 1446.

All the altarpiece's saints are somber and remote, but their garb is enchanting, their brilliance enhanced by Piero's selective use of oil paint along with the traditional tempera. The great frock of Augustine, painted in black and gold, is filled with miniature stories of remarkable detail and coloration, achieved by Piero with oil as a supplement to his tempera (for in this transitional stage of Renaissance painting, oil was often used experimentally with tempera or fresco). The saint, in his almost-Technicolor frock, has been called "one of the first examples in Italy of the use of the new technique of oil, of a decisively Flemish character."[12]

Not to be outdone, the other compelling figure in the altarpiece is St. Michael the archangel. He is a cherubic-looking young man—a typical Piero angel—with breastplate armor, sword, beheaded dragon, and wings modeled on those of a swan. Michael had resonance in Sansepolcro. For some time already, the most popular pilgrimage for Sansepolcrans had been to a distant mountain shrine in honor of the archangel. In Piero's hands, and right downtown, the citizens now had another rendition of this fearsome protector. Piero's St. Michael projected an eerie mix of a sweet-looking youth and the razor-edged wrath of God, for the inscription says "Emissary of God's Power."

More than in any other painting to date, the Saint Augustine Altarpiece offers countless passages of light reflecting off different materials, hard and

soft, textured and shiny. This was the wonder of oil paint, which Piero was now using in greater fullness. Only part of the St. Augustine image was done in oil—his flamboyant cape—and that is why St. Michael, painted entirely in oil, has been heralded as the first *total* oil painting by an Italian.[13] By the time he applied his brush to St. Michael, Piero had ended the old practice of a green underpainting, and instead adopts the brown undermodeling of the Flemish technique. His Flemish-type glazes, however, are used merely to deepen shadows or enhance a passage of color, for he retains the pastel-type tones seen in his tempera works and which would characterize most of Piero's oeuvre (as compared to the heavy, dark glazing of a Leonardo da Vinci, for example). Piero's achievement was to apply oil painting to full-bodied human figures, a departure from the overly detailed, but anatomically awkward, visages typical of the Netherlanders.

These were transient times for Piero. He was at the peak of his powers artistically, and he was forever on the road, apparently being in high demand in central Italy. Through the early 1460s, he was rarely in the city, the two surviving dates being summer 1462 and early 1464. Then in 1466 Piero was homebound with an illness, and at this time he probably worked on the Saint Augustine Altarpiece. In these years he was also in nearby Arezzo, where he painted a St. Mary Magdalene fresco inside the Arezzo cathedral (and much else in Arezzo, according to the chronicler Vasari, a native of that town). Whatever the chronology, Piero had painted the saints in the Saint Augustine Altarpiece in different-enough styles to suggest gaps in time. It may have been a fifteen-year project, at least according to the payment dates that survive in documents.[14]

At this point, it may be proper to ask whether anything peculiar about Piero's approach to his artworks turned them into such long, drawn-out enterprises. One theory is that, as a mathematician, Piero spent an inordinate amount of time preparing a work. Arguably, the preparation shows: Piero's strokes in his panel paintings tend to match his underdrawings precisely, suggesting that there was no need for corrections, thanks to his careful, drawn-out, methodical planning. Evidence also suggests that Piero prepared cartoons that he could later reuse, which required a certain amount of mathematical scaling before he drew them. For example, the head of one saint in the Saint Augustine Altarpiece is exactly the same

as the head of a king in the Arezzo frescos, just scaled to a different size. According to the chronicler Vasari, Piero made clay models that he draped fabric over to study the proper rendering of the folds in clothing and other draperies, yet another way to spend time getting his drawings just right.

Whether his patrons appreciated such prolonged preparation is uncertain, but in Sansepolcro this seemed to be beside the point: they were patient with Piero, one of their own. The Saint Augustine Altarpiece was not the only project the Sansepolcrans had given Piero from 1454 onward, but it would turn out to be unique in Piero's legacy. Being made of several small panels, the polyptych, in later centuries, would be separated into pieces, each panel sold as an individual painting, finding homes in collections around the world.[15]

This was justified because so many of the panels were remarkably splendid in their own right, including the smallest scenes, located in the section below the main picture area. This was the well-known *predella* common to all polyptychs. The scenes in the predella were often done by a master painter's capable assistants. In the Saint Augustine Altarpiece, one surviving image is surely by Piero's hand: a full-blown landscape with figures, the *Crucifixion*. Albeit a very small panel, the painting conveys a remarkable composition with strong lines, solemn figures, heraldic banners, and bright colors jostling against each other in mesmerizing clarity and detail.

It was features such as these, no doubt, that prompted Vasari, a century after Piero's death, to speak of the entire Saint Augustine Altarpiece as a "thing much extolled."[16] Over the centuries, its various extollers dismantled the work and dispersed its many panels. All four of the saint panels survived, as did the small *Crucifixion*. That, along with one large saint and three other small peripheral panels, eventually found homes in the United States, passing through private collections to final resting places in museums. In effect, the Saint Augustine Altarpiece would provide America with five of its seven original Pieros, a national grouping of Pieros that would be second in number only to Italy.[17]

The Saint Augustine Altarpiece had anchored Piero in Sansepolcro during the 1460s, at least off and on. Local patrons had plenty of other requests for Piero's works. This may have also delayed the altarpiece project

further. And, of course, there were commissions away from home—such as in Perugia.

As an apprentice, Piero may have studied in Perugia, a commercial hub in the lower Tiber Valley. It was a city that his father, as a merchant, must have dealt with often. Now, probably in the later 1460s, Piero returned to negotiate a major painting project. Perugia was somewhat legendary for its Renaissance tyrants, but its religious life was no less vibrant. Around 1455, the nuns of Sant' Antonio delle Monache had opened their convent. Drawn from a pool of wealthy, well-connected noblewomen, these pious ladies had taken Franciscan vows of poverty. Still, they naturally wanted an altarpiece worthy of renown, and so it came to pass that they appealed for public support to have Piero produce a new and elegant polyptych for their sanctuary.

To complete what became known as the Saint Anthony Altarpiece, Piero did not need to start from scratch.[18] The convent's patron saint, Anthony of Padua, was designated as needing to appear somewhere in the work, and the nuns had furthermore decided on a traditional central theme, the Madonna and child enthroned. Then they obtained a wooden structure that was by no means conventional. Towering more than ten feet high, it was not very wide, giving it the feeling of a monolith, or even a medieval rocket ship. It was presented to Piero as a blank, with a little gilt on it. Piero would do each of the polyptych's distinct paintings on separate panels, then attach them to the structure, allowing him to work just about anywhere, even back in Sansepolcro. In his capable hands, it would become one of his most complex visual experiments.

The polyptych would feature Mary twice. In the central band this would be as a seated Madonna, resplendent in a blue cape and red-and-gold dress. She is also holding her child, and it is here that Piero was also developing something of a pattern. Piero's surviving works feature just five images of the Christ child. Compared to other Quattrocento painters, his infant Jesus is unusually "grave, poised, portentous, no less than the adults," according to one art historian.[19] For the Perugian nuns, he presented a perfect example of this serious little boy, his tiny hand raised in admonition.

On her throne, Mary has other company as well. On either side stand the saints. To the left are Anthony of Padua and John the Baptist, and to the right St. Francis and Elizabeth of Hungary, a Franciscan saint canonized in Perugia. Behind the human figures, Piero combines flat spaces of gold leaf and also his distinctive faux variegated marble, and with these flat colorations he nevertheless creates an illusion of deep space, making the figures seem round and solid. The altarpiece might have simply looked like a medieval throwback with its pointy shape, its Madonna theme, and its gilt of gold; Piero makes it strangely modern instead by modeling the figures and adding some extreme touches of linear perspective.

This is especially evident at the very top, where Piero introduces the second image of Mary in a strikingly different venue. The story is of the Annunciation. A surprised Mary is being visited by the angel in the sunlit cloister of a convent. Piero builds the scene with a hyper-architectural perspective. Eleven archways, supported by Corinthian columns, recede into the background, a linear pattern that verges on an optical illusion. In one modern 3-D analysis of the complex architectural perspective, Piero has actually made the angel figuratively "invisible" to Mary—though they seem to face each other—by placing columns between their lines of sight.[20]

Across the entire altarpiece, Piero has abandoned some of the love of decoration he had showed in his youth. The faces, gestures, and clothing of the figures are irregular, and thus more real in their physical presence. At first glance, the polyptych seems a mosaic of disparate parts, much as if the owners had cut and pasted different altars together. As modern research would show, however, it was indeed built as a single structure and painted by one hand, mostly Piero's, with assistants working on some images in the predella. One of Piero's predella images illustrates the stigmatization of St. Francis, and in this he employs the same kind of nocturnal chiaroscuro—a dark night illumined by directional light—that he virtually pioneered in the *Dream of Constantine* in the Arezzo frescos. The altarpiece also features Piero's charming roundel portraits of saints Clare and Agatha, two women who renounced their wealth to be early followers of St. Francis.

Knowing human nature, we can plausibly assume that the death of Piero's mother was a significant moment in his life (as would be the death

of his father not too many years later). Working for the nuns may have given him some motherly assurances, if such were needed. However, if Piero ever had a truly significant turning point in his life—spiritual or familial—it has never been documented. Nor would it be easy to detect such a time in any of his paintings. Doubtless, though, he was changed by his experiences, and between the Arezzo frescos and his work for the nuns in Perugia, one event stands out—Piero's trip to Rome to paint for the papacy. After his time in that great city, a venue of history, theological controversy, humanist learning, and urbanity, Piero's intellectual life was presumably never the same.

CHAPTER 5

Piero Goes to Rome

Rome was becoming a magnet for early Renaissance artisans. The city had always had its native talent, but at the start of the Quattrocento, others from across Italy traveled there to view the ancient ruins, carrying home visions and stories of ancient days. With the return of the papacy, a more permanent patronage was put in place. The various popes began to commission painters to come to Rome to decorate the Vatican and artistically revive many broken-down churches in the city. Masaccio of Florence and Gentile da Fabriano of Venice both ended their days in Rome, and Fra Angelico, the Dominican monk, worked intensely there from 1447 to 1451. His ultramarine skies, filled with glittering stars, seemed to take over the fresco look of the city's chapels.

Piero's invitation came around 1458, most likely with the election of the new pope, Pius II.[1] Piero's name may have come to the papal household's attention through the strong Franciscan connections that existed between Tuscany and Rome; or it may have been at the advice of Piero's cousin (once removed), the papal scribe, cleric, and architect Francesco da Borgo (Francesco da Benedetto Bigi), who worked in Rome, where the papal favorite, Leon Battista Alberti, was supervising all architectural projects. What is more, Piero may have had a Rome contact through Arezzo: the Bacci family,

patrons of the Arezzo frescos (and not to be confused with the Arezzo painter Bicci di Lorenzo), had one of its members high in papal circles.[2]

Pius II was the latest of the popes to support the humanities. The papal treasury was now paying for translations of Greek science, and it underwrote an expanding papal bureaucracy, a culture of learned scribes and translators. A former poet laureate himself, Pius had loved the classical past and the fame of the worldly life—until he became a monk. During his promiscuous days, he was known by his humanist name, Aeneas Silvius Piccolomini. After his spiritual reform, he famously wrote: "Reject Aeneas and accept Pius!"[3] Under his tenure, humanists, natural philosophers (i.e., scientists), and architects expanded their roles under the patronage of the Church.

In this sort of cultural atmosphere, Piero would stretch his own intellectual horizons. Rome must have given him his most robust encounter with Platonist thinking, and in Rome he may have been more fully initiated into the Greek science of Archimedes. An earlier pope, Nicholas V, had commissioned a translation of Archimedes's works into Latin.[4] Historically, a basic corpus of Archimedes combined in one manuscript his seven basic tracts: *On the Sphere and the Cylinder*; *On the Measurement of the Circle*; *On Conoids and Spheroids*; *On Spirals*; *On the Equilibrium of Planes*; *On the Quadrature of the Parabola*; and *The Sand Reckoner*. Once this translation was done, it became a well-thumbed manuscript available in the Vatican Library.

The Archimedean compendium fascinated Rome's Platonist churchmen, and at some point a copy came into the possession of Piero's relative Francesco da Borgo. Having his own library collection, Francesco seems to have had this Archimedes in Latin transcribed into more copies for himself. For all his extraordinary talents and his once-trusted role as a Vatican bookkeeper, Francesco was addicted to collecting valuable works. He also pilfered money from the papacy, for which Pope Pius II had him executed in 1468. Well before these macabre events, however, Francesco probably had shown the Vatican's Archimedes to Piero. This goes far toward explaining Piero's future interest in the Greek science of the polyhedra. Indeed, Piero may have obtained (in Rome or later) a copy of Archimedes in Latin from Francesco for copying it *into* Latin (which Piero was gradually learning to

write, apparently). To this replication Piero then added his own careful illustrations.[5]

More than Archimedean polyhedra, however, it was Greek philosophy itself that was stirring debate in Rome. Piero must have been attentive to this as well. The theological question of the hour was the proper Christian attitude toward Greek pagans such as Aristotle and Plato. This dispute began in Florence but had now moved to Rome, finding its natural orbit around the two great Hellenists in Vatican circles, the German cleric Nicholas of Cusa (known as Cusanus in Latin) and Basilius Bessarion, the Greek churchman who had joined the Roman Catholic confession. By the time Piero arrived in Rome, both Cusanus and Bessarion had obtained high ranks in Church affairs (and both had perused the Archimedes manuscript). As if leaders of Christian Platonist salons, both of them had city villas that were gathering places for clerics, humanists, and artists.

Bessarion had settled in Rome much earlier than Cusanus. Following the Council of Florence, he had returned to Constantinople. A vociferous wing of the Greek clergy had assailed him for capitulating to Rome, and this offered the opportunity for Bessarion to follow his own inner lights: he converted to the Catholic Church. Bessarion himself had been a papal candidate—though, by the time of Piero's arrival, he had become the dean of the College of Cardinals and a venerable right hand of sitting popes. Pius II made him protector of the far-flung Franciscan order, which included its mission in Oriental lands. Having failed to unite the Latin and Greek churches and thwart the Turks, Bessarion nevertheless would succeed in promoting a revival of classical studies, and this included all the ways that Plato could be reconciled with Christianity.

It would be hard to argue that Platonism, as a topic of study, was for the common man. At least Aristotle had called for activity in public life, and allied with a Roman orator such as Cicero (a philosophical Stoic), Renaissance writers found in them a basis for their ideology of liberty and civic duty, especially where communes, with their town councils, governed. This democratic idealism did not last, however. Even the leaders of communes—with the Florentine Medici as indicative—turned into autocratic dukes and princes. Soon it would be the age of Machiavelli's *The Prince*. This cultural change in Italy was an opening for Platonism, which, in Plato's

Republic, did advocate an elite rulership over the citizenry. More significantly, Plato argued that the highest calling was one of contemplation, not worldly ambition. When Platonism took on its more formal characteristics in Italy—such as a so-called Platonic Academy in Florence—its goal was cultivation of the mind. Virtue was located in learning per se, not in the ancient Roman ideals of Cicero, who gave up personal interests to serve in the raucous body politic.

For Bessarion's part, this Greek churchman was particularly attuned to the practical power of Platonist thinking in the world of ecclesiastical politics. The Council of Florence was testimony to how the hard-edged logic of Aristotelian scholasticism lacked the flexibility to resolve insoluble differences on beliefs. A Platonist approach relied as much on intuition as logic. It allowed for degrees of ambiguity. On the whole, for its Christian partisans, Plato's metaphysical vision of a universe seemed to be far more spiritual than that of Aristotle. Apologists for Plato knew well enough of the many outrages against Christianity in his dialogues, especially in the *Republic*. These included the transmigration of souls, the sharing of wives, euthanasia, and allusions to homosexual practice.[6] One way around these was to argue that Plato was often being ironic, or that his dialogues were simply a wild clearinghouse of fantastical Greek opinion, since the texts always pitted various arguments one against another and Plato's own viewpoint was not always clear.

Bessarion was a master at navigating these disputes. His approach was to elucidate the more obvious and acceptable areas of Plato's Socratic wisdom (since the dialogues often gave voice to the irenic Socrates), and to focus on Plato's larger metaphysics, which had a strong doctrine of Creation and the individual soul. These two doctrines were not always welcomed by the revival of Greek thought; the Aristotelian movement that dominated the Italian universities—called the Averroists (followers of the Aristotelian Arab Averroës)—denied both beliefs.

From the days of the Council of Florence, Bessarion and Cusanus had known each other as supporters of the Latin and Greek union. Such ties may have paved Cusanus's way to Rome, where he would become a leading theologian. Reared in Germany, Cusanus had been nurtured in its *devotio moderna*, a culture of lay piety and classical learning. He also

found a guiding light in Meister Eckhart (1260–1327), the German mystic. However, at age seventeen Cusanus went to Padua, the center of worldly Italian humanism. This profound experience pulled him in the direction of natural science and spurred his interest, rare among theologians, in mathematics and astronomy.

Cusanus also adopted the humanist predilection for book-hunting and collecting of ancient manuscripts, and this allowed him to achieve an uncommon mastery of Platonist thought.[7] There seemed to be no end to these lost works of antiquity. What soon became apparent was this: the past offered a confusing abundance of Platonist writings. Most valuable, of course, were Plato's original dialogues. Then, in early Christian times, Platonist theologians such as Origen, and in part Augustine, penned volumes of material. Next came the "secular" Platonists in the last stages of the Roman Empire: Plotinus and his student Porphyry. Later still was Proclus, who had a student too, the Syrian Christian mystic Dionysius (erroneously thought to be the New Testament's Dionysius of the Areopagite council in Athens). All together, this medley of thinkers produced volumes on pure Plato and on their own derivations, to be known as Neoplatonism.

A figure such as Piero, depending on the degree to which he joined humanist circles to discuss Platonism, would have been introduced to the world of its many interpretations. According to later historians of Platonist thought, Plato's dialogues and their later interpretation by Neoplatonism were different in two ways. While Plato emphasized the dualism of the sensible and intelligible, Neoplatonism emphasized the dialectic between the One and the Many (as found originally in Plato's *Parmenides*). Second, while Plato vaguely said that objects in the world "participate" in their transcendent forms (or Ideas), the Neoplatonists developed an elaborate scale, or ascending ladder, by which reality emanates from the One, and by which the human soul ascends back to the One. This was an idea that was adopted by some of the early Greek monastics and that was still alive in the tradition of Camaldolese spirituality, which had a strong influence in Sansepolcro and the life of Piero and his family.

The belief in such metaphysical scales and ladders in the universe materialized in the physical vision of the Great Chain of Being, an ordering of all of life—from God and souls down to insects and brute matter—which

gained in popularity in the Middle Ages.[8] Study of the physical chain of being was part of speculative science in the Renaissance, and it continued up to the time of Charles Darwin's theory of biological evolution (which presented compelling new arguments against a natural order that is hierarchical).

As best as Piero could tell, this world of Neoplatonist speculation was an amalgam that tried to preserve many strains of ancient Greek thought and science.[9] Through all the Neoplatonist fog, it was still possible for Piero to grasp the essentials of a Christian Platonism. This was an outlook that acknowledged the role of number and proportion in the universe, and it also espoused the dualistic doctrine of the intelligible world of Ideas and the sensible world of material objects. This was relevant to Piero's mathematics, to his paintings, and to his acceptance of basic beliefs about God, the soul, and a spiritual and physical realm.

Piero was only an amateur in such Platonist matters, and, as the opportunities arose, he no doubt looked on in silence when the more scholarly humanists probed ways to reconcile ancient thought with the Christian faith. An expert in this task was someone like Cusanus, who was eleven years older than Piero and from a very different world: the environs of German mysticism, priestly ordination, and the Italian university.

Cusanus had begun his path to Rome as a young scholar enthusiastic about church reform. He supported the idea of the papacy's sharing authority with the councils. Disheartened by the Council of Basel's bitter disputes over this topic, he swung to the papal side. When it became time for the pro-papal party in Basel to invite the Greeks to a unity council, the erudite Cusanus was sent to Constantinople as the Latin ambassador. Later "at sea en route back from Greece" in winter 1437–38, he had a deeply religious experience. This would shape his novel Platonist theology, expressed in the most important of his several written works, *On Learned Ignorance* (1440).[10]

Beginning with this work, the influence of Cusanus's Platonist writings would have a lasting impact in three areas: his view of human knowledge, his picture of a mathematical universe, and his interest in making artworks a part of theological discussions. It was this smorgasbord of ideas that would have appealed to someone like Piero, who, for all we know, may have seen a copy of *On Learned Ignorance* being passed around in Rome in those days.

By "learned ignorance" (*docta ignorantia*), Cusanus meant the wisdom that comes with recognizing the limits of human knowledge about the physical world and about the infinite. This was an idea he found in the "divine Plato" and an idea that was a precursor to the modern philosopher Immanuel Kant.[11] Given human finiteness, the most reliable knowledge came by mathematics. Indeed, God had ordered the world by number, "the principal exemplar of things," Cusanus said. "For if number is removed, the distinctness, order and comparative relation, and harmony of things cease."[12]

As a form of measurement, number allowed a method of comparison in an otherwise indeterminate world of flux, where "all perceptible things are in a state of continual instability." Except for mathematics, Cusanus suggested, "Precise truth is inapprehensible." The human mind makes do by creating mental categories or "conjectures" to organize the world.[13] In his many writings, Cusanus is not exactly consistent in whether he is saying mathematics is a divine and transcendent system behind the world, or a numerical system of conjectures that humans invent to organize their perceptions. He may be suggesting that the Platonist Ideas and human conjectures should be matched up as closely as possible, this being a point of true human insight and knowledge. Either way, in his ambiguity, Cusanus foreshadows the modern debate on mathematics—is it ultimate, or is it relative? By his concept of conjecture, Cusanus also foreshadows a modern hypothetical approach to science: in this method, scientists adopt a plausible conjecture, and then test it as rigorously as possible to see whether it is true enough, or useful enough, to be called a theory about how nature works. And if applied to art, Cusanus's notion of conjectures was similar to the emerging medieval idea of "imagination." In the imagination (or intuition), the finite human mind mingles with the divine mind or the Platonist Ideas, such as the Idea of Beauty.[14]

As a second feature of Cusanus's thought, he offered a view of the cosmos derived from Plato. Amid the many versions of Renaissance Platonism, he argued for a return to the more original. Cusanus rejected Neoplatonism's idea of gradations in the physical universe between God and created things. Such comparative measures, according to Cusanus, were impossible to use in relationship to an infinite Being such as the deity: measurable gradations and ladders to the *infinite* are not possible.

The finite and infinite are entirely different in nature. As a consequence, Cusanus said, all things are "immediate to God."[15] This not only helped break down a universe of hierarchical structures; it also proposed a kind of independence of all things, tethered to God, yet in their motion they are relative to other things in motion (the essence of Einstein's future theory of relativity). This outlook allowed Cusanus to say the unsayable for his time: "the earth, which cannot be the center, cannot be devoid of all motion."[16] Though he dabbled in science, Cusanus was not a scientist, and his logic was based in metaphysics. Nonetheless, future thinkers in science, from Giordano Bruno to Galileo and René Descartes, cited Cusanus as they pushed back scientific frontiers.[17]

Cusanus's political fortunes in Germany, alas, had never been something he could be sanguine about. The northern cardinals and the emperor were resistant to the papal will. As the clash between imperial and papal power thickened, Cusanus, a cardinal since 1448, pulled up his northern roots and headed for Rome. By the time Pius II was elected, Cusanus was a leading theologian around the Vatican. The new pope turned to him, as to Bessarion, for help in the affairs of state. Soon after taking office, Pius began to travel. He had called for a three-year crusade against the Turks and summoned the Council of Mantua. During his absences, Cusanus served as vicar-general of the papal territories, adding to his already considerable influence.

Perhaps remarkably, both Bessarion and Cusanus avoided charges of heresy for the way they opened Christian doctrine to both a Platonist metaphysics and a new universalism (and tolerance) among religions. Cusanus was the last breath of a Roman theology of universal natural religion among all people. It was an ecumenical and interfaith idea that became modern, but it did not survive the Reformation and Counter-Reformation, and their new subcultures of intolerance, which came in the generation after Cusanus's death.[18]

Bessarion and Cusanus offered a picture of God and the universe that was sufficiently dualistic to avoid the problem of pantheism, in which God *is* the material universe. By contrast, the apostate Dominican Giordano Bruno, an ardent pantheist, had insisted that natural philosophy, on its way to becoming modern science, must separate itself from theology. The idea

of such a separation, endorsed also by Galileo and Descartes, was attacked by the Counter-Reformation's Inquisition, which threatened the writings of Bruno, Galileo, and Descartes. Bruno refused to give up his pantheistic, self-existing, and infinite universe and was burned at the stake; Galileo was put on trial for saying the Earth moved; Descartes kept his Earth-moves theory quiet to avoid censure.

Both Bessarion and Cusanus, by their time and place, and probably by their suave ability to bypass ultimate showdowns (in which Bruno and Galileo seemed to specialize), avoided all of this unpleasantness. Even so, both had virulent critics from the Aristotelian camp, for Cusanus in Germany and for Bessarion in Rome: with a strong preference for Aristotle, these critics found Plato too ethereal and illogical.[19] Nevertheless, related to science, Cusanus and Bessarion had nurtured a Platonist subculture that would break with Aristotelian orthodoxy. This would influence the rise of a new astronomy and the inclusion of mathematics in experimental science.

When Piero arrived in Rome in 1458, there was no reason that he could not have shown up in the humanist circles hosted by Bessarion and Cusanus. With Bessarion, Piero may have had common acquaintances in Tuscany or through the Camaldolese order, with which they were both on fairly intimate terms. Cusanus in particular was known to take an interest in meeting with painters. In such a setting, Alberti probably found opportunities to draw upon Cusanus's thought about God's numerical world being a basis for artistic design and proportion.[20] In his writings, Cusanus used examples of paintings, such as by Rogier van der Weyden. He was perhaps the first theologian to speak, metaphorically, of God as an artist.

Piero had been in humanist courts before, of course. But if he had picked up on the new mental skepticism espoused by Cusanus, it must have satisfied the soul of a world-weary painter. He knew well the difficulties of achieving precision and perfection in art, and now he was hearing some of the early scientific debates about how physical appearances often obscure deeper law-like principles. This dualism suited his religious outlook, but it was also proving fruitful in how he viewed mathematics and painting

(which modern commentators have inferred from his work).[21] In mathematics, perfect formulas are found below the world's rough surfaces. Some of this can be brought to the surface, he realized, by geometric harmonies that convey a feeling of spiritual harmony. The idealized world he tried to produce in paint would always fall short. Nevertheless, a painting could give viewers a transcendent moment with Beauty as an essence. Many of Piero's paintings prior to this Rome trip already evoked this dual sense. But the Christian Platonists in Rome must have deepened his thinking on how this applied to his craft.

On his arrival in Rome, the church officials under Pius II gave Piero painting tasks in the Vatican complex and in one of the city's basilicas, Santa Maria Maggiore. He probably painted two frescos in rooms of the Apostolic Palace, rooms used by popes as chapels, libraries, or reception areas. As it turned out, sixty years after Piero completed one of those frescos, Raphael would paint over it when Pope Julius II wanted one of the rooms—now called the Stanza d' Eliodoro—redecorated.[22] Piero's Vatican project was well enough along by April 12, 1459, that the papal household made a substantial payment to him. Its record books note that it was for "paintings made in the room of his Holiness our Lord the Pope."[23] Piero may have brought one of his most talented students with him, Luca Signorelli, who would go on to become a prominent painter in his own right.

By painting in Santa Maria Maggiore, Piero was putting his mark on a historic religious setting. Standing on the other side of Rome from the Vatican, the church was founded by the papacy in the fifth century. At this location, it was said, God had produced miraculous snow in August. Now it was a pilgrimage site that drew many rising stars to paint its interior surfaces. For his part, Piero produced ceiling frescos of the four evangelists, just one of which survives. He is St. Luke, a blond young man on a cloud. He holds his writing instrument over an ink cup, producing his Gospel. For this painting, Piero improved on the normal plaster by using a paste of pulverized marble. This gave him a hard and smooth surface, as if a panel, more amenable to painting detail.

Piero's projects in Rome lasted no more than a year and a half, from fall 1458 to the end of 1459, an apparent break from projects he had already begun in Arezzo and Sansepolcro. He returned home after hearing of his

mother's death, which came on November 6, 1459. As far as we know, Piero never returned to Rome, and he probably left the work for his assistants to complete. When Piero had arrived in Rome, many of the churches had the ambiance of Fra Angelico's starry ceilings. After Piero worked in Rome, according to some art historians, paintings done in the papal city departed further from old medieval conventions, taking on the more geometrical and light-filled look of Piero.[24] It was a style later brought to perfection by Raphael. In turn, Piero's sojourn in Rome surely left a lasting impression on his own life as an artist. In one historian's assessment: "the Platonic and mathematical inspiration of his mature works . . . were fostered by his meetings in Rome . . . with the humanists of Pius II's court—perhaps with Bessarion himself."[25]

After his year and a half in Rome, Piero did not have anything specific to say about Platonism, except by way of his brush. But he felt it was time to write something more about mathematics and art. He was persuaded that the artist could aspire to be a humanist, and this required the application of painting as a true science. Such were his thoughts when he decided to write a second treatise, this one directly tied to painting and going under the title *On Perspective for Painting* (*De prospectiva pingendi*). His first treatise, on abacus, had been geared to practical mathematics, such as calculating the price of a fish at the market, and offered nothing directly useful to the painter. Now, his *On Perspective* tried to guide the artist in his workshop, if such a painter was willing to endure a good deal of technical precision.

To move ahead on this second treatise, Piero needed a patron, not only for possible funding, but, even more important, to have the cover of legitimacy. During the Renaissance, labored-over treatises needed an audience, which might amount to just a single patron.[26] Wealthy merchants and Italian courts valued original manuscripts to fill their libraries. Works of polished rhetoric were most popular, though anything about devices, mechanics, astronomy, or anatomy were valued for collectors' shelves.

By now, Piero could read enough Latin to see how the more traditional, high-tone treatises of the humanists were done (as compared to the simple

abacus tracts used in schools and written in the Tuscan vernacular). But over his lifetime, Piero would never master the writing of Latin in full, sequential sentences. When he put pen to parchment sometime in the 1460s, Piero would write *On Perspective* in the popular tongue. There was no shame in this, of course. Dante, the exemplar poet of medieval Italy, had elevated Tuscan to middle-brow eloquence a century before Piero's birth, and even Alberti, seeking a wider reading audience, had written a version of his *On Painting* in the vernacular.

When *On Perspective* was done, however, Piero still felt it was below humanist standards, or not appealing enough to a high-ranking patron. Forthwith, he had it translated into Latin, the language of the learned. At some point, he organized a small shop, probably in Sansepolcro, to bring this Latin transformation about, setting up what one Piero scholar calls "a scriptorium with all the equipment and assistance, a scribe and at least one translator, necessary to produce at least eight manuscripts, most notably five copies of his *On Perspective*."[27]

Piero addresses *On Perspective* to painters. Its most insistent emotion is that painting in perspective is a "true science."[28] He wants to demonstrate the "power of lines and angles produced by perspective." Before the book is over, in fact, he will declare: "Many painters are against perspective. . . . Therefore it seems to me that I ought to show how necessary this science is to painting."[29] By "against perspective," Piero must have been speaking of vying attitudes within his profession, for some painters would have been skeptical of, or intimidated by, the introduction of highfalutin mathematics to produce effects they had estimated well enough by the skill of the eye and hand (as even Michelangelo would later suggest).

Piero divides his treatise into three parts (again, "books") and opens each with a brief essay of a few paragraphs. His first states simply that "Painting has three parts"—perspective, composition, and color—but he will address only the first of these in this treatise.[30] As ever, Piero is a man of few written words. He uses these mainly to explain Euclidian propositions and define some of his terms, such as the names for basic shapes, from the triangle and circle to the hexagon, and so on. He works directly from Euclid's *Elements* and must have known about Euclid's theories in *Optics*, for, like Alberti, Piero explains that as the visual angle in the

eye grows smaller, distant objects also shrink, this being the basic reason for optical perspective.

The three books build upon one another, showing methods that match the difficulty of the object: flat space, three-dimensional objects, and then objects that are irregular. The first is easiest and is demonstrated with floor tiles, much as Alberti had done in *On Painting* with diagonals, a center point, and what would later be called a "distant point." Piero builds on these to construct, in perspective, examples of architectural objects such as a simple square house. By the time he is done with the first two books, he has demonstrated perspective constructions with methods that range across optics, geometry, and surveying.[31]

The third and final book opens with an overview. "In the first [book], I demonstrated the diminution of plane surfaces in a number of ways," Piero writes. "In the second I demonstrated the diminution of square bodies. . . ." He concludes: "But as I now intend in this third book to deal with the diminution of bodies which are more difficult, I shall describe another way and another means of diminishing them. . . ."[32] This alternative will avoid the drawing of a "multiplicity of lines" typical of the floor-tile approach, and will help "the eye and the intellect" avoid being deceived by such diagrammatic confusion.[33]

The third book, in other words, will be about drawing irregular bodies in perspective—"heads, capitals . . . and other bodies positioned in diverse ways"—and to do this, Piero will use a method that modern architects now call "plan and elevation." Back when the method was explained by Alberti and Piero, it instead evoked the idea of finding points on an object as they are seen intersecting a visual plane, such as a window. Piero applies this method to the drawing of human heads, buildings, column bases, column capitals, coffered domes, goblets, rings, hats, baptismal fonts, and wells. It is a practical form of drawing, requiring the tracing of lines from points on objects. Piero even offers some hands-on advice for transferring the points by using "a nail with a very fine silken thread; the hair of a horse's tail would be good," and also introduces the use of paper and wooden rulers.[34]

In completing *On Perspective*, Piero summarizes the two basic Renaissance approaches to drawing in perspective. The first, being more theoretical, organizes the visual space by laying down a geometric floor plan

with a horizon, diagonals, and visual rays; the other is the practical method of tracing a "perfect" image so that it takes on its "diminished" form in perspective as it intersects a visual plane, such as a window (an approach that in later decades would be done by mechanical devices for drawing objects in perspective).[35] Invariably, though, *On Perspective* was complex and tedious enough that it was destined for a humanist library or an interested mathematician, not necessarily a street-side artisan workshop.

In hindsight, mathematicians have pointed out that Piero actually attempted a geometrical proof of perspective. From Euclid onward, proof had been a central idea to geometry; and to the extent that Piero had studied Euclid, he would have picked up the Greek method of making a formal argument to prove the veracity of a geometrical or mathematical principle. To prove that a triangle with one right angle would have a determinate third side, for instance, Euclid defined its geometric parts, stated axioms, and then offered a step-by-step demonstration that the law of the third side is always valid. In *On Perspective*, Piero seems to do something similar. Based on a complex diagram, he points to the mathematical equivalency of some of its lines. Modern-day mathematicians look back on this aspect of Piero's work and applaud it as an early accomplishment in geometry. Unfortunately, Piero does not explain his thinking, as the Greeks so often did verbally. Admirers of Piero have had to presume what his true intentions had been regarding a proof of perspective.[36]

In *On Perspective*, Piero once more deals with what seem to be the outspoken critics of academic perspective in his day. At one point, Piero speaks of a group of "detractors" who have more specifically pointed out that perspective lines actually distort forms at the wide angles of a picture. These people claim that a draftsman's perspective, therefore, could not be correct. On the curvature problem, these critics are actually correct, since this distortion is a property in the curvature of the eye (or of the visual ambiguity that arises when humans try to judge curved surfaces). Undeterred, Piero claims that the geometry of straight lines is nevertheless true. The distortion, he wrongly suggests, is based on limits to the eye's angle of vision.[37]

In this passage, Piero reveals that he has been reading on the physiology of optics, presumably from Pecham's *Perspectiva Communis*, which was

used by humanists. Yet Piero has unaccountably stuck with an antiquated view of vision, espoused by Plato, Galen, and others, that the power of the eye begins in the mind and then physically extends out to the world as visual rays (the opposite of light entering the eye by its own power). As Piero asserts in *On Perspective*, "[The] eye, I say, is round and from the intersection of two little nerves which cross one another the visual force comes to the center of the crystalline humor, and from that the rays depart and extend in straight lines, passing through one quarter of the circle of the eye, so that this part subtends a right angle at the center. . . ."[38] Here Piero is trying to explain the "visual force" and its limits, but in ways that naturally fall short of the better science to come.

For anyone at that time in history, the science of optics was still complex and enigmatic. In Piero's case, the question was, How do you reconcile the "natural perspective" of the physical eye and the interpreting brain with the "artificial perspective" drawn by a draftsman with rulers in the form of rigid geometric lines? Piero lost this argument because of the confusion between geometrical optics—what he called "painters' perspective"—and the physiological optics of the eye. He saved himself at the end by proposing a valid rule: a painter should limit the painting to cover no more than what the eye sees at sixty degrees (in other words, as if the viewer is not too close to the scene viewed). A generation later, Leonardo da Vinci would puzzle further over the curvature problem. He would also state the obvious: that human binocular vision (two eyes at different points) made perfect human perception of linear perspective impossible, except by looking awkwardly with one eye, or with two eyes at a very great distance.[39]

Piero had made a valiant attempt to link his true science of painting and perspective with natural philosophy and humanist learning. *On Perspective* was not playing to the casual reader. Its pages are filled with diagrams, skeins of tracer lines, and countless tiny numbers to designate points on a shape. By this time in the Renaissance, most craftsmen had learned linear perspective by a rule of thumb, doing what Michelangelo later said: the trained eye itself, not mathematics, could be the compass, "because the hands work and the eye judges."[40] Piero's *On Perspective* was too complex to influence the more popular drawing books that were cropping up with the invention of the printing press. Nevertheless, it established Piero as

an early authority, and it guaranteed that Leonardo, the third significant Renaissance writer on perspective after Alberti and Piero, was not completely novel in his more famous discussions.

When *On Perspective* was done, Piero dedicated the manuscript to the House of Montefeltro in Urbino, where it was gratefully received. At this juncture, Piero had apparently been exposed to the wonders of Archimedean geometry in Rome, where his relative Francesco da Borgo showed him the Vatican's rare Latin translation of Archimedes, a copy which Francesco may have pilfered, like an overdue book, from the papal library. In *On Perspective*, however, Piero does not cite the ancient Greek mathematician. His passion for complex Archimedean geometry was still growing, and in time Piero would become the first modern European to try to master such Archimedean topics.

Three years after Piero left Rome, Pius II declared a crusade. This was 1463. The princes of Christendom remained reluctant. So Pius vowed to lead it himself, traveling finally to the port city of Ancona, and there he waited for promised vessels from Venice to carry an army across the Adriatic. Pius II died waiting. The ships came, but too late. The crusade fizzled. With the demise of Pius II, the later High Renaissance papacy of legend—a papacy fraught with familial self-interest and free spending on the arts—was about to commence.

The aged Bessarion, champion of Platonism, carried on the old humanist tradition. As dean of the College of Cardinals, he oversaw the next two papal elections, which came in 1464 and 1471. The great Cusanus was passing from the scene. When he died in 1464, the baton of Christian Platonist scholarship was just beginning to be taken up by a successor, the humanist Marsilio Ficino in Florence. Bessarion, Traversari, and Cusanus were the theological Platonists of the first half of the Quattrocento, the figures under whom Piero would have learned his Platonism. Generationally, though, Piero would have probably missed the work of Ficino, who dominated the late Quattrocento. In those twilight decades, Piero was far from Florentine circles and far more interested in three-dimensional geometry than in new Platonist commentaries in Latin.

Ficino was the son of Cosimo de' Medici's physician, which assured him of the necessary patronage. Being a physician, his father wanted Ficino to pursue Aristotle, who put an emphasis on the biological brain and material sensations. The age of medicine had begun to expose both theologians like Ficino, and painters such as Piero, to the inner anatomy of the body, including the vital systems in the head: the eye and brain.[41] Neither physiological optics nor nascent brain science would advance much beyond old Roman explorations. Yet the newly investigated anatomy and organs of the body were part of the new visual picture for painters, as would be suggested in one of Piero's later paintings.[42]

Internal anatomy notwithstanding, Ficino was most interested in theology, for it still was the rare Renaissance thinker who gave up on classic religious belief even as the human body was looking very much like a machine. Ficino was persuaded by Plato's view of the soul, the mind, and the transcendent Ideas. After not a few crises of conscience, he embarked in this Platonist philosophical direction, advocating it with energy and productivity.

Cosimo de' Medici would give Ficino a villa and the resources he needed, and through the 1460s Ficino completed a Latin translation of all the dialogues of Plato. He was also planning an original work, a kind of Platonist version of Thomas Aquinas's *Summa Theologiae*, which had relied on Aristotle as "The Philosopher." Ficino called his work *Platonic Theology* (*Theologia Platonica*, 1482), and in it he assured Renaissance readers that "Plato does not forbid us putting our trust in the theology that is common to the Hebrews, Christians, and Arabs."[43]

Like Cusanus, Ficino was also in search of an "ancient theology" that showed that the earliest cultures, from the Egyptians to the Greeks, agreed on basic metaphysical truths. This was part of the solution to his own crisis of conscience—common among Christian humanists—that arose from spending so much time enjoying ancient pagan authors. During the writing of *Platonic Theology*, Ficino also was ordained a priest, rising in the ranks to become canon of the Florence cathedral. When his summa was finally published, it was the Renaissance's most systematic Christianization of Platonism. Critics in Rome would cry heresy and say *Platonic Theology* was a slippery slope to heterodoxy. Yet Ficino's Platonist translations, and

his furtherance of the Platonist and Franciscan solar theology of the Sun and light, became the dominant alternative to Renaissance materialisms, especially those of Epicurus and Lucretius. The influence of Ficino's cosmology lasted for the next two and a half centuries, up until the Newtonian revolution.[44]

When Ficino was just getting started with his Platonist writings at a Medici villa in Florence, he was in his thirties, and this was at a time (in the 1460s) when Piero was in his fifties. Accordingly, Piero's Platonism was derived from the earlier Platonist ferment stirred by such events as the Council of Florence (1439). To this he added his mathematical interests, which fit nicely with Plato's dualist concept of the "intelligible" and the "sensible" realities. On occasion, Piero would apply this dualism to the problem of appearance and reality, as he drew a contrast between "the eye and the intellect" in later writings.[45]

It was this complex vintage of Platonism that Piero, having recently worked in Rome, took back with him to Sansepolcro. He eyed the town as not yet a place to retire, but as the continuing hub for his further travels to paint. A major transition came in 1464, when his father died, and Piero and his closest brother, Marco, began to settle the future of the family properties. As a new future awaited Piero, one major feature of his home region on the peninsula was fast crumbling away.

About this time, the House of Malatesta in Rimini was in a state of disintegration. The lands under its control were dwindling. Sigismondo had ended up at odds with an increasingly powerful papacy. At one point, the pope had designated Cardinal Cusanus to preside at a church court to which Malatesta could make humble appeal, which he did not. Pope Pius II, using the colorful images of perdition, excommunicated him, saying that "Until now, no mortal has been solemnly canonized in Hell." A humanist poet who could always turn a nice phrase, Pius consigned Sigismondo to "Orcus and eternal fire."[46] The next pope, Paul II, treated the Duke of Rimini no better, leading to a reported attempt by Sigismondo to arrive in Rome intent on murdering the pontiff with his own hands. He returned to Rimini and died a month later. It was late 1468.

By contrast, the rival House of Montefeltro in Urbino had cultivated its relations with the papacy, even to the point of one intermarriage. Piero's

regional travels began to attach him to Urbino, a kingdom on the rise. He might have sought fame in Florence—but there, Medici tastes had turned to a more decadent decorative art, now a specialty of the closed-shop art worker guilds.[47] Piero, too, had evolved, but in old age had retained his purist—some would say primitive—style. It was a style welcomed in Urbino, where Federico da Montefeltro had set up an elaborate court of humanist arts and letters.

CHAPTER 6

The Aging Geometer

In Piero's day, whenever the plague arrived, the best course of action was to leave the crowded town or city. That was Piero's choice when the pestilence swept through Sansepolcro once again in 1468. The death toll had risen in that decade. It was no wonder that Tuscany had become known for its banners with "plague saints," protectors against the scourge.[1] Not wanting to risk anything, Piero headed to the countryside and took his work with him.

In the village of Bastia, five miles away, Piero's family owned property. It was there that he set up shop, completing a banner he was working on for a confraternity in Arezzo. Its topic was the Annunciation. Compared to a major fresco, a banner could seem small indeed. Yet even a banner had demands for quality and detail. It was in effect a large canvas mounted on a square frame that could be transported on a pole, either placed in a chapel or carried in a procession. This banner was much anticipated in the city where Piero had completed his wall-to-wall frescos. Journeying to Bastia, the confraternity treasurer paid Piero on November 7, 1468 and then loaded the painted fabric in a horse-drawn cart for the return trip to Arezzo. The next Sunday, the confraternity was awestruck by its beauty.[2]

Seasonal plagues weren't the only things that could delay the work of painters, of course. In Piero's case, he still faced his perennial dilemma of having too many projects going at once. With a good many outstanding matters hanging over his head, the latter stage of Piero's life could be characterized by three themes: his completion of some striking madonna paintings; his commissions in the city of Urbino; and his upgrading of the family estate in Sansepolcro, which included paintings for his own home, a time of apparent religious reflection at the end of his life. A fourth great preoccupation also arose along the way, and it was no less revealing of Piero's final fascination with Plato's numerical world and the ideal Archimedean shapes: this was Piero's production of exceedingly complex manuscripts related to geometry.

During his travels around Tuscany and its borderlands, Piero would paint two of his most memorable madonnas, one for his late mother's home town nearby and another, much later, while working in Urbino. Piero's mother was born in Monterchi, a hillside town just thirteen miles southwest of Sansepolcro. It was on the road to Arezzo, Perugia, and Rome. Outside the town stood the small Church of Santa Maria. The church sought a new madonna image for its altar, and, perhaps in honor of his mother's native soil, Piero agreed to the commission. This was no ordinary altar picture, however. As a fresco, it was painted life-size on a wall directly behind a free-standing altar, not on a typical panel structure. Measuring eight and a half by six and a half feet, the fresco introduced one of Piero's most notable madonnas, a regally dressed Mary with the rare feature of her midsection bulging with pregnancy, now called the *Madonna del Parto*.

Mary stands in a kind of red-cloth tent that is lined inside with fur-like panels. She is striking for her monumental presence, but also for the attitude she projects. This queen of heaven has the bearing of a confident country girl. Absent both a crown and a throne, her hand rests on her stomach. Her blue dress swells to show an opening in the overgarment. Though a visibly pregnant madonna was rare in Italian art, Piero used a not-unknown composition. The *Madonna del Parto* stands at the center of a stage on which two smaller-scale angels pull back a curtain.

The painting projects Piero's taste for symmetry and heraldry, in which bright flags use matching patterns. Each angel steps forward with one leg,

each has a single wing showing, and each is drawn by Piero from the same cartoon. The two angels are poised as mirror opposites, and even their red and green garments are like thesis and antithesis. At this country Church of Santa Maria, tradition was appreciated, and this meant exaggerating Mary's size to drive home her symbolic significance (she stood for Mother Church itself), even if Piero's realism made her look like a graceful giantess. The *Madonna del Parto* was Piero's atypical solution to his patron's need of a madonna, and no other work by him would be comparable.

It is not known how many madonnas Piero painted. But with a third of the churches in Italy devoted to Mary, it was a common theme for commissions. Another such Piero commission—to be known as the *Senigallia Madonna*—produced one more extraordinary image of Mary. She was modern and domestic; and if any painting by Piero echoed the look of the portraiture coming from the Netherlands, this madonna was the one. Piero may have painted it for one of the daughters in the House of Montefeltro. While this links the work to Urbino, where the paintings by traveling Flemish craftsmen were highly appreciated, the painting's name speaks to how it was placed in a church outside the Adriatic coastal city of Senigallia.

In the panel, a male and a female angel stand on either side of Mary and her child. The setting is indoors with outdoor light breaking in, casting shafts of light on a distant wall, shafts that also seem revealed by passing through dust particles in the air. Gone is Piero's love of ornate columns, marbles, and moldings. The interior is of the starkest kind, lending to a simple and peaceful composition. Using soft colors, he allows the light and shadow to reveal the figures and geometrical setting.

For this work, Piero adopts the Flemish practice of painting on a walnut panel; in fact, in its entire feeling, the *Senigallia Madonna* suggests Piero's familiarity with, and admiration for, Flemish portrait painting.[3] This may explain his choice of an indoor domestic scene, as if the Madonna is a housewife at home with child and attendants, and his use of the shafts of light. After these, he adds his own Tuscan traits. Painting in tempera, he has achieved the subtlety of oil, defining all of his figures and their geometrical setting purely by color and form, with very little sense of line present. Unlike the Flemish, his figures are classically statuesque, not organically busy, and

he puts them in a room of Italian gray stone, not a wood interior favored by the Netherlanders.

Piero's Italian/Flemish hybrid was important, at least as a harbinger of things to come. For this time in Italian painting, his use of a simple domestic background for a madonna (or for any portraiture) was relatively unknown. In future years, it would become a European standard in genre scenes, prescient even of the Dutch master Vermeer.[4]

The *Senigallia Madonna* was not the only lure that had taken Piero on the rocky mountain journey to the princedom of Urbino. During his post-plague visit to Urbino in the spring of 1469, he had lodged with the court artist Giovanni Santi, the future father of Raphael (who was born fourteen years later).[5] Vasari would call Santi a "painter of no great excellence, and yet a man of good intelligence," the latter evidenced by his surviving poetic chronicle, *Cronica Rimata*, of events in the Urbino court, including a few lines of praise for Piero.[6] Piero had arrived at the invitation of a confraternity that needed an altarpiece finished; the Florentine painter Paolo Uccello had completed the scenes in the small lower panels, the predella, but then had apparently moved on, leaving the rest undone.

The records say that Piero "had come to see the panel in order to do it."[7] He was probably asked to finish the work, and he may have agreed, except that plans changed. In the end, a Flemish painter in Urbino, Justus of Ghent, would complete the main part of the altarpiece, a logical conclusion since Federico da Montefeltro, duke of Urbino, was extremely fond of the new vogue of oil painting. What awaited Piero was something different—the opportunity to paint the portraits of Federico and his wife, Battista. He would do so in the enchanted world of a flowering Renaissance court.

Through the 1460s, Federico was rebuilding the walls of Urbino. When he began to reconstruct his Palazzo Ducale, he turned to the architect Luciano Laurana, a classicist who was of the generation following the innovations of Brunelleschi and Alberti. In the rival city of Rimini, Sigismondo Malatesta had emphasized a synthesis of the pagan and the Christian. At Urbino, Montefeltro was classical in style and Christian in thought with far

less conflation and confusion between the two.[8] The new Urbino complex combined a rough-hewn fortress with a Renaissance palace. Inside were classical courtyards and patios with vistas off the mountaintop. A grand staircase reached Federico's throne room. Downstairs was a family chapel (and, adjacent, a pagan chapel). A private study, or studiolo, was lined with intarsia, the elaborately inlaid wood. In all, the building was like a classical temple and a monastic cloister combined.

Through the 1460s, Montefeltro still offered his services as a condottiere, assembling armies for various republics or the papacy. At home, his concern was to build a dynasty. This required that he produce a male heir. That family drama was filled with romance and tragedy. Having fathered no legitimate male heirs, Federico negotiated with the house of Sforza, which ruled in Milan, and in 1460 entered marriage (his second) with the fourteen-year old Battista Sforza, daughter of the Sforza lord of Pesaro. She was an exemplar of the humanist education of women in the Renaissance. So skilled was Battista that during her husband's absences, she ruled his fiefdom, drawing praise for her abilities in the memoirs of Pope Pius II.

Over eleven years of her marriage to Federico, Battista gave him nine children, the last being a son. It was early 1472, and that spring Montefeltro was called away: the Florentines hired him to put down a rebellion in nearby Volterra. In his absence, Battista, weakened by childbirth, was struck by pneumonia. He returned to her side just before she died. She was twenty-six. Federico's remorse changed some of his priorities, but not most. Now in his fifties, with only a decade more of life, he lived as intensely as ever—as a humanist patron and a political calculator. Part of that was to commission Piero to commemorate himself and Battista with a rare double portrait. Federico's learning that Piero could paint in oil, still viewed as cutting-edge in Italy, undoubtedly secured the duke's choice.

The common problem of royal portraiture was to have a prince sit quietly for sketches or even a final work. Piero may have persuaded Montefeltro to sit for a time. He had seen Battista in life, but as he began to conceptualize portraits of the two, he most likely turned to her death mask and a marble sculpture that already had been made. Piero chose a side profile of Federico and Battista. This was a precedent from ancient Rome and the new trend in Quattrocento Italy of bronze medallions. Piero had another

reason to choose a profile, of course. Federico had lost an eye in a jousting tournament in 1450, and had a large gouge in the bridge of his nose as well. Once again, Piero was mindful of Flemish innovations. They had begun to put portrait subjects against a full landscape in a new way, making it look as though the person was standing on a mountain, the distance receding dramatically. Piero would do the same for the first time.

Piero painted the dual portraits of Federico and Battista on separate panels, but facing each other with a continuous landscape in the distance. Federico wears a red coat and hat and Battista a bonnet and jewels. Working with oil—and in contrast to his simple *Senigallia Madonna*—Piero adds immaculate details: pearls and embroidery catch the light; small boats cast their reflections on a distant lake. He has added a theoretical touch as well. Whereas the Flemish oil painters might casually simulate glitter and highlights on jewels or pearls, Piero painted it according to a truly accurate analysis of reflected light.[9]

On the back of the same two panels, Piero continues his pictorial narrative, now in miniature, painting a vision of Federico and Battista in a parade of their personal "triumphs." In the previous century, the Italian humanist Petrarch had inaugurated a tradition of poems, the *Triumph of the Virtues*, and by Federico's day the themes in this work were being employed by painters and poets to flatter patrons.

Petrarch's *Triumph* is a vernacular allegorical poem in the medieval tradition of the soul's journey from young passion to maturity and union with God, reflecting very much Petrarch's own Augustinian and Platonist leanings. He parades his story and its characters before Laura, a married woman toward whom he felt unrequited love. Though the *Triumphs*, Petrarch's most popular work, would be a future model for court literature in Italy, critics through history would often say that the inventive storytelling did not quite equal the moral and poetic inspiration of Dante's poetic epics, also written in the vernacular. Be that as it may, Petrarch composed his *Triumphs* in six parts—Love, Chastity, Death, Fame, Time, and Eternity—and Italian writers and courtiers ever after turned to these as a catalog of famous persons and lists of worldly vanities.

For his painting of the duke and duchess of Urbino, Piero turned to such allegorical lists of virtues as well. His choice in this may reveal a personal interest in reconciling Christianity with classicism. For the viewing public,

such visual storytelling was a kind of benign propaganda. It educated the public on the virtues; it also added prestige to the Montefeltro name by linking it to the Roman past and to Christian and classical morality. Piero put this into a single visual saga, for the most part sincere. Indeed, the regal Battista did insist on the simple burial of a Franciscan nun.

Allegorically portrayed, Federico and Battista sit on triumphal chariots, which are more like field wagons. The wagons carry the duke and duchess toward each other along the edge of a cliff. Behind them is a far-off landscape of great detail. In his Arezzo frescos, the soft blue backgrounds often gave the impression of aerial perspective (a sense of distance created by bluish vapor in the air), but in the vistas of the Montefeltro triumphs, Piero has employed it with technical panache, using oil paint's ability to produce subtle gradations by glazing. Otherwise, the landscape still has a similarity to the one painted in his *Baptism of Christ* so many years before.[10] As always, Piero's landscape is part Tuscan, part generic, and a bit fantastical.

Piero's tastes in furniture for his paintings had, from early in his career, turned toward frequent use of the Roman field chair. In these he placed kings, saints, and madonnas. Now it is Federico and Battista who are poised on these imperial, yet practical, seats as they ride on chariots, in his case drawn by white horses, in hers by unicorns. They are each surrounded by allegorical figures. For the duke, this human coterie symbolizes the four cardinal virtues. Seated in front of Battista are the three theological virtues, while other virtues stand behind. At the bottom of the two panels, as if the Latin wording has been chiseled into a stone plaque, both duke and duchess are praised in a text suited to the flowery triumph tradition of Petrarch:

He rides illustrious in glorious triumph[,] he who as he wields the scepter with moderation, the eternal flame of his virtues celebrates as equal to the great generals.

She who observed restraint in success flies on all men's lips, honored by the praise of her great husband's exploits.[11]

Federico finished out his eventful life during the reign of one of the Renaissance's most wily popes, Sixtus IV. Though Sixtus was the pious head of the

Franciscan order when elected, he had no qualms in behaving like any other rapacious Italian prince. He increased the privileges of the Franciscans, perhaps to the chagrin of other religious orders, and practiced nepotism openly. As part of his desire to give relatives positions of power, in 1478 he was a party to the attempted overthrow of Lorenzo de' Medici, who survived an assassination attempt while he worshipped at a church in Florence. This drew Sixtus into a fruitless two-year war with Florence, relying on his military alliance with King Ferdinand I of Naples. No sooner had that conflict petered out than Sixtus was enticing Venice to attack rebellious Ferrara, in the middle of which he changed sides. By the end of his reign, Sixtus's duplicity had rallied most of the princes of the Italian peninsula against him. At the high point of his machinations, he needed allies, and one of the more reliable for the papacy had been Montefeltro in Urbino.

Sixtus had an attractive side to him as well, and perhaps this quality is why Federico saw himself as a humanist prince helping a humanist pope. Sixtus had finally changed Rome from a medieval to a Renaissance city. He built the Sistine Chapel (1473–81), invited artists and scholars to Rome, promoted medical studies, opened the Vatican Library to general scholarly use, and established the Vatican archives. Observant of this pope's glory, Federico dreamed of negotiating a marriage between one of his own daughters, Giovanna, and a member of the papal household, a papal nephew named Giovanni della Rovere (who was not, by the way, one of the six nephews whom Sixtus IV had made a cardinal).

For such a delicate matter, Federico traveled to Rome, arriving in May 1474, about two years after the death of Battista. Pope Sixtus welcomed him, but the College of Cardinals was mildly scandalized, since Federico had previously led forces against Pius II. The hour was dire, however. The cities in Umbria were in rebellion, and, by the summer of 1474, Milan and Florence were coming to their aid. The pope needed a military leader. Federico agreed to rally a force of two thousand. By August the rebels had sued for peace, and in September Federico was marching through Rome's gates in a triumphal procession. Naturally, the cardinals approved the marriage of the pope's nephew to Federico's daughter.

All at once, honors seemed to shower down on Federico, and not only from the pope, who made him general of a new Vatican league. Ferdinand

of Naples decorated Federico with the Royal Order of the Ermine, and the King of England extended to him that nation's highest military honor, the Order of the Garter. In the darkness of conspiracy, though, it was not Federico's finest hour in every respect. When the pope had conspired with Florence's Pazzi bankers and the bishop of Pisa in 1478 to overthrow the Medici, Federico apparently had promised to have a small army outside the city of Florence, ready to take it over in the name of the Pazzi and the pope, a would-be Renaissance coup that failed to transpire in the end.[12]

The annals of history would tell of Federico da Montefeltro's good and bad sides. Piero's job was to present him as he saw him, and this would be manifest in two versions. His first portrait of Federico (opposite Battista, and with the triumph themes on the back) was unsparing in its detail, including his broken nose, wiry hair, and the blemishes on his skin—a portrait that would, in fact, become a kind of icon of the Italian Renaissance. Now Piero's task, in a second portrait, was to present Federico as mourning husband and knight of honor, and this was a far more delicate project.

The second portrait is known today as the Brera Altarpiece for its museum location in Milan. It is a full-scale altarpiece on the model of the patron kneeling before Mary and the saints. They are gathered in what was called a "sacred conversation." Piero had done something like this with the Misericordia Altarpiece, with eight local donors before a towering Mary, and with the fresco of Sigismondo Malatesta, who knelt before his patron saint. With Federico, Piero, now in his sixties, would take this motif to new heights.

The painting was presumably to be placed above Federico's tomb. For such a setting, Piero seems to be striking a balance of visual symbolism: Federico as soldier and as Christian humanist. Too gaudy a presentation of his military honors would destroy that balance, so in the end Federico appears as a pious knight of old. Piero keeps the shiny armor simple, Federico's helmet and gloves set humbly on the floor. The Flemish had done paintings of kneeling soldiers in armor, and perhaps this is the kind of look that Federico had asked for. All the same, a kneeling donor, a sacred

conversation with Mary, and a holy enclosure were safe bets for the duke's honor. Piero had already done the diptych's profile portrait of Federico, which he presumably liked, so Piero retained that visage, using the same drawing as a kind of stencil.

A new kind of altarpiece—a large single painting surface—was emerging in Italy, and with the Montefeltro monolith Piero would be extending its use. He set the size at about nine feet tall by six wide. His carpenter made it by joining together nine horizontal planks, a Flemish approach being adopted in Italy. (Furthermore, in general, Italians used poplar planks, while the Flemish preferred walnut, often in full solid panels sliced from trees, as Piero had used in the *Senigallia Madonna* and would again in future projects.)

Once such practical matters were in place, Piero followed his natural instincts for innovation, which was now becoming so cerebral that only the most acute observers might have noticed. Most obvious to all was the thrust of lines in his composition. Federico, Mary, and the standing group of saints are vertical thrusts, and against these are contrasted the diagonals of Federico's arm, the sword at his side, and the seemingly floating Christ child in Mary's lap. Piero's use of oil further built his reputation as an early Italian exploiter of the craft. Fully in control of the medium, he created a marvelous set of effects, both textural and luminous, from crystal and gauze to gold-embroidered fabric and the reflective surface of metal.

Although Montefeltro's honor was the visual priority in this composition, Piero infuses it with clever geometrical underpinnings, producing what modern commentators call his "spatial games." Piero's human figures are gathered in a great architectural setting, a church apse under a half dome rendered in the classical motif of a scallop shell. By modern analysis, Piero's perspective represents an interior going back forty-five feet, a cavernous area supported by columns and ceiling elements. Despite this depth, Piero has made his figures seem to tower at the very front, as if larger than life. Then, in an illusionist quirk, they also seem deep within the church. As if to add a further touch of novelty, Piero portrays them engaged in their sacred conversation without halos.

A sense of architectural space absolutely clarified by light dominates the scene, and into this space and light Piero has dangled the simplest of perfect

shapes. From the ceiling hangs an overly large egg on a gold chain, taking "so peculiar a prominence" that it will forever baffle art historians.[13] The egg has been calculated to be six inches tall in real life, and thus probably an ostrich egg. Piero might have seen one in a prince's bestiary. Nothing is ever so simple in art-historical interpretation, however, and therefore Piero's use of the egg has been attributed to a wide range of possible sources: pagan stories, Islamic decorations, Christian symbolism, a symbol used by secular princes, a symbol of the elements or mathematical perfection, and even a symbolic allusion to the much-celebrated birth of the duke's son.

In the Montefeltro altarpiece, Piero makes a conventional topic look strange and monumental. The architectural backdrop was the first of its kind in Italy. In a generation, this extravagant stage-like atmosphere would be emulated in major paintings from Venice to Rome. It has been worth noting that the Venetian master Giovanni Bellini had been painting in nearby Pesaro through 1472 and 1473, and perhaps had the opportunity to see Piero's newest work. Whatever Bellini's actual sources or inspirations, he would carry a Pieroesque sense of perspective, color, and space back north, setting a new standard for Venetian painting.

Piero may have completed the Montefeltro altarpiece in as little as two years, though there is really no telling how long.[14] In this case especially, there was no great hurry. He was painting ultimately for Federico's tomb, and the church to bear that tomb was still on the architect's drawing board, drawings which Piero may have seen as he embarked on his painting. This made the project a rare case in which the design of the church and the painting may have been organized in tandem, a contrast to the expedient mix-and-match decoration of so many churches. Clearly, Piero painted faster than the architects could build (finishing Federico's church years after the duke's death). This destined the painting for a smaller interim setting, the Observant Franciscan church of San Donato on the outskirts of Urbino.

Like his completed painting, Piero was a bit off to the side in such a magnificent court as Federico's. One chronicler of Urbino had called the duke the "light of Italy" for his patronage and the company he kept. The court was filled with luminaries.[15] Alberti may have passed through around 1470, and the architect Laurana gave Urbino its unrivaled classical achievement, the ducal palace. Also at Urbino, Florence's legendary book

collector, Vespasiano da Bisticci, built one of the best libraries in Italy, and humanist and diplomat Baldassare Castiglione (1478–1529) would also settle there, writing a Renaissance handbook on manners that would shape future European gentlemen. In the pictorial arts, the court of Montefeltro would become equally famous for his private den, or studiolo, which was lined with some of the most elaborate intarsia in Italy. It also had a cycle of great-men paintings along the wall.

How brightly Piero himself might have shown in the blazing atmosphere is uncertain, as is who met whom in the hallways of the Urbino kingdom. Piero may have met Alberti, for example. Laurana might have seen Piero's painted architecture and copied some of its features. As to Piero's influence on architecture, the better-known theory is that he inspired the painter and architect Donato Bramante, who probably trained in Urbino, and who would specialize in creating architectural illusions with perspective.[16] The city was the birthplace of Raphael, who would learn much in that local setting before making his way in Florence and finally Rome, where he became chief artist for the papacy. Vasari had said that Piero produced a number of small pictures in Urbino, and who knows how much of this legacy young Raphael may have seen?

Working with Federico's court gave Piero the opportunity to emerge as a full-blown humanist. He was taking a rare step in Italy's class-conscious society, bridging the social gap between the mere artisan and the humanist, who usually needed a university credential and mastery of Latin. (It was the kind of step made later, and more famously, by the life of the polymath Leonardo da Vinci, who openly shunned pompous university education.) Piero's first humanist calling card had been his *On Perspective* treatise. He had dedicated that manuscript, his second, to the House of Montefeltro, where it occupied a spot on the library shelf. Now Piero began to write a third original work, a treatise on geometrical shapes. By its bookish size and ornate rendering, the treatise would commonly be called the *Little Book on Five Regular Solids* (*Libellus de quinque corporibus regularibus*).

Piero may have been encouraged to write the work by one of Montefeltro's humanist advisers, Ottaviano Ubaldini, a connoisseur of Flemish art, astrologer, and regent when Montefeltro's son, Guidobaldo, inherited his father's rule in 1482. In the end, Piero dedicated *Five Regular Solids* to Guidobaldo, stating that it might go well on the Urbino library shelf alongside *On Perspective*. Piero described his offering as a kind of contrast in social rank; his work was like the "uncultivated things and fruits gathered on a humble table" now being put on the duke's "most opulent luxurious table." Yet by accepting the work, he says further, the House of Montefeltro will ensure his memorial, "a monument and reminder of me." All humility aside, Piero then declares his work's true novelty. Euclid and other geometers had dealt with this topic, but now Piero had handled it "newly expressed in arithmetical terms."[17] His little book would indeed pioneer making geometry mathematical, not just descriptive and verbal.

On the theory that Piero had already set up a scriptorium to make copies of his earlier *On Perspective*, he may have used the same setting to write *Five Regular Solids*, or he may have worked on it between Sansepolcro and his residency in Urbino, which had a library of ancient works. As with his previous writings, Piero first composed in the Tuscan vernacular. Then he had it translated into Latin (to which, in at least four Latin copies, he added the meticulous drawings of geometrical shapes).[18] The Latin introduction to *Five Regular Solids* seems to have borrowed a good deal of rhetorical style from Vitruvius, the ancient Roman writer on architecture and art. In this reaching back to antiquity, however, Piero's *Five Regular Solids* was clearly most interested in the Greek legacy of Archimedes, who had begun the high art of analyzing three-dimensional shapes.

Five Regular Solids is precise enough in its citation of Archimedes that Piero must have had a copy of the works of Archimedes with him, very probably as a personal possession obtained from his relative Francesco da Borgo in Rome, but alternatively as a copy in the ducal library of Urbino. The library also had a rare copy of Euclid's *Optics* (which Piero cites only in *Five Regular Solids*).[19]

Whereas Euclid had worked primarily on plane geometry, Archimedes probed spheres and cylinders more extensively. It is said that he was most proud of discovering that the volume of a sphere is two thirds of the volume

of a cylinder in which it fits exactly.[20] In *Five Regular Solids*, Piero reveals his Archimedean fascination with fitting shapes one within another. Breaking new ground, he did this using mathematical calculations, not just visual demonstrations or verbal explications. His *Abacus Treatise* may have skipped over the "golden ratio" topic, but *Five Regular Solids* uses this golden proportion—1 to 1.6—to calculate and render polyhedra.

Some of his discussion also points to a kind of Platonist viewpoint on mathematics and reality, since, as Plato said, Ideas and essences are transcendent, and even attempts at achieving the highest forms of *intelligible* knowledge by precise numbers can be elusive. Or as Piero made the case in *Five Regular Solids*, "Truly demonstrated knowledge has not yet been discovered concerning the circumference of the circle. But since those who excel in geometry have determined it approximately, let us follow their statements concerning it. For they pose that the circumference is less than $3\frac{1}{7}$ the diameter and more than $3\frac{1}{8}$," though to be practical in the real, sensible world, Piero thereafter uses $3\frac{1}{7}$ as his approximation in his exercises.[21] (The actual numerical value, like the golden ratio [*phi* in Greek], is an irrational and therefore infinite number, namely 3.14159 . . . [known also as *pi*]).

Piero begins *Five Regular Solids* by working through the five basic Platonic shapes. He goes in sequence, according to the number of their sides. After this, he shows a new method to transform these Platonic shapes into increasingly complex polyhedra, the so-called Archimedean polyhedra. He then moves into demonstrations of fitting complex polyhedra precisely inside spheres or other complex solids.

Piero did not give names to his shapes, but Johannes Kepler would take care of that (for Archimedes and Piero) in the future. One particular shape that Piero produced when he cut the corners off a three-dimensional triangle is what Kepler would designate as the truncated tetrahedron. In his earlier *Abacus Treatise*, Piero had demonstrated an Archimedean polyhedron that Kepler would call a cuboctahedron. In *Five Regular Solids* he demonstrates four additional "lost" Archimedean polyhedra, which Kepler nobly names the truncated cube, truncated octahedron, truncated icosahedron, and truncated dodecahedron. Using mathematics, Piero also found a new way to determine the volume and altitude of a tetrahedron,

which is a solid with four triangular sides. Moving on, he shows the calculations necessary to inscribe an octahedron (eight-face) solid inside a dodecahedron (twelve-face) solid.

Finally, Piero brings this down to earth, possibly for use by a painter. The challenge here is to know the volume of irregular shapes, and none is more irregular than a human figure. On this problem, Piero turns to a human statue. His solution to finding its volume is comically practical (and no doubt borrowed from Archimedes): immerse the statue in a known quantity of water, and then calculate how much water is displaced. This is not analytical geometry. Yet Piero believes that every shape, no matter how irregular, has a precise measure that is *sensible* and can be expressed in numbers, at least to the highest possible human approximation. Accordingly, he presents a procedure for determining the surface and volume of a cross-vault, one of his most sophisticated results. Piero does this by relating a sphere, a pyramid, and ellipses to the curved vault section. In all of his geometrical procedures and solutions, Piero reveals his intuitive sense of how local space works, proved also by how he had already used many of these complex constructions in his paintings.

At this stage of his life, Piero was challenging the limits of human mortality, which included his brain's mental capacities. He had labored on his *Five Regular Solids* in "my old age," he recounts, "lest the mind should become torpid by inaction."[22] He was nevertheless filled with a remarkable "passion for geometry and Archimedes," says Piero scholar James Banker, an interest that "eventually surpassed his commitment to painting."[23] This explains Piero's next great project with geometry, which must have been equally taxing on his mind—the copying in Latin of the entire corpus of Archimedes, a compendium of seven Archimedean tracts.

The facts surrounding this project by Piero remain elusive, but they have been reconstructed well enough. By this time, Piero must have not only mastered Greek geometry, but he could conceptualize geometry in the Latin language as well. This allowed him to produce a 150-page copy of the Archimedean works that also featured 225 of his own geometrical illustrations. To carry this off, Piero may have used the little scriptorium he had presumably put in place for his previous copying exploits. The final evidence of this episode is a manuscript that now exists in a Florentine

archive, and while it has no title or author's name, it has not only the marks of Piero's mind, but his own distinctive handwriting and quality of illustrations—all of it part of a modern-day detective story to be told in the late twentieth century (see Chapter 11).[24]

Piero's fascination with complex Archimedean solid objects was at the high end of the general Renaissance interest in spatial reality. The concept of infinite Space itself, except when theologians spoke of infinity, was actually not a Renaissance concern, probably because the problem had no practical application and, again, theology had claimed that territory. In the tradition of the ancients, Renaissance artisans were attentive only to objects, their spatial relationships to each other, and their visual and numerical proportions.

Back in ancient Greece, for example, Plato had said that space was simply "where" a creator made things. Aristotle said about the same. Space was what an object occupied, what it "extended" itself into. This did not change much under Christian thought, except to conceive of the biblical God as perhaps the receptacle of all spatial reality and, to further mystify space, to conceive that God is everywhere at once and can incarnate himself also as a human being.

Following Plato, Aristotle, and Euclid, Renaissance perspectivists focused on the space of each object, finding its coordinates and then extending its surfaces accordingly. Nobody was yet talking about an infinite physical space into which visual rays disappeared. For all practical purposes, for drawing a picture, the physical horizon was the limit. Alberti's *On Painting* was characteristic: "A painted thing can never appear truthful where there is not a definite distance for seeing it."[25] More than a century later, the art chronicler Giorgio Vasari offered a similar appraisal of space—what he called the "perspectives" of objects—as the local extension of one thing or another.[26] Space was about extension, foreshortening, or diminution of objects: horses, colonnades, chairs, groups of figures or a figure alone. With the Scientific Revolution, the nature of space itself finally became a central conundrum. It was a chief philosophical puzzle for modern minds such as Descartes, Newton, and Kant, for non-Euclidian geometry, and finally for Einstein.

Piero's approach to space might be taken in two different lights, one of them more mischievous than the other. As a master of mathematics, Piero

seemingly had a playful knack of producing effects akin to optical illusions in his paintings. Modern-day interpreters would look back and call these "spatial games" and "optical tricks," something that the mathematically minded Flemish master Jan van Eyck was also quite capable of achieving in his works.[27] Where Piero toyed with such spatial illusions, they generally related to seeing a subject in the painting as both far and near, or perhaps to seeing two kinds of perspective in one painting (as in the *Resurrection of Christ*). As three of the most obvious examples, the Arezzo fresco of Constantine sleeping in his tent offers a sense that he is both inside, and outside, the enclosure, depending on the viewer's far or near study of the scene; similarly, the two angels in the *Madonna del Parto* seem both inside and outside a royal tent featuring Mary; and perhaps most strangely, the gigantic foreground figures in Piero's Montefeltro Altarpiece look as if poised both deep inside the church, but also right at the edge of the visual field.[28] Although Piero was dedicated to the precision of geometrical perspective, he was also apparently aware of how perceptions can invariably distort it, and he used this to his advantage as a painter. As he said in *On Perspective*, "The intellect cannot distinguish that part nearest to the eye from that farthest from it without the help of lines."[29] With a few tweaks of those lines in a painting, Piero could cleverly keep the discriminating eye from distinguishing far and near too easily.

Piero's second approach to space drew upon a theme coming down from antiquity, and that was the belief in harmonious proportions, often attributed to divine origins, as had been asserted by Pythagoras and Plato. Since ancient times, for example, proportions and predictable ratios had been found in harmonious musical scales. To cite just one more example, this proportional harmony was extended to ideal measurements of the human body, and then from the body to architecture. There was always a word of dissent against ideal proportions, a skeptical rejoinder that all people really had their own opinions on a beautiful shape. And yet the mathematics and visual power of certain proportions continued to support a belief in their divine nature: the ideal proportion showed a linkage between God, nature, and the human mind.[30] It was also a metaphysical link between mathematics and works of art, and this is where Piero inserted himself.

Alberti had attributed the perception of beauty—the unity, variety, and balance of elements in a picture—to an ability in the innate human mind, a capacity that simply went along with how God had made the universe. Piero was the same. Like most natural philosophers of the Renaissance, both Alberti and Piero found geometry to be especially at the foundations of Beauty, revealing—in both mental and visual form—ideals, shapes, proportions, and laws not found so precisely in other kinds of visual experiences.

Of course, Plato had told them so, and even if that Platonist lesson originated in metaphysics, modern science could not escape some of Platonism's central observations about human psychology. One of these is that the mind, or brain, seeks essences. A type of essence, moreover, is a kind of proportionality to things in the world. Furthermore, some of these proportions seem to produce mental pleasure, while others do not. In the modern view, the brain has evolved to grasp certain ratios, sizes, and shapes as normal, crucial to survival, and even enjoyably attractive.[31] The simplest example is the brain's ability to judge sizes, and thus distances. Symmetry is another powerful example of proportion. When perceived "out there," it signals to the brain the presence of health, vitality, and order. Symmetry tells of a living thing, threatening or benign. When symmetry is broken in the visual world, the mind sees a deviation and it snaps to attention, just in case something unusual is happening.[32]

As much as brain science may want to finally retire the ancient Platonist doctrine of essences, this reality seemingly won't go away. From a neuroscience point of view, the brain, whether viewing a painting or moving through the world, tries mightily to sort through the flux of reality and find what is essential and constant. If a painting excites the brain, it could well be because the brain has evolved to find in that imagery a confirmation of valuable and lasting knowledge. The brain's ability to recognize an important essence is based on memory. In Platonist doctrine, memory plays exactly the same role, albeit with metaphysical origins: Plato proposed that each person's soul has a divine memory, and that this is refreshed by learning true knowledge in the world. Similarly, to make use of its everyday perceptions, the brain must compare them with what is remembered.

In Piero's day, such mental powers typically were attributed to innate spiritual origins, not neurons and nodules in the brain. That conundrum aside, Piero seemed to paint an idealized world in which the brain and memory readily find essences, characterized by his use of geometry, symmetry, and unusually effective proportions. Amid the flux of the world, Piero's images prod the brain to remember essences that are pleasing. The ultimate question remains: Is such a mental act of pleasurable remembering purely biological, or does it have a transcendent nature as well?

On such existential matters, Piero would have turned to his religious beliefs, not his geometry. A painter of theological topics, Piero must have been aware of the role religion played in his era. After so much turmoil in the papacy over previous centuries, the laity had taken religion into their own hands. Popular preaching was at its all-time height. The religious ferment balanced off the new emphasis of the Renaissance humanists, which was to reject older Christian beliefs about the "renunciation" of the world and to embrace it in all its glory. On this they quoted the Roman orator Cicero: "The whole glory of man lies in activity."[33] The new ideal of the Renaissance man, following the Roman code of *virtù*, was to combine classical learning, good style in manner and dress, cleverness in speaking and writing, military courage, and a general boldness.

As a result of the classical revival, Greek science influenced Renaissance religion as well, producing a re-Hellenization of Christian thought. This orientation allowed Christianity to adapt to the new sciences and achieve a new tolerance in beliefs, at least until the Reformation and Counter-Reformation made religion a matter of doctrinal combat once again. The Middle Ages had already produced a method of avoiding conflict between theological dogma and philosophical speculation, and this was the doctrine of "double truth."[34] Oddly, it was men of faith, often working in the Church, who manifested this duality by presenting the sharpest arguments against many Church doctrines, all the while being upholders of the faith.

What the Renaissance added to this discourse by way of reconciliation of theology and philosophy (and science) was a more coherent and

systematic restatement of Platonism. The Platonist doctrines provided an avenue to achieve a tolerant ambiguity between conflicting claims. Classic Platonism, as read in the dialogues of Plato, put limits on the human knowledge that was achieved through the physical senses (the sensible). It was also careful, and even skeptical, about obtaining the true knowledge of transcendent essences (the intelligible). Nonetheless, Platonist thought and its Renaissance subculture still promoted secular learning and spiritual self-cultivation, and indeed what one late Renaissance Platonist called "the dignity of man."[35] The Platonist outlook motivated rational inquiry, mathematics, experiment, *and* the acceptance of faith and mystery.

Where Piero stood on all of this can be inferred only from his environment and his acute interest in Greek science and its interplay with Christian thought. His paintings also tell that tale, and perhaps his two final surviving works provide a summary of how Piero existed within the philosophical tautness of his age. One painting is a fresco of the mythological figure Hercules. The other is a private, quirky, and joyous panel painting of a nativity scene, to be known as *Adoration of the Child* (and as the *Nativity* for short). They might be taken to represent a kind of double truth for Piero, or a Platonist reconciliation of two opposing viewpoints.

The *Hercules* has survived as a fresco fragment, suggesting that it had been part of a series of figures—perhaps both pagan and Christian—that Piero had painted as a mural in the ancestral family house in Sansepolcro, much as the princes had had done in their houses. The *Nativity*, by contrast, may have been his final religious painting. For burial, his family had space for tombs at the abbey, but not a chapel. Hence, Piero probably painted the *Nativity* for his home as well, sharing its ambience with Hercules and perhaps other famous characters that Piero had painted in fresco around the house.[36]

Like other Roman myths, the story of Hercules had made a comeback during the Renaissance. Wide use of the *Golden Legend* had proved the popularity of heroic figures, sometimes rulers but mostly saints. They were visual topics for mosaics, stained glass, and paintings. Speaking to Renaissance sentiments, this genre evolved into a great-men theme. It had been encouraged in the humanist triumph-and-glory literature. Not a few courts around Italy had begun to commission cycles of portraits of storied personages of Greek and Roman myth. One example, having survived intact, is

the Montefeltro studiolo in Urbino, where the upper walls are embellished with portrait paintings of great figures in literature.

How Piero may have done likewise in his home can only be speculated upon. If Hercules is typical, then he painted figures with presence and vitality. Piero presents Hercules as young, with scruffy black hair. Standing in a relaxed contrapposto, he is all but naked except for his lion-skin apron. He is shown coming through a stone door, extending his club as in a show of power. In Piero's house, he probably aligned the painted architecture around Hercules with the actual interior, as was the illusionist style of the Renaissance.[37] Though a pagan figure, Hercules was like an echo of Piero's early theological work. The anatomical naturalness and pale skin of Hercules are much like that of Jesus and John in the *Baptism of Christ*.

In his other homebound painting, the *Nativity*, Piero drew directly upon his church tradition. This nativity scene is based on the medieval story of St. Briget, a Swedish mystic. In a vision, Briget had seen the infant Jesus and his adoring mother amid the "miraculous sweetness" of the music and song of angels. The beguiling story became a popular pictorial, with a special emphasis on the angelic choir. On this musical group feature, Piero would not disappoint, and the painting's overall pleasantness suggests that he had brought it to completion as a leisurely and gratifying project.

Piero painted the *Nativity* in oil on an approximately square panel. He began with an underdrawing, now leaning toward the new Flemish methods of more modeled rendering in brown on a white surface before the color is applied. By this time, the classical revival had produced many biblical scenes in the midst of crumbling Roman buildings. Piero turned in a different direction. He portrayed a broken-down shed or lean-to, the kind that farmers tolerated in their workaday world and that a poor couple such as Mary and Joseph would have welcomed as shelter. The story unfolds in the kind of dry clearing that Tuscan farmers used to thresh grain. The scene is high above the valley, which stretches out into the distance in one of Piero's typically idealized Tuscan landscapes. Also typical, Piero divides the vista into two different ethoses. On one side is a distant city with a basilica, towers, and geometrical streets; the other looks down a winding river that courses through a valley and past cliffs.

In this work, Piero drops all courtly and classical pretenses. Here is a rustic and even humorous world. The Virgin is a red-haired maiden, elegantly dressed yet kneeling on dusty soil. She has more the look of a young woman in Flemish pictures than in Roman statuary. To her right are five barefoot angels like a choir troupe, wingless and without halos. Three of them are singing, the other two playing lutes. Joseph is a saddle maker, and two shepherds appear as if travelers on a country road. Piero also includes a mule and an ox, perhaps inspired by a popular devotional work, *Meditationes de Vita Christi*, which painters used as a reference. Piero's mule is braying with the choir, and the ox is admiring the baby. To top off this holy bestiary, Piero places a black bird, probably a magpie, on the shed's roof, seeming to announce the event.

All of Piero's elements are here: a sense of unlimited space defined by light, color, and an idealized human story. The colors are reminiscent of Piero's early *Baptism of Christ*, and he is clearly in a more informal mode of painting. He uses only a shadow in the shed to suggest linear perspective, and his painting strokes don't always match his underdrawing. The scene is a Christian story. It is also a Renaissance story of man and nature, and, in that sense also, a final word on the accumulated skill and sensibility of an early Quattrocento artist.

In this final period of his creativity, Piero had also been busy writing or copying treatises. Quite naturally, the amount of painting he did would decline with his age.[38] He also was putting his traveling days behind him, with only one known exception. In April 1482 he was in Rimini on the Adriatic coast, and, whether on holiday or working, he rented a furnished room with the use of a kitchen garden. The changing world of Renaissance art, however, was becoming beyond his physical reach. He probably did not make the trips necessary to see the new directions in painting taking place in Mantua, Florence, Venice, or Rome, change that was typified by artists such as Andrea Mantegna, Sandro Botticelli, Giovanni Bellini, Antonio Pollaiuolo, Domenico Ghirlandaio, and Pietro Perugino. As Piero sat back on his considerable laurels, as it were, these younger painters opened the way to the nascent High Renaissance, a time when painting became far more elaborate, playing on emotion, drama, and princely glamour, and pushing perspective to new inventive uses.

Piero's last painting, the *Nativity*, defied all of this in its regal homeliness. As a kind of ending, it shows his Renaissance classicism tinctured with the Flemish aesthetic and the casualness of a painter in old age. The composite effect of all his paintings, strong in their cool, classical look, would influence some of his immediate successors in Italian painting, but the Pieroesque style was not going to be a bridge to the next age. This was the age of the baroque, an ebullient and hotly emotional time in the arts that was driven by the Counter-Reformation. The Roman Church and its patrons would become far stricter on the theological imagery that could be painted, but they otherwise put no limits on the melodrama that could be infused into the orthodox Christian story.

Free to follow his own vision in his last paintings, Piero had produced *Hercules* and the *Nativity* for his own final surroundings, the family's large ancestral house in Sansepolcro. Piero had perhaps been on the cusp of his sixties when he returned home permanently, mustering enough energy still for himself and his brother Marco to consolidate and expand what they owned in Sansepolcro as heirs to the Francesca family.

Although Piero now made it a family known for the arts, it was essentially a family steeped in Quattrocento commerce. From the day Piero received his first payment in 1431, his father had been his agent, and would continue as such, though he had obviously tapered off by the time he died in 1464. From around that time, Marco had overseen the family house, and, probably even before this duty, had also begun to operate as Piero's agent, as a paper trail of documents has shown.[39] For the Saint Anthony Altarpiece in Perugia, Marco received the final payment for Piero on June 21, 1468—years after its commissioning—suggesting again how slowly Piero could work (or how slowly patrons paid their debts).

For all of Piero's travels, which for thirty years had taken him far from the family hearth, he seems to have had a remarkable bond with his father and Marco, a deep camaraderie in all things mercantile, including art. This common cause in business may also explain why Piero, such a prominent artist, never had a famous workshop that produced disciples who perpetuated his style and methodologies beyond his lifetime. As shrewd as the next man, and a veritable walking calculator as well, Piero may have been looking for ways to escape extra costs, such as paying exorbitant taxes. As

one assessment states, "Piero's artistic activity was carried on under the legal and administrative aegis of the family's commercial activity."[40] In this scheme, Piero could share overhead, rents, and tax liabilities with his family, shoehorning his studio space into buildings where his family operated a warehouse or workshop.

In such a setting, Piero probably never established a permanent workforce of assistants, the kind of influential workshop that had been seen in Florence under Lorenzo Ghiberti (who trained Donatello) and Andrea del Verrocchio (who trained Leonardo da Vinci), or in Padua under Francesco Squarcione (who trained Mantegna, among others). No Piero "school" was left behind. Nonetheless, Piero was unique among notable painters for making a lasting mark on a home town, something possible because his family was influential and a possessor of property.

Besides the ancestral house, the family had a rural villa in nearby Bastia and also had rented a structure on the main piazza, which probably served as Piero's studio on many occasions. By the 1460s, however, the family had acquired two new properties nearby, and with this their living circumstance would dramatically change. The first property was a broken building just a block down the hill from their house. They restored this as a wholly owned workshop. This would have been where Piero set up a new studio, perhaps his best-accommodated, and certainly his last. He may have produced the Perugia polyptych (the Saint Anthony Altarpiece) and works for the House of Montefeltro at this location, then delivered them overland. If Piero had indeed organized a scriptorium to copy his written works into Latin, and to labor on his copying of Archimedes, this, too, may have been the location.

In another physical expansion, the brothers acquired the house next door and merged it with their original structure. This would be Piero's first chance, apparently, to design something like a classically decorated urban palace. When the two buildings were joined—externally by a new façade—it became the new and final look of what local pride would eventually call "Casa di Piero," a true Renaissance house.[41]

The new house, one of the city's largest, had the normal three tiers of a Renaissance palace. The lower level had cellars, a stable, and a workshop, while the second floor had rooms for social gatherings and probably for

Piero's living quarters. The third floor had private family rooms. Outside, the old house was surfaced with a new façade that featured Renaissance tabernacle windows (given this name because of their squat triangular pediments on top). Inside, Piero installed decorative doorframes and ornate corbels (the protruding brackets that support cornices), all of which resembled the architecture he had put into his paintings.

Piero's exposure to the architectural doings of the Quattrocento had been lifelong. It began with watching his own father's fix-it trade. Then at the princely courts he saw greater things erected in wood and stone, all the while analyzing the engineering and the various kinds of decorative surfaces. When Piero settled down in Sansepolcro—from the 1470s to his death in 1492—his skilled work on the house was no surprise, nor was his election as overseer of construction in the city and supervisor of fortifications.

Although retirement was on the horizon, Piero seemed to keep up with the family, civic, and spiritual duties that a respected senior citizen might have been willing to perform. Being the eldest son, he probably oversaw some of the affairs of the extended family. For two years, beginning in 1480, he was head of the craftsmen's Guild of Saint Bartholomew. The city called upon him to be a councillor and auditor, and for several years running he was leader (prior) of the Confraternity of San Bartolomeo, the city's largest charitable organization.

In 1487, when Piero was probably seventy-five, he wrote out his brief will and testament in the Tuscan vernacular and then gave it to a notary for official transcription. Incredibly, that scrap of paper with the vernacular would survive down to the present, revealing Piero's statement that he was "in sound mind, intellect, and body" and that "I want to be buried in our family burial place."[42] He left money for his nieces, who needed a dowry, and the rest to his surviving kin.

Piero's eyes were still strong enough to see what he was writing at this point, as evident in his clear script. Yet in the years following his will and testament, he would be going blind. A young boy, according to one local memory passed down through history, may have helped him around town in those final days. That town had changed, thanks to Piero. Cosmopolitan in trade, Sansepolcro had been medieval in art when Piero was young:

this echoed in its altarpieces and statuary. Piero conformed to that, but also broke that medieval mold. He gave Sansepolcro its first freestanding, undivided panel paintings, as if windows on a new world. He moved the local aesthetic away from Gothic spires to Renaissance rectangles. He probably introduced the first lunettes into local design.

When Piero died, he was buried alongside his family in the Saint Leonardo Chapel at the Camaldolese abbey. The abbey, soon to become a cathedral, was said to mark the original foundation site of Sansepolcro. The registrar of deaths, applying quill and ink to the town's "book of the dead," told the final story: "M. Piero di Benedetto de' Franceschi, a famous painter, on October 12, 1492; buried in the Badia [abbey]."

This was the same day, of course, that Christopher Columbus arrived in the New World. After the revolution in painting and geometry brought by Piero—and in mapmaking by his fellow geometers—the landing was another signal event in the growing impact of the Renaissance.

A year before Piero died, the Church of San Bernardino was completed in Urbino. With its opening for public worship, Piero's altarpiece featuring a kneeling Federico da Montefeltro was first seen by a wider public. All the faces of the saints in the painting were remarkably well done. To some viewers, the face of St. Peter might have looked strangely familiar. Its model was Piero's acquaintance, the Franciscan mathematician Luca Pacioli. In the last years of his life, Piero and Luca were comparing notes. They were both from Sansepolcro, and Luca, the younger of the two, was a traveler, often teaching mathematics around Tuscany. Luca was also writing his own treatise on mathematics, to be known as the *Summa de Arithmetica*.

As the memory of Piero rapidly faded in the tumultuous days of Italy at the end of the Quattrocento, Luca Pacioli's treatise would become the first document to guarantee that Piero's name remained in circulation. Pacioli was turning out to be the most noted mathematician at the end of Piero's century. The Italian Renaissance still had a few more generations to go, highlighted by Michelangelo, and then ending in the sixteenth century

just before the rise of Galileo. Across this period, Italy was blanketed by military invasions. It would see a great rebellion in the Church—the Protestant Reformation surge—and the last vestige of communal republics. Those short-lived Italian experiments in something like democracy were eclipsed by old-fashioned autocracies just about everywhere.

In a quiet corner of this all, Pacioli wrote down that Piero was a "monarch of painting."[43] Piero, who had traveled most of his life, was now in his grave. But his journey into history had just begun.

PART II

CHAPTER 7

After the Renaissance

After Piero's death, Italy witnessed a tide of artistic achievements and political catastrophes. There was the ebullience of High Renaissance painting, and then the summit of the Renaissance papacy, its Vatican soon decorated by gold from the New World. The sixteenth century also brought the Protestant rebellion in the north, and, like a cresting wave, an increasing number of invasions of the Italian peninsula. These French and German invaders, as compared to the derring-do condottieri on horseback, arrived with armies that were terrifyingly modern.

Small wonder that Piero's calm and measured works of art began to look dated. Reflecting the mood of a new, tumultuous, and extravagant century, paintings such as Titian's playful *Bacchanal of the Andrians* (1526), Michelangelo's terrifying *Last Judgment* (1541), and Caravaggio's erotic *Bacchus* (1597) were far more typical. Beyond the walls of Sansepolcro, Piero's name dropped from view; indeed, one pope, Julius II, had Raphael paint over his Vatican murals.

Though hardly a consolation, Piero's own descent into obscurity was paralleled, on a much larger scale, by the misfortunes of his homeland for the next 350 years, lasting until the modern unification of Italy in 1870. During the preceding block of centuries, Italy was occupied by foreign

empires, starting in 1494—two years after Piero's death—with the invasion of the French. "A most unhappy year for Italy," said Francesco Guicciardini, the country's first modern historian.[1]

In Florence around that same time, the apocalyptic preacher Girolamo Savonarola had chased out the Medici family. A too-ardent Dominican, he welcomed the French as God's judgment on even the papacy, chastising his foes with such thundering flourishes as "Tyrants are incorrigible because they are proud, because they love flattery, because they will not restore their ill-gotten gains."[2] For that matter, Savonarola also put Plato and Aristotle in hell, hardly an encouragement to Renaissance humanists, who now circulated widely, from court scriptoriums that translated ancient works to a so-called Platonic Academy in Florence and the universities of the north, which continued to be hotbeds of Aristotelian thought.

The next very unhappy year came in 1527, when German armies sacked Rome. Some of the northern mercenaries, being pro-Martin Luther, a German priest who was now leading a rebellion against the papacy, gouged Raphael's Vatican frescos with their swords. On the whole, though, the invaders had no particular grievance with Italian art. The great works of Florence, Venice, and Rome continued to receive admiration, acclaim, and confiscation by foraging foreign royalty.

Such attention was fated to overlook Piero. He lacked an urban showcase like Florence, and his Vatican frescos had been painted over. Nor had he joined the artisan/guild system of the larger courts, where opulence prevailed over artistic scruple, but where his name might have resounded nevertheless. The Arezzo frescos, though large enough to demand praise and attention, were off the beaten path. Piero's two treatises in the Urbino library, *On Perspective* and *Five Regular Solids*, were not turning out to be the kind of "monument" he had hoped people would notice after his death. Tucked away on a library shelf, they would take generations to be recognized for their originality. Piero's eclipse outside Italy was notable as well. A century after his death, a leading Dutch art historian compiled an influential volume on Flemish, German, and Italian artists, the *Schilder-boeck* (1604), but did not bother to include Piero among the forty Italians featured.[3]

Despite this general voiding of Piero's memory, a small cadre of chroniclers would begin to put his name in print. Piero's first chronicler was Luca Pacioli (1445–1515), his mathematician friend with the same Tuscan roots.[4] Born in Sansepolcro, Pacioli had a natural vista on the life of Piero. Younger than Piero by thirty years, he was an eyewitness to the French invasion. He was present in Milan when troops breached the gates in a rampage and, soon after, used Leonardo da Vinci's clay model of a giant equestrian statue for target practice. Along with Piero, Pacioli had seen more peaceful days. He was educated in Venice, where he studied mathematics and lived with a wealthy merchant, whose sons he tutored. Around 1470, he joined the Franciscan order. Like any Italian humanist with a scientific bent, friar Pacioli attached himself to the courts of various princes.

Back in Sansepolcro, Piero might have taught Pacioli about mathematics. During Piero's last years in Urbino, Pacioli was probably on the scene as well, tutoring Federico's son Guidobaldo. Pacioli was the rare associate of Piero who could follow what he was writing about in his treatises on mathematics, perspective, and geometry. Pacioli had also been writing on mathematics informally but, like Piero, wanted to publish something momentous. That opportunity came two years after Piero's death. Bolstered by the Venetian publishing trade, Pacioli issued in vernacular Italian in 1494 his *Summa de Arithmetica*, the first printed book on commercial arithmetic. On its dedication page to Duke Guidobaldo of Urbino, Pacioli offers Piero's first, if brief, footnote to history. Pacioli calls him "our contemporary, and the prince of modern painting."[5]

In Pacioli's second major work, *De divina proportione* (*On Divine Proportion*), written in 1497 and published in 1509, he goes further with biographical details:

> The monarch of our times of painting and architecture, Maestro Piero deli Franceschi, made famous, thanks to his brush, at Borgo San Sepolchro and, as one can see, also at Urbino, Bologna, Ferrara, Arimino, Anconna, and in our own land, whether in oils or gouache, on murals or woods, but especially in the city of Arezzo, where he painted that great chapel, one of Italy's most worthy achievements and one acclaimed by

all; then he wrote the book about perspective which can be found in the magnificent library of our most illustrious Duke [Guidobaldo] of Urbino.[6]

Pacioli's emphasis on Piero as a painter, not a mathematician, was perhaps not without judicious, or devious, reason. As became apparent in time—according to what may be called the pro-Piero viewpoint—the geometry section in Pacioli's *Summa de Arithmetica* is essentially lifted from Piero's *Abacus Treatise*. Thus was born the charge of plagiarism, which has circulated through history, and been hotly debated, ever since.[7] A similar pattern shows up in Pacioli's *De divina proportione*. In this, and without attribution, he seems to have copied Piero's entire *Five Regular Solids*, though he translates it into Italian. In a famous Renaissance painting of Pacioli, he is shown garbed in a Franciscan frock, pointing at things of a geometrical nature. A great deal of what Pacioli knew about such topics—geometrical proportions and the polyhedra of Archimedes, for example—had apparently been gleaned from Piero's work.

All of this aside, Pacioli nevertheless established Piero's name in history. By way of Pacioli, Piero's interest in geometrical shapes and Archimedean polyhedra probably reached the mind of Leonardo da Vinci. In Milan, Leonardo had purchased a copy of Pacioli's *Summa de Arithmetica*. Being the court painter and jack of all trades, Leonardo persuaded the Milanese ruler Ludovico Sforza to invite Pacioli to teach geometry. Pure mathematics was never Leonardo's forte, though he tried, once writing in his notes: "Learn the multiplication of [square] roots from Maestro Luca."[8] Leonardo's notes on linear perspective never amounted to a formal treatise. If the brilliant yet procrastinating, distracted Leonardo had actually aspired to write such a formal treatise, he might finally have balked, knowing that it had already been done in Piero's *On Perspective*. Meanwhile, Leonardo's fascination with polyhedra grew.[9]

The relationship of Piero to Leonardo may finally be interpreted in two ways. At the minimum, when Leonardo produced sixty illustrations of polyhedra for Pacioli's *De divina proportione*, those drawings appeared just following the section Pacioli had copied from Piero's *Five Regular Solids*. Piero's text must have served as a guide. If Piero's influence on Leonardo

was greater than this, it would come by positioning Piero as Leonardo's teacher—with Pacioli the tutorial go-between. As one such generous interpretation says, Piero's "knowledge of Archimedes made its way into the mind of Leonardo."

At any rate, whatever Piero's influence on Leonardo may have been, they shared a unique kind of role in the Renaissance. By painting in their workshops, and by penning intellectual theories at their writing tables, both of them operated between the two opposing social classes and cultures of their time, the humanist Latinists and the practical artisans. By producing achievements in both realms, Piero and Leonardo represented a new kind of figure in their century: "Their uniting of the two cultures enabled them to make important innovations in art and thought."[10]

The French harassment of Italy soon began to seriously disrupt life in Milan. So in 1499, Pacioli left for Florence. He launched a career as university teacher and popular speaker, transfixing his audiences from Naples to Bologna and from Perugia to Florence. His public talks were filled with entertaining stories and jokes, but his most popular were about the mathematical mysteries of Christianized Platonism. These presented mathematics as a doorway to even God's nature and providence. Elected a superior in his Capuchin order of the Franciscans, Pacioli lived out his latter days in the Santa Croce Monastery of Florence. For all his speculation on the mystical quality of numbers and proportions, Pacioli's influence was ultimately practical. Europe was advancing quickly in commerce and science by the rush to quantify the physical world. In the long run, Pacioli assisted by inventing the technique of double bookkeeping. Wherever Pacioli died—it may have been Rome, Florence, or Sansepolcro—records locate him teaching in the papal city until 1515, well before it was sacked by invaders. He would have seen Rome in the final glory days of the Renaissance.

The sack of Rome in 1527 signaled the end of the Italian Renaissance's cultural and political idealism. Some features on the Italian peninsula seemed impervious to change, however, and one of these was the enduring resilience of the Medici dynasty. It proved remarkably adaptable, despite

brief exiles and constant intrigues. The family continued to claim power in Florence. It also managed to extend its power to Rome by way of three Medici popes, the first being Leo X from 1513 to 1521. Piero had never been active enough in Florence, presumably, to have been part of the Medici circles, a social niche into which many ambitious artists competed to enter. If any artist of the sixteenth century was famous for that affiliation, it was the painter Giorgio Vasari. He was the next person in history to give Piero della Francesca his due.

Vasari was born in 1511 in Arezzo, not far from Piero's home. Later in life, Vasari claimed that his great-grandfather had helped Piero on the great Arezzo frescos. Vasari loved to make such connections. He would assert, among other things, that he had studied in Florence as a youth under Michelangelo. Most important of all, the young Vasari had become friends with two young Medici heirs, Alessandro and Ippolito. Once they had all come of age, the two Medici became Vasari's Florentine and Arezzo patrons, funding his considerable energy as a designer, painter, and architect. This was from 1532 to 1537, the year that Duke Alessandro was assassinated. Now Vasari headed out on his own. Under church patronage in Rome, he began a new stage of his career.

At this point, Vasari would invest a great amount of energy in writing his *Lives of the Artists* (1550), a chronicle of 250 years of Italian art. By the time of his second edition in 1568, it would include 142 artists, a wide range of lucid observations on art, and finally his own autobiography. To compile this material, Vasari relied on his many travels, observations, and conversations. Despite his reliance on a good deal of hearsay, a defect that introduced numerous factual errors into the artist biographies, his encyclopedic memory, treks around Italy, and observant note-taking were unparalleled for his day.

When it came to Piero, Vasari had as good a source as anyone. A native of Arezzo, he had seen Piero's frescos for years: they were his first impression of what a Renaissance painting looked like. In nearby Sansepolcro, he had glimpsed other Piero works—the *Baptism*, the *Resurrection*, and the altarpieces—and when as a working painter Vasari managed a large artisan workshop, he had two storytelling assistants from Sansepolcro. Mostly, Vasari was necessarily vague in what he wrote about Piero's life. If he

inserted mistakes, he was at least correct in attributing the right paintings to Piero. His excuse was a good one: much of Piero's legacy had been destroyed or ruined by the half century of tumult in Italy since his death. "I cannot write the life of this man," he admitted, and then wrote what he could.[11]

In Vasari's time, the classical simplicity of the early Renaissance had given way to a new emotional and elaborate drama on canvases and in fresco. This was the High Renaissance opening the gate to the baroque. At a time like this in the arts, Vasari placed Piero in a bygone era, an early time when Italian painting had a "certain dryness, hardness, and sharpness of manner," which Vasari compared unfavorably to the new look of Leonardo, Michelangelo, and Raphael.[12] Although Piero fell short of Michelangelo, Vasari embraced him with a sense of local Tuscan pride. Foreshadowing the custom in future generations of art travel guides, Vasari gave the most ink to Piero's Arezzo frescos. A second high point in Vasari's "Life" of Piero was his praise for him as a mathematician. Piero "had a very good knowledge of Euclid, insomuch that he understood all the best curves drawn in regular bodies better than any other geometrician, and the clearest elucidations of these matters that we have are from his hand."[13]

In this area, Vasari felt that Piero had been robbed of that Renaissance fame. Vasari somehow knew the back story of Piero and Pacioli, and thus said that Piero had been "cheated of the honor due his labors." Thus it was that Vasari was the first to establish the charge that Pacioli had stolen Piero's mathematical material without giving him credit. "Truly unhappy," Vasari said, is such an artist who did not find fame when he was alive. "Time, who is called the father of truth, sooner or later makes manifest the real state of things," he said of Piero's accomplishments.[14]

As the veritable father of art history, Vasari introduced the idea that "competition" was the motive that had driven Renaissance artisans. He told Piero's story in this light, speaking of him as a young painter with his "glory and fame" at stake. Piero's misfortune, he suggested, was that no one (with Pacioli as chief villain) acknowledged this greatness.[15] Vasari's *Lives* was designed to praise Florentine artists the most. Significantly, he did not find any evidence in his day that Piero had lived or worked in Florence; accordingly, Piero was viewed as a regional painter whose influence may have spread to the hinterlands, but not to the big cities (though modern

art historians have disagreed with Vasari, believing that Piero's most com-
pelling works gradually influenced painting styles in Ferrara, Venice, and
Rome). More than three hundred years after Vasari, the question of Piero
and Florence would again stir debate among art historians: Was Piero a
product of Florence, or was he something homegrown and original?

In the end, Vasari's *Lives* created an enduring theory about the three
stages of the Renaissance, all of them leading up to the apex, which
was realized in Michelangelo, Vasari's hero and for whom Vasari was
commissioned to design a final tomb. For Vasari, true art began when
painters pursued realism with nature as their model. Hence, the first
stage began with Cimabue and Giotto in the early fourteenth century.
Then, new techniques developed and a second stage emerged, character-
ized by artists who looked at nature more closely and who managed "to
give rules to their [use of] perspectives."[16] With his bias toward Florence,
Vasari naturally touted the Florentine sculptor Donatello and painter
Masaccio as bellwethers of this second epoch, and he would also trace
the painterly invention of perspective to the Florentine painter Paolo
Uccello, not to Piero of the hinterlands. Nevertheless, unlike any other
artist mentioned in the second epoch, Vasari recognized Piero for his
superior knowledge of geometry and of Euclid and, not least, because
he "gave no little attention to perspective."[17] It would take a few more
centuries for these superlatives to be widely acknowledged by historians
of art and science in the Renaissance. Everyone in Vasari's second epoch,
meanwhile, was merely a prelude to the ultimate perfection of art, which
came in the third and final stage, the time of Leonardo, Raphael, and
ultimately Michelangelo.

More than any single person so far, Vasari, by writing his *Lives*, raised
the status of artists, a profession in which he also made a living as a
painter, art writer, and eventually architect. The term of his era was not
artist but "artisan." Yet Vasari broke that barrier and spoke in terms more
like our modern understanding of the artist, a kind of genius who makes
objects of beauty. Accordingly, he extolled the "divine Michelangelo."
At the moment when artists were finally being welcomed into the upper
classes (and could almost speak to aristocratic patrons as equals),
Vasari justified that seemingly divine rank. He also began a tradition of

connoisseurship, the practice of interpreting, comparing, and contrasting the looks or styles of different artists.

Vasari gave fairly good, or at least sympathetic, marks to Piero. Yet thanks to Vasari as a tastemaker, it would soon be common opinion that Piero was simply too old-fashioned. After a glimmer of recognition in the *Lives*, Piero was pushed farther into the shadows of history. For the next several centuries, Vasari remained the primary reference point for anything said about Piero, which was not a great deal.

Fortunately for the memory of Piero, there was one more book that, by its practical success, established his name in the field of art and geometry. This was *Pratica della perspettiva* (1568/69) by Daniele Barbaro, a Venetian patrician, cleric, and diplomat who was active in publishing at a time when his city was a leader in the book industry. The *Pratica* was probably the most popular book on perspective in the sixteenth century. And in producing this book, Barbaro was apparently confronted with a choice: Would he use Albrecht Dürer of Germany as his model, or would he use Piero?

Now that book publishing was in full swing, Barbaro had a number of works by Dürer, who was Germany's greatest graphic artist, illustrator, and advocate of the very perspective that had been rediscovered in Italy during Piero's generation.

About the time that the French were occupying the Italian peninsula, Dürer had aspired to visit Italy and learn what he called the "secrets of perspective."[18] Northern painters had achieved a kind of realism of space in their pictures, but Dürer must have felt that the Italian approach had a deeper theoretical basis, something almost magical, even a kind of alchemy. How he learned Italian perspective remains elusive. He may have learned the techniques in 1499 in Nuremberg, where an Italian follower of Pacioli had fled the fall of Milan to the French. In turn, Dürer would speak of his proposed journey to Bologna, and if he made that trek, this too could have been a point of contact.

Whatever the route of transmission, Dürer eventually became familiar with Piero's work. Before Dürer wrote his own book on perspective, *The*

Painter's Manual (1525), his notes copied Piero almost exactly. "Perspective is based on five things," he wrote. "The first is the eye that perceives things. The second is the object seen," and so forth.[19] The day would come when Daniele Barbaro aspired to write an even more expansive book for the Italian market, and Dürer's *Painter's Manual* was a very tempting model—until he learned about Piero's older manuscripts, apparently now available in more duplicate copies. Perhaps naturally, Barbaro turned to his fellow Italian, and in doing so acknowledged his accomplishments by name.

Barbaro was a type of Renaissance man, an amateur in mathematics, but articulate enough to produce a modern edition of the Roman architect Vitruvius's *De architectura*, in Italian and Latin, and to represent Venice as a diplomat. His book on perspective flowed, in fact, from his interest in Vitruvian concerns about stage or theatrical scenery; in this, *Pratica della perspettiva* was geared not to mathematicians, but to draftsmen and designers.

No particular method of drawing perspective was dominant in the age of Barbaro, but it was a time characterized by extravagant new directions in illusionistic painting, as perhaps seen in Venice, with its apotheosized ceilings and paintings with viewpoints at dramatic angles. Barbaro himself commissioned the famed Villa Barbaro, built by Palladio and decorated inside with illusionist murals by Veronese. But Barbaro nevertheless warned against using perspective for extreme effects alone: such excess could undercut a painting's natural or pleasant effect, producing an effect that is "strained, dizzily steep, deformed, or awkward."[20] At another extreme in Italian experimentation were the late Renaissance "Quadraturisti," a small school of painters who produced "ideal cities," absent human figures and plants but excruciatingly rendered as perfectly geometrical architecture.[21]

With these trends as backdrop, the section on perspective in Barbaro's *Pratica* nevertheless copied Piero's plain method almost exactly. Unlike Piero, his book waxed historical and philosophical in his treatment of perspective. Whereas Piero had plunged immediately into explanations, demonstrations, and practice exercises, Barbaro cited the ancients. And, when it came to the Platonic solids, he explained that "by these [bodies] Plato signified the elements, and heaven itself, and through the secret intelligence of their forms he rose to the highest realm of the speculation on things."[22]

In the book's preface, Barbaro interjects that "Piero and the others," by their simple formats of presentation, had pandered to "the idiots" when it came to teaching perspective, step by step, as if to schoolchildren.[23] Nevertheless, Barbaro gave Piero credit for his pioneering work more than anyone else had in the nearly eight decades since his death. He brought his name to the attention of future writers and the growing audience of patrons who wanted to stock their libraries with books on various new sciences.

Within the writings of Albrecht Dürer, Giorgio Vasari, and Daniele Barbaro, art historians have found the modern origin of what today is called "art theory," which is distinct from art-practice manuals and, in turn, is essentially derived from the theoretical (and speculative) Platonist tradition. Barbaro spoke of the Platonic "secret intelligence" behind mathematical forms, but Dürer and Vasari went further. Their writings proposed two alternative ways to reconcile the Platonic Idea of Beauty with the finite world of the artist, his inventive mind, and his materials.[24] Vasari in effect said that the artist's mental idea can merge with the Platonic Idea, thus giving art an improvement on nature plus a quality of divinity (something that Plato had not quite allowed). This was the origin of the modern neoclassical definition of Beauty: beautiful creations enhance or perfect nature *and* participate in a divine Idea by way of their images and aesthetic effects.

By contrast, Albrecht Dürer had offered a more brooding solution to how the Platonist Idea of Beauty could make contact with earthly art. Dürer, perhaps in the tradition of German mysticism, offered a bridge that was something like the modern idea of intuition, an innate ability of the human mind to be in the transcendent world and the physical world. As Dürer said, "A good painter is inwardly full of figures [images], and if it were possible that he live forever, he would have from the inner ideas, of which Plato writes, always something new to pour out of his works."[25] From the days when the revival of Platonism had introduced concerns about mathematics and geometry into Renaissance art, its influence had grown and spread. Both art theory and the perennial debate on the nature of Beauty may be seen as two of its children. To take a step further, Platonism did more than influence the psychology of art. It would also play a role in the coming Scientific Revolution, and this by way of Platonist cosmology.

It has always been tempting to place two such prominent features of the Renaissance as Platonism and linear perspective at the threshold of the Scientific Revolution. Historians disagree on the exact causes of scientific progress. But the arguments for the influence of Platonism, mathematics, and the new visualization of the arts have been made often enough.[26] If Platonism gave early scientists a new model of the cosmos (an alternative to Aristotle), the arts gave new tools: visualization and quantification. The tools of the new artisans drove progress in architecture and mapmaking, for example, and in inventing the two characteristic devices of the Renaissance, the telescope and the microscope.[27]

More generally, the growing use of artistic perspective had generated a more confident foundation for observing the real world. The arts may have led to the "rationalization of space," which would prove to be a key feature of modern physics.[28] It was also realized that diagrams, drawn based on perspective, could be matched up with mathematical calculations or measurements. In this, the modern scientific method was born. It became a method with a two-part dynamic. The scientist produced both a visual model and a mathematical equation, trying to fit the two together exactly, or to refute either one in the process of scientific hypothesis and testing. By this approach, early modern astronomy and physics made their first great strides, and the same model-and-equation method would be applied to the biological sciences in the far future.

The chief obstacle for the new astronomy in the age from Copernicus to Galileo—a span across the sixteenth and seventeenth centuries—was not necessarily religion or the church. It was the dominance of an Aristotelian cosmology, and by extension the church's adoption of the Ptolemaic astronomical calendar, both of which placed Earth at the hub of things. Renaissance Platonism would question the age-old Aristotelian cosmology, helping to open the way for new thinking in science and astronomy. At the end of Piero's generation, the figure who established Platonism as major school of thought was not a scientist, but a theologian, Marsilio Ficino. His voluminous *Theologia Platonica* (completed in 1482, a decade before Piero's death), along with his many commentaries on the texts of Plato, allowed

for a learned Platonist subculture to develop within the Aristotelian world of science. Anyone interested in mathematics, light, optics, astrology, and astronomy read Ficino's translations and commentaries. Those readers would include the standard-bearers of the new science, Nicolaus Copernicus, Johannes Kepler, and Galileo Galilei.

There are two ways that Ficino's Platonism set the stage for new thinking in science. First was his discussion of the Sun and light, and second was his mathematical universe. Ficino perpetuated the tradition of "light cosmology." For many Platonists, including Copernicus, the metaphysical centrality of the Sun—as in Ficino's claim that "all celestial things appear by divine law to lead back to the Sun"—was plausibly a more impressive idea in Platonism than the contrary assertion in Plato's *Timaeus* that the Sun orbited the Earth like a planet.[29]

Ficino also promoted a "light psychology." It was a parallel to the kind of Platonist art theory found in Dürer and Vasari and, similarly, Ficino's thought was a prelude to more modern notions of intuition. For instance, this role of intuition or insight was suggested by Ficino's Platonist psychology of optics. "When anyone sees a man with his eyes," Ficino wrote, "he creates an image of the man in his imagination and then ponders for a long time, trying to judge that image. Then he raises the eye of his intellect to look up to the Reason of Man which is present in the divine light. Then suddenly from the divine light a spark shines forth to his intellect and the true nature of Man is understood."[30]

Ficino did not know the mechanism by which light rays stimulated the retina, sending signals to the physical brain with its one thousand trillion neural connections. But he essentially was accurate in the two-step process. The first is purely mechanical, while the second—interpreting sense data—is mentally subjective for each individual, subject also to divine illumination if one cares to add that theological element.

Ficino's second contribution to undermining the Aristotelian hegemony in science was his literary explication of Plato's most basic work on the physical cosmos and natural world, *Timaeus*. Plato extolled number, unlike Aristotle, who preferred to put things in various categories, such as substance and accident as one example, or mineral, plant, and animal as another. "Plato, in the manner of the Pythagoreans, seems to build natural phenomena on the

principles of mathematics," Ficino wrote. "Natural phenomena dissolve into shapes and numbers as if into their limits."[31] Ficino's commentary, called *Compendium in Timaeum* (1484), was owned by Galileo and would frequently be used in lectures at Italian universities.

Plato and Aristotle differed in one other important respect. Aristotle's system said that the higher elements in the cosmos are different from the lower, and, being unchanging, the higher move only in circular motion while the lower move in a rectilinear (straight) fashion. In the Platonist cosmos, as summarized by Ficino, all the elements in the universe are homogenous (not higher and lower), and therefore the rectilinear motion of things can be translated, by mathematical calculations, into circular motion, which becomes the basis for calculating orbits, momentum, and other central concepts in physics.[32]

By the time of Kepler (born in 1571) and Galileo (born in 1564), the Platonist subculture that had been nurtured by Ficino was affecting their scientific outlook. Kepler spoke for both himself and Galileo when he wrote: "The Creator, the true first cause of geometry . . . as Plato says, always geometrizes. . . . [His] laws lie within the power of understanding of the human mind."[33] Temperamentally, Kepler and Galileo took different approaches to their work, of course. Mystically drawn to the Sun, Kepler was more willing to extend Platonic geometry and mathematics into the heavens. Galileo, by contrast, was a down-to-earth character.[34] He jettisoned the dreamy world of the stars to focus only on objects he could see or touch, as illustrated by his building a case for heliocentricity on seeing the Moon, interpreting tides (though wrongly), and, in part, rolling objects down inclines. His feet firmly on the Earth, Galileo also was willing to debate the Church's Aristotelian theologians, who insisted that the Earth did not move.

If the theologians were being stubborn, it was not just for stubbornness's sake. They had their own doctrinal dilemmas to deal with. Foremost was that Aristotle's philosophy allowed Catholic theology to explain the Eucharist—the body and blood of Christ in bread and wine—under the categories of substance and accident. Aristotle's Earth-centered world came with the package, so questioning Aristotle's cosmology also questioned the Eucharist, the basis of the priesthood's role in the Church. After Thomas Aquinas, "Aristotle's philosophical vocabulary becomes the basic idiom of Scholastic theology

and philosophy . . . waxing and waning with Scholasticism," according to one Catholic authority.[35] In Galileo's era of the Counter-Reformation, Rome made the Earth-centered universe a kind of doctrinal litmus test as it revived scholastic Aristotelian theology and reasserted its use of the Bible to counter Protestants; in both the Bible and Aristotle, the Earth did not move.

Thanks to the Renaissance artists, there was more than just Aristotle, Plato, or the Bible by which to visualize the world. In the tradition of Piero (followed by Leonardo and Pacioli), Albrecht Dürer would draw page upon page of polyhedra, and this at a time when book publishing made such illustrations widely available. Kepler studied Dürer's precise drawings; by this he surely learned something about the art of visualization of the heavens. Such visualizing became a new rage of the times. A growing number of mathematicians and decorative draftsmen used perspective and polyhedra as a great analytical plaything.[36] Other books followed in the Dürer tradition, stuffed with diagrams of visual rays, extreme perspective on many shapes, architectural decorations, Platonic solids, multifaceted polyhedra, and star-like crystalline structures that seemed to come from another world.

As his own contribution, Kepler would chart the basic system of the thirteen Archimedean polyhedra, drawing and naming each. He felt that the older humanist geometers in Italy, by their imprecision, were "in a dream."[37] Still, Kepler was indebted to their revival of visual geometry, and, to be sure, Kepler was dreaming a bit himself at this early stage of his work. He began his scientific quest by believing that the five Platonic solids defined the orbits of heavenly bodies. He gave up that mystical chimera when he discovered the mathematics of elliptical orbits.

Galileo, in turn, if not particularly interested in the technicalities of linear perspective, was attracted to the power of drawing in three dimensions. Galileo taught drawing, since perspective had become part of humanist studies in the Italian universities; he famously drew the changing shadows on the Moon's surface. It has been argued, furthermore, that Galileo's aesthetic preference for perfect circles prompted him to view planetary orbits that way, despite Kepler's new theory of elliptical orbits.[38]

Ellipses notwithstanding, Galileo may have followed other pointers by Kepler, pointers to Plato's *Timaeus*. It was in that book and in Ficino's

Platonist writings that Galileo found the poetically expressed ideas that God had made the universe by turning rectilinear motion into curved motion. Whether for rhetorical or scientific reasons, Galileo famously evoked Plato on the topic of motion in the Italian astronomer's two major works, *Concerning the Two Chief World Systems* (1632) and *Two New Sciences* (1638).[39]

There is no easy way to translate Plato's poetically stated cosmology in *Timaeus* into the precise mechanics of Galileo's final theories. Poetry aside, the Platonic subculture in Italian science was an important prod for the new direction: the universe was one substance, motion was mathematically continuous, and the key to science was matching a visual model (an experiment or drawing) with a mathematical law.

The new astronomy, meanwhile, had turned attention to problems of sight. Kepler recognized that human error in judging the night sky properly originated in the error of the eye. Over the century that separated Piero from Kepler and Galileo, the science of classical "perspectiva"—the most comprehensive idea of seeing—remained unchanged. This is made evident by the fact that the texts that artists such as Ghiberti, Piero, and Leonardo had read, those by John Pecham (*Perspectiva communis*) and Erasmus Witelo (*Perspectiva*), were the same ones found in the libraries of Kepler and Galileo.

Then Kepler tipped the scales. He took the first major step in understanding how the eye collected so many visual rays and focused them into a remarkably accurate and singular image.

Kepler had the advantage of higher-quality lenses for his experiments on how light refracts and focuses. With this, he set out to simulate how the eye might operate. The most perplexing puzzle of optics was this: If light rays went in all directions from objects, this meant the rays entered the eye not only at perfectly perpendicular points, but also at many angles. Therefore, how did the eye choose the perfect points of light, eliminating all the blur of the other angled rays?

Kepler began his inquiry with a fairly common observation, known since the invention of the camera obscura. In that device, which is a pinhole in a dark box, the small aperture sent the image to the back of the

box. Remarkable as this was, the image was weak, fuzzy, and upside down. Kepler asked: How did the eye make a clear image, first, and then make the image right side up? New anatomical discoveries of his age helped Kepler determine that the "seeing" part of the eye was indeed its retina, for, as one medical report said in 1583:

> The primary organ of vision, namely the optic nerve, expands when it enters the eye into a hollow retiform hemisphere. It receives and judges the species and colors of external objects, which, along with brightness, fall into the eye through the pupil and are manifest to it through its looking glass.[40]

With this knowledge, Kepler could approach that crystalline lens of the eye as the "looking glass," a mechanism of focus much like an eyeglass, telescope, or microscope. He combined lens experiments with ray geometry and calculated that it was the special shape of the lens in the eye that allowed it to gather up all the light rays—perpendicular and angled—into a focused impression. It produced a package of optimum light, unlike a fuzzy camera obscura. The inversion of the image, Kepler discovered, resulted from the way light passed through the lens. A ray coming in at the top of the eye was refracted, in other words, to the bottom of the retina, and vice versa. "That which is to the right on the outside is portrayed on the left side of the retina," and so forth, Kepler explained.[41]

Much about the mystery of light remained, so Kepler stopped while he was ahead. He stayed with a tradition that viewed light rays as colorless, noncorporeal mysteries. How the mind or soul captured vision was still too deep. Kepler stopped at the edge of that precipice. "How the image or picture is composed by the visual spirits that reside in the retina . . . I leave to be disputed by the physicists [medical practitioners]," he said.[42] The nature of the "visual spirits" would be the great dispute of psychology and neuroscience, which were both generations to come in the future. In the short run, optics was brought under a new outlook that marked every kind of modern science, a mechanistic outlook.

During the Renaissance, neither Aristotle nor Plato provided a direct model for the world as a machine, although Plato's geometry was approaching that threshold. The pushing of geometry into quantified modules, whether in architecture or mechanical devices, opened the way to do the same with nature. When addressing nature, however, the mechanistic view had to become a theoretical abstraction, unlike a real, tactile machine. The mechanical outlook, using the tools of mathematics, abstracted the universe into predictable, moving, interacting parts. This vision, nurtured by the Renaissance and even by some of its art, finally was personified in the central figure of the Scientific Revolution, the Englishman Isaac Newton, an unrepentant Platonist in his own way.

Of his many accomplishments, Newton would revolutionize the way the Renaissance had approached the question of beauty by presenting the first scientific theory of color. To do this, Newton began not with art, but with a "triangular glass Prisme, to try therewith the celebrated phenomena of Colours," as he said in 1666.[43]

A classic tool of optical experiments for centuries, the prism was used in a new way by Newton. He transformed his room into a kind of camera obscura: he shut out all the light except a beam that he allowed through a crack in the window shutter. When the beam hit the prism, it divided the white light into colors. Each field of color was bent at a different angle, being "variously refrangible," as Newton said.[44] These colors could not be further divided by refraction; and when he merged the colors back to a common point, they recombined into white light.

In the past, white had been considered a color that gave brightness to other colors, but Newton discovered that in physical reality all the colors originate in, and return to, white. Since light originated in the Sun, he extrapolated his theory to a higher physics: pure light is made up of a limited number of "primary colors," all of which refract differently when viewed by the eye and thus create the consistent spectrum found in sunlight and the visible world. Newton presented his findings to the Royal Society in 1672, and then elaborated in his monumental work, *Opticks* (1704).

There still were anomalies in Newton's theory to be swept under the rug for the time being. To name just a few, light rays seemed to produce an almost infinite number of colors, and Newton could not explain how this

occurred if there were a distinct number of "colorific rays," presumably just seven. He conceded furthermore that all seven colors were not necessary to produce white light. As few as three, or even two, primary colors (as beams of light) could produce white, according to experiments. For the world of art and the painter, meanwhile, Newton would not make the important distinction between color in pure sunlight and color mixed from pigments. This would continue to be the great conundrum for another century: Why do colors mix differently in sunlight and in colored materials such as paint?

The brilliant Newton had nevertheless opened the modern debate on the nature of light. Was it a wave, or a particle? It was no longer considered something that had to be strictly divine or spiritual. Relying on the Renaissance study of the harmonics of music, Newton used hearing and sound waves as an analogy for vision. It was known that the proportional lengths of taut strings produced scales of sound, each with distinct vibrations. Newton hypothesized that light, too, is a vibration, for, in the case of hearing, "Vibrations of the Air, according to their several bignesses, excite sensations of several sounds." Light and its colors are also vibrations, Newton proposed. These wavy rays of light "are not colored," but in them is "a certain Power and Disposition to stir up a Sensation of this or that Color." This was akin to how the "sound in a Bell or musical String, or other sounding body, is nothing but a trembling Motion."[45]

Newton eventually stepped back from his convictions about waves in the face of one compelling fact: light did not bend around corners as did sound. On the proverbial fence, he ended with a strong suggestion that light was therefore a corpuscle or particle that traveled in straight lines. Different colors, he said, might result from different masses in the particles. Newton left these two options—the wave and the particle—on the table in his final writing. But in an age when corpuscular theory was growing in popularity, the advocates of ancient Greek "atomism" insisted that Newton favored light as a hard particle. Furthermore, Newton's new mathematical physics of gravity had suggested a machine-like universe, and so other natural philosophers (exceedingly tired of Aristotle, and perhaps of Plato, too) viewed hard little particles as fitting that mechanical picture splendidly. Actually, Newton was a bit of a mystic on the side, and he was reticent about the world as a machine. But in the ebullient days of the Enlightenment and

deism, when a God of the clockwork universe had appeal, others would be eager to attach his name to this clockwork belief.

<div align="center">⊸◈⊷</div>

Under this new mechanistic view of the Enlightenment, the question of beauty itself would be subjected to a new debate, both in the human sciences and in art history. The classical ideal of Beauty, traced to Platonism and revived in the Renaissance, continued to dominate general opinion—that is, Beauty is proportion and brilliance, a quality both metaphysical and mathematical. The Newtonian era, however, opened the way for mechanistic skepticism about what seemed to be pure mysticism about the sources of Beauty. In this debate, the line was drawn between two parties. One was the "innate" school, which located the sense of universal beauty in the spiritual mind; the other was the empirical school, which argued that "opinions" about perceived beauty were simply learned from external physical experiences, prejudiced this way and that, person by person.

The clash of these two outlooks was personified in a friendship between two English thinkers, the doctor and philosopher John Locke (1632–1704) and his student, the 3rd Earl of Shaftesbury, Anthony Ashley Cooper (1671–1713). Locke personified the new empiricism, while Shaftesbury, a popular writer of his age, an implicit Platonism. Both were products of the age of Newton, who invited Locke to Cambridge on occasion. Locke in turn oversaw the young Shaftesbury's education. Shaftesbury would finally reject Locke's argument in the *Essay on Human Understanding* (1690) that there were no "innate" ideas in the mind, though they remained good friends.

Shaftesbury believed that there is a higher ideal of beauty, which existed in a metaphysical essence. Arguing that the sense of beauty is innate, he defined it as a perfect unity of parts: "particulars . . . must yield to the general Design."[46] Shaftesbury also reasserted a Platonist psychology: Beauty was certainly a pleasure, but primarily a mental pleasure. From that point of view, a sense of beauty arises in a person who is in a disinterested state of mind. That is, the pleasure has nothing to do with self-interest, as Shaftesbury illustrated in a story about the wealth connoted by owning a metal coin. This coin's beauty is not in its metal, but is traced to the mind of its

designer, and thus to the coin-maker's idea of beauty. Once this realm of ideas is reached, a final sense of beauty relates to something universal, the Platonic ideal, "the Principle of Beauty." This is the essence that can make coins beautiful.[47]

Shaftesbury's belief in Platonic Beauty was not persuasive to Locke, of course. Over time, Locke's anti-innate theory of beauty has been taken to be the utter antithesis of Platonism. Actually, and oddly enough, Locke himself was a type of Platonist. This is evident both in his *Essay on Human Understanding*'s discussion of the thinking action of the "soul," and in his treatise defending Christian ideas about providence. Often forgotten, Locke believed that after the Fall of Man, human mental operations had been naturalized. Every human being since has been born with a mind that is a blank slate (*tabula rasa*). It has no innate ideas, let alone Platonic or divine memories. Nonetheless, Locke suggested that the intellect can indeed ascend to a higher mental clarity, a concept that is parallel to positions in Plato's dialogues. Locke admitted to higher powers of intuition, those having "no need of Reasoning, but that are known by a superior, and higher Degree of Evidence" and that give people immediate and true knowledge.[48]

However, in a fast-moving age of science, Locke's psychology was seized upon by others to argue for a pure materialism of the mind. For the debate on beauty, Locke's writings did support the belief that judgments about what is beautiful are learned and therefore relative. In this he was joined by the Scottish philosopher David Hume (1711–76), who came a generation later. Summarizing the dominant conclusion of that age, Hume said that judgments of beauty are indeed relative, but that some judges are better by their experiences and education: they can tell a society what is in fact beautiful.

As the English made this contribution, the Enlightenment was stirring another type of debate in Germany: this was a debate on the very nature of art history, or the practical appreciation of the particular "beauty" of arts from different countries. At the time, the presumption was that art history was essentially about Italy, an idea made evident by the popularity of the Grand Tour of that country. The story of the Italian Renaissance provided

a kind of gold standard for chronicling art history; and, in addition, Italy was still Europe's best preserve of antiquity, a showcase of surviving Greek art, especially as it was imitated and emulated in Roman sculpture, painting, and architecture. This classical allure of Italy was illustrated by events in 1755. In that year, the German historian Johann Winckelmann moved permanently to Rome to explore the roots of classicism. From that ancient baseline, his intention was no less than "to trace the history of art."[49]

Giorgio Vasari had done this for 250 years of Italian art. But now Winckelmann would make it a global project. "We have enough lives of painters," he said.

> To my mind it would be much more useful to begin replacing them with entire histories of art. . . . A history of art should treat the origin, growth, mutation, and decline of a tradition along-side its presentation of the various styles of nations, ages, and artists—all of this, as much as is possible, must be extracted from the surviving works of antiquity.[50]

With this assertion, Winckelmann established Greek art as a universal standard. Thus was born traditional Western art history: moving from the Greeks through each culture, marking the origin, high point, and then decline into decadence. Vasari had created a similar periodization, but for Italy alone. Vasari had also ended at a high point, never suggesting that Italian art had declined, as Winckelmann would by pointing to the late baroque and rococo. By his approach, Winckelmann freed art history from its normal context of princes, patrons, and local patriotism. He viewed it as a historical process, a story of the rise and fall and recovery of styles, not just a survey of art collections of one royal court or another. "He was soon to hurdle over particulars with his ideal of an entire 'history of art,'" wrote Johann Wolfgang Goethe (1805), the admiring German poet. "Like a second Columbus, he discovered a long-heralded, long-dreamed-of—or, rather, once known and long-forgotten—land."[51] For Winckelmann, great art everywhere had a quality of "noble simplicity and quiet grandeur." This was a somewhat unequivocal stance, and it was solidified by his unrivaled opus, *History of Ancient Art*, published in 1764.[52]

The urge to write art history had now been unleashed. If Winckelmann heralded the classical age of the Greeks, it was an Italian who gave pride of place to the medieval period of the arts. This was Luigi Lanzi (1732–1810). In an age still emerging from patriotic art history, Lanzi did try to write more broadly. His masterpiece, however, was *History of Italian Art*. Covering Italy in such breadth and depth, Lanzi resurrected the story of Piero.

Lanzi had been a young Jesuit when that religious order was dissolved by the papacy in 1773, so he found refuge in a different profession: he became a court scholar of antiquities for Grand Duke Leopold of Florence, investigating and writing on the Italian past, especially the Etruscans. This allowed him to canvass the country and see its paintings as well. The result was his *History*, published in 1795. Like Winckelmann, Lanzi innovated. Rather than present a medley of artists, he identified the most "celebrated painters" as a way to survey various schools of style and influence. And, invariably, he began with Leonardo, Michelangelo, and Raphael. "Those artists were the ornaments of the Florentine and Roman schools, from which I proceed to two others, the Sienese and Neapolitan," said Lanzi, continuing down in his list of five major schools, which in the end required three hefty volumes.

> I first give a general character of each school; I then distinguish it into three, four, or more epochs, according as its style underwent changes with the change of taste, in the same way that the eras of civil history are deduced from revolutions in governments, or other remarkable events. . . . A few celebrated painters, who have swayed the public taste, and given a new tone to the art, are placed at the head of each epoch.[53]

In Lanzi's quest to find celebrated painters as fountainheads, he could not identify such a master who had taught Piero, suggesting quite accurately that "under the guidance of obscure masters he raised himself, by his own genius, to the high degree of fame he enjoyed." Fitting somewhere in the broad Florentine/Roman school, Piero was "one of the most memorable painters of this age" and (according to Vasari, he says) "made himself master of the principles of mathematics, and he rose to great eminence both in art and science." After that, Lanzi gave at least one reason why Piero himself

could not be placed at the apex of a school: his work often had the feeling of a "rude sketch of that style which was ameliorated by P. Perugino and perfected by Raphael."[54]

Reading this comment in the most positive light, Lanzi was almost suggesting that Piero had influenced—or certainly anticipated—someone like Raphael. This was just one of the Lanzi highlights in Piero's legacy. His superlatives for Piero would be adopted by future interpreters: Piero's distinctive use of light, the Greek quality of his figures, and his influences on Raphael, Bramante, and north Italian painting. And of course there was always Piero's seminal use of perspective:

> The art of perspective, the principles of which he was, as some affirm, the first among Italians to develope and to cultivate, was much indebted to him; and painting owed much to his example of imitating the effects of light, in marking correctly the muscles of the naked figure [and] in the study of drapery. . . . On examining the style of Bramante and his Milanese contemporaries, I have often thought that they derived some light from Pietro, for he painted in Urbino, where Bramante studied, and afterwards executed many works in Rome, where Bramantino came and was employed by Nicholas V.[55]

Having seen the evolution of painting in the northern schools, from Milan to Ferrara, Lanzi said it revealed the presence of Piero, "from whom perspective in Italy may truly be said to have dated its improvement."[56] Although there were many mediocre painters in Ferrara, "others attained greater celebrity, having modernized their style in some degree, after the example, as I incline to think, of two foreigners. One of these was Piero della Francesca, invited to Ferrara to paint in the palace."[57]

In his quest to write a "general historical narrative," indeed a fairly concise "compendium" for his day, Lanzi put aside many traits of past art history, such as unverifiable gossip about individual artists and, as he said, the style of "so much verbosity by Vasari." Despite Vasari's many errors with dates in his *Lives*, Lanzi said, his treatment of Piero should be taken as reliable enough.[58] An inveterate traveler himself, Lanzi frequently noted how

painters could move to different cities in a few days, giving an empirical sense of how the influence of painting styles spread.

Unavoidably, Lanzi added his own omissions and misnomers to the story of Piero. He perpetuated several erroneous dates, mishandled the Rimini frescos, and basically overlooked Piero's works in Sansepolcro (and excusably so, perhaps, because Piero's dramatic *Resurrection* fresco at Sansepolcro's city hall had been whitewashed over). In a common mistake over the centuries, Lanzi at times confused Piero with another artist who excelled in perspective, the Dominican Fra Carnevale, a native of Urbino. Art history was still in search of its facts, and some would prove unattainable (or be happily rediscovered) as the centuries passed. Looking to the future, Lanzi said art history was now a topic for the edification of general readers in a modern age. "The history of painting is the basis of connoisseurship," Lanzi said. For his renown as expositor of Italy's art heritage, he was buried next to Michelangelo in the Santa Croce Church in Florence.[59]

The publication of Lanzi's *History* a few years after the French Revolution of 1789 made it a benchmark in the transition from the Enlightenment to the age of romanticism, a transition into the nineteenth century that would deal Piero a new fate. Among art historians, he would no longer be ignored. Modern science, too, would turn its attention to questions of art and beauty, catching Piero in its net as well. Piero probably would not have objected to these developments, for it was he who had endorsed painting as a "true science." The Platonist ethos of Piero's Renaissance age had made its mark, perhaps, in the rise of a new astronomy and emphasis on mathematics. Science would shed its Christian and Platonist background, however, and be caught up in the forces of secular ideology. A new challenge lay ahead. If Piero's art evoked the idea of a transcendent mind—with all its implications for art and religion—could that belief survive the rise of philosophical and scientific materialism?

For the time being, however, the nineteenth century would open with Napoleon's war on Europe, delaying some of these philosophical debates for later. What the Napoleonic conflict did in the meantime was actually spread more knowledge of Italian art. By wartime seizure, early Renaissance paintings began to reach France, and in the wartime chaos of the free market this art was sent along to England as well. As a consequence, the art of Piero began to cross national borders for the first time.

CHAPTER 8

Piero Rediscovered

During the Napoleonic Wars, the French armies scoured Italy and brought back cartloads of art to Paris, where it was installed in the Louvre as a testament to France's continental hegemony. The road back to Paris passed through Milan. In that city, Napoleon had turned the Austrian royal Brera Academy into a half-way station to accumulate the best of the art in north and central Italy. In 1811, Piero's altarpiece of the kneeling Federico da Montefeltro arrived at the Brera, unloaded by the French who had pilfered it from Urbino. A few years earlier, in 1807, the French had closed down the Sansepolcro church that held Piero's *Baptism*.[1] That painting, overlooked by the Francophone art raiders because of its poor repair, was moved to the abbey, scene of Piero's tomb. It escaped the fate of Piero's frescos at Arezzo, which were subjected to target practice, here and there, by French soldiers.

One nation that watched these cultural violations was England, and its hatred of Napoleon gave it a new sympathy, albeit with a Protestant tinge, for the land of the papacy.[2] Along with the political sympathy came a renewed British cultural taste for Italy, a taste that built upon past precedents, including opera, Palladian architecture, and the Grand Tour. The Tour's main destination had long been Rome, a city of ancient ruins, and

to get there British travelers had enjoyed the sublimity of an "agreeable kind of horror" crossing the Alps to begin their journey through Italian cities and landscapes.[3]

Modern British appreciation of Italian painting had its history as well, and a good place to start would be 1749, the year that the English portrait painter Joshua Reynolds arrived in Rome to study and copy the Italian masters of the sixteenth and seventeenth centuries. Having discovered Michelangelo and Raphael, he returned to England advocating them above all others, espousing for his own nation a similar "grand manner" in painting. When Reynolds became head of the Royal Academy of Arts at its founding (1768), he sent students to Rome to copy High Renaissance works. His legacy established in England a traditional "academy" of art instruction. It was a model of High Renaissance and neoclassical taste, and it was against this tradition, in the tumultuous nineteenth century, that a group of young artists would rebel, using the term "Pre-Raphaelite" (and "Sir Sloshua" Reynolds) as a slogan.

Before this in-house British art rebellion was afoot, the Napoleonic Wars had virtually ended the Grand Tours. Another consequence of the wars, ironic to be sure, was to light a fire under the market for Renaissance art. Knowing that the French invaders would confiscate a wide variety of valuables, many Italian families, churches, and clergy began selling off their works of art. European collectors knew the game well enough. During the French Revolution, English collectors purchased a good deal of French heritage that was being liquidated rapidly by a crumbling aristocracy. Now eyes were set on Italy. Collectors used brokers to buy directly from Italy; and whenever the English captured a French contingent, or sequestered a French ship, the caches of stolen Italian art were taken back to London, only some of which was returned to Italy in the end.

After the war, the British interest in things Italian reached new heights. The fascination ranged from medieval tales to histories of the Roman Empire. The enthusiasm lasted for more than twenty years. It revived the Grand Tour, to the point that British travel books on Italy reached record numbers. Inevitably, a number of British literary figures headed for the land of Dante and Michelangelo. In 1816, George Byron, the romantic poet, fled there (from his marriage), followed by Shelley, Coleridge, and Wordsworth.

England's rising new star in painting, Joseph Turner, first set foot in Italy in 1819. In all this, the stage was being set for Piero's name to reach the English-speaking world.

For the history of early Italian painting, Vasari's *Lives of the Artists* was still the primary sourcebook. By the 1830s it had been translated into German, and the Italian version was receiving updates that added notes on Piero and more clarity on the list of his works, although some confusion still prevailed. Among Italian art historians especially, the quest was to expand on Vasari by confirming, correcting, or improving his data on all his subjects. New data on Piero in particular was taking centuries to resurface. It was not until 1822, for example, that the first modern discovery was made of a concrete date in his life: the archives of Urbino disclosed a document showing that Piero had arrived there in 1469 to consider an altarpiece commission.[4] More information dribbled out, but at a glacial pace. In the 1830s, when Piero's descendants in Sansepolcro, the Franceschi Marini family, had his "life" from Vasari's *Lives* specially printed, the annotations noted that some of his old manuscripts were still held in the ancestral library (alas, only to disappear again, apparently, into the voracious antique-manuscript market).[5]

For non-specialists in the 1830s, Piero began to show up in Italian art guides, if just barely. One of the first was for the Tiber Valley (*Istruzione Storica-Pittorica*), a work by the amateur historian and lawyer Giacomo Mancini, who noted Piero's "excellent" works in Sansepolcro.[6] Still, for foreign travelers in Italy, it was not exactly easy to discover Piero. Not being a Florentine painter, he did not get much ink in the Grand Tour guide-books. It was still Arezzo that put him on the map. This was illustrated by one popular French work, *Historical, Literary, and Artistical Travels in Italy* (1831), which cited his madonna painting in Arezzo but, meanwhile, presumed that Piero was "a great Florentine artist . . . who lost his sight at the age of thirty-four."[7] The story of early blindness, while dramatic for a great artist, was one of the erroneous tidbits in Vasari's *Lives*, and now greatly exaggerated. Piero may have finally lost his sight, but hardly at a young age, proved by his writing of his own will at about age seventy-five.

If ordinary tourists were still essentially blind to Piero, the painters of Europe were opening their eyes to him—and to much else from the early

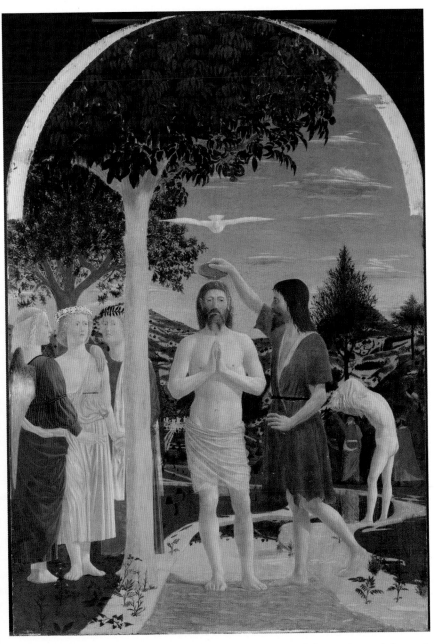

The Baptism of Christ, done with tempera on wood, may be Piero's first major work, begun in 1438. Measuring about 4 feet by 5½ feet, it has been a public favorite at the National Gallery, London, since the 1860s. © *National Gallery, London/Art Resource, NY.*

The Misericordia Altarpiece, a classic polyptych, was commissioned in 1445. The stoic Mary at center, compared to the expressive Crucifixion at the top, reveals Piero's future choice of a monumental style. The panels total about 9 feet by 10½ feet, and the work is on museum display in Sansepolcro, Piero's home town.

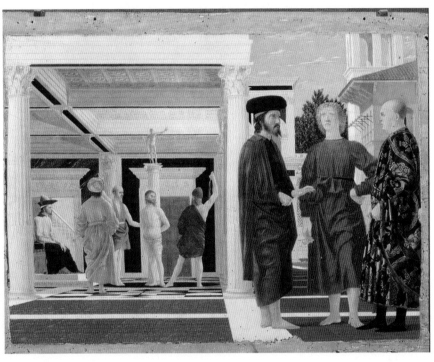

The *Flagellation of Christ* may be Piero's most mathematical work. Done with tempera on wood, it could have decorated a household chest (cassone) or an altar, and measures just 23¼ inches by 32 inches. The human figures have intrigued interpreters for centuries.

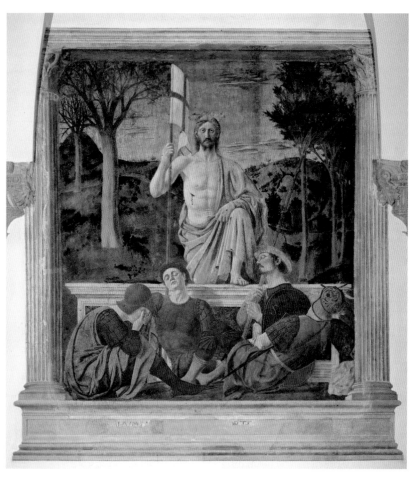

Piero's *Resurrection* fresco, which has survived whitewash and wartime bombings, was done for the city hall of Sansepolcro, whose name means "holy sepulcher." Aldous Huxley called it "the best picture in the world." It measures about 6½ feet by 7½ feet.

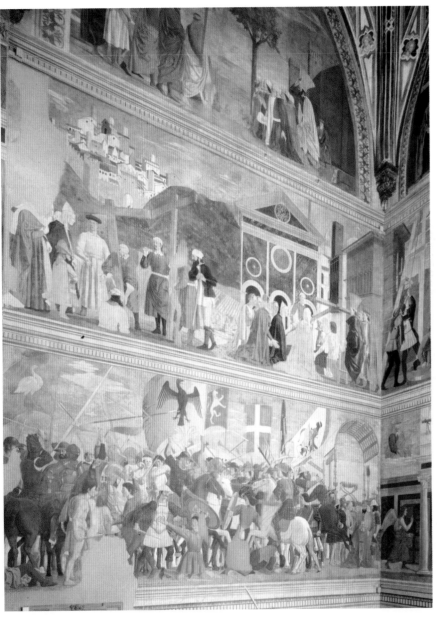

The left wall of the choir of San Francesco Church, Arezzo, towers three stories high with the fresco cycle Legend of the True Cross. Each scene measures 11 feet by 24 feet. Begun around 1452, Piero finished in the 1460s. Its total restoration was celebrated in 2000.

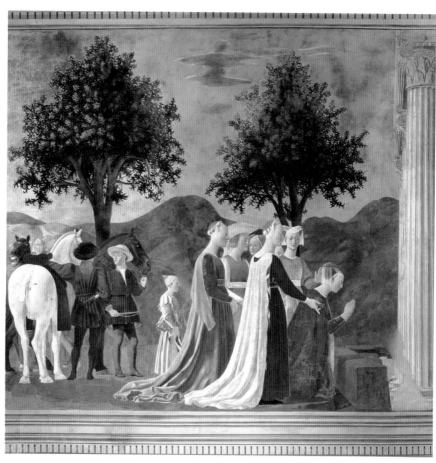

In this detail of *Adoration of the Sacred Wood and the Meeting of Solomon and the Queen of Sheba*, Piero presents the exotic royalty of a queen. This detail from the right wall of San Francesco Church, Arezzo, is itself about 11 feet by 12 feet.

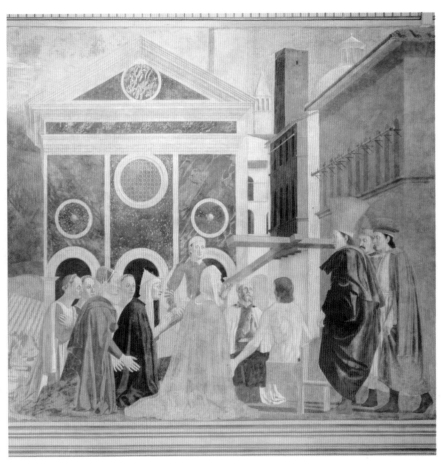

In this detail from *Discovery and Proving of the True Cross* at Arezzo, Piero incorporates a number of architectural features being used in the classical revival around Renaissance Italy. His emphasis is on linear perspective and perfect Platonic shapes.

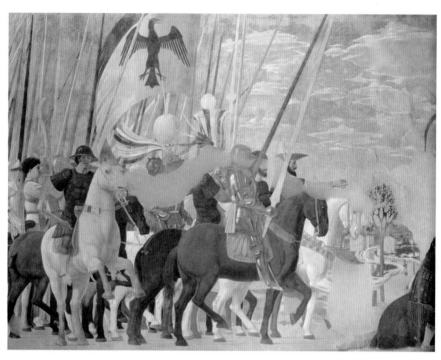

The English connoisseur Kenneth Clark praised Piero's colors and shapes in this detail from *Battle of Constantine*, Arezzo, speaking of its Platonic idealization.

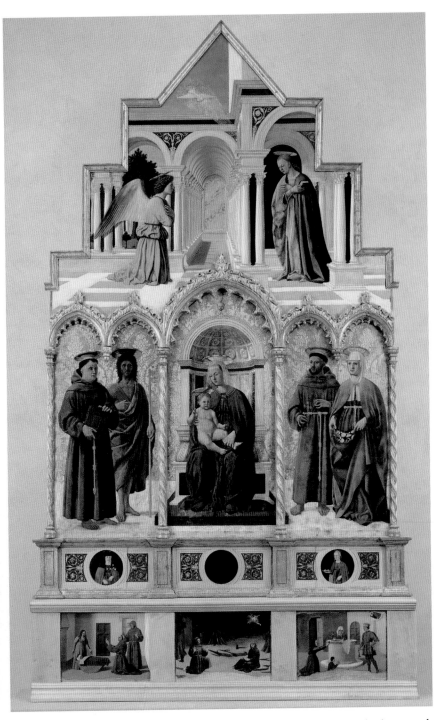

The Saint Anthony Altarpiece, which Piero did for a convent in Perugia, is not only unusually tall, but employs highly sophisticated perspective in the top panel (which was cut to a point by later owners). It rises 11 feet high and is 7½ feet wide.

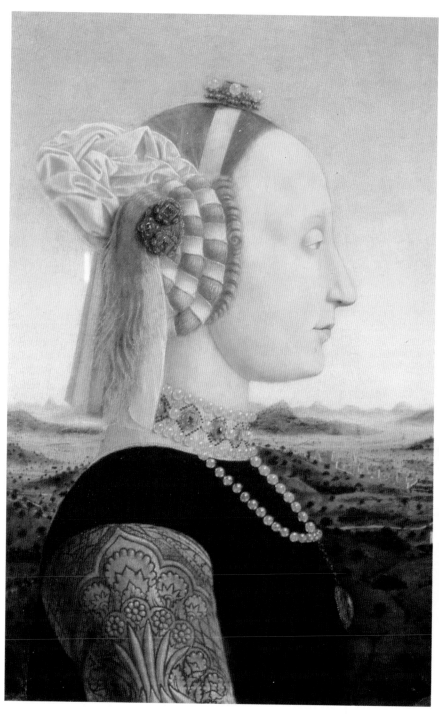

Piero may have painted this portrait of Battista (Sforza) Montefeltro, who faces husband Federico in a diptych, soon after her death in 1472. Completed in oil and tempera on a panel of about 13 inches by 18½ inches, its home has long been the Uffizi Gallery, Florence.

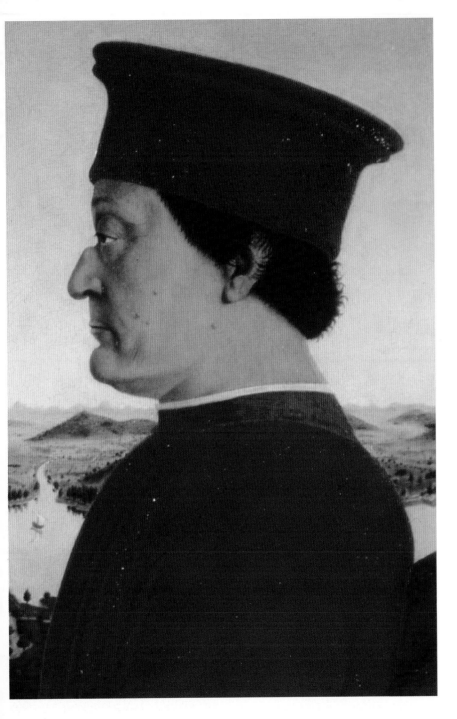

Piero's diptych of Federico da Montefeltro is an icon of Renaissance imagery. A single landscape falls behind the duke and countess, and on the diptych's back is Piero's narrative of their "triumphs." The portraits share a single gold frame in the Uffizi Gallery, Florence.

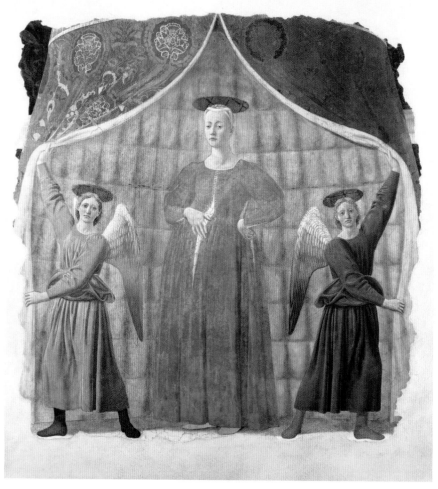

The pregnant *Madonna del Parto*, attended by mirror-image angels, is a fresco painted behind a freestanding altar. It is about 6½ feet by 8½ feet, and still occupies a rural cemetery chapel outside Monterchi, the home town of Piero's mother.

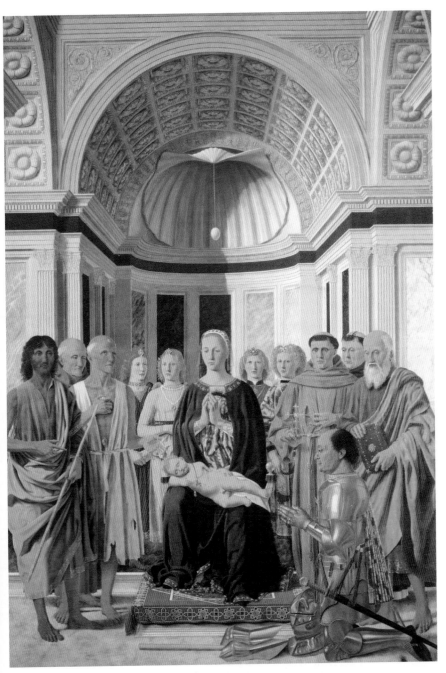

The Brera Altarpiece (of Federico Montefeltro) is Piero's masterwork in oil. It is named for the Milan museum to which Napoleon's troops carried it in 1811. Done in remarkable architecture detail, the painting's hanging ostrich egg has puzzled interpreters for ages.

Puvis de Chavannes's 1873 oil painting, *Summer* (above) and Georges Seurat's 1885 *La Grande Jatte* (below) both reflect some of the monumental stillness seen in early Renaissance frescos, especially those by Piero della Francesca. *Top image © RMN-Grand Palais/Art Resource, NY.*

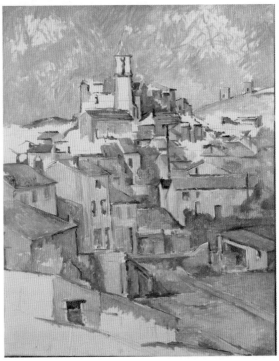

At the École des Beaux Arts in Paris, Paul Cézanne saw a copy of Piero's *Discovery and Proving of the True Cross*, with its hillside town (detail, above), which may have inspired his own landscape (below), *View of Gardanne*, painted around 1886. *Bottom image* © *The Metropolitan Museum of Art. Image source: Art Resource, NY.*

As illustrated in this page from Piero's second treatise, *On Perspective for Painting*, Piero gave painters meticulous instruction in how to draw various objects in geometrical perspective, including a Corinthian capital.

Renaissance. Probably driven by the romanticism of that era, artist colonies had begun to gather in romanticized Italy, where they found time to study and copy the Italians of the past. In an altruistic vein, some painters began to worry about the deterioration of many great frescos, including Piero's in Arezzo. Reportedly, this is what sent the Frenchman Antoine Ramboux to Arezzo, at points between 1816 and 1842, to paint a duo of watercolor replicas from the walls. One was a true-cross scene and the other a battle scene. These Ramboux copies provided the last record of the frescos' rich color and detail before a period of further deterioration set in at the centuries-old church.

As the gathering of artist colonies testified, young painters on the Continent had long viewed Rome as a place of pilgrimage, especially in the nineteenth-century age of romanticism. No colonizing group would become more significant (in hindsight) than a gaggle of German painters belittled by their critics as "the Nazarenes" for their desire to fuse romanticism and Christian art. Some of them lived a somewhat monastic life, taking up in an abandoned monastery in Rome. They experimented with frescos, the lost art of the early Renaissance. From Austria and Germany, these young painters were rebelling against the same kind of neo-classicism that had been established in France and England, and from them would emerge one of Europe's most significant chroniclers of the visual arts, the German painter Johann David Passavant (1787–1861). Still an unknown quantity at the time, Passavant would eventually cast new light on early Italian painting and on Piero as well.

Passavant would put down his brushes to become an art scholar, indeed a developer of several genres—scholarly biography, travelogue, and reference book—that would shape art writing. He retained his Nazarene aesthetic, which had much in common with early Italian religious painting. As a kind of archetype of the cross-cultural artist, he lived and worked in Paris, Rome, London, and finally Frankfurt, cross-fertilizing information among the new generation of connoisseurs. For example, in 1833 he published a memoir of his visit to England's art and collections, which was put into English three years later as *Tour of a German Artist in England*, translated by the English Germanophile Elizabeth Rigby (of whom more later).

Italy, however, was the place where Passavant had wedded his artistic soul. He had made his first of many visits to Florence and Rome around

1817, and returned to Italy in the 1830s to offer what the Germans were doing best, a rigorous form of scholarship, which he now applied to the first authoritative biography of Raphael, "the greatest genius of modern painting."[8] The Passavant volume was published in 1839, and the result was to throw more light on Urbino, still a storehouse of information related to Piero. Up until then, German art historians had tended to see Piero as a mere student of an otherwise notable school of early Italian painters at Padua.[9] Passavant's volume began to correct that impression in the German-speaking world. His index of painters who had worked in Raphael's home town itemized all the currently known facts on Piero's life.

Much that was in common with the Nazarene romanticism had been catching on in England in the meantime. One manifestation was the surprising decision of Parliament in 1835 to decorate the new Palace of Westminster with frescos, shades of early Italy. For everyone the great Raphael, willing or not, was becoming a kind of reference point in the debate over art styles that England should adopt or appreciate. Thus was born the term "pre-Raphaelite," a kind of umbrella phrase for all early Italian styles, although it became best known when the young painters used it as a slogan of rebellion against High Renaissance academicism.

Passavant also played a role in making Raphael a touchstone for the English, and in inspiring a British search for things "pre" Raphael. Viewed as a kind of trigger, Passavant's biography of Raphael would galvanize three up-and-coming people who would shape British art tastes in the Victorian era. They were Elizabeth Rigby, her future husband Charles Eastlake, and the Scottish art collector James Dennistoun. Together, these three Renaissance aficionados (and two or three other enthusiasts in England, to be sure) would revive British interest in early—so-called primitive—Italian art, and thus in Piero as well.[10] Their attentiveness to Passavant also revealed a shift of British cultural interest for Italy to things German, and it came for a very good reason: in 1840, Queen Victoria would marry the German-born Prince Albert.

⊸◇⊶

As the Victorian era began, Eastlake was destined to be one of England's most important figures in the arts. He was perhaps more conversant with

the historical art of Italy than anyone else in Britain.[11] He was also hand-maiden to a small, but historically important, revival of Piero's legacy. This began in 1840 when he wrote a review of Passavant's biography of Raphael, taking it as an opportunity to call Piero "one of the most accomplished painters of his time," which was probably a first-ever mention in an English typeface.[12]

Such a comment on Piero had required Eastlake's own familiarity with early Italian works by dint of his travels on the peninsula. As a young painter, he had been eyewitness to some of the events of the Napoleonic Wars. Having seen the captured Napoleon embark on a prison ship for exile on St. Helena, he painted that scene to some acclaim. Like many gifted painters, he transplanted himself to Italy, where he relished "a union of History and Landscape." He especially relished "the retirement, quiet, and the cheapness of Rome," where he essentially lived for most of the next fourteen years.[13] Eastlake became a host to other English on the Grand Tour and was elected, young as he was, to the Royal Academy of Arts, later being its president. He wrote articles on Dante and painted such romanticism-era topics as *Byron's Dream* (1827). And he must have seen something of Piero's works either in Arezzo, Sansepolcro, Urbino, or Florence, where the Montefeltro diptych was displayed in the Uffizi Gallery. About a decade after he returned to London, Eastlake was made secretary of the government's Fine Arts Commission. That was in 1841. Soon after, he also became "keeper" of a government art collection, the National Gallery.

Despite his roots in Italian art, Eastlake had met many German painters and art scholars, and he watched the art literature in Germany closely. His marriage to Elizabeth Rigby, a notable translator of German, opened the way for their teamwork on several Germanophile publishing projects on the history of art. They began with an English translation of the 1810 work by Johann Wolfgang Goethe, *Theory of Color*, translated by Elizabeth and annotated with her husband's commentary.[14] In this project, Charles Eastlake thought of himself as being like the Italian humanist Portius, who had translated Aristotle's *Treatise on Colors* for the Medici. The Eastlakes quickly moved to something more ambitious: the translation of the modern German school of art history's leading work, the multi-volume *Handbook of the History of Painting*. Written by Franz Kugler, it was a comprehensive

look at world art far surpassing the offerings of Winckelmann. When the Eastlakes published the work in 1841, it was a milestone in art-historical translation. By contrast, Giorgio Vasari's massive *Lives of the Artists* would not be put into English and published in London until 1850.[15]

Kugler was well worth the trouble of translating, of course. He was a product of the Berlin school of historical writing. That academic school was led by Leopold von Ranke, a pioneer of the so-called scientific methods of history, relying on critical use of documents and hoping, as Ranke said, "simply to show how it really was."[16] Alongside Ranke was Kugler (1800–58), who tried to achieve the same scientific objectivity for the history of art. Kugler began publishing his multi-volume *Handbook* in 1837. Winckelmann had made Greece the measure of art; in contrast, Kugler set down the much-imitated format of an all-purpose descriptive art history of the entire world, though still focused on Europe, which was his publishing market.

A man of his age, a time of German romanticism, Kugler wrote extensively on the medieval period in Italy. He gave similarly ample coverage to the early Renaissance and, like Lanzi, compared Piero to the styles of other painters, weaving him more densely into his time. Still, his coverage of Piero was short and bland. Eastlake tried to make up for this, if only in footnotes. In the English translation of the *Handbook*, he opined regarding Kugler's neglect of the Sansepolcran: "Considering the claims of some painters in the author's [Kugler's] catalogue, perhaps Piero della Francesca deserved more honourable mention. His frescos at Arezzo, so highly extolled by Vasari, are now almost ruined; but at Borgo S. Sepolcro, his native place, several of his works still exist."[17] Revealing his traveler's knowledge of Tuscany, Eastlake said that Piero's best painting was the *Resurrection*, and though he did not name it, he offered the homely fact that it was on display in Sansepolcro's old city hall, where some rooms seconded also as a church pawn shop (the ubiquitous Monte di Pietá, present at the grass roots across Italy).

Eastlake's book review of Passavant a year earlier was still having an effect, like an echo. Reading the review, James Dennistoun of Glasgow had been galvanized to uncover the true story of Urbino, the birthplace of Raphael. This inexorably led him to Piero as well. A Scottish person of means, Dennistoun had taken his first Grand Tour in 1825. In the 1830s, he began a twelve-year excursion across Europe, spending winters in Rome

and summers touring Italy and Germany, researching literature and looking at the monuments of art. Then, after Eastlake's book review alerted him to the Passavant volume, Dennistoun was launched on his mission in life: to write a book on the rulers of Urbino. During a total of six years in Italy, Dennistoun traveled to Urbino three times. There he collected everything that was known of the Montefeltro dynasty. A good deal of his book was written while in Italy. On his return home to Glasgow in 1847, he completed his authoritative *Memoirs of the Dukes of Urbino*, published in 1851.

With the Urbino glimmer in his eye, Dennistoun—a "humble pioneer" in his research—had both Vasari and Lanzi as guides, including on the topic of Piero, and he openly concluded that Vasari had gotten the whole story of Piero off on the wrong foot, coming up short on Piero's importance, since Piero "ranks high among the reformers of painting."[18] On this, Dennistoun was already receiving pro-Piero signals beyond Eastlake's praise. His friend and fellow Scot collector, Alexander Lindsay, who was leading a movement for Christian appreciation of early Italian art, first saw Piero by way of the Arezzo frescos in 1842; at that time, Lindsay wrote home that Piero was "totally unknown and underappreciated by modern historians and alas!"[19] Over time, Lindsay, too, would become an advocate of Piero (and indeed, Dennistoun dedicated his Urbino book to his fellow Scot).

Dennistoun's story of the Urbino dynasty paid full attention to its patronage of artists. Perhaps following Lanzi, he further argued that Raphael must have learned from Piero, and even competed to outdo his works, adopting similarities to Piero's composition and use of chiaroscuro. He reminded readers that Piero's *Flagellation* was in the Urbino cathedral, and provided new information on some of the popular interpretations of its meaning. And perhaps for the first time in memory, he told an English-speaking audience of Piero's fresco of the kneeling Sigismondo Malatesta in Rimini, while also warning of the otherwise impressive Arezzo frescos as being "mere wrecks" with "menacing cracks."[20] Such comments abroad probably helped prompt the first modern restoration of the frescos by Italian officials in 1858, and further prompted copyists to go see them before they were long gone, victims of time, the weather, and neglect.

As another superlative, Dennistoun was the first to report that one of Piero's original manuscripts of *Five Regular Solids* existed in the Urbino library. He recited parts of Piero's dedication to Duke Guidobaldo Montefeltro, the last of the family line. Dennistoun thus treated English readers to the first flavor of Piero's humanity: Piero called himself "a rude and unpolished peasant," but then declared his "novelty" as better than Euclid, and then finally confessed that his old mind was going.[21] This was a far less splendid voice, of course, than the way Michelangelo's utterances were immortalized in his letters and poetry, or the way Leonardo exalted himself in his voluminous scattered notes. In the midst of their celebrity, Dennistoun had nevertheless managed to let people hear Piero speak.

Writing on the Urbino dynasties, Dennistoun corrected some errors in Vasari's *Lives* and introduced a few new ones regarding Piero. But his literary labors emerged as the first in English to extensively praise Piero as the painter of "perspective and light."[22]

As English knowledge of Italian art and literature was reaching an apogee in the decades after Napoleon was gone, the brightest Renaissance lights continued to be figures such as Michelangelo and Raphael. They were High Renaissance giants, and it was going to require a detour around them for the English to notice earlier Renaissance art: the so-called "primitives."

In a romantic age that was looking for rebellions against aristocratic classicism, the so-called Nazarenes were among the first to hark back to the early Italian aesthetic, and poets and writers were soon to follow. If the German term "Nazarene" began as a slur against a group of apparently foggy-headed romantic art students who fled the academy in Vienna, the English term "pre-Raphaelite" would have less clear origins. Whatever informal use it had previously had, it was formalized in 1849 when a group of young painters, some at the Royal Academy, met as the secret Pre-Raphaelite Brotherhood.

This romanticized act of looking back to a time before Raphael had also been imported by way of Italian expatriates. They had fought Napoleon and other European dictators, and on arrival in London they earned a storied

place among exponents of English liberalism and the study of Italian arts and letters. At the forefront of this importation was the Rossetti family. The father, Gabriele Rossetti, had arrived in England in 1824. He taught Italian and extolled its literature, and his British-born children, Christina the poet and Dante the painter, carried it deeper into English culture. When the "Revolutions of 1848" stirred across Europe, and the Chartist movement of workers' voting rights was revived in England, some young artists also felt the need to throw off the old order, and thus was born the insurgent gathering of the Pre-Raphaelite Brotherhood. Three of the younger Rossettis and some Royal Academy students made their secret pledge to the cause in a London living room, and then cryptically went public at a Royal Academy exhibit, each putting the initials "PRB" at the bottoms of the paintings along with the artist's signature.

As perhaps England's first real avant-garde movement in the arts, the Pre-Raphaelite Brotherhood was a small affair. The more successful painters among them did indeed pioneer a distinctive style, somewhat like the early Italians, a style that one expert aptly describes as "minute description of detail, a luminous palette of bright colors that recalls the tempera paint used by medieval artists, and subject matter of a noble, religious, or moralizing nature."[23] A literary branch of the movement also mixed evocation of Dante Alighieri—whose divine comedy tales from the *Inferno*, *Purgatory*, and *Paradise* were being reworked in paintings as well—with current English romantic poetry.

Remarkably, the Pre-Raphaelites (who actually had little to do with early Renaissance painters) infused England with nostalgia for the early Renaissance, all of which boded well for Piero, but in a very roundabout way. None of the Pre-Raphaelites actually paid homage to figures such as Giotto and Masaccio, and for the most part their own work was melodramatic. By contrast, a painter like Piero was not emotional at all; rather, he was Stoic and archaic in spirit. Among the PRB members, only Edward Burne-Jones copied and admired Piero, whereas one of the Rossettis described Piero as "unrefined" in the *Encyclopedia Britannica*.[24]

Nevertheless, for most of the English public, "pre-Raphaelite" meant early Italian Renaissance, as illustrated by the effusions of one British art dealer in Florence. He wrote home in 1854 that his stock included ample

supplies of "the sort of [p]re-Raphaelite paintings now so much sought after."[25] Writing from Italy the next year, Elizabeth Rigby (now Lady Eastlake) also minced no words, saying "I am fairly bitten with all the *true* pre-Raphaelites," those early Italians of "grandeur and earnestness"—and she was obviously not speaking of the "PRB" painters in London.[26]

Whoever was bearing the truest image of Italian art before Raphael, it was amid this new ferment—abetted by a thriving Grand Tour and an ebullient antiquities market in Italy—that the first paintings by Piero began to reach England. Technically, the first such panel was not entirely by Piero; it probably shows the hand of his assistant. Nevertheless, this work—done for a patron in Sansepolcro and now titled *Virgin and Child Enthroned with Four Angels*—was sold by a Florentine dealer as an authentic Piero to Lord Walter Trevelyan and his wife during their Grand Tour in 1837. In her journal, Lady Trevelyan hinted at the modicum of familiarity the English may have had with the Sansepolcro painter. Having just seen the *Baptism* in the home-town cathedral (the former abbey), she called it "very pretty" but noted that it was in worse condition than the painting bought in Florence by her husband.[27] The Trevelyan purchase was effectively hidden away in a private collection, and so it would take a subsequent purchase in Sansepolcro itself—that of the *Baptism*—to truly bring the authentic Piero to public light in England.

That avenue to the public, for all early Renaissance art, would require an intervention by the British establishment in the form of the National Gallery. Founded in 1824, its collection began with Parliament's purchase of thirty-eight paintings from John Julius Angerstein, a Russian-born merchant. After that, the national purse kept a close eye on what was bought, both in price and in type. When the gallery moved into its Trafalgar Square building in 1838, it still was a rather informal, haphazard affair. Four years later, Charles Eastlake became the supervising "keeper" of the collection, a next step in the gallery's future prominence.

Outside the collection, the private English inventory of medieval and Renaissance art had some impact on the public by way of specially arranged exhibits. They began with London's "Medieval Exhibition" in 1849 and peaked with Manchester's "Art Treasures Exhibition" in 1855. A year later, when England's largest private store of medieval and Renaissance art, the

Ralph Bernal Collection, was sold off, more artifacts went into circulation. Finally, the National Gallery had to decide its official stance on the art of Piero's period in Italy. That moment of decision, not coincidentally, came with the appointment in 1855 of Charles Eastlake as the gallery's first official director, a position that went along with reforms in the institution's management.

Before Eastlake became director, the gallery owned just four early Italian Renaissance paintings. The pertinent committee of Parliament had noted this deficit. But when it came to making choices and spending money, the National Gallery had to weather a storm of controversy. Rooted in the money question, the gallery controversy was about its role in British culture. Should the gallery *instruct* the public, or *please* the public? Instruction required less exciting works and historical breadth, whereas the masses liked to see the most famous and extravagant works (today called the "blockbuster" art exhibit). The debate came to a head in 1853 when a parliamentary committee held hearings.

Some National Gallery trustees firmly opposed buying "antiquarian and medieval pictures," and yet the committee went forward—or backward, as it were. "What Chaucer and Spenser are to Shakespeare and Milton, Giotto and Masaccio are to the great masters of the Florentine School," said a final report. It was after this that Eastlake was charged with buying "good specimens of the Italian Schools, including those of the early masters."[28] Backed with a budget, he and his wife traveled throughout Italy to carry out the mandate, which suited their own tastes splendidly. From Italy they brought back works by Botticelli, Mantegna, and Bellini—and, after that, works by the medievalist Cimabue. In a collector's coup of sorts, they obtained one panel of Uccello's famous triptych, *The Battle of San Romano*, which had adorned a Medici bedroom.

During the debates on National Gallery purchases, the Scottish collector Dennistoun was also pulled into the fray. At the 1853 hearings, he was asked to justify Protestant and liberal England spending money on old Italian works saturated in Catholic piety, questionable also for their primitive treatments and constant repetition of subject matter. Adding insult to injury, some critics noted that many of these Italian works had been done for tyrants, hardly a worthy story for a public collection. When Dennistoun

defended the universality of the pictures, a retort came from one commissioner, Lord W. Graham. "But if the public taste is not prepared for these pictures, might it not be possible that the public would call them trash?" Graham asked. Dennistoun replied: "I should hope that a very brief acquaintance with those pictures would correct the public taste."[29]

Eastlake added his own enthusiasm. "There is at present what may be called a rage for very early works of art," he told the hearing. On the Grand Tour, "there were always fine works by the early Florentines not only in galleries, but in churches and in public buildings in Italy, which were passed over" by typical Tour routes. Now, he said, the public wanted to see them in museums. "The taste is a modern one," Eastlake argued.[30]

The tastes in Italy for its works of art had always been wide, but in this era it felt the additional pride of being flocked to by European painters and travelers on the Grand Tour. Among the Italian connoisseurs, the new rage was to more accurately document the history of Renaissance art. Anyone doing this task naturally began with Vasari, and there was no more intrepid group of Vasari detectives in Italy than the Fine Arts Society (Società di Amatori delle Belle Arti). Founded in 1845 and based in Siena, it was a group project, joined by such art experts as Carlo Pini and the Dominican cleric Vincenzo Marchese. But the energy came from its two youngest members, the Milanesi brothers.

Gaetano Milanesi was the oldest (born 1813) and, along with his younger brother Carlo (born 1816), had studied law before entering the field of interpreting antique Italian language and art. Accordingly, Gaetano took a post at the Biblioteca Comunale at Siena. As it turned out, Gaetano would emerge as a founder of modern Italian art history. He began his career mastering the history of Sienese art and then writing a modern text on the subject.

The Fine Art Society had a larger mission, however: it decided to correct all the mistakes that could be found in Vasari's voluminous *Lives of the Artists.*

This included, of course, Vasari's chapter on the life of Piero. The Fine Arts Society published the first volume of its annotated version of Vasari's

Lives in 1846. The society members continued probing Vasari's accuracy by putting out journal articles with new data, and then more annotated volumes. Volume IV, published in 1848, contained the first significant additional notes to Vasari's chapter on Piero. While not directly correcting Vasari errors, and not yet knowing of Piero's presence in Florence in 1439, this first Milanesi edition updated new sources: it quoted Luca Pacioli, cited data divulged by the Franceschi Marini family (modern heirs to Piero), drew upon the writings of Lanzi, and gave a few hitherto unknown dates for Piero's works in Rimini and Urbino.[31]

Eventually, Carlo and Gaetano moved permanently to Florence, where in 1852 the Grand Duke had decreed that an official State Archives be established. Carlo was hired there first, followed by Gaetano. In the meantime, Gaetano continued to follow his leads. One of them led to the archives of the Hospital of Santa Maria Nuova in Florence. It was here that he found the 1439 account-book entry in which Domenico Veneziano was paid for doing frescos in the choir of the hospital's Sant' Egidio Church. The notation said that Piero "is with him." With all the artists on the Milanesi plate, one more fact about Piero was not grounds to rush anything into print. It reached the printed record by way of a correspondent of the Milanesi brothers, the German collector and amateur art historian Ernst Harzen.

In his work as an art sleuth, Harzen was most excited about his own discovery regarding Piero. At the Ambrosiana Library in Milan, he found a Latin copy of Piero's *On Perspective*, a copy that Piero had illustrated. Harzen's 1856 article on the discovery bore a headline suggesting that Pacioli's "supposed" plagiarism was untrue. Even more significantly, Harzen announced the 1439 date found by Milanesi (who later put the date in notes to his second edition of the *Lives*, published in nine volumes from 1878 to 1885).[32] Harzen did not make a great deal of the 1439 date. But for a small but growing band of Piero scholars, Piero's being in Florence changed their image of the painter from Sansepolcro. To be a Florentine painter was, in the eyes of the new connoisseurs, to have been shaped by its great figures, from Brunelleschi and Alberti to Masaccio, Fra Angelico, and Uccello.

The new attention being given to Piero seemed to be peaking in 1858, when a number of forces conspired in his favor. The British explorer Austen Henry Layard, the discoverer of Nineveh and aficionado of Assyrian art, was praising Piero in a major article on public art education in the *Quarterly Review* (presumably because Piero had the archaic look of the Assyrian and Egyptian past).[33] Publisher John Murray's popular *Handbook for Travelers in Central Italy* was just out in a fourth edition (since 1843), mentioning even more about Piero's works and their locations. Eastlake was again touring Italy, this time taking detailed notes on Piero and attempting (unsuccessfully) to buy the *Flagellation of Christ* in Urbino. In Arezzo, the first restoration of Piero's frescos was taking place; and with the political instability of the Grand Duchy of Tuscany and Florence, more European collectors and buyers than ever were in Florence to spirit away—at a goodly price, as this high-demand market dictated—as much early Italian (that is to say, pre-Raphaelite) art as possible. In a year, the Grand Duchy would be swept away, and Florence would become the temporary capital of the emerging Kingdom of Italy.

It was into this historical maelstrom that the English museum collector John Charles Robinson, a frequent visitor to Italy in the late 1850s to buy Italian art, returned to fulfill a kind of destiny, at least in hindsight: he was to purchase Piero's *Baptism of Christ* and bring it to England. As Eastlake had observed, some very good Renaissance paintings were often hidden away in churches (still the most common repository of historical religious art), though invisible to the Grand Tour, which tended to follow a beaten path to a few major cities in Italy and, once there, the most monumental of the palaces, cathedrals, and museums. Piero's *Baptism* was not entirely unlucky in this, as evidenced by reports about it through the 1830s. The family of Piero heirs, the Franceschi family, had boosted the painting by having its history annotated in a family reprint of Piero's chapter in Vasari's *Lives,* and the 1832 Italian guidebook for art in the Tiber Valley, *Istruzione Storica-Pittorica,* noted the *Baptism* as among Piero's "excellent" works in Sansepolcro.[34] But if the touring Lady Trevelyan called the *Baptism* "very pretty" in 1837, when Eastlake saw it in the late 1850s, situated in an eclectic altarpiece in the dimly lit cathedral, despite his growing admiration of Piero, he described the painting with an unremitting candor: it was "almost ruined by sun & damp . . . [with] almost colourless silvery flesh."[35]

Perhaps the managers of the cathedral of Sansepolcro were feeling about the same way in the 1850s. They were trying to update the Gothic church with neo-baroque styles, and the vicar general had put the *Baptism of Christ* on the art market, first trying to sell it to the Tuscan government as a cultural legacy, but then turning to the active network of art dealers, based especially in Florence, where Robinson had his best contacts. In 1858 and 1859, Robinson was visiting Florence in search of Italian sculptures for London's South Kensington Museum, where he was head of art collections.

Traveling the Tuscan valleys with a fellow art buyer, Robinson had arrived in Sansepolcro in early 1859, and, not personally being in the market for paintings, he wrote the National Gallery in London to see if they wanted to buy the *Baptism*. No reply came, so Robinson probably urged a wealthy collector friend in England, whose collection Robinson was shaping, to obtain the *Baptism*—this was the British merchant and railway director Matthew Uzielli, a member of the Burlington Fine Arts Club in London, which Robinson had helped found. Robinson successfully offered the cathedral four hundred pounds for the *Baptism*, a move that surely reflected his own interests more than those of Uzielli (who did not otherwise collect early Italian paintings).

The Robinson purchase had to go through church and government channels, since it finally needed an export permit. Along the way, the local fine-arts assessor told the cathedral it was getting a very good deal in its sale. "You should be reassured and not allow this good opportunity to slip through your hands," the assessor said.[36] The new owner, Uzielli, allowed the *Baptism* to be exhibited in the Kensington Museum for the next two years. Then, in 1861, Uzielli put his art collection on the auction block at Christie's in London.

By now, Piero was known on the Italian art collectors' circuit for his side-profile diptych of Federico and Battista Montefeltro at the Uffizi Gallery in Florence, and for madonna-and-child images in general. Therefore, early Italian works of similar composition were often attributed to Piero. Six such would-be Pieros ended up in British collections in the nineteenth century, doubtless by the machinations of unscrupulous art dealers, but surely by a good deal of confusion on the authorship of early Italian paintings as well. On the collectors' side, the motive was often simply to own an

early Italian Renaissance specimen, not necessarily a Piero. Of course when Queen Elizabeth bought a painting of Duke Montefeltro, she *did* believe it was by Piero (though it was actually by Justus of Ghent), as did the National Gallery believe (wrongly) it had real Pieros when it bought two side-profile paintings of Italian ladies. The Louvre bought two inauthentic Pieros as well.[37]

The rarity of an authentic Piero was becoming evident in the second half of the nineteenth century, and it was perhaps this realization that fixated English attention on a single work that had generated a good deal of ambivalence, namely Piero's *Adoration of the Child* (*The Nativity*). Piero's heirs had put this panel painting on the market through a Florence dealer in 1859, the year Robinson had traveled through there to purchase the *Baptism of Christ*. Before Robinson fled Italy in that hour of political overthrow, he was offered the *Nativity* for seventy pounds, but found it to be in too ruined a state. "It was, in fact, the merest wreck and shadow of a picture—a thing of the past, ruined beyond all redemption," he recalled fifteen years later, somewhat chastened for not buying it as the Italian revolution boiled over. "Nevertheless, it was a venerable relic, and it possessed in certain respects special interest and importance, and the only thing to be done with it was to leave it untouched, inasmuch as the particular interest which still attached to it would be completely destroyed by any attempt to 'restore'—in other words, to 'repaint'—the picture."[38]

For better or worse, however, that sort of repainting is exactly what would happen to the *Nativity* when the eccentric British collector Alexander Barker, the son of a wealthy bootmaker in London, obtained the work in 1861, giving it a home in a private English collection. Barker's having the panel touched up with paint was one of the great "restoration" controversies of that time. The controversy was compounded when, at the auction of the Barker collection in 1874, the National Gallery was willing to pay the extraordinary price of 2,415 pounds to obtain the work, and this at the urging of the once and future Tory prime minister, Benjamin Disraeli. (The National Gallery removed all the restoration painting, and in 1888 it put on display as authentic an original of the work as possible.)[39]

As Barker was directing his agent to purchase Piero's *Nativity* in Florence in 1861, Charles Eastlake—head of the National Gallery—was in London

turning his attention once again to Piero's *Baptism of Christ*, which was going on the auction block at Christie's to liquidate the late owner Uzielli's collection. Despite Eastlake's earlier low opinion of the *Baptism*—perhaps because he had been yearning to buy *The Flagellation of Christ* from its Urbino owners at the time—he began to see the *Baptism* differently, having gained a good deal of advance notice that it was coming up at auction. For six months he anguished over whether to buy the *Baptism*, for it was in "a very ruined state" (a choice of words that today's National Gallery experts categorize as exaggerated).[40] Eastlake further wondered whether he should buy it for his own collection, or for the National Gallery. On April 13, 1861 he bid for the painting, and took it home—to the National Gallery.

It was placed in a gold-painted Renaissance-style frame. The painting, done with tempera on a poplar panel, had suffered all the normal trials of antique art, from splitting wood to discoloration, fading, and spots of erosion or flaking. Opinions of its quality varied, from those who said it was hard to enjoy due to its wear and tear, to others who delighted in its combined antiquity and luminosity. Nevertheless, as the years passed, it grew in familiarity and popularity with the English public who saw it at the National Gallery. It has been said that up to the twenty-first century, Piero's *Baptism* has been a visiting public's favorite at the gallery. As Eastlake had hoped, "The taste [became] a modern one."

The broader nineteenth-century philosophical debate over tastes in art and what constituted beauty was a different matter entirely. If a British parliamentarian could worry publicly that early Italian works of art might look like "trash" to the public, how was a modern culture to evaluate the nature of beauty? Which kinds of art achieved that goal? Do Piero's paintings possess a quality known as beauty, even an ideal Beauty, and why or why not?

Thanks to the British, this topic for works of art in general had been in turmoil for some time. During the Enlightenment, the likes of Shaftesbury, Locke, and Hume had laid out the two opposite possibilities: either essential beauty had a Platonic origin and was captured by an innate quality in the mind (Shaftesbury); or, alternatively, beauty was a matter of learned

opinion (Locke), although some people can be public judges of true beauty based on a superior sensibility and training (Hume).

When such a knotty English debate reached the Prussian philosophers, steeped as they were in the Platonism, idealism, and rationalism of the early Enlightenment, it was bound to produce a reaction of some consequence. This came in the work of the German philosopher Immanuel Kant (1724–1804). From his outpost at Königsberg University, hard by the Baltic Sea (Prussia's old capital, and now part of Russia), Kant wrote a benchmark work for modern debates on the judgment of beauty, which he, too, called the judgment of taste.

Once a follower of pure rationalism—the belief that things can ultimately be proved with reason—Kant was awakened from those "dogmatic slumbers" by the radical skepticism of Hume, who said ultimate causes of things could not be proven by reason, or even known, and that humans operate primarily on passions and appetites, not logic. Although Kant jettisoned his earlier faith in pure reason in the face of Hume's challenge, pure skepticism would be going too far for this truth-seeking German thinker.[41] He wanted to find a middle way, recognizing the limits of knowledge yet giving the mind the power to know what is real. Judgments of beauty face the same dilemma, Kant said, so he wrote his *Critique of Judgment* (1790) to suggest how beauty could nevertheless be known. First of all, Kant defines the beautiful as an "object of an entirely disinterested satisfaction" (not too different from Shaftesbury).[42] After that, Kant applies his theory about the categories of the human mind to explain how beauty is judged.

In his wider philosophy, Kant said that the mind has a somewhat mysterious power to put sensory data into categories. His prime example is the mind's ability to organize time and space, and he goes further to explain that the mind also has the ability to make scientific, moral, and utilitarian judgments (these are all things that don't come from the senses, so must originate in a quality of the mind). In this, Kant is not too different from the way Nicholas of Cusa said the mind creates "conjectures" to organize the data of the world, since, as Kant acknowledges, ultimate reality (the "thing in itself") eludes the power of reason. Kant famously applied this to traditional theological questions, arriving at the conclusion that religion was a matter of "practical" reason—it was morally helpful and useful—but in all

ultimate questions about God, immortality, and the cause of the world, logic fell into contradictions. In the end, Kant said, he had to "deny knowledge in order to leave room for faith."[43]

Now, at the end of his career, Kant offered an explanation of how the mental category of beauty, or aesthetic judgment, seems to work in human beings. Parallel to his argument that a beautiful thing provides "disinterested satisfaction," he added that such things in themselves possess the strange quality of "purposiveness without purpose." This idea is essentially captured in the latter-day slogan "Art for art's sake." From this point, however, Kant seems to say that ultimately, beauty must be a matter of individual judgment, since nobody can rationally list its qualities. In common parlance, this is "Beauty is in the eye of the beholder." Every mind is free to arrive at its own opinion on beauty, Kant asserted. This is contrary, of course, to all the classical definitions of beauty, which have said it is characterized by flawlessness, proportion, brilliance, a unity of parts, and other such criteria.[44]

At this point, however, Kant proposed a seeming contradiction: despite the ability of individuals to hold diverse judgments on beauty, he said, people will finally agree on what is truly beautiful. That is because the mental category for judging beauty, shared by all human minds, will tap into a kind of universal standard of what is beautiful. Reflecting this merging of personal opinion and universal agreement, Kant's famously difficult philosophizing spoke of the "subjective universal."[45] When it comes to public sentiments about beauty, in other words, people make judgments that are both personal and transcendent. They agree on beauty in the end, even if rational definitions fail.

What Kant has revived in his theory of judgment is the medieval idea of imagination and intuition, which in turn had been derived from the notion of Platonist Ideas. Medieval thinkers acknowledged that the mind creates its own "exemplary ideas" that have the potential to reflect transcendent Ideas, as either Plato or Christian theology would state the case. Because imagination creates art, then works of art can be seen as having both human and transcendent qualities, and it is the transcendental part that presumably sparks a common sense of beauty in the beholders of art. "Art involved an idea or image of beauty not found in nature," the historian Umberto

Eco explains. That medieval notion "was the beginning of a concept of the imagination which was in turn the basis for an aesthetics of intuition."[46] Kant has been the modern prophet of that intuition.

Kant had called his era the "Age of Enlightenment," and indeed deemed his own philosophical work—which focused on the intuitive categories and powers of the mind to know—a kind of second Copernican revolution. Even if that is true, Kant was working in the long Platonist tradition (called idealism in modern times), which had moved from a purely theological approach to one that now would become psychological.[47] Even though Kant was mostly a lecturer in the natural sciences at Königsberg University, he never said where, physically, this intuitive and universal ability of the mind comes from; he simply proposed a logical bridge between the particular and the universal. He also furthered the secularization of the Platonist Idea, which has continued down to the present: intuition is the new natural mystery for the sciences.

Although Kant actually said almost nothing about particular works of art, he did hand down two salient principles that would shape art theory thereafter. The first was his extensive discussion of "genius," again a medieval idea (which once merely meant a "maker").[48] The second was Kant's corollary assertion that artists of genius produce true art when it is something beyond nature; it obtains something superior by way of the artist's idea, and free play of imagination, and mastery of a medium, coming together to produce an object of purposeless purpose and disinterested satisfaction. It is only at this level, Kant suggests, that we find true art and beauty. All the rest is merely pleasant. Over time, art historians would grapple with what to call the existence of a human "idea" in a work of art. It would be called "significant form" in the era of modern art, and another description was "symbolic form," both drawing upon Platonist and Kantian traditions of mental forms. In art, this form was a kind of ill-defined, yet palpable, visual effect that worked powerfully on human intuition.[49] Having gone beyond nature, this form in art can aspire to authentic beauty.[50] As the British connoisseur Clive Bell one day would assert, what ranks Piero alongside other superior artists in history are not his religious topics, physical materials, or painterly style: it is his achievement of significant form.[51]

Kantian-style thinking would eventually have its day in the sun in the Anglo-American world. For the time being, in the nineteenth century, this kind of Germanic speculation was not exactly suited to the dry empiricism of the British soul. And yet as illustrated in Charles Eastlake, German writings on art and art history were not ignored. The question of beauty and aesthetic judgment was on the front burner, as indicated by Eastlake's commentary on Goethe's *Theory of Color* and his own aesthetic theory, which he called "specific style" or "distinct representation," by which he meant that significant beauty, and superior artists, were known by a strongly identifiable trait (indeed, a trait he found in Piero by way of his color and volumetrics, not necessarily his perspective).[52]

From Kant to Eastlake, everyone was in pursuit of the best definition of beauty, especially as a suitable standard for art appreciation in society. What seemed to work for everyone was a combination of Hume and Kant, both of whom gave compelling reasons for society to have capable people who could be judges of genius in the arts. This judge was the connoisseur. By cultivation or native talent, the connoisseur, who in practice was typically a collector or art historian, was increasingly upheld as making better judgments on art than ordinary people. Connoisseurship became a calling, and the connoisseur a profession. Knowledge of art history was essential to connoisseurship, as Lanzi had noted in 1795, and it was this kind of gnosis that would dramatically set figures such as Winckelmann, Lanzi, Eastlake, and Dennistoun apart from ordinary museumgoers. This line of experts began to know hundreds, if not thousands, of paintings close up and in exquisite detail. This often required journeys to see artworks *in situ*, that is, still in their original settings and context. In an age before photography, it also meant doing actual sketches of paintings, often crowded around with detailed notes on what the connoisseur was looking at.

At the end of the Italian Renaissance, Vasari had begun to exemplify the role of an expert judge of the fine arts. Clearly, Vasari was a gatekeeper through which artists won recognition. This was supremely evident when the Venetians attacked him for his pro-Florentine choices. In his second edition of *Lives*, Vasari added many more names, especially from Venice. In that time, Vasari played the role of connoisseur, a position of superior judgment of beauty. In the modern age, Kant further justified connoisseurship.

The connoisseur would even begin to claim a special intuitive power of interpretation. When it came to the products of past artisans, the connoisseurs of the world created not only the idea of "fine art"; they also firmly established the field of art history.

It was through both these gates that an artist such as Piero had to pass to gain stature in the future.

In his notes on the *Baptism* purchase, Eastlake had said that the work was "characteristic" of Piero and his age.[53] That age was being called either "primitive," or the age that came before Raphael. Surprisingly, though, as late as the 1850s, nobody was talking about it as "the Renaissance" with the implication that it was a distinct period or turning point in history.

For centuries already, there had been some claims about the achievements of the era. This began with the way Petrarch contrasted his time—Italy in the fourteenth century—with the "barbarian" past. Vasari's *Lives* would block off 250 years of Italian art for special treatment. Much later, the French Enlightenment figure Voltaire would speak of Vasari's sixteenth century as a time when human reason began to awaken. The French term *renaissance*, which means "rebirth," received its first formal use in 1855. In writing his multi-volume *History of France*, the romantic historian Jules Michelet titled volume seven *Renaissance*, which he defined as a rather dramatic break from medieval religion and "the discovery of the world and of man."[54] This was an apt definition of Renaissance humanism; but by now, European intellectuals were departing from the original Christian humanism represented by Petrarch early in the Renaissance, and later by Cusanus, Ficino, and Giovanni Pico della Mirandola, the Renaissance Platonist who famously declared "the dignity of man" in 1486, a year before Piero wrote his last will and testament.[55]

Chopping history into periods, turning points, and great epochs has been a human inclination for as long as the written record has been available. Following the Enlightenment, this approach had become more documentary, and thus presumably more "scientific." Such a periodization of history would never escape controversy (especially after the twentieth

century). But it remained the most viable way to tell a story. From Winckelmann through Lanzi and Kugler, the story of art history was told by various periods. And now, in the shoes of the German school, one cultural historian would assert that, when it came to the greatest periods of all, the Italian Renaissance was a very large notch above the rest.

This was the claim of the Swiss art historian Jacob Burckhardt. In Berlin, he had become the prize student of Kugler and was co-author with him of some of the volumes in Kugler's art-history *Handbook*. A native of Basel, Burckhardt was the son of a Protestant minister. In his first phase of university studies, he was persuaded that medieval history was the most significant crucible for the story of Italian art. During a stay in Rome, he further conceived of writing several short books on great periods in human culture, each one worthy of note for the ability to achieve a renaissance.

Burckhardt gradually focused all his thoughts on Italy, producing a major work on the art of the peninsula. This was a summary of his travels presented as *The Cicerone: A Guide to the Enjoyment of the Artworks of Italy* (1855). Under Burckhardt's pen, Piero would attain a rather minor status; Burckhardt continued the German tradition of believing that Piero had learned his craft in the northern Italian city of Padua, since his realistic style and use of perspective matched later developments there in the famous painting school of Francesco Squarcione (c. 1397–1468). Although this made Piero sound derivative, Burckhardt, the Swiss historian, at least christened him an "interesting master." He noted the good preservation of some of Piero's paintings and then, giving mixed reviews, described his works as both "naïve" and, when pointing travelers to Sansepolcro, "very remarkable" as well.[56] Burckhardt finally was persuaded that the Italian Quattrocento was a crucial bridge in history, no longer medieval and yet not quite modern: it was a unique Italian event that planted the seeds of a wider Renaissance period across Europe. He was further persuaded of the Quattrocento's genius by reading a biographical collection of Renaissance figures, written by the Florentine bookseller Vespasiano da Bisticci.[57] Burckhardt had found his turning point in the modern world, and he made that case in his most significant work, *The Civilization of the Renaissance in Italy* (1860).

By now, Burckhardt was a professor of history in Basel and Zürich. After *Civilization* was published, the idea of a special period, the Italian

Renaissance, began to take off in the Western imagination (reaching a much more elevated idea, for example, than the earlier British enthusiasm merely for things Italian). Burckhardt's chief argument was that the age of political constraint and dictatorship in Italy had given rise, in reaction, to an ebullient individualism. This individualism produced new horizons of creativity in literature, art, manners, and political attitudes. He was aware of Michelet's thesis, for Burckhardt titled one chapter in *Civilization* "The Discovery of the World and of Man," but he pressed the point more thoroughly in the context of Italy.

For a historian to make such sweeping claims was always to put his reputation at risk, and this may be why Burckhardt called his book-length *Civilization* a mere "essay." In his day, there were still great limits on gathering documentation on the past, as continues to be the case for even our digital age. Future scholars would gleefully expose his errors, pick at his sweeping conclusions, and challenge the very idea that any one period could mark the dawn of the modern world. Perhaps anticipating this, Burckhardt presented his book as his own speculation, "a different picture" from what others might see. His picture was that "the Italian Renaissance must be called the leader of modern ages," and whatever his critics might say, that idea would become a pillar of Western thought.[58]

A political liberal of his age, Burckhardt could travel, teach, and write in relative tranquility, supporting in principle the revolutions in Italy after the 1850s, but always from a safe distance. This luxury was not the case for one of Italy's leading art writers, Giovanni Battista Cavalcaselle. During his colorful life, Cavalcaselle had participated in the Europe-wide street Revolutions of 1848. When they failed in Italy, just as they did elsewhere, he fled for his life. Like many Italian expatriates, he landed in England. It was there that his fortunes improved when he crossed paths with an old acquaintance, the English writer and diplomat Joseph A. Crowe. The two had met in Munich in 1847 when Crowe, a sketcher and former war correspondent, had diplomatic duty in Prussia. In England, their first project together was a successful book on Flemish art, an expertise of Cavalcaselle. It was of special British interest since the art of the Netherlands, arriving well before Michelangelo and Raphael, had shaped the English landscape and portraiture traditions.

As the Flemish book appeared, the ever-active Charles Eastlake was casting about for someone qualified to produce an English-language correction of Vasari's *Lives of the Artists*. Before long, Cavalcaselle came into view, and so the Italian writer began to work on Eastlake's vision of an annotated Vasari. This, of course, was a project already under way in Italy in the Milanesi circle. In any case, working from London, the Cavalcaselle project proved futile. A more plausible plan was to return to Italy, where a successful revolution had quelled the former dangers, and to work with Crowe on something more original than a newly footnoted Vasari. Thus was born their authoritative three-volume *History of Painting in Italy*, published first in English from 1864 to 1866.

This talented duo gave remarkable coverage to Piero, even if they could not break from convention. They inevitably portrayed him as a Florentine, something that Vasari did not say but which now seemed proved by the 1439 date of Piero's presence there. Residing in London, the two authors studied two of Piero's imported works, the *Baptism* and the *Nativity*, the former in the National Gallery and the latter in the private collection of the eccentric bootmaker scion Alexander Barker.

Drawing on new material plus their travels in Italy, Crowe and Cavalcaselle situated Piero more clearly in the world of Quattrocento painting, improving on Lanzi and Kugler. In Italy, a few more Quattrocento painting contracts with Piero had been found. Moreover, a relative of Piero in the Franceschi Marini family—who married an Englishman— had also compiled information from family records. In this period, the bitterness against monarchy that drove the revolutions of Europe remained with the two authors, especially Cavalcaselle, and it led them to comment on the evils of tyranny, in this case Renaissance tyranny; they noted how it was "truculent soldiers, known as faithless leaders of armies, or guilty perpetrators of dreadful crimes" who nevertheless patronized the best architects and artists, "spending the fruit of their depredations" on beautifying churches and courts.[59]

By comparison, Piero came away completely untarnished, "a man of a rare type, endowed with great penetration and powers of reflection, able to fathom the problems of abstruse science, and capable of searching and coordinating the secrets of nature." His masterpieces were enough to prove this,

the authors said. "He was, in a word, an artist enjoying a happy conjunction of the talents which adorned the van Eycks and Leonardo da Vinci."[60]

To support such praise, Crowe and Cavalcaselle made several connoisseurial claims about Piero's concrete accomplishments. Echoing Lanzi, Piero had influenced central Italian painting, quite apart from Florence. His impact appeared in the future styles of the Ferrara painters. Comparing him favorably to Michelangelo and Raphael, the two authors credited Piero with painting the first classical nude in the Renaissance and with marking the transition from tempera to oil in Italy. Against the backdrop of what painters had accomplished in Florence, Piero added "something like perfection to the system" of naturalism and perspective. He treated the human figure like the ancient Greeks, often "as a mere geometrical unit."[61] Just as Rembrandt and the Flemish painters had their distinct look—chiaroscuro and bright color contrasts, respectively—Piero had his own singular effect: a clarity of parts and their unity with the whole.

For all the accolades that Crowe and Cavalcaselle showered on Piero, however, they did not say he was modern. That suggestion would require the dawn of the twentieth century.

CHAPTER 9

Piero and Modernity

Once Piero had been entombed on the abbey grounds in Sansepolcro, a mere two years would pass before his first chronicler would call him "modern." This came from the mathematician Luca Pacioli in 1494, though Giorgio Vasari would downgrade that superlative a bit later. Vasari positioned Piero instead as having "enabled the moderns," those of the High Renaissance who perfected naturalistic painting.[1]

On his way to true modernity, however, there was nothing yet for Piero like the suggestion made by the English art critic Roger Fry at the turn of the twentieth century. He looked at Piero's paintings and declared: "What strikes me so much here is the modernness of Piero's attitude."[2] Perhaps like no other painter in memory, Piero was about to become a patron saint of modern art. It would be one of the more beguiling aspects of his legacy in the twentieth century. Modern connoisseurs had already linked Piero to the archaic sensibility of the Greek past, but now he was to be associated with a new futurism, this being due to the silent and spare look of his paintings, and also to a growing awareness that he had, indeed, been a Platonist mathematician in addition to being a master of color, geometry, and form.

The modernizing of Piero began in late nineteenth-century France, a national cauldron for the next revolution in art, which pitted the modern

spirit against the classical past. France had laid claim to classicism in the form of academic neoclassicism. But when a new generation of modern French painters began to visit Italy, something equally new began to happen. This was manifest in the life and influence of Puvis de Chavannes, whose two journeys to Italy put him under the spell of Piero's frescos at Arezzo. He became so familiar with Piero, it has been said, that when the Louvre bought and displayed a portrait claiming to be by the same, Puvis protested that it could not be by the hand of the Quattrocento master (and he was proved correct). His opinions mattered because, in time, Puvis became one of France's most famous national painters. He retained a classical and fresco-like look to his paintings—much in the spirit of Piero—and yet was a predecessor to the revolution toward Impressionism and later Cubism, all of which took hold in the late 1800s.[3]

If some of the Pieroesque spirit was carried from Italy back to France by Puvis, outsized samples of Piero's actual works would also begin to show up in Paris. At this time, the new style of Impressionism was openly challenging France's neoclassicism (and thus France's link to the Renaissance), so one defender of tradition decided to take counter-measures. He was the prominent French art historian and administrator Charles Blanc. Blanc's plan was to open a Museum of Copies at the École des Beaux Arts, presenting Renaissance examples of what he believed to be the legacy of France's own "National Art."[4] Once the museum initiative was under way, teams of French artists put their shoulders to the task. They replicated Raphael's work in the Vatican, the prophets and sibyls of Michelangelo, the swan of Leonardo, and frescos by Masaccio, Ghirlandaio, Mantegna, and Andréa del Sarto.

Blanc also commissioned copies of two of the major panels in the Arezzo frescos by Piero. The copies were painted by Charles Loyeux, a skilled copyist. A copy of the *Battle of Heraclius and Chosroes* was begun in early 1872 and shipped to Paris in October. The *Discovery and Proving of the True Cross* was commissioned in February 1873 and arrived at the museum in August of that year. Both of the painted facsimiles were done at their original large size from the Arezzo church wall, about 11 feet by 24 feet each.[5]

At some point, Blanc himself traveled to Italy in preparation for a book he was writing on *The History of Italian Renaissance Art* (1889). In this, too,

he emphasized the primitives and praised Piero. The primitives were important, the preface said, because although everyone knew Michelangelo, his predecessors were being lost. Blanc's *History* described Piero as a "singular genius who strangely combined the qualities of an artist with the geometrical exactitude of a scientist." Well acquainted with the Arezzo church's bad repair, Blanc openly worried about the frescos' rapid deterioration. At least, he said with wise diplomacy, "they have escaped complete loss thanks to the beautiful copies that have been made by the French government." Loyeux's excellent work, in fact, made him a hero in Arezzo, now a relative backwater in Italy that appreciated any commercial attention it could get, especially from tourists on the Grand Tour.[6]

Blanc's effort to revive early Renaissance art as an example for France's national culture did not succeed. The Museum of Copies was dismantled just before the copies of Piero's Arezzo frescos could be installed. The Impressionists rose and rose. Nevertheless, Piero did survive: since the entire enterprise had been so expensive, the copies of the Arezzo frescos and others in the project were instead placed high on a wall in the chapel of the École des Beaux Arts, still visible enough to make an impression on visitors, it seems (and still there today, according to an account from the 1990s). It was on that chapel wall that another young painter, Georges Seurat, open to all the influences of his era, saw Piero's monumental style.

An art student since he was fifteen, in 1878 Seurat qualified to enter the École at age eighteen. He embraced the school's classical training and became an admirer of Puvis's mural style. Although Seurat would become famous for his experiments with color, the framework on which he proceeded was the kind of monumental classicism typified by Puvis and Piero. In the latter case, he must have surely viewed, and contemplated, the copies of the Arezzo frescos at the École.

Seurat made his debut as a young painter with two now-famous paintings that reflect this Pieroesque aura. The first was *Bathers at Asnières*, completed in 1883. At a time when the Impressionists did not use rigorous composition, Seurat employed a highly classical, even rigid, scheme. The *Bathers* was too innovative to be accepted by the official government salon exhibition of 1884. Even so, it was a success at the rival Salon des

Indépendants later that year, both for its use of color and the monumental treatment that Seurat gave his figures and landscape. In Seurat's next large canvas, *La Grande Jatte*, worked on from 1884 to 1885, he created an even more geometrical world of human figures in a park by a river, all of them well defined by light and shadow. It was an idealized world. Whatever Seurat's sources might have been, *Bathers at Asnières* and *La Grande Jatte* presented the distinct impression of the light-filled, geometric, and tranquil atmosphere of a work by Piero.

Obviously, Seurat had tried to use color in a totally different way from his predecessor colorist. Whereas Piero applied evenly spread fields of color and was inclined toward cool tones and pastel hues, Seurat used the primaries in little dots to model forms, believing that the tiny applications of pure color would keep their richness, even in the shadow areas of a painting. Regardless, both Piero and Seurat produced a similar effect of classical solidity in their figures and a luminescence of color in their atmospheres, making them kindred spirits. The two painters were similar in other ways.[7] They both were interested in the mathematics and science of their day. They were meticulous in applying math, and, as a result, their works have been subjected to searches, by art historians, for underlying mathematical formulas. For subject matter, they both liked large scenes of spectacle with groups of people and individuals in sumptuous and interesting clothing and costumes. They showed their figures clearly: side, front, or back. Their works exuded a sense of stillness, light, and space. Clearly, they both liked classical monumentality.

The other young painter who would have walked past the copies of Piero's Arezzo frescos at the École was Paul Cézanne. While not a formal student like Seurat, Cézanne visited the art academy and other art haunts in Paris. The evidence of the Piero effect on Cézanne is circumstantial and stylistic, based primarily on a painting that he would do around 1886, just as Seurat was moving beyond his experiments with the successful *La Grande Jatte*.[8] This was Cézanne's painting *View of Gardanne*, a hillside scene filled with geometrical buildings. In treatment and color, it looks very much like Piero's rendering of buildings on a hillside in the Arezzo fresco *Discovery and Proving of the True Cross*, which at the time covered nearly 260 square feet in the École chapel.

The son of a banker, Cézanne began studying law, but gave up its logic-chopping world for art. Nevertheless, Cézanne's eye still was geared to quantification. It was this kind of geometric solidity that he doubtless saw in Piero. Cézanne also felt that he was coming out of the classical tradition. Before his death in 1906, he wrote that his goal had been to repaint the French neoclassical history painter Nicolas Poussin (1594–1665) according to nature. By wanting to repaint Poussin, Cézanne aimed to take classicism back to the rudiments of nature, which he defined as being made up of the "cylinder, sphere, and cone."[9] Piero could not have agreed more.

Chavannes, Seurat, and Cézanne—all three conspired with their painterly skill to create compelling effects on the visual senses. They all found roots for this in an early Renaissance tradition and, similarly, evoked what is luminescent, geometrical, still, and monumental in the tradition of Piero. There is no direct connection to be proved, of course, but the strong association of influence has always been a fascination among art historians. Just for example, if Cézanne had used Piero directly for his *View of Gardanne* landscape, then it may also have been *View of Gardanne* that Cubist founders Pablo Picasso and Georges Braque had in mind—perhaps after seeing it at the first Cézanne retrospective in Paris in 1907—when they produced their first simplified, geometrical landscapes in 1908.[10] This sort of speculation begins the tangible link between Piero and modern art.

Among European connoisseurs, it was the British painter, art historian, and critic Roger Fry who first built the case for a more than casual connection between Piero, Puvis, Seurat, and Cézanne.[11] An expert in Renaissance art, he began visiting Italy in 1891, eventually writing a major work on Giovanni Bellini of Venice. He was familiar with Piero's panel paintings in the National Gallery but, on his first visit to Arezzo in 1897, he was bowled over by the frescos, writing home that he admired Piero "almost more than any other early Italian painter," noting further that "he certainly comes nearer to the Greeks than any other Italian."[12]

Fry had first studied natural science at Cambridge, giving him a flair for categorizing species and classes of things, which surely groomed a talent for doing likewise with the disparate world of antique paintings. On his first foray to New York City, his impressive mastery of such topics earned him the job of curator of painting at the Metropolitan Museum of Art.

He was prone to making visual statements about historical connections. When he organized the Met's exhibit of early Italian art, he purchased a large Puvis canvas, *The Shepherd's Song*, to serve as a kind of modern link and centerpiece.

Earlier still, however, Fry had begun to sort out his feelings, and his taxonomy, for Italian painters. He performed this sorting through a series of public lectures he began giving at the Cambridge University extension program. His best known series was about the painters of Florence, and his lecture on Giotto in 1900, when published as a small book, did much to acquaint the British public with that thirteenth-century pioneer of Renaissance realism. The next year, Fry decided to make Piero an honorary Florentine by presenting two lectures on him and his Renaissance style. If Fry had published these two as a small book, Piero's fortunes in the English-speaking world would have certainly risen more rapidly than they actually did.

Fry's lectures, in which he cites the "modernness of Piero's attitude," were an early sign of his growing preference toward a method of art analysis called "formalism," which essentially placed all emphasis on the painted forms, shapes, colors, and proportions in a work. Formalism valued paintings that eliminated all nonessentials. Fry had been reared a Quaker and thus may have been inclined toward liking unadorned clarity. But in the parlance of the day, he referred to such clarity as the "plastic" dynamic— that is, the power of visual shapes—in any work of art. "Piero's imagination was for the most part purely plastic: he conceives his subjects in terms of plastic forms," Fry told his audience.[13] At this time in Fry's assessment of Piero, he was connecting him to the modern world not through the so-called Pre-Raphaelite Brotherhood avant-garde, but through Puvis, an accomplished painter who had truly come under the spell of early Italian frescos. "Artists in England were too pre-Raphaelite to look much at Raphael's precursors and had not begun to realize the importance of Piero's work," Fry said, displaying his dry wit. "It is, perhaps, partly through Puvis de Chavannes that we have come to see the extraordinary qualities of Piero's art."[14]

Fry spoke of Piero as a "scientific realist" in his painting; yet it was not really perspective or geometry that excited him. Fry was instead enamored

of Piero's unparalleled color combinations, having achieved a "supreme power as a colourist."[15] At the time of his Piero lectures, Fry was not yet the "apostle of formalism" that he would later become, and, as part of that transition, he would move beyond associating Piero with Puvis. When the time became right, he linked Piero to Seurat and Cézanne, two figures who had ridden the cresting wave of what Fry would call Post-Impressionism.

All of this transpired after Fry's famous falling-out with the trustees of the Metropolitan Museum of Art, at which time he returned to London to organize the first major exhibits of painters in Cézanne's generation. To pull this off, he coined the term Post-Impressionism, mounting exhibitions in 1910 and 1911 (with an old-masters exhibit in between). In his writings and lectures around the Post-Impressionist Exhibitions, Fry presented Piero as a kind of proto-modernist. Being the first English-speaking advocate of Cézanne—"he is incomparably greater than I had supposed"—Fry naturally began to link Piero accordingly, and not without good stylistic reasons (being that Piero, Seurat, and Cézanne had a common affinity for solid, geometric shapes).[16] The evidence was that the "mood" of Seurat's paintings echoed Piero's "monumental and motionless groups," and that Cézanne's "great monumental quality" had similar roots.[17]

A small band of mid–nineteenth-century connoisseurs, those around Charles Eastlake, for example, had already decided that there was something perennial about Piero. Now Fry shepherded the Piero revival into modern art criticism, and indeed into such storied circles as the Bloomsbury group of literary bohemians, of which he and his wife were a part. During his early lectures on Piero, Fry seemed to balk at the impersonality of his style. All resistance to Piero's eerie stillness was gone by 1913, when Fry wrote from Italy: "I've no doubt that Piero della Francesca is the greatest artist of Italy after Giotto, incomparably beyond the men of the High Renaissance."[18] Now that this cultural gate was open, it was easier for everyone writing about new trends in modern art to point to the geometrical and abstract similarities of the gang of four: Piero, Chavannes, Seurat, and Cézanne.

Although the new and rising modernist approach to painting would defy such Renaissance features as looking through a window, linear perspective, or the single viewpoint of a spectator, Piero seemed to obtain a foothold in modernity by his color, form, and geometry. Modernist art had

also taken cues from the historical use of the term "primitive" as it was now being liberally applied to interpretations in art history. During Piero's revival in the mid-nineteenth century, "primitive" meant early Renaissance painting. At the turn of the twentieth century, under the formalist doctrines of "plasticity," it came to mean having the appearance of simple archaic art, such as that from ancient Egypt and Assyria, or contemporary Africa and Oceania. With the writings of Roger Fry and other modernists, Piero was able to play both sides. He could win praise for being primitive under two different definitions, one as pre-Raphaelite and the other as archaic.

As the modern connoisseurs and critics were finding both modern and enduring elements in the early Renaissance paintings of Piero, more about his actual life and his treatises was also being uncovered.

A fairly solid list of Piero's surviving works had been formed—and it was not large, just about sixteen works or sets of works—yet there was plenty of room for enhancing his biographical chronology. There was discovered, for instance, a ledger entry showing that Piero had been partly paid for his Misericordia Altarpiece in 1462, giving it some firm dates for the first time. It also pointed to Piero's habit of long procrastinating projects. Then, a disputed 1451 date on Piero's Rimini fresco—*Sigismondo Malatesta before Saint Sigismondo*—was confirmed as valid by a second documentary source. The discoveries continued. In 1909, a document surfaced on Piero's stay in Rimini in April 1482, his retirement years. Down in Rome, construction workers stumbled upon the covered-up remnants of Piero's frescos in Santa Maria Maggiore; that ceiling had become a storage room in the much-rebuilt basilica. Presently, Piero's last will and testament, written in 1487 in his own vernacular hand, was found. This proved that he had not gone prematurely blind, as Vasari had claimed. Similarly, a notation about Piero having a power of attorney in Sansepolcro in 1473 gave historians one more data point on his whereabouts.[19]

Most stupendously of all, perhaps, an account book of Pope Pius II was found. It stated that on April 12, 1459, Piero was paid 150 florins for "certain paintings he is making in the room of His Holiness Our Lord Pope."[20]

This established, beyond Vasari's general hearsay, the time of Piero's trip to Rome, a turning point in his life. The Rome trip would thereafter be a fulcrum in any Piero biography, a place to try to balance out all the conflicting claims on the dates and stylistic formats of his paintings.

Next to the Roman question, the history and authenticity of Piero's treatises, now being identified with some rigor, loomed large once again. This search for authenticity had begun in the previous century, and one of its central figures had been Girolamo Mancini. As a young man in the 1860s, Mancini had fought in Italy's wars of liberation. Then, as a scholar and parliamentarian, he wrote on the humanists of the Renaissance—Alberti and Lorenzo Valla, but also the painter Luca Signorelli—and ended up being a groundbreaking researcher on Piero as well.

Mancini is credited with several important discoveries about Piero, including the finding of a sheet of paper on which Piero, in his vernacular handwriting, had instructed a notary on the exact wording for his last will and testament.[21] This sample of Piero's handwriting would become crucial in trying to determine which surviving copies of Piero's treatises were "autographs," that is, written down or annotated with notes by Piero himself. Mancini found a kind of code-breaker: the peculiar way that Piero wrote his "e," which looked like a "z." Mancini identified other patterns in Piero's handwriting, and Piero's concise diagrams also provided clues that linked him from one manuscript to another.

With these tools of the manuscript detective, Mancini authenticated for the first time—this was around 1917—an autograph copy of Piero's *Abacus Treatise*, before then never identifiable in the miasma of countless anonymous abacus works from the Renaissance centuries, layered and combined chaotically in modern-day collections of antique texts.[22]

Piero's unusual "e" was just the beginning of the detective work. The quirks of his handwriting and finesse of his diagrams one day would lead to a stunning new hypothesis: that Piero himself had copied, from Latin to Latin, a full manuscript by the Greek mathematician Archimedes. This manuscript was held out as evidence that, by the end of his life, Piero had mastered reading and writing Latin well enough to thoughtfully copy it, though he probably could not write original works in that classical humanist language.[23]

Whenever Piero's treatises became a topic, meanwhile, there was no escaping Vasari's ancient claim that Luca Pacioli had plagiarized him and stolen his glory. Over the centuries, Vasari's claim was increasingly viewed as baseless. Pacioli had allies. He had been defended by his fellow Franciscans. Having founded modern-day accounting, Pacioli also had become a mainstay figure in books on the history of mathematics. Naturally, the prestigious 1911 *Encyclopedia Britannica* was inclined to summarily dismiss Vasari's plagiarism charges. Whenever the mathematical profession even recognized Piero della Francesca, it was as an artist who had merely dabbled in math and who had codified an arcane book on perspective.

Piero's true mathematical prowess was hard to interpret because his original manuscripts, so few in number, were difficult to find, and authenticity was always a difficult question; then, when actually located, they were laborious to read. Not that they weren't found on occasion, and then compared to Pacioli's books. On his cursory reading of Piero's *Five Regular Solids* in Urbino in the mid-nineteenth century, the Scottish collector James Dennistoun felt that Pacioli had been honorable since, after all, he had praised Piero. Around the same time in Germany, the collector Ernst Harzen entered the debate. In 1856, he reported finding a Latin copy of Piero's *On Perspective* in Milan's Ambrosiana Library, where it was listed incorrectly under "Pietro Pittore di Bruges." Comparing it to Pacioli, and considering the dates of the two men, Harzen suggested that not only was Pacioli innocent, but Piero actually might have borrowed from *him*. Then, in 1880, the German scholar Max Jordan's sleuthing in the Vatican Library turned up the Urbino copy of *Five Regular Solids* (the one seen by Dennistoun). Jordan compared its mathematics to Pacioli's *De divina proportione*. The verdict: Pacioli had indeed tacked on Piero's Latin work (now poorly translated into Italian) as the third book of Pacioli's treatise.[24]

The full rehabilitation of Piero as a significant and original mathematician, however, did not begin until the early twentieth century. The plagiarism debate was reopened at a more sophisticated level by Giulio Pittarelli, professor of descriptive geometry at the University of Rome, who made Piero and Pacioli his topic at the 1908 International Mathematical Congress meeting in that city. Pittarelli, too, had compared the Vatican's original *Five Regular Solids* to Pacioli and announced that Pacioli, famous now in

the history of mathematics, had undoubtedly attached Piero's work to his own. Being conciliatory, though, Pittarelli argued that in the Renaissance, such borrowing without attribution was common enough at the time (and not condemned as plagiarism in the modern sense).[25]

As the surviving Piero manuscripts were gradually located and their antique verbiage penetrated, Piero could no longer be ignored. Modern book versions appeared of his *On Perspective* in 1899, *Five Regular Solids* in 1916 (by Mancini), and, last but not least, the *Abacus Treatise* as late as 1970.[26] From the grave, Piero was forcing mathematicians to think about Renaissance painting and goading art historians to think about mathematics. After 1920, histories of mathematics began to mention Piero as an important mathematician, innovative beyond Euclid, as even Piero himself had said: filled with Quattrocento self-confidence, Piero had written that he had re-done Euclid "newly expressed in arithmetical terms," which meant the novel application of algebra to problems in geometry.[27]

One European scholar, Leonardo S. Olschki, would go even further in linking Piero to scientific achievements and developments. Of Prussian extraction, Olschki set up a publishing firm in Italy and specialized in antique works. This sent him back to the natural sciences in Italy pre-Galileo, and the result was a two-volume work on the history of modern scientific writings. In the first volume, *The Literature of Technology and the Applied Sciences: From the Middle Ages to the Renaissance* (1919), he drew a straight line from Dante and Alberti to Piero, Pacioli, Leonardo, and Dürer. They had paved the way, he said, for Galilean science, an idea he further popularized in his later work, *The Genius of Italy* (1949). Olschki practically overlooked Piero as an artist. He ranked him as having closed the age of empirical geometry, begun by Brunelleschi and Alberti, a necessary stage in history before Galileo could move on to modern scientific theory.[28]

As Piero was being pulled into modernity, it was the Grand Tours in Italy that would first tether him to the United States. By the end of the nineteenth century, several notables of the Gilded Age had visited Italy, and, with agents in the field, they began to buy Renaissance art. American writers also had begun to cite Piero, but it was the artifacts that made the difference.[29] Touring Americans had two major vistas on

Piero's work: first was the Brera Gallery in Milan; after that, the Arezzo frescos, which had undergone two modern restorations, first in 1858 and again in 1915.

One American to take notice was Isabella Stewart Gardner of Boston. She traveled through Italy in 1892, stopping in Arezzo. She was also thinking about building an art collection in her great mansion. She relied upon a fellow American, Bernard Berenson, the Harvard-trained art connoisseur living in Italy, to alert her to opportunities to make a Piero purchase. When, in 1903, Piero's *Hercules* fresco came up for sale, Gardner enthusiastically bought it for $40,000, although it took five years for her to get it past customs to Boston.

In time, the demand for Piero's works exceeded supply. The prices rose exponentially, from Gardner's $40,000 at the turn of the century to a Rockefeller purchase of a much smaller Piero in 1929 for $375,000.[30] The very few available works were being liquidated by three kinds of sources: the modern heirs to the Franceschi family; royal collections that had owned works by Piero for generations; and dealers who had invested in them, waiting for the hour of profitable resale. Over the next four decades, a handful of rich Americans—Philip Lehman, Robert Sterling Clark, John D. Rockefeller, Jr., and Helen Clay Frick—bought a total of seven Pieros. After these arrived in American collections (the last being in 1950), they amounted to the largest national grouping of Piero's works outside of Italy. Except for the *Hercules*, they were all panel paintings, five of them small, cut out of the Saint Augustine Altarpiece that Piero had completed in Sansepolcro.

Increasingly, Piero had gained legs internationally. He had also come down off the museum wall and assumed the weighty profile of a historical figure. The number of documents showing his presence in history had grown, and his role in the history of math and science was given serious consideration. This all, of course, took place in Italy, where such original sources were to be found. It was only natural, then, that other experts on the Renaissance, especially art experts in Italy, would catapult Piero into higher levels of aesthetic appreciation as well.

<div align="center">❖</div>

The first of these Italian figures was actually an American whose life as an art connoisseur stationed in Italy nevertheless made him something of an Italian legend. This was the dashing and multilingual Bernard Berenson (1865–1959). He had begun to work in Italy in 1888 and then took up permanent residence there. By his exposure to public and private collections, Berenson became an influential authority on Renaissance art. He also became rich by dealing in the discovery, authentication, and sale of such works. As if holding a permanent Renaissance seminar, Berenson became host in Italy to three generations of visiting art historians, collectors, and dealers, basing himself at a grand villa, I Tatti, outside Florence. More than Fry's unheralded lectures on Piero, Berenson's outspoken writings would boost Piero's stature at the end of the nineteenth century. Berenson did this by boosting the status of central Italian painting, long neglected in the shadows of Florence, Rome, and Venice.

Berenson made the case in his book, *The Central Italian Painters of the Renaissance* (1897), which he updated with authoritative lists about a decade later. He recognized that Giovanni Battista Cavalcaselle and Joseph A. Crowe had covered many of these artists, including Piero, in their mid-century *History of Painting in Italy*. But Berenson, eager to eclipse past critics, dismissed their tepid enthusiasm for the central Italians as "sawdusty appreciations" at best. Connoisseurs in general, he suggested, had unjustifiably disregarded the painters of central Italy—from Siena, the Marches, Umbria, and the Tiber Valley—putting them "under the hard ban of Academic judgment."[31]

Berenson set out to lift the ban. He described the central Italians as a bridge between the medieval and the modern, being "not only among the profoundest and grandest, but among the most pleasing and winning Illustrators that we Europeans ever have had," and by illustration he essentially meant narrative story-telling. Head and shoulders above most others on Berenson's list was Piero, a judgment with which he presumed the "most cultivated public" would agree. "He was perhaps the first to use effects of light for their direct tonic or subduing and soothing qualities," Berenson said. No other painter "has ever presented a world more complete and convincing, has ever had an ideal more majestic, or ever endowed things with more heroic significance."[32] Berenson's effusive literary style, which

would influence the style of many critic-connoisseurs to come, was obviously in full swing.

Piero was not perfect, of course. His use of perspective and geometry could make his paintings "clogged by his science," said Berenson, not citing particular works, but probably referring to something like the *Flagellation of Christ* with its hyper-perspective. And yet when Piero's "science" worked, that architectonic feeling was a key to Piero's accomplishment: he accomplished a feeling of impersonality, a quality that avoids distracting emotions and presents pure phenomena, the "essential significant facts and forces" (and here Berenson may have been thinking of the more monumental Arezzo frescos). Although this Pieroism may come across as "impassive, that is to say unemotional," Berenson continued, this was precisely Piero's distinguishing virtue: "The grand figures, the grand action, and the severe landscape . . . exercise upon us . . . their utmost power," an aesthetic experience in the viewer to be sure, but nebulous enough as a "power" or emotion to defy description (and, indeed, Berenson provides none).[33] A half century later, around 1950, Berenson would return to writing about Piero, surprised at his growing popularity in the twentieth century. He again attributed it to the mute power of his unadorned stillness, a quality that now he would call "the ineloquent in art."

By "ineloquent," Berenson again meant paintings that avoided the ornament, flourish, or melodrama that distracts from a primordial sense of an art object. Piero was an antidote to the *"over-expressive"* art of the past, and especially of the present too, when artists competed with cinema. "In the long run the most satisfactory creations are those which, like Piero's and Cézanne's, remain ineloquent, mute, with no urgent communication," Berenson said. "If they express anything it is character, essence, rather than momentary feeling or purpose. They manifest potentiality rather than activity. It is enough that they exist in themselves."[34]

More than even Berenson, however, it was the native Italian art historian Roberto Longhi who raised Piero's profile. Longhi had launched his career as a young art historian just as the Italian Futurists were in Paris, around

1912, issuing their manifestos in competition with the Cubists and, in England, as Fry was making the Cézanne and Seurat connections. The son of teachers, Longhi hailed from north Italy. He was naturally enthused by Italy's own modern trends in art, taking a close interest in the Futurists and the so-called "metaphysical" painters. But having seen the ancient classics all around him, he became a specialist in Renaissance art. At the University of Turin in 1911, his dissertation was on the Italian baroque painter Caravaggio. Longhi's teacher had studied under the noted art historian Adolfo Venturi, also a northerner, and Venturi had become chair of medieval and modern art history at the University of Rome. So as like attracts like, Longhi headed south to study at Venturi's School of Advanced Studies in Art History.

Venturi was the living master of Italian art history. As Gaetano Milanesi had developed the science of art-historical research in Italy, Venturi elevated art history to a university field of study. He brought it under the purview of Italian academia. He achieved this in large part by producing his multi-volume *History of Art*, of which volume seven (1911) gave a full treatment of Piero della Francesca.[35] Longhi followed the interests of his new mentor and taught art history in high schools and contributed to Venturi's journal *L'Arte*. Inevitably he became enamored of Piero, launching one of the boldest theses ever attached to the Quattrocento artist.

Longhi presented his argument in a 1914 article for *L'Arte*: "Piero Francesca and the Development of Venetian Painting."[36] In sum, Longhi suggested that Piero's aesthetics—his mastery of perspective, color, and form—had guided the two most important early Venetian artists. Piero had thus shaped the very foundations of the Venetian style. Longhi arrived at this conclusion, he later said, by a close study of chronology and stylistic analysis of the two Venetian painters in question, Antonello da Messina and Giovanni Bellini. They had reworked their styles, Longhi argued, "on the basis of Piero's in the period 1475–80." This link between Piero and the two Venetians no less than explained "the origins of the new Venetian painting," Longhi said. "The perspectival, and in a certain sense Classical, underpinnings of Bellini's painting . . . are thus clarified, as regards both their origins and their consequences, which reach all the way to the chromatic classicism of Veronese," a late Renaissance painter who shared

his fame alongside Titian and Tintoretto as part of a supreme triumvirate of Venetian painters.[37]

By Piero's influence reaching Bellini, and Bellini's reaching Veronese, Longhi was suggesting that Piero had set the stage for all European painting, since it tended thereafter to follow the opulent Venetian fashion. This put Piero at the fountainhead of four centuries of Western art. After making his claim in 1914, the response was encouraging, at least in sowing lively disagreement among art historians and stirring a degree of excitement. One opposing German critic wrote that "The influence of Piero on Venetian painting has been recently claimed, but not demonstrated."[38] Longhi's teacher, Venturi, had already asserted that Piero had been the dominant influence on central Italian painting, and after Longhi's article he was willing to risk a further step. In a 1922 work, Venturi concluded, "A great heir received Piero's gift: Venice."[39] A happy Longhi noted later, "With such authoritative support, my conviction was winning ground."[40]

Soon enough, the Italian publisher Mario Broglio, a painter and art collector who had mastered marketing art monographs, asked Longhi to expand his article into a first-of-its-kind book on Piero. It was published in Italian and French in 1927, titled simply *Piero della Francesca* (appearing in English in 1931). Broglio knew what he was doing. He aimed the book for Paris, the nerve center of modern art. In Rome's Piazza San Silvestro, with Longhi's help, Broglio filled his Buick with French copies and then headed across the Alps. Parisian bookshops and reviewers were waiting.

Longhi's book catapulted Piero into a broader modern discussion. On a popular level, the Italian newspaper "culture pages" were happy to declare that another great Italian painter had changed the face of Western art. For fastidious historians, though, Longhi had presented a number of audacious claims that, if true, would require rewriting past monographs and textbooks, and this was hardly convenient. As Longhi suggested, art-historical debates over dates and influence often deteriorated into "personal controversies."[41] The dating of Piero's works was an especially contested field, but it was two other kinds of claims that made Longhi a target for academic rivals.

The first claim was that Piero had made a kind of "intellectual break-through" in the Renaissance with a new "chromatic style," which Longhi

called a "perspectival synthesis of form-color."[42] This was the style that proved that there was a "lyrical affinity between Bellini's and Antonello's spatial sense and the spatial sense of their source, Piero." Speaking this way, Longhi was wearing his hat as the elite Italian connoisseur, venturing a highly intuitive interpretation of how paintings look and feel.

Longhi's second claim was initially hinted at in his book, but then was elaborated more strongly in later editions. Here he stated that Piero's geometric cityscapes preceded the same unique effect produced later by Cézanne, who produced an "impressionism [of] such accessible form and synthesis."[43]

Going beyond Fry, Longhi made the historical point that Seurat and Cézanne probably had been influenced in their own innovations by constantly seeing the copies of Piero's Arezzo frescos in the chapel at the École des Beaux Arts in Paris.[44] In making the Cézanne connection, gradually and then firmly, Longhi was suitably careful as well. In a moment of introspection, he questioned whether modern painters had really discovered Piero, or whether it was the "critics" who had made the discovery and spread the idea. Either way, nobody could any longer ignore the suspicion that the Renaissance had complicity in modern art—and that Piero was a prime suspect.

Longhi effectively set the agenda for Piero studies thereafter. He did this by chronicling how other critics and historians had evaluated Piero across four centuries. And he stayed at the forefront by updating his book in 1946 and 1962. On top of that, Longhi's analysis of Piero's underlying visual forms, and his placing of Seurat and Cézanne under Piero's glow, led other writers to take his argument further than he found acceptable. Before long, Piero was being called the first Cubist.

The occasion was a review of Longhi's book by the French artist, Cubist, and critic André Lohte. His article in the January 1930 issue of *La Nouvelle Revue Française*, an influential organ, said that in reading Longhi's biography of Piero, the reader "will greet the first Cubist."[45] In the decades before Lohte, other critics had been tying Piero to modern painters from Édouard Manet to Picasso, but Lohte's insinuation was bold and attractive enough to catch on.[46] It was also compelling enough to chagrin Longhi. Thereafter, his rebuttals of the "cubist interpretations" of his book were

frequent and articulate, beginning with his questioning of Lohte's political motives: he said the Cubist painter was trying to get Cubism accepted inside France's art establishment, the École des Beaux Arts, where Piero was admired and Cubism definitely was not. More to the point, Longhi made known his actual distaste for Cubism and abstraction, lamenting the "esthetic confusion" they had invited into Western art.[47]

Longhi was more impressed by the era just before Cubism, it seems, when plenty of innovation was already taking place. It was Cézanne and Seurat, not the Cubists, who achieved "a synthesis of form and color," Longhi reiterated late in his career. And it was this achievement of the Post-Impressionists that recovered Piero's "great poetic idea" of the Quattro-cento. "Piero was rediscovered by Cézanne and Seurat (or by others on their account), and not by the brilliant rhapsodist Picasso."[48]

Berenson and Longhi began their writing about Piero at a time when the great philosophical struggles of European thought—especially between classical idealism and the new mechanistic sciences, a view known as "positivism"—were influencing even art-historical interpretation. For the most part, Berenson had operated outside of this ideological debate. He had been the classic connoisseur and art dealer, concerned primarily with the facts and visual effects of a painting. As he said of a work such as Piero's, for example, "No explanations are called for."[49] Excellence, authenticity, and simple art appreciation were the priority.

It was slightly different for the group of Italian art historians who circled around Adolfo Venturi, the man who was Longhi's influential teacher. They had done their thinking and writing under the considerable sway of the Italian philosopher of art, Benedetto Croce (1866–1952). As a philosophical idealist, Croce engaged in a dramatic battle with the positivists in the new social sciences. He argued that the story of art is about creative individuals, not about material and social force or about faceless stylistic trends.

In faulting the excessive emphasis on the evolution of styles, Croce pointed to the master of this technique, the leading German art historian of his own time, Heinrich Wölfflin (1864–1945). Across the Alps from

Croce, Wölfflin had been in search of a "history of art as the doctrine of modes of vision." This was to be a lawful and systematic linkage, nation by nation, of how physical and psychological processes of seeing changed the creation and appreciation of styles in painting and sculpture. "Vision itself has its history," said Wölfflin. He thus probed for a "visual strata," "visual schema," or a given "mode of perception" amid the rise or fall of painterly approaches. Finally he proposed that changes in art could be explained by a seesaw of five persistent stylistic "categories of beholding" (which he carefully separated from Kant's categories of mental perception, though he was operating in a similar philosophical spirit, which was the Kantian search for the laws of human nature).[50]

It was against Wölfflin's faceless art history of laws that Croce had rebelled. He called his German rival's search for changing external features of art—Wölfflin's phrase was the "effect of picture on picture"—as mere "fables about line and color." This was "only pseudohistory," Croce said, not the real experience of the individual artist.[51] As a counterproposal, Croce emphasized the importance of human intuition. Contrary to the abstracting tendency in positivism—with lawful physics as the model in science—Croce insisted that human experience is concrete, immediate, and motivated by intuitive forces. And so it should be in describing the history of art.

Accordingly, Croce's theory of art was this: art is the human experience that simultaneously joins pictorial "intuition" and "expression." Together they produce concrete "images," a place in visual arts and in literature where the senses and the imagination meet, "the borderland in which dreams and reality are mingled."[52] This is a capacity of all people, Croce said. But the artist does it best, not as a genius, but instead by expressing *intuitions*—that is, mental images—that are more profound or more complex. Writing as an idealist, and working in the stream of Platonism, Croce's search for the concrete did not deny a universal sense shared by all humans. He thus endorsed a common sense in people of the quality of beauty.

Although not a professed Platonist, Croce positioned himself in the idealist school of philosophy in what historians have called the great conflict between metaphysical idealism and positivism in modern European thought.[53] In ancient times, that was the conflict between Plato and

the Epicureans, for example. Since the time of the Napoleonic Wars and the rise of European romanticism, the idealist historical philosophy of George Wilhelm Friedrich Hegel (1770–1831) stood for the Platonist side. Hegel had a distinct vision of art's spiritual evolution in history, and this prompted art philosophers to look for the "spirit of the age" in individual artists and works. In the early twentieth century, as scientific positivism swelled in Europe, Croce identified strongly with Hegel's search for Spirit, and although Wölfflin was a founding positivist among art historians, he, too, could not entirely reject the idea of an inexorable Hegelian evolution of epochs in art. Nevertheless, Croce and Wölfflin represented the growing split in philosophies of art—the idealist against the positivist—and it would only widen and become more antagonistic through their modern century.

For the time being, the work of Croce was amenable to fellow Italian art historians such as Venturi and Longhi. Croce made one other important argument: art is independent of utility, such as politics, industry, or economics. It is a force of meaning and gives an essential quality to civilization. In some ways, the experience of art is not historical, Croce suggested, even though various artists lived and worked at distinct times in history. Croce thus questioned the relevance of dividing art history into periods and styles. He argued instead that individuals define a period, and not the other way around. Giotto, he famously said, explained the Trecento, the 1300s in Italy, more than the Trecento explained Giotto.[54] By this analogy, Piero explained more about the Quattrocento than his era told about him.

Increasingly, Piero became caught up in the new debate on approaches to art history. After all, his paintings seemed to join disparate themes, be they faith and science or Christianity and pagan classicism. The new art-historical approach went beyond looking for mere trends in style. It was ultimately about interpretation. How much can the modern mind find in a painting? Because it was the modern mind at issue, theories about the mind—ranging from the spiritual to the Darwinian, psychological, and scientific—began to play an increasing role in art interpretation.

The earliest novelty in this debate over interpreting art emerged from Germany, the land of Wölfflin. The novelty was driven by art philosophers working in the German idealist tradition, which included Platonism and Kant's philosophy. German philosophers were always a bit Hegelian in their search for a spirit of the age. Among them, the more dedicated idealists sought forms of deeper meaning in every aspect of art and culture. It was a depth not touched on by Wölfflin's "categories of beholding," which still seemed too external, missing the hidden layers of meaning that accumulated in culture and that was said to still be alive in art objects as some kind of transcendental, or intuitive, quality.

The setting for this new search for meaning was among a generation of young assimilated Jewish intellectuals, all of whom treasured art, Germany's cosmopolitan culture, and the heritage of idealistic philosophy. The name that appears first on this horizon is Aby Warburg, a banker's son. Like others before him, Warburg's love of art began with his travels to Italy. In Florence he studied Botticelli, the so-called Neoplatonist painter. On his return in 1901, Warburg devoted his inheritance—leaving the banking to his brother—to building a library of all the ancient cultural sources that fed into images and philosophies of the Renaissance.

Warburg, too, was dissatisfied with Wölfflin's formalism, with its surface analysis of forms, lines, colors, and subjects in paintings. His quarry was instead the deeper, lasting traces of classical and pagan mythology which, below the surface, he believed, shaped the way Renaissance artists made their pictures. At a time when Darwinian evolution—or, more precisely, evolution as human progress—was a dominant intellectual theme in Europe, Warburg wanted to find this evolution in art as well. Art was thus a story of how past superstitions, often dark and sinister, had transmuted into enlightened and beneficent ideas and images—the very definition of the Renaissance, as he saw it.[55] Having developed this agenda, at the peak of his career, Warburg showed his hand in a famous 1912 paper at the Tenth International Art Historians' Congress in Rome, which he helped to organize.

The paper focused on the Renaissance art of Ferrara, a city where Warburg investigated the frescos produced for the House of Este in the 1470s, a time after Piero's visit. What Warburg found in the frescos of the Palazzo

Schifanoia, he said, was an "international astrology." Such a mythology was the key to unlocking many riddles in the paintings, which were filled with symbols, items, and allegories. Warburg's method was to take a few of these pictorial items and discuss every possible literary, occult, and linguistic source for them. This was a new method for art history, and he called it "iconology." It was not the old "iconography" that simply discussed subject matter in a painting. Warburg was calling for a new depth and breadth, and as he presented it to the Rome congress, its ambition was fairly stunning.

> In attempting to elucidate the [Ferrara] frescos, I hope to have shown how an iconological analysis that can range freely, with no fear of border guards, and can treat the ancient, medieval, and modern worlds as a coherent historical unity—an analysis that can scrutinize the purest and the most utilitarian of arts as equivalent documents of expression—how such a method, by taking pains to illuminate one single obscurity, can cast light on great and universal evolutionary processes in all their interconnectedness.[56]

After Warburg, art history would often do just that: take one simple item, not necessarily a masterpiece, and extrapolate at great length about its interconnections with just about anything a scholar could find of interest in the history of culture. In Warburg's era, the fledgling science of anthropology was digging into the human past for the origins and "survivals" of human beliefs. With Warburg came the parallel search for primeval roots behind the ideas in art objects. What would be called the "Warburgian method"—both seriously and humorously—may have been too diverse and freewheeling to define as a clear methodology; it did nonetheless shoo away the "border guards," who had prescribed normal ways for art history to be done.

In the same year as the Rome conference, Warburg drafted a paper on Piero. Warburg's topic was the Arezzo fresco *Battle of Constantine*, and his approach was really more like normal iconography than like a deep, controversial, probing by the new iconology.[57] In this paper, Warburg, among the earliest to do so, associated Piero's use of various exotic hats and garments

in this particular Arezzo fresco to three possible influences: his 1439 visit to Florence; his seeing a Pisanello medal of the Greek emperor; and his likely desire for the Constantine story to symbolize the Quattrocento battle of Christians against Turks.

Later in life, Warburg went into seclusion to deal with a long bout of mental illness, prompted not incidentally by the First World War. His library nevertheless grew and, having become affiliated with the University of Hamburg, he would move from his home to a new building. In time it became the hub for a Warburg circle, of sorts, that would make its mark on the art-history profession. Prominent in that circle was the philosopher of science Ernst Cassirer (1874–1945), who arrived in Hamburg around 1920 to teach at the university. He came upon the Warburg Library, which rekindled his long-held fascination with art and culture. He became a self-described member of "that group of scholars whose intellectual center is [Warburg's] library," a place that embodied "the methodological unity of all fields and all currents of intellectual history."[58]

Twelve years younger than Warburg, Cassirer had begun as a university student of German literature, turning finally to science and its related philosophies. In making this shift, Cassirer transmitted his idealist (that is, Platonist and Kantian) views into the modern problems of exact scientific knowledge. One of his early writings was on the importance of Marsilio Ficino's Platonism during the Renaissance. In his 1907 work, *The Problem of Knowledge*, which made Cassirer famous, he argued that it was idealist thinkers, such as Ficino and many others, who had given rise to science. When it came to the Renaissance, Cassirer felt that Burckhardt's influential *Civilization of the Renaissance in Italy* had left out the most important part, which was Renaissance philosophy.

Not only did Cassirer highlight the importance of Ficino, but he became the first modern biographer of Nicholas of Cusa (Cusanus), whom he credited as a Platonist who broke down old scientific conceptions, allowing new ones to be born. Cassirer also augmented Burckhardt's definition of the Renaissance as a "leader of modern ages" by defining it further as a "unity of direction." That direction created new systems of thought, especially thought that focused on the importance of the individual and the problem of knowledge, both concepts that were promulgated by someone

like Cusanus. "Like the whole Quattrocento, Cusanus stands at a historical turning point . . . —the decision between Plato and Aristotle," Cassirer said. "This position toward the problem of knowledge makes of Cusanus the first modern thinker."[59]

For his own time, Cassirer was struggling to find a way that modern thought could unite both science and culture. This led to his signature philosophy, published as *The Philosophy of Symbolic Forms* (1923). A new mathematics of "logical relations" had given Cassirer the tools to argue that knowledge was also a form of relations, and thus true knowledge could include symbols of meaning as well as the facts unearthed by scientific investigation.[60] Building upon Kant's categories of the mind, Cassirer said that the mind actually had a wide array of innate forms of knowledge—symbolic forms—indeed, many more than Kant could have imagined. One example for Cassirer was Einstein's new theory of relativity. Relativity defied normal sense experience. It spoke mathematically and unintuitively of strange time-space "events" in the physical universe rather than the old Newtonian model, with measurable times and places. And yet, Cassirer said, humans understand relativity because it must be a form in the mind. These forms—almost like mental versions of Plato's Ideas—were able to reconcile scientific and cultural knowledge.[61]

Meanwhile, Hamburg University was turning out to be a consequential meeting place for these new approaches to art. It was there that the young art scholar Erwin Panofsky heard Cassirer's lectures and in time became a university instructor as well.[62] Panofsky had begun his research on Albrecht Dürer's "theory of art." In this, he was another thinker who opposed Wölfflin, who may have shown that styles do indeed change but didn't show why. Drawing upon Warburg and Cassirer, and not a little German idealism, Panofsky set out to answer the "why" question. His most powerful tool was Cassirer's symbolic form. Cassirer crafted it as a psychological model of knowledge, specifically bridging culture and science (for Cassirer wrote only once on the topic of art). Panofsky applied symbolic form expansively to art objects. In his hands, artworks became living entities in themselves, substantial symbolic forms pregnant with all the "intrinsic meanings" of the time in which they were made. Unanticipated even by Panofsky, his use of this approach spread the Warburgian iconological method across the

English-speaking world. The claim of Panofsky's biographer—that he was "arguably the most influential historian of art in the twentieth century"— was barely an exaggeration.[63]

For much of the Warburg circle, the rise of National Socialism became a dark, dispersing power. Warburg died in 1929, not seeing the worst to come. While Panofsky's family still resided in Germany, he was recruited in 1931 to lecture at New York University. During this time, he was offered a permanent American haven and a means to leave Germany, where he soon was dismissed from Hamburg University in 1933 for being Jewish. Thus, Panofsky made his final home at the independent Institute for Advanced Study (also Albert Einstein's outpost until his death in 1955) in the town of Princeton, New Jersey. On settling in America, his theory of symbolic form began to shape the young field of art history among Americans (although it also has been argued that Wölfflin's comparative, factual approach dominated the American classroom teaching of art history). The Warburg Library itself spread a similar influence. After attempts were made in Hamburg to ship the vast Library's holdings to the United States, Holland, or Italy, it was finally solicited by the University of London. Thus was born the Warburg Institute, the voluminous collection of Aby Warburg finding its first crowded home in Thames House and, after the Second World War, joining the University of London.

With this migration, the unique combination of German thought, often rich with philosophical idealism, began to sow its influence in the institutions of Anglo-American art history. Cassirer taught at Oxford and later in Sweden and the U.S., while the Warburg Institute became a magnet for other talented art historians fleeing Germany.

Already, in 1925, Panofsky had applied the idea of symbolic form to one of the mainstays of the Renaissance: linear perspective. In this, he posed an indirect challenge to Piero's claim that it was an objective "science." The nature of this challenge was plain enough in Panofsky's title, *Perspective as Symbolic Form*. Having mastered the life and work of Albrecht Dürer and showing how Dürer had adopted Italian perspective theory, Panofsky argued that perspective was not objective science, but rather a cultural product of the mind. As a symbolic form, it was a system of visual knowledge invented by Western experience. It began with attempts to look

through a "window," and it ended in a cultural propensity of Westerners to seek a single domineering viewpoint. "The Renaissance would interpret the meaning of perspective entirely differently from" other times and places, Panofsky said.[64] Perspective was about cultural "meaning," not about Piero's true science.

This undermining of linear perspective as a fact of nature was an early indication of how far the new interpretative art history could go in the hands of Panofsky, iconology, and symbolic form. For Piero, perspective had been a geometrical science of how God allowed humans to see the world in a proper way, free of illusions and misconceptions. With a similar belief in objectivity, modern science saw perspective as a law of optics, much as eyeglasses function on all people's eyes despite differences of culture or "meaning." By contrast, symbolic form made perspective a subjective experience.

Working from the Platonist tradition, Piero and Panofsky had arrived at starkly different conclusions about perspective. For Piero it was objective, given by God and nature, while for Panofsky it was subjective, a product of psychology and culture. As a Christian Platonist, Piero believed that the world, with its laws of nature, basically matched up with the human mind as a matter of how God created all things. Looking for something deeper, non-theistic, and secular perhaps, a psychological Platonist (that is, a Kantian) like Panofsky believed that the mind could overrule the physical world, a more extreme application of the Platonist legacy.

Following Warburg's lead, Panofsky would turn connoisseurship into a kind of priesthood in search of the secret forces and forms behind art. He explained this quest in a seminal book, *Studies in Iconology* (1939). Ordinary art interpretation operates at two normal levels, Panofsky said. It looks first at surface facts and then at the content, which was already the role of traditional iconography. After that, a deeper iconography—namely, *iconology*—probes at a third level. At this level, art objects are taken to be symbolic forms, organic and living entities that crystallize—through the act of the artist—all the meanings of the world in which the artist had lived.

Digging at this level requires interpreters to have a power of "synthetic intuition," which Panofsky describes as "a mental faculty comparable to that of a diagnostician." With this ability, an iconologist can reveal the true

"intrinsic meaning" and "symbolic values" attached to material art objects. This level of interpretation requires a careful and disciplined comparison of all available knowledge, Panofsky says, conceding that the complexity of the process can go awry, even at times seem irrational. Still, synthetic intuition combined with academic research may also discover the hidden "cultural symptoms" of a period. This is a reality so deep that it may be "unknown to the artist himself and may even emphatically differ from what he consciously intended to express."[65]

As part of the Platonist legacy, deep iconology had roots across the history of idealist thought. They can be found in the medieval idea of God-given human imagination and, after that, in Kant's theory of intuitive categories of the mind. Cassirer modified this into symbolic forms that mediate all human knowledge of reality. In the wake of Kant, this had been called the idealist or "transcendental" tradition, which even theologians tried to apply to modern religion. Art was its own religion, however. So iconology jettisoned both Plato's transcendent Ideas and the mind of God. Symbolic forms now played the ultimate role as mediators of knowledge between humans and reality. To its critics, it was a kind of secular mysticism. Yet in its many guises (it has been called transcendental, postmodern, semiotic, and more), this post-Kantian approach has been the primary alternative to simple positivism, a brutally "factual" approach to life that has dominated the natural and human sciences and, to an extent, textbook art history.

Put another way, deep iconology suggested no less than a psychoanalysis of the unconsciousness of art and culture. On the crest of the mid-century Freudian revival in the West (and alongside that, the psychological symbolism of the Swiss psychiatrist Carl Jung, too), iconology had a natural appeal. It would inevitably put Piero della Francesca on the couch, so to speak.

The influence of iconology would begin to reach a peak after the Second World War, a time when some of the first English-language books on Piero began to appear. Interpreting Piero now became a philosophical, if not ideological, topic worthy of debate. To vastly oversimplify, art interpretation

was veering in two diametrically opposed directions. One sought deeper meanings in art. The other seized upon the tools of positivist science, quantifying and describing art. The first was often a journey into the human unconscious. The second preferred simple data, whether about economic and political forces or how the physical brain operates. There was no area of art history in which this bifurcation of methods became more aggravated than the Renaissance, drawing Piero inexorably into the maelstrom.[66]

The first glimmer of Piero's involvement appeared in 1951 when a former assistant to Berenson in Florence, the Englishman Kenneth Clark, wrote his book, *Piero della Francesca*. It was literally the first full treatment of Piero's art in English in three hundred years. It was also the first presentation of color photographs of works by Piero. But if Berenson celebrated ineloquence, Clark excelled in not only one of the most eloquent surveys of Piero, but perhaps the first one that included a psychological treatment of the artist and the meaning of his works. A gifted writer, Clark ranged over a number of standard findings on Piero, adding a strong measure of traditional art appreciation by his frequent use of the adjective "beautiful."[67] He found Platonism in some of Piero's imagery. And he took some normal iconographical risks by offering an interpretation of Piero's enigmatic *Flagellation*: he said it was Piero's commentary on the Italian crusade against the Turks (an association that had been made almost forty years earlier by Warburg).

Riskier still, Clark ventured into Piero's self-consciousness. He said that Piero had had the mind of a rustic, tied as he was to a farm culture. On the other hand, Piero was also a kind of universalist, tapping into a primal sense of mystery that impressed both the pagans and the Christians of his day. Clark's example was the *Resurrection* fresco: "This country god, who rises in the grey light while humanity is still asleep, has been worshipped ever since man first knew that seed is not dead in the winter earth." On Piero's *Nativity* painting, moreover, Clark enthused that:

> No painter has shown more clearly the common foundations, in Mediterranean culture, of Christianity and paganism. . . . It is a serious antiquity, without either the frenzies of Dionysus or the lighter impulses of the Olympians. Yet it is more profoundly

antique. This unquestioning sense of brotherhood, of dignity, of the returning seasons, and of the miraculous, has survived many changes of dogma and organization, and may yet save Western man from the consequences of materialism.[68]

Such effusions were common enough in the writings of connoisseurs. After all, Clark was writing for the general public. He would go on to an illustrious career in public education, becoming director of the National Gallery in London, presenting television specials, and writing popular books. Because of Clark's prominence, it was only a matter of time before someone called his speculations about the meaning of Piero a gambit of "danger" that is "destructive of" proper art history.[69] That issuance of a danger signal about Clark was a bit overwrought, because Clark was never in the Panofsky camp; he once commented that iconology often ended up in "metaphysical fantasy" when it interpreted art.[70] Clark was nevertheless looking for depth in art appreciation. He was congenial, for instance, to Sigmund Freud's idea that the identical smile that Leonardo da Vinci put on his female figures, foremost the *Mona Lisa*, was Leonardo's unconscious yearning for his mother. In the case of Clark's interpretation of Piero, at least one contemporary felt that he had gone too far, a reaction that revealed a new and essential division between art historians.

The danger warning against Clark was issued by Ernst Gombrich, another great art historian in London. As an immigrant, Gombrich liked to refer to himself as a "Viennese from England." In 1936, he had fled Austria and been given a research appointment at the Warburg Institute in London. Already an expert in Renaissance art, Gombrich's first assignment was to organize materials on the life of Warburg himself. He would eventually write Warburg's intellectual biography. Respectful of his elders as a young scholar, Gombrich had begun by imitating Wölfflin. Later he followed Warburg, writing a deep-iconological paper on Botticelli's Neoplatonism.

Despite such congenial feelings toward his forebears, Gombrich finally broke with any kind of "ready-made paradigm," even though such a break could never be complete. Reading Gombrich could at times seem like reading Wölfflin, a positivist in his own right. They both speak of "schemas" and the physical psychology of vision (that is, the "eye").

However, if Wölfflin had adopted a kind of Hegelian march to artistic development in history, Gombrich rejected all such idealist philosophies, and most especially the Germanic Hegel.[71] Gombrich finally preferred a diverse scientific approach, revealing a particular interest in psychological science, which had a great deal to say about how the brain operates in visual perceptions.

Naturally, then, Gombrich used his review of Clark's book to criticize all attempts to overly mystify or symbolize what could be explained by common sense. No one had written more pleasantly about Piero, Gombrich said of Clark. But Clark was allowing the fad of psychoanalysis to creep into his work. Clark had put Piero on the couch. Doing this is unnecessary, Gombrich said, because the facts of style and history are quite enough to understand why Piero did such paintings. "Seen in its historical setting Piero's art stands in no need of support from archaic emotions and modern associations," Gombrich said.[72] There is really no "corn god" that Piero is thinking about. He was simply painting a Christian story.

Gombrich's main concern was that such a mainstream authority as Clark had gone down the perilously deep iconology road. Intentionally or not, Clark "lends his authority to psychological ideas which may ultimately prove no less destructive of the standards of rational historical criticism" than the wild speculation of less-learned iconologists. There were often limits to knowledge of the past, Gombrich reminded, and these should be quite acceptable: "It may turn out that the records of history are hardly ever sufficient to provide the psychologist with material for his [Clark's] kind of interpretation."[73] Returning the non-compliment, perhaps, Clark would later write a review of three Gombrich books, and while praising the Austrian's erudition, ended with a kind of blanket complaint: "sometimes the Warburgian approach seems to obsess him, and is worked out in such detail that we begin to grow a little impatient."[74] Clark was clearly aware that Gombrich was a positivist; but regardless, even positivists could lean Warburgian by hyper-analyzing a work of art to death.

This sort of exchange was taking place between England's two unparalleled experts on art, the two reigning voices for public art appreciation. No less than Clark, Gombrich had become an eloquent popularizer of art history. While still in Austria, he had worked on books for children,

including an introduction to the story of art. This draft was highly attractive to a publisher in England. So Gombrich revised and completed the book in English, published in 1950 as *The Story of Art*. It would turn out to be the most widely read art-history text in the world (and in it, Piero was identified as "perhaps the greatest heir of Masaccio").[75] As early as his first draft of *The Story of Art*, Gombrich hinted at his ultimate life interest, which was to reconcile human perceptions of art with the new developments in biology and scientific theory.

Going in this direction, Gombrich most starkly represented an opposing trend to deep iconology, which often denied not only science but also the reality of "nature." Gombrich's skepticism and positivism were characterized by his frequent agreement with his close friend, the philosopher of science Karl Popper, a hardnosed empiricist who suffered no foolishness about Plato, Freud, or symbols being living entities. Meanwhile, the natural sciences of the twentieth century had begun to say a lot more about art and its origins. There was the Darwinian approach, of course, which explained art as a bright signal of sexual fitness in the struggle for survival (or, alternatively, an accidental side product of evolution, just like music, mathematics, and religious belief).[76] And there was the approach of brain science: a soft machine inside the head perceiving the world, finding its shapes and colors quite interesting.

None of these approaches allowed for a transcendental quality to art, and such approaches were even skeptical about so-called intuition. What Gombrich found most convincing was something like the Darwinian model, and, indeed, a model used in explaining progress in science as well: this was the model of trial-and-error. Applied to art, progress came by "making and matching": putting down familiar images, then correcting them to match objects or perceptions, thus producing more excellent or innovative images. Added to that, Gombrich drew on psychological theories of how people develop those familiar images (schema) or expectations (mental sets). These visual and mental habits operate in art appreciation, but they also provide a target for rebellion in art. The net result is that art history is much like the fashion market. Clothing styles rise and fall, some gaining dominance for a period, only to be overthrown by rival designers who want to lead a new trend.[77] By this logic, for example, Piero

promulgated his geometric pictorialism as a competitor to the older Gothic styles, and in turn, the High Renaissance "mannerists" dismissed Piero as dry—namely, as old-hat—in order to catch the latest wave of fashion.

Finally, though, Gombrich had to follow the scientific approach where it ultimately led, and that was the human brain, the basic means by which people perceived art.[78] Wölfflin, the positivist forebear, spoke of the physical eye and modes of vision that seemingly controlled how national cultures perceived a work of art. Gombrich went further, tracing vision to the biological brain, presenting his findings as a "psychology of pictorial representation." Gombrich's interest in the physical brain made him a precursor to the field in neuroscience to be called neuroaesthetics, a completely biological approach to all questions about art, perception, and beauty.

For good reasons, Gombrich took this art-as-biology path slowly and carefully. His Jewish family, too, had once been happily assimilated into the cosmopolitan culture of Vienna, a happiness upturned by the new Nazi emphasis on biological purity of the races. This alone was enough for Gombrich's reluctance to link artistic experience to biological determinism. Those dangers seemed to slowly pass away from his concern, however, as would become evident in some of his later writings.[79] In opposition to Panofsky's deep symbolism, which gave each culture its own "perspective," Gombrich argued that linear perspective, despite some anomalies, was simply how all biological humans saw the world; it was not cultural, but rather dictated by the common human brain and visual systems. Renaissance painters were simply discovering how vision really works. "Can it not be argued," Gombrich wrote in 1967, "that perspective is precisely what it claims to be, a method of representing a building or any scene as it would be seen from a particular vantage point?"[80]

By trying to pull art history back from overheated and now-over-wrought speculation, Gombrich moved it toward a biological interpretation. In his Story of Art, biology plays almost no role, except in pointing to tricks of the eye. His 1960 book, Art and Illusion, cited studies of fish behavior related to colored objects, a first crack in the biological door. By the time of his The Sense of Order (1979), Gombrich is tying decorative order to biological evolution as much as to humanist reason and culture. He

cites the popular ethnologist Desmond Morris, who wrote *The Naked Ape*, and then discusses recent discoveries in visual brain science of cells that are "feature extractors," detecting both colors and shapes such as edges.[81] Humanist that he was, Gombrich nearly always used biology as a metaphor so as not to come down dogmatically on the side of science, which also had its ready-made paradigms. Nevertheless, at the end of his career, he said: "My approach is always biological."[82]

The divide over how to interpret art, a clash ultimately between transcendental ideas and scientific positivism, was taking place across modern Western culture. It echoed the ancient Greek debate between Platonist idealism and Epicurean materialism, showing that the more things change, the more they stay the same. Like the history of art, the history of religion was also being unraveled by these opposing interpretations.

A complete positivism in religion was an unlikely option, since that would rule out a transcendent Creator or other numinous realms of reality. However, within Piero's tradition of Christianity, there were ways that religion could call a truce with science.[83] One Protestant approach was both orthodox and modernist, duly named neo-orthodoxy. The epitome of this view was expressed by the Swiss theologian Karl Barth, who shaped twentieth-century Protestant thought more than any other single person. For him, God and Christ were "wholly other"—existing in dimensions so utterly different that the only question between God and humanity is God's forgiveness of the human state of original sin. Barth called it the "apartness of God," showing, in fact, his indebtedness to the paradox of how the finite and the infinite (or the One and the many) can exist side by side, a topic grappled with since the time that Plato's dialogue *Parmenides* introduced the idea of dialectical reality.

Barth's ideas were, of course, built on the core of Martin Luther's revolutionary doctrine, which was justification by faith, not works, and its corollary doctrine that, therefore, humans live in two kingdoms—that of heaven and that of the autonomous secular world. Barth took this autonomy of the world to a modern extreme and, before long, some critics of his

supposedly orthodox "Barthian" thought said it was a kind of atheism, since God is too exceedingly transcendent to be involved in the messy affairs of the world.

Viewing God as entirely beyond the world, and even hidden from humanity except by his single revelation, would put a painting such as Piero's *Baptism of Christ* in a certain theological light. In the *Baptism*, the Christ figure is from another world, a wholly other, arrived on earth just once in history. This Christ may also invoke a call for ethics, but it is almost entirely faith in things unseen, and surely not questions of science, that he calls attention to.

Theological liberals of the West also had their own form of "secular Christianity." They effectively made God a psychological or cosmic symbol and, by doing this, no less than by orthodox Barthian thought, put all the questions of earthly life at the doorstep of human powers alone. The German theologian Paul Tillich, who competed with Barth for twentieth-century influence, was a representative of this deep psychological approach. With an ear for contemporary issues, Tillich wrote on how modern art is an expression of existential religious experience.[84] Art can play this role, Tillich said, because in actuality God is the "ground of being"—not necessarily a Supreme Being—and religion is "ultimate concern," both of which can include art. In this light, to look at Piero's *Baptism* is to see a symbol that points beyond itself to something ultimate; thus, arguably, it could give even a professed atheist a "religious" experience.

Admittedly, Barth and Tillich are indebted, each in his own way, to the Platonist dualism that has pervaded Christian thought since the days, so long ago, that the Greeks met the Hebrews in the sweep of Alexander the Great's Hellenistic empire. That Hellenism, revived in the Renaissance, presents another theological alternative to the secularizing dualism of Barth, Tillich, and other forms of existentialist and liberal theology. This is a Platonist theology through the tradition of Cusanus and Kant. In approaching God, this kind of Christianity recognizes that intuition and insight, not only revelation, can be a link between man and a transcendental realm. If secular Christian thought looks at the Christ figure in Piero's *Baptism* as a one-time event brought about by a hidden God (Barthian), or a mere psychological symbol (Tillich), the Platonist and Kantian approach

takes Christ's story to mean that God participates in the human imagination: the mind has innate access to transcendent realities, thus bringing them into the physical world, both in daily life and in the practices of making and appreciating art. This continues the Hellenized Christianity of the Renaissance, a time when a wide variety of beliefs, dogmas, and philosophies coexisted in mutual tolerance.

If the great battle between positivism and philosophical idealism forced Christianity to go in these modernist directions, science was not completely immune either. The arrival of Einstein's relativity and the "uncertainty" principle in physics has forced science to cast doubt on the positivist creed. Nature is turning out to be an abstraction, even a philosophical entity, which puts limits on the strict measurement of its parts. It has been increasingly acknowledged that true scientific discovery, furthermore, can begin with irrational and personal insights and intuitions, or that cultural "themes" can shape the way scientists plot their experiments and arrive at their findings.[85]

Science's confrontation with the uncertainty in knowledge was forecast by Plato's dialogues, perhaps best known in his story of the cave in the *Republic*, suggesting how opinion and perception (things that are *sensible*) fall short of higher truths (things that are *intelligible*). As Plato stated the case in *Timaeus*:

> One kind of [intelligible] being is the form which is always the
> same . . . invisible and imperceptible by any sense, and of which
> the contemplation is granted to intelligence only. And there is
> another [sensible] nature . . . perceived by sense, created, always
> in motion, becoming in place and again vanishing out of place,
> which is apprehended by opinion jointly with sense.[86]

And as seen in art and religion, Platonism's dualistic scheme—an intelligible realm that is ideal and transcendent, and a sensible realm that is physical and roughly measurable—still offers a framework for scientific progress at times when simple positivism comes up short.

<p style="text-align: center;">⬥</p>

In the twentieth century, the positivist approach to Piero still had its advocates in traditional art history. They would include, perhaps, connoisseurs such as Kenneth Clark, but also Ernst Gombrich by way of his scientific preferences. But it was the more transcendental approach, derived from Kantianism and the iconology of Warburg and Panofsky, that seemed to dominate approaches to Piero in the second half of the twentieth century.

It was an approach that looked for depth, and one of the first such forays into Piero's works was a mathematical analysis of his linear perspective in the *Flagellation*. This was co-authored in 1953 by historian of architecture Rudolf Wittkower. In addition to offering a groundbreaking technical analysis of Piero's lines and measurements, Wittkower was in search of its deeper mathematical or geometrical meaning. In that spirit, he concluded that it was "more than chance" that certain numerical patterns emerged from Piero's painting, some used in objects, others in a kind of mystical design. "Piero may have chosen this curious relation between the module scale and the 'mystic' scale to symbolize the interweaving of this-worldly space with that belonging to the Kingdom of Christ," Wittkower said.[87]

Another leading scholar of Piero has been Marilyn Aronberg Lavin, a tireless researcher and organizer of activities related to the Quattrocento painter, from conferences to a computer program to map and analyze his frescos. At the heart of Lavin's work lies a deep iconology that has made her richly authoritative, but also much commented on for her vivid speculations. "She finds hidden meaning in absolutely everything," said one critical reviewer.[88]

The search for something—indeed anything—new in Piero was perhaps only natural in an academic world that was not able to go any further on dating Piero's life or paintings. The last major attempts to pin down dates on his works came in 1941, by one estimate.[89] Kenneth Clark, the British connoisseur, said chronology didn't matter with Piero because his painting styles did not change. This claim prompted a rejoinder by Renaissance historian Creighton Gilbert, who devised a highly elaborate, speculative, and at times convoluted book-length chronology of "change in Piero."[90]

Otherwise, for lack of any consensus or new empirical evidence on Piero, the art "theory" that was rising in Western academia—Marxist, Freudian, feminist, and more—became the method *du jour* for Piero as well.[91] Although

Sigmund Freud may have seen better days, he was only now being evoked to interpret the arts. A new wave of Freudian analysis of artists and their viewing public arose, splashing on Piero as much as anyone else.

Such were the exploits of Piero scholar, Renaissance expert, and seasoned art-history writer Laurie Schneider Adams. She began her career analyzing the Arezzo frescos for their typology, a method of finding everywhere the symbolism for "types" of momentous people or places, which even St. Augustine had recommended as one of three levels for finding deep truths in Bible interpretation. She went on to become a licensed psychoanalyst as well, and naturally turned that lens back on Piero's enigmatic story-telling at Arezzo. Not surprisingly, she found evidence of Piero's struggle with his oedipal complex (which, of course, Freudians presume every child who knows a mother and father supposedly grapples with). In this Freudian analysis, Piero showed all the predictable traits of suppressed desires: he was attracted to his mother (suggested by his paintings of women) but rebellious against his father, and thus against male authority figures (as illustrated in paintings of God, kings, or leaders).[92]

Then came the French postmodernists with the new "Lacanian" interpretation of Freud (named for the French theorist Jacques Lacan, who applied Freudianism to art objects, since art could arouse hidden desires after being gazed upon). Piero was subjected to this Lacanian approach by the noted historian and philosopher Hubert Damisch. Damisch began by attempting to analyze Piero in the same way that Sigmund Freud had famously analyzed Leonardo da Vinci—by the maternal abandonment of Leonardo's childhood and one of his dreams. As Damisch conceded, though, nothing is known of Piero's childhood. Evidence suggests, meanwhile, that he was probably close to his parents and siblings throughout his life. In his final years, Piero wrote in his own hand: "I want to be buried in our family burial place."[93] Using Lacanian theory, however, Damisch said it is proper to generalize Piero's psyche onto the viewing public. In this way, Piero's *Madonna del Parto*—a madonna painted as a visibly pregnant woman—can be taken as evoking a sexually conflicted "childhood memory" in anyone who spends some time looking at this Piero painting.[94]

The search for secrets in Piero's works continues to the present, and many of the purported findings have drawn protests from, if not the

positivist school, then the common-sense school of art historians. Such was the protest against the Italian historian Carlo Ginzburg, whose book, *The Enigma of Piero*, looked for a deep symbolism in three major paintings by Piero. Ginzburg arrived at an elaborate story of how Piero was saying specific things about the unity of the Latin and Greek churches, a charged ecclesiastical topic in his lifetime.[95]

For some Piero experts, Ginzburg's iconology was spinning tales from whole cloth. Piero biographer John Pope-Hennessy, then of the Metropolitan Museum of Art, acknowledged the entertainment value of Ginzburg's Sherlock Holmes approach. But as factual history, he impugned it as "a tissue of tendentious nonsense that far surpasses anything previously written about Piero's paintings."[96] Many years earlier, Renaissance art historian Bruce Cole had already lamented that nonsense had seemingly become a new norm. "Excessive iconomania has been one of the banes of art history for the last two decades," he said.[97]

As suited these secular times, the legacy of Platonism was playing out in the visual arts in the form of iconology, with Freudian overtones. There no longer seemed to be room for evoking the spiritual or religious mystery of Piero's works, which would have been an alternative evocation of Platonism, a very Renaissance type of evocation. In the modern world, it was hard to see how anything like religious faith or Christian intuition could be acceptable in academic treatments of Piero della Francesca. Outside academia, of course, this spiritual approach might be exactly the way that individuals would enjoy, through the eyes of faith, his paintings and his story.

When, in 1963, Roberto Longhi last updated his seminal book on Piero, he noted how much the fortunes of the Quattrocento painter had risen. Piero had become, Longhi said, "a major artist whose fame is in the ascendant, references to him multiply with inevitable rapidity, in every sphere of culture."[98] Nevertheless, the modern world was not yet done with Piero, art, and the Renaissance. Piero himself had been enthusiastic about the "science" of painting, but in the twentieth century—with its golden ages of physics and biology—science was casting an entirely new light on how artists and their works are perceived. Once the iconographers are done with Piero and the history of painting, what is left for science?

CHAPTER 10

The Eyes of Science

Although he addresses the bulk of his arguments and narrative to painters, Piero's *On Perspective* opens with topics that would fascinate modern science. One such is color and light, which Piero speaks of as "colors as they are shown in things, light and dark according as the light makes them vary." Another is Piero's brief mention of the biological eye, which "is round and from the intersection of two little nerves which cross one another the visual force comes to the center of the crystalline humor, and from that the rays depart and extend in straight lines."[1]

Finally there is perspective and optics. This is Piero's "power of lines." How to draw this illusion of optical reality is, in fact, *On Perspective*'s core subject, with Piero begging pardon, in effect, for not discussing color: "I intend to deal only with proportion, which we call perspective."[2]

As he wrote this work, there is no reason to believe that Piero subtracted metaphysics from his science, or saw science as an enemy of his religion. Such Platonist concord, however, would become rarer in future centuries when physics and biology tried to reduce human perceptions to strictly material causes.

The progress of Western science in the area touched on by Piero's treatise may be tracked in historical parallel to the revival of interest in Piero

himself. At the mid-nineteenth century, when Europe was rediscovering the Quattrocento painter, biological science was arriving at our modern understanding of vision. Then, at the start of the twentieth century, when Piero was revived again in the context of modern art, modern physics was discovering the true nature of light. Finally, at the close of the twentieth century—the time of our current wave of fascination with Piero—neuroscience would combine the lessons of biology and physics to explore how the entire human brain puts all the perceptions of light, color, and space together. Neuroscience also presumed to find in the material brain the origin of all artistic and religious experience, seeming to leave very little room for the kind of transcendental reality that Piero had presumed to exist in the world.

A nineteenth-century generation of people such as Milanesi in Italy, Eastlake in England, and Burckhardt in Switzerland was important for understanding Piero today. The same could be said of another figure in this generation, the German scientist Hermann von Helmholtz, who was born in 1821 and did his major work in the years, for example, when Piero's paintings were entering the National Gallery in London.

Much about the nature of color had been understood before Helmholtz came on the scene, but he would add to this knowledge of how the physical eye and brain "see," and he would also speak to how these scientific principles applied to making art and seeing art, paintings in particular. By Helmholtz's time, the theory of light as a wave was back in fashion, especially for the field of physics, which was finding that wave frequencies explained a good deal of natural phenomena. Furthermore, the realm of electromagnetism had been discovered, an omnipresent world of energy in wavelengths, and now light and color were understood to be a particular part of this electromagnetic spectrum. Indeed, without the human eye to detect this "light" spectrum, there would be no light at all, just darkness and electromagnetic waves of various lengths.

Helmholtz also worked on the foundations of a new theory of how the eye retrieved the different wavelengths of light. For the eye to find and

mix the so-called primary colors in the light spectrum—red, green, and violet—it needed "particles," now known to be cells shaped like cones and rods (and thus their modern anatomical names). This matrix of cells begins the brain's process of distinguishing dark and light and mixing the primaries to produce all other colors.

Much of this broader knowledge was based on the original work of Isaac Newton. As Helmholtz knew well, however, Newton's theory of the light spectrum was not escaping all protest. The most famous and singular protest came from the great literary figure and amateur scientist Johann Wolfgang Goethe, the German poet. With his rhetorical powers, Goethe questioned whether a mathematical and mechanical explanation of color tells the real story of human psychological perception, a polemical argument he made against the Newtonian party in his *Theory of Color* (1810).[3]

Resolving this debate would require more knowledge about the biology of vision, and this was the accomplishment of Helmholtz. Taking the Newtonian side, he went on to invent the key medical optical instrument of his century, the ophthalmoscope. "I had the great pleasure of being the first man ever to see a living human retina," he recalled.[4] In his popular lectures, he used the new findings in optics to analyze the craft of painting. And he gave due credit to Renaissance artists for discovering all the illusionist principles of representation well before science understood the laws behind them.[5]

In his *Handbook of Physiological Optics* (1867), however, Helmholtz surveyed other facts of nature that were too deep for artistic manipulation. He moved beyond the older descriptions of the eye as a camera obscura, now explaining its defects and its powers. As to the first, light and color can be distorted by the fibers and liquids in the eye. These distortions were compensated for by extraordinary strengths also found in the eye, especially the eye's focal point, which has such a strong acuity that it can produce the illusion of sharp vision everywhere by the eye's rapid movement. Pictured now as machinery, the retina at the back of the eye was a complex detection device. Its layers of nerve cells interacted with light, the "visible" part of an electromagnetic spectrum, a reality of energy waves that permeate the world.

Under electromagnetism, Helmholtz explained, the cells in the human visual system behave in patterns. When excited by light, they let off an impulse. After that, they fatigue and recharge. Here was an explanation for afterimages: after the eye sees red, red receptors are fatigued, so the eye sees green as the green receptors dominate. Even more remarkable, Helmholtz said, is how the visual system, bombarded by every kind of electromagnetism, nevertheless produces a lawful perception of color and form.[6] Of the three basic qualities of color—hue, intensity, and brightness—the third (also called luminosity) was turning out to be the most important for visual perception.[7] This was another point already made during the Renaissance, when Alberti argued that the dark/light contrast, even before color, was the heart of artistic representation.

Going well beyond Alberti, Helmholtz finally proposed a mechanical source for beauty itself. Renaissance belief, again typified by Alberti, had located beauty in both the innate mind and in a transcendent realm. Helmholtz was familiar with such a tradition, for even in the natural sciences of his day, as exhibited by the late Goethe's popularity, there was a desire to find vital forces, even metaphysics, by which nature speaks to human intuition. Helmholtz called himself a Kantian, agreeing that the mind partly invents the laws of nature. Finally, however, his goal was a thoroughly mechanistic science. Vision, perception, and even beauty might have purely mechanical explanations. In this he anticipated the field of neuroaesthetics, which would study how cells and modules in the brain perceive visual art—and even beauty itself.

On that topic, Helmholtz went as far as nineteenth-century science allowed. He suggested that beauty is based on comfort to the eye, whereas glaring colors cause fatigue, not aesthetic pleasure. For instance, he said, "a certain balance of colors is necessary if the eyes are not to be disturbed by colored afterimages."[8] The artist must cooperate with nature in this pleasing effect, for while a "beautiful painting" must be vivid, its success is "not just in reproducing colors, but in imitating the *action of light upon the eyes*." In fact, paintings can have advantages over the real world in producing beauty, he suggested. They can tone down the power of nature, give it a focus, and represent the world "without injuring our eyes or tiring them by the harsh lights of reality."[9]

After Helmholtz's achievements in optical biology, the puzzle of vision was handed back to physics, whose golden age began with the twentieth century, when new discoveries included the atom, the x-ray, the quantum, and finally Einstein's theory of relativity.

All this was bubbling up from scientific laboratories around the same time that modern art connoisseurs, from England to Italy, were discovering Piero's "color-form," "unemotional" stillness, and "plasticity" of design, and mathematicians were re-evaluating his accomplishments in mathematics and geometry. It was also a time when, in fact, new and weird geometries had begun to fascinate a group of painters to be called the Cubists. Some of them searched for a new "painter's geometry" and, though futile, desired to paint the "fourth dimension."[10] None of this actually led to the application of new scientific knowledge to age-old painting techniques.[11] But the artistic ferment did parallel some astounding new discoveries in physics—discoveries that would alter our understanding of not only art, but even of how the universe operates.

This new vision of the cosmos began with a challenge to the reigning wave theory of light.[12] It was an unwitting challenge, and yet it inexorably arose in 1900, when the German scientist Max Planck was experimenting with blackbody radiation (heat with no color spectrum), the uniform heat typified by an oven. Planck discovered that heat, which is the energy given off by electromagnetism, does not change smoothly, but rather in small leaps, as if in packets of energy. This implied that energy comes in particles; thus was revived the corpuscular theory of light. On closer inspection, light was found to behave as both a wave *and* a particle. Eventually, light would be spoken of as a wave frequency, but also as a fast-moving particle called a photon.

Light became still more enigmatic when Einstein proposed that the speed of light—that is, the speed of a photon—is the only absolute constant for humans in the universe. In the theory of relativity, at the largest scales of the universe, space and time were "relative" to the human subjects, depending on how fast they are moving in the universe, with the speed of light as the maximum speed possible. In Platonist terms, the space and time

of the universe is in flux, regulated by only one type of signal to human perception: the photon, which unveiled the world by its light and its rate of motion. Yet the photon has not yet revealed its own mystery. It has a particle-wave duality that remains elusive to mechanical descriptions. It can be understood only by tapping into the Platonist realm of mathematics, which can use numbers to make a relativity universe comprehensible.

The ancient Platonists had given light a metaphysical role in the universe, and now it seemed to be no less important for how moderns understood their perception of reality. By uniting the new knowledge about light and atoms, physics explained color at a deeper level, the level of atomic particles. When photons hit any object, all of which are made of atoms, the atomic particles make jumps in energy. Some of these jumps emanate a wave in the visual spectrum, thus producing the effect of the object's "color" on the human retina. Any molecule that operates this way, absorbing a color frequency or emanating one, is a pigment. In his *Baptism of Christ*, for example, Piero painted the tall hat on one of the men in red tempera. It appears red because the pigment absorbs light frequencies of green and violet, emanating mostly a red frequency.

From the point of view of light and color, the world was turning out to be a strange place indeed. In truth, it is a dark and colorless world, at least until the energy particles and waves reach an eye. In the old Platonist system, light was the source of the world; in modern physics and biology, the same could be said almost exactly. How the brain turns these quantum effects into mental apprehensions of color, form, and beauty would await a next leg of the scientific revolutions. Physics handed the problem back to biology, and it, too, would evoke a central theme of Platonism: essences and change.

<center>◈</center>

In the Platonist traditions of Alberti and Piero in the Renaissance, the world might change, but behind it God had fixed a range of unchanging essences, from the revealed truths of the faith to the geometries of music, proportion, and beauty. The next modern revolution in biology, characterized by everything from the modern Darwinian synthesis of the 1930s

to the foundations for modern genetics and neuroscience after the 1950s, would lead to a new understanding of what changed and what stayed the same. As to a benchmark, the fifties was also the decade that Kenneth Clark wrote the first modern English book on Piero, and Ernst Gombrich began proposing, if just barely, a biological approach to art in his worldwide bestseller, *The Story of Art.*

The new Darwinian biology looked at nature operating over time, so naturally change was the issue of most interest. Under the Darwinian view of the world, it was popular to see change and progress everywhere, especially in culture and society, where knowledge, technology, books, or education could significantly alter a society in a human generation or two. As appealing as the marvel of rapid progress could be, however, it was not going to be fully applicable to the fundamental biology of the human brain. The human brain, as science generally acknowledges today, has not essentially changed since the rise of modern humans on the Pleistocene savannahs of Africa.

For the science of perception, this means that the brain has retained a high degree of constancy. In the timeline of human evolution, the physical powers of the brain were virtually identical in Piero della Francesca's era to what they are today. People in the twenty-first century, in other words, are equipped to see the most basic elements of Piero della Francesca's artworks just as he and his contemporaries had perceived them, at least in terms of brain function.

Naturally, many art critics and theorists reject the evolution of the brain as the fundamental basis for human tastes in art. They prefer to argue that social psychology, culture, and language are such powerful external forces that they override any biases, or constraints on perception, dictated by the physical brain structure. Indeed, in postmodern thought, the idea of "nature" itself is denied, and while biology (made up of molecules, cells, and organisms) may be real, it is a lesser force on human behavior than the "socially constructed" world of culture, language, and ideology.

In the challenging of science, postmodern thought—and even some philosophical theology—has had one great crack in the door: science itself is still struggling to solve the philosophical problem of distinguishing the physical senses from the "mind." In Piero's day, the Platonist answer to this

puzzle had been the existence of the soul, which was separate from matter and was able to perceive transcendent things amid the flux of the physical world. This was a view, borrowed especially from Greek thought, that was deeply embedded in Christian belief. Today, neuroscience has preferred an alternative Greek idea, which is the materialism of the mind. Still, the problem of explaining how the mind, with all its subtle powers, emerges from the vibration of atoms and cells remains one of the greatest enigmas of human knowledge.[13]

The mechanics of "seeing" has proved easier to resolve than explaining the full breadth of human "thinking about" a visual experience. One helpful fiction about vision, which had helped as long as it lasted, was the belief that images landed whole on the retina, like movies on a screen. But more precisely, and to the contrary, the retina receives so much data that nothing is really "seen" until, somewhere back in the brain, the data is sorted through and organized. In short, it is the brain that finally sees, and the noble eye is merely a window and lens.

After the data of the light gets through the window, it is transmitted between cells as electrical and chemical signals. These move up the line to the visual cortex, an area of the brain at the back of the skull. The signals are further distributed to an estimated dozen more areas. At still another mental level, all this information is integrated: the "mind" distills the essence of the visual impressions, which meanwhile are still coming in almost as rapidly as photons can fly and cells can fire.[14] Amid this incredible overload of sensory data, the mind does something remarkable: it compares the visual stimuli with "memory," and from those memory banks it can identify and evaluate what is being seen in the world.

Equally remarkable, the workhorse of this event is the nerve cell, called a neuron. The brain contains a hundred billion, which in turn send a thousand trillion neural signals among themselves.[15] In this biological matrix of the brain, the visual system is perhaps the best understood of the sensory areas.[16] This is due to the clarity of its anatomy, beginning with the eyes and ending in the visual cortex. Along the way, the neurons accumulate and distribute visual information in a hierarchy of importance, serving the needs of the brain, of which accurate perception and physical survival is first and foremost in the evolution of the modern human.

According to evolutionary theory, the visual system has developed many remarkable efficiencies. For one, the eye's tiny focal point expands its neural reach extraordinarily widely into the brain. For another, neurons specialize as "feature detectors." Neurons in the retina turn each other on and off depending on whether light hits a center or "surround" area. Neurons do the tricolor mixing of light as well. Up the line, "opponent" neurons oppose specific colors against each other, such as blue against yellow or red against green. Here is found a solution to the long-festering debate on the origin of color, pitting Aristotle, Goethe, and the field of psychology (which favors the opposition theory) against the Newtonian tradition and its allies in physics (to whom color is simply electromagnetism).[17] Both views are correct in their own way. The mixing cells and opponent cells integrate as a unified act of perception, producing a mystery, as some neuroscientists admit, much like the way a photon is both a particle and wave.[18]

What does this mean for art appreciation or for the practice of painting per se? For viewers of art, it is enough to know that the mixing and the opposing systems work together, the end result being the pleasure of color in its constancy and its shifting variety. For the practicing artist or scientist, the two systems provide handles on two contradictory realities in color. Under the light spectrum, the three primaries are the basis for mixing the purest possible paint colors, and yet at the same time we have developed the so-called color wheel, which reveals that certain colors predictably oppose others: blue opposes orange, green opposes red, and violet opposes yellow. Juxtaposed, these oppositions are visually exciting and flashing. When mixed, however, they produce browns and grays, which are called neutral colors on the artist's palette. The light spectrum itself cannot explain this quality of contrast and opposition. Something must be happening in the human visual system, where color arises from both mixing *and* opposing, an inherent mystery to color perception.

Despite such enigmas, the biological structure of vision is revealing many of its remarkable functions. Farther in, from the eye toward the visual cortex at the back of the brain, feature-detection cells increase their specialization. By their orientation, they detect edges, lines, curves, contrasts, and motion. They also apprehend the most basic feature of light itself, which is luminosity, the relative contrast of light and dark, which

now is understood as the most fundamental visual perception. Judging luminosity produces form and depth, allowing the brain to move through the world. The perception of color is overlaid on luminosity, another feat of integration by the brain that remains a mystery.

In explaining this entire process—first specialized detection, and then integration—some scientists have emphasized the behavior of modules of the brain. The modules each handle an aspect of perception, such as edges or color contrasts. Related to art, therefore, different modules of the brain would be activated in the presence of different artistic styles. This way of seeing the brain, called "functional specialization," is an important theory in neuroaesthetics, which studies "the neural bases for the contemplation and creation of a work of art."[19] By analogy, functional specialization sees the brain as a parallel processing machine, a term used in computer science when a problem is broken into separate parts and then united later. Nothing is passive in this process. The cells and modules are constantly receiving and sending signals.

There is another way that scientists have tried to explain what the brain is doing in visual perception. Rather than focus on modules, this second approach charts two kinds of general functions across the brain: the "What" and "Where" systems of visual perception.[20] The "Where" system is the most fundamental facet of the biology of seeing. Although it is color-blind and has less power of detail, it is highly sensitive to small differences in brightness, namely luminescence. The Where system—which combines a number of cellular functions in the brain—picks up contrast, and therefore edges. In short, this system gives the seeing brain the reality of form in the world based on shape, size, depth, and distance. The Where system may be more basic, for it is possessed by many other animals, all of whom must be able to visually make out forms and spaces to survive in the world.

By contrast, the "What" system sets the human primate apart from all other organisms with a sense of sight. The What system is the power of visual precision and recognition. It detects color with great exactness, although it requires large differences in brightness to distinguish one shape from another. Cooperation between the Where and What systems underwrites all the powers and wonders of vision. Behind this simpler description, further complexity lurks, as is to be expected. To do its job, for example,

the What system operates with two subsidiary functions. One sees forms by detecting both color and brightness. The other focuses on color alone; it typically apprehends fields of color as they appear on surfaces of objects. Such subdivisions and specializations are evident to science and medicine by the fact that specific parts of visual perception can be absent in humans, usually due to brain damage. Some people have Where powers, but no specific What powers, and the opposite is equally true.[21]

At the center of everything in the visual system, however, sits the ability to judge luminescence. "I suspect light-dark contours are the most important component of our perception, but they are surely not the only component," says David Hubel, the modern Nobelist in visual neuroscience.[22] Centuries earlier, Alberti had arrived at a similar observation. In *On Painting*, he says the artist's mastery of dark and light is most important for an effective work of art. Such contrasts seem to speak ultimately to the needs of the brain, and here is a start at understanding why paintings such as those by Piero can evoke mental interest, even pleasure.

After luminescence is detected, however, something more must happen. The mind must recognize, interpret, and connect those visual experiences with all else that is mental—memory, emotion, insight, and even inspiration. How does that take place? Short of finding a completely anatomical answer, the Platonist philosophy of mind retains a certain modern relevance. The Renaissance Platonist Ficino offers an overview that, while poetic, continues to ring true: "When anyone sees a man with his eyes, he creates an image of the man in his imagination and then ponders for a long time, trying to judge that image. Then he raises the eye of his intellect to look up to the Reason of Man, which is present in the divine light. Then suddenly from the divine light a spark shines forth to his intellect and the true nature of Man is understood."[23]

This metaphysical view of the mind is hard to swallow for modern psychology and neuroscience, of course. In social psychology, moreover, tastes in art and culture are said to arise primarily from the outside: from social conditioning, competition, economics, and such mundane and ephemeral realities as fashion. There is little room here to search for an innate—let alone metaphysical or transcendental—apprehension of Beauty as a universal essence. Even more than social psychologists, perhaps, neuroscientists

will roll their eyes at the Platonist prose typified by Ficino. Nevertheless, it continues to be part of the lineage of idealist philosophy, which includes modern names such as Immanuel Kant and Ernst Cassirer, and it remains an alternative to a purely naturalistic explanation of the mind.

Even in the sciences, there is disagreement on how far the scientific method, including its ethics of experimenting on humans, can go to crack the mystery of human consciousness and mental life. For some, it will always be a frontier that cannot be crossed for reasons of the sheer interiority of human perception.[24] In the nineteenth century, Hermann Helmholtz had cited these limitations: "We cannot at present offer any complete scientific explanation of the mental processes involved, and there is no immediate prospect of our doing so."[25] For a number of reasons, a complete explanation may forever be elusive. In the meantime, one fairly solid finding about mental perception has proved to be remarkably similar to the traditional Platonist assessment, the basic finding that the physical brain seeks essences and constants.[26]

Essences and constants—these have recently become terms in the toolbox of psychology. And within the study of vision, even neuroscience is sounding like a Platonist doctrine. Where Platonism and neuroscience can agree is that the brain, finally, is sorting through the flux of impressions in search of essences, both for the survival of the organism it serves and in apprehending a pleasure that traditionally has been called beauty. Platonism and neuroscience are both looking inside the "mind" for the seat of our deepest perceptions.[27] The stark difference is this, of course: Platonism acknowledges a kind of transcendental intuition in the brain, while philosophical materialists and neuroscience itself reject such a "Ghost in the Machine," as one twentieth-century philosopher cleverly put the case.[28]

Ghost or no ghost, for both neuroscience and Platonism the experience of beauty is said to arise from the recognition of what is essential and constant. This goes further than Helmholtz's tentative theory that comfort to the eye produces the pleasure of beauty. Adding to that, neuroscience now suggests that the greatest works of art may be those that are able to

capture the greatest number of the essential qualities related to the needs of the brain.[29] Operating very much on its own, the brain seizes upon these qualities and they produce an automatic sense of satisfaction. Perhaps this is why, historically, beauty has been tied to a contemplative mode, not to merely satiating an appetite such as food, sleep, or sex. The brain's automatic recognition of visual constants—and thus features it deems pleasant—may explain why philosophers have called the experience of judging beauty "disinterested," done for its own sake and not mixed with other motives.[30]

A corollary to the brain's easy recognition of constancy is its encounter with anomalies in the world—that is, visual events that run counter to what the mind expects: the mind is taken aback by things that defy normal expectations, or that defy what seems to be natural. An optical illusion, for example, or a "counterintuitive" event, puts the mind on alert. This is a well-recognized form of mental stimulation, and the resulting alertness has been linked to both the nature of aesthetic experience, in which shapes defy normal expectation, and the nature of religious experience, in which events that go against the grain of nature seem supernatural.[31]

Platonism and neuroscience find consonance in one other important area, it seems. Although the basic structure of the brain has not changed since the emergence of modern humans, the neural networks in each individual brain can change by experience. The brain, it turns out, is both constant and "plastic." This is one way to reconcile the fact that, while humans perceive beauty in some common ways, each culture or period in history may see, or define, specific kinds of beauty based on local experience. In his philosophy of judging beauty, Immanuel Kant grappled with this very conundrum: how individual judgment must be free, and yet humans tend to arrive at a similar conclusion about what truly is beautiful regardless of specific cultural norms.

For centuries, the classical and Platonist traditions have acknowledged that people make claims in regard to seeing absolute and relative beauty.[32] In a Platonist psychology, too, the mind is both constant and plastic. The mind recognizes the flux of reality. Plato called this the assertion of "opinion" on the way to true "understanding," which exists in unchanging and transcendent Ideas. This kind of mind—situated between the material and transcendent worlds—is the very premise of religion. In artistic

practice, moreover, the quest of a painter such as Piero della Francesca is no different. The maker of art stands between some unchanging ideal—either transcendent or a product of imagination—and the world of material transience.

On the foundation of neuroscience, the field of neuroaesthetics is attempting to explain the satisfaction—namely, the experience of beauty—that is felt through various kinds of artworks.[33] So far, few art historians have pushed this approach as far as it might go. One of them has been Michael Baxandall, a British historian of Renaissance art. In the positivist tradition of Heinrich Wölfflin and Gombrich, Baxandall proposed the notion of the "period eye," which is a biologically based visual preference of people at particular times and in particular cultures (based on the presumption that their brains have evolved slightly to established tastes for what they experience as satisfying art).[34] Nevertheless, even amenable art historians such as Baxandall have gone down this path of neuroaesthetics carefully, even reluctantly. Of the biological brain's perception of art, Baxandall says:

> The process is indescribably complex and still obscure in its physiological detail. . . . Higher levels of the attentive visual process introduce different kinds of problems, particularly when the attention is to complex paintings, and for various reasons I do not feel the cognitive sciences invoked here [in his overview essay] offer art criticism as much broadening suggestion for dealing with those higher levels: for that we must go elsewhere.[35]

Baxandall is saying that social, cultural, and educational factors are the "higher levels" that finally may determine why, for example, the Italian Renaissance celebrated its type of art while art patrons in China or Africa had different tastes. With such major caveats in mind, the field of neuroaesthetics nevertheless presents a range of theories based on experiments

with the visual system. How, then, have these theories interpreted some popular types of paintings? Second, what might neuroaesthetics say about the works of Piero della Francesca (whose works, meanwhile, have not been subjected to a full neuroaesthetic analysis)? Some of the published neuroaesthetic conclusions about well-known kinds of art include:

- Paintings done in the Renaissance tradition of perspective and naturalism offer a geometric reality that satisfies the visual system's quest for clarity, essences, and constancy.[36]

- Realistic paintings that offer a degree of ambiguity also satisfy the brain's ability to fill in constants where a familiar setting is otherwise not too precise. One example is a Vermeer domestic scene that does not reveal all the details behind the human circumstances. In such cases, the mind can insert into the visual scene an archetype from memory (or, from a metaphysical standpoint, what Plato might call a universal Idea).[37]

- Many kinds of paintings play off the eye's focal and peripheral vision and thus send a kind of unique stimulation to the brain. These optical effects would include, for example, the way peripheral vision picks up a shadow around the *Mona Lisa*'s mouth that makes it seem like she is smiling—when she is not exactly doing that. The peripheral vision of viewers is also active in filling in colored areas in Impressionist-style paintings that otherwise lack precise shapes and edges; this visual filling-in gives even sketchy Impressionism a solidity and reality that satisfies the mind.[38]

- Abstract art has been useful in studying neuro-responses because it activates the most basic feature-detector neurons in the visual system, those that detect strong edges, directions of lines, and contrasts in luminosity, including color contrast. In studies of blood flow in the brain, abstract art stimulates

certain visual-detector cell areas without fail, whereas art that is more representational—adding a complex story to be interpreted by the viewer—will disperse the blood flow to other higher areas of mental perceptions as well.[39]

• Many kinds of modern paintings stimulate the mind by confounding its What and Where systems. For example, Impressionism and Post-Impressionism—from a Monet to a Seurat—create their famous flickering sense of movement and light because the What system finds recognizable objects, but the Where system cannot always find precise edges. Similarly, when confronted with Cubist paintings that suggest a fragmented reality with many viewpoints, the What and Where systems are stimulated by the discordant perceptions. The brain attempts to arrive at an identifiable essence: a violin or portrait hidden in the Cubist painting, for example. The brain must compose the essence out of multiple viewpoints and memory, much as the brain over time creates knowledge and memory out of constant fragmentary views of well-known things in the world.[40]

• Paintings with a wide range of luminosity strike visual perceptions as particularly rich because they emulate all the subtleties of seeing in the real world. The range of dark and light used by Leonardo da Vinci and Rembrandt, for example, exploits the satisfaction that the brain normally experiences from familiar luminosity contrasts found every day in nature.[41] The same is obviously true the world over today; but historically, such three-dimensional modeling with luminosity is a unique innovation of European art (only later adopted, for example, by Japanese painters, or painters in India, who added this range of modeled luminescence to their flat and high-contrast prints, miniatures, and screen paintings). Hence, the old European masters continue to be admired today for their subtlety of using a scale of values

of luminescence to create a sense of space (rivaled only by photography, centuries later).

Given this range of findings—and there are more—what can neuroaesthetics say about the enduring attraction to the works of Piero della Francesca? Connoisseurs such as Roberto Longhi have described Piero's unique visual effect as "color-form," Bernard Berenson spoke of his monumental stillness as the "ineloquent in art," and Roger Fry pointed to the marvelous "plasticity" of his paintings. Now that neuroaesthetics is providing an additional vocabulary in art appreciation, we can follow that line of speculation to Piero and ask: How might his art conspire with the strengths of the visual system to evoke mental satisfaction?

Like a good many painters, Piero starts by simply hitting upon rudimentary features in biology that make visual art compelling. His perspective provides a clarity that satisfies the mind, and, by the care in which he organizes his objects, Piero creates a unique illusion of space, certainly quite novel in the Renaissance, but still engaging for the human eye today. Closely related to this, he portrays reality with a naturalism that very nearly becomes pure geometric shape. These set up a wide variety of edges—vertical, horizontal, curved, and diagonal—that in turn set off feature-detection cells up the line toward the visual cortex and beyond.

Piero's realism activates the mind's power of depth perception, as has been analyzed in perhaps the only study that attempts to probe the effect of a Piero painting on the brain. This is Baxandall's analysis of Piero's *Resurrection*. While it is not based on a laboratory experiment (in which, for example, subjects are wired to brain scanners as they look at a Piero painting), Baxandall brings to bear much that is known about how depth perception works. It is new, but also old, for Baxandall covers tricks well known by some Renaissance painters and by methods that Hermann von Helmholtz, a century earlier, had summarized in his lectures on physiological optics and painting. In this updated survey, Baxandall credits the *Resurrection* with providing ten cues to the brain—from foreshortening to shadows and object sizes—to make it think it is seeing authentic depth.

One new feature identified in research on visual psychology is called the "texture gradient," which Baxandall also adds; it is the way a surface's visual texture changes as it recedes into the distance, which a skilled painter may replicate.[42]

This sort of analysis may also suggest the effectiveness of Piero's geometric use of perspective, his famous "power of lines." However, it has today been argued that modern viewers don't need mathematical perspective; they just need enough in the way of visual cues—a few suggestive lines, for example, or some visual tricks on the Baxandall list—for their brain, conditioned for generations by photography, to decide it is seeing the full-blown illusion of depth. If Piero were painting today, in other words, he could put aside his Euclid, compass, and ruler and apply his brush more casually. According to experimental psychology, the modernly conditioned brain will fill in the details in even an ambiguous painting.

This is the theory of "mental sets," advocated by Ernst Gombrich, who said that the "laborious constructions [of Piero] ceased to be necessary for the suggestion of space and solidity when the public was prepared to 'take them as read' [i.e., take them on faith]." Piero's hyper-perspective, with its overbearing power of lines, might even be repellent, Gombrich suggested: "Once the requisite mental set was established among beholders, the careful observation of all [perspectivist painter] clues was not only redundant but something of a hindrance."[43] Nevertheless, while such laborious geometric constructions may no longer be needed to suggest space, especially in modern or Impressionist painting, the value of Piero's clarity seems undiminished. Our over-acquaintance with perspective has come primarily from still photography, with its images of railroad tracks meeting on the distant horizon. But it remains clear that Piero achieved his unique effects by way of a difficult manual craft.

Although very few of Piero's works use a strong chiaroscuro, which provides the highest contrasts of luminescence, Piero strikes a consistent balance of dark and light. The effect is one of full sunlight, generally. This often is accented by a cool range of colors, all of which produces a pale harmony that, for reasons beyond the detection of science, is acknowledged as pleasurable. Perhaps deep in the human brain, the full light of day is greatly valued (for effective living and survival), and on that basis

the paintings of Piero have been spoken of as idealized portrayals. They turn organic forms into geometric or ideal Platonic shapes. They offer utter clarity across a visual field.

Piero also produces exotic effects. Often the colors he puts next to each other are of a similar luminescence, and this sets them up to flicker when, as in Impressionism, the What and Where sides of the visual system are dealing with edges of different shapes, and yet shapes with equal luminescent values. The other effect here, which is why Piero has been tied to Cézanne and Cubism, is the way his equally luminescent colors can at times flatten his painted world (just as his clever use of perspective lines can play "spatial games" with perception, making objects in a painting appear both far and near, depending on the distance at which a viewer is standing).[44] A vibrating visual flatness (with no perspective to contend with) can be activated by close color values or by an arrangement of contiguous shapes, and these, in the parlance of modern art, can seem to be "pushing and pulling" on the surface of the painting (another way of talking about Fry's plasticity).

Piero's other unusual effect is to freeze action, which assaults the brain with a thrilling anomaly. In real life, action is seen in glimpses; the eyes dart around constantly, catching instants of flux. All along, the brain sorts through the myriad data to build a constant picture of motion. To the contrary, Piero petrifies motion in a way anomalous to the brain: action is seen, but there is no flux before the eyes. Of course, this is a visual effect well known in stop-action photography. Back when Piero plied his brush, his inert imagery must have conveyed a compelling quality, as it still does. The stillness, when there should be motion, is taken by the mind as counterintuitive. In this, the mind senses something abnormal—and "beyond normal" is one definition of a transcendent experience.[45]

There are other ways that Piero's art might trigger a transcendental experience. Studies of brain activity in subjects viewing artworks show that, once basic "feature detectors" are in action, paintings with narrative stories, human faces, or identifiable atmospheres move into the higher mental capacities.[46] The visual cortex is pushed to its limits, and the What and Where systems have been brought into full awareness; beyond them, however, the mind must apply imagination, memory, and even intuition to

find sense and meaning to it all—to find its essence. This process endows Piero's works with their eerie, mystical, or Platonic feeling.

The aforementioned experience applies almost entirely to representational painting, which requires the mind to interpret a complex story in addition to shapes and color. Neuroaesthetics argues that some representational paintings can give the mind an additional way to experience the search for essences. One example is the work of the Dutch painter Vermeer, who presents a realism that may nevertheless remain ambiguous in terms of what really is happening in the painting. Thus the brain fills in that vacuum with essences from its memory, and this presumably evokes satisfaction in the mind. Even though Piero might paint in visual clarity, the painting's story can remain ambiguous. Who are those people, what are they doing, and why? In most of his works, Piero pursues what Alberti called historia— an evocative, perhaps well-known, story. Yet those same works can activate the fill-in-the-meaning part of mental perception, adding to their appeal.

For those who find such neuroaesthetic interpretations unsatisfying, perhaps the best single explanation for the many effects that Piero has on viewers comes from the connoisseur who simply declared that Piero is an "artist of unrivaled visual sensibility."[47] Yet there is one final type of essence in art that the mind can find extremely satisfying, and this not only applies to *all* painters, but would find few doubters as well. This essence is what psychologists call a knowledge of the back story. What is the story "behind" the work of art? Typically it is the story of a person who possesses an impressive skill, an enchanting personality, or an ability to pull off a virtuoso performance. When people know the back story, the impact on human perception is one of more fascination and more mental satisfaction.

Knowing that a real person stands behind a work of art, thus establishing its origin, has defined the prices in art markets from time immemorial. A high price is put on an object by its authenticity, not simply by its perfect imitation or high quality.[48] Fake Vermeers have looked exactly like the real ones but, when found out, they become valueless. There has never been a great controversy over an attempted fake Piero being floated on the market by evildoers. However, during the nineteenth century, a number of would-be Pieros were bought by collectors or museums, such as the National Gallery in London and the Louvre in Paris, only to be

traced finally to other early Renaissance sources. As predicted, those non-Pieros have not risen in fame, while the few real Pieros that reached the West—often in deleterious condition—are now viewed as priceless, even national treasures.

In his own day, Piero's patrons worked under the same psychology: they wanted his essence, not just a fine picture. Some of those patrons required that his "hand" alone produce the work. Even today, the few Pieros that may have a strong mark of his assistant's or a follower's hand are demoted in value, even when the non-Piero brushwork is done quite well. In art, it is the authentic story of the artist, in addition to the materials and the skill, that provides an irreplaceable sense of essence to a work.

Piero's story, in all its details, is unlikely to ever be fully told. But over the centuries a combination of new information and the old mysteries has created an "essential" Piero that has added to his appeal, and that is because the human mind seeks essences. At the end of the twentieth century, however, with the discovery of still more new information, the essential Piero was going to be added to again and his story slightly amended.

CHAPTER 11

A Celebrated Life

I n the long line of Piero investigators, the social historian James R. Banker
may have been the most persistent. One day in the early 1980s, the
American professor was again cajoling every bit of Piero information he
could find from the modern-day Sansepolcrans. "I impertinently insisted
that a fifteenth-century 'Libro dei morti' [*Book of the Dead*] be taken from
its display case in the Museo Civico so I could study deaths other than
Piero della Francesca's," Banker recalls.[1] No offense was taken. Banker was
to become one of the great biographers of Piero. In time, he was made an
honorary citizen of Sansepolcro, where in academic retirement he would
live eight months of every year.

Banker had taken a new approach to Piero, reconstructing the environ-
ment and people around him to let him emerge as a person of his time.
Importantly, Piero's family and social context justified a date of 1412 for
his birth, much earlier than once thought, thus situating Piero in an earlier
generation of Renaissance painters. The evidence further showed that Piero
had matured as a skilled painter well before his famous appearance in Flor-
ence in 1439, a date by which most scholars—especially Roberto Longhi—
argued that Piero was a Florentine apprentice. For some time, says Banker,
"scholars wished to conceive of Piero as a teenager in Florence in 1439 as

a means of making him a child of Florentine painting."[2] To the contrary, now Piero could be viewed as a regional talent. He was a true outsider and innovator, not an acolyte of the glory-seeking Florentines.

Beyond his art, Piero could also be seen as contributing to science and culture. For Banker, this was evidenced in Piero's mastery of Archimedes. Piero achieved this even though he was not of university stock; he wrote almost entirely in the vernacular and managed a painter's workshop. Nevertheless, Piero breached the barriers of the elite culture of the Renaissance by his work on mathematical manuscripts. His mathematization of geometry and his probable conveyance of Archimedes to others—most notably to Luca Pacioli and then Leonardo da Vinci—was a helpmate in the recovery of Greek science, even a prelude to the Scientific Revolution.[3]

This new ranking of Piero as an important contributor to cultural history, both in the sciences and art, did not come quickly. The lost foundations of Renaissance history had to be cleared again in the mid-twentieth century, allowing for a new period of rigorous research. The nature of the Renaissance itself was being debated anew and, for the first time, a generation of English-speaking researchers seriously entered the fray of archival research and cultural interpretation. Naturally, Piero and his age were thrown open to new viewpoints and, indeed, to new technological interventions; cutting-edge art conservation would illuminate the material world of Piero in ways not possible before.

Banker's work on Piero was part of the historical ebb and flow of the American interest in the Italian Renaissance. From the nineteenth century, the Renaissance had a storied place in American literary—if not religious—culture, an echo of the English penchant for all things Italian in the time when the "primitive" art of Piero was rediscovered. It was not until after the Second World War, however, that the United States produced its own intrepid teams of Renaissance investigators, such that one historian could say "For about twenty years following the mid-1950s, [the surge of interest in] Renaissance history was a great success story."[4]

To make their mark, the Americans had to imitate their Italian predecessors. They had to scour the obscure, sometimes confusing archival materials in Italian vaults that still held secrets from the late medieval period and the Renaissance. Besides the various archives in Rome and the

Vatican, the richest source was still the State Archives in Florence. That is where the American search for the Renaissance began.

Among a small cadre of Americans who made this journey abroad—forming a vanguard of sorts—was the young scholar Marvin Becker, who was, in fact, Banker's teacher at the University of Michigan.[5] In tandem with the Marshall Plan, young Americans interested in European history began to travel to Italy in academic programs. A war veteran with a newly minted doctorate in medieval Italian society, earned in 1950 from the University of Pennsylvania, Becker began to seriously study the so-called "problem of the Renaissance" under a Fulbright scholarship. His teachers had been in the tradition that saw the real European renaissance in medieval times, even as early as the twelfth century. Nevertheless, in 1953, Becker headed for Florence to find out how that city, at the end of the Middle Ages, had developed as a commune pursuing liberty and economic cooperation, a significant step on a continent still dominated by feudalism, princes, and kings.

The migration of German scholars to America had already shaped a general approach to the Renaissance. On the rigorous side, the German approach investigated the economic and political forces of the time, but then on the visionary side it interpreted the Renaissance as a source of humane values for modernity.[6] For the Americans, caught in an era when democracy and totalitarianism were at loggerheads, both the rigor and the vision made good sense. They would find a German example, for instance, in the Renaissance scholar Hans Baron, an émigré sociologist, whose *Crisis of the Early Italian Renaissance* looked at how Florentine tax policy created a communal system. More influential, though, was Baron's argument that the Renaissance revival of classical sources produced a philosophy of "civic humanism" and thus a guiding light for liberal Western democracy.

A young scholar such as Becker would echo this dual approach. He dug into the minutiae of old Florentine economic records to understand how that society had functioned and changed. For relief, perhaps, he also turned to a good deal of the émigrés' more visionary literature, reading the works of Ernst Cassirer, Erwin Panofsky, and others such as the Italian philosopher Eugenio Garin, all of whom believed that art, culture, and philosophical trends had significantly shaped Renaissance society.[7] Like others, Becker was swept along by the general search for the roots of liberal democracy, and not a few American

scholars were taken by the idea that the humanism and rationalism of the Renaissance might hold clues to democracy's future.

This all seemed especially relevant as long as the Renaissance retained its identity. The idea of the Renaissance as a distinct period, and even—as Jacob Burckhardt had claimed—the "leader of modern ages," had stood the test of time, even through the war years in Europe and the West. That premise, however, was beginning to look too simple, if not erroneous. Had the Renaissance really existed? And did it bode good, or ill, for the future of the West?

A German historical tradition of looking for a turning point in modern Europe definitely bolstered Renaissance identity, but there were more popular buttresses as well to make the idea all the more palatable: the larger-than-life Michelangelo; the perennial interest in the plotting Medici; and, as lighter fare, the allure of Dante and late medieval romance. In England, the artistic heritage of the Italian Renaissance had always loomed large. This explains why, in the postwar years, an outpost such as the Warburg Institute, now merged with the University of London, would shape the Renaissance curriculum in all British universities and stand as a chief defender of its importance for Western history. This defense of the Renaissance, not surprisingly, was enhanced by London's best-endowed art history center, the Courtauld Institute of Art, which soon was in close affiliation with the Warburg Institute, jointly publishing a scholarly journal.[8]

Nevertheless, there was a growing worry that the Renaissance was becoming hard to define. This is one reason for the increasingly piecemeal approach that historians began to take to Italy's past, as evident in the detailed documentary work done by Marvin Becker and other archivists. The American approach even began to limit its focus to be on just one city. In general, it became harder to make sweeping statements about the Renaissance, and much safer to produced detailed and limited arguments. This was a long-term drift in history writing, a drift toward a narrower specialization that one historian called "learning more and more about less and less."[9]

In the face of this, the German émigrés in America, and the Warburg/ Courtauld alliance in England, continued to defend the Italian Renaissance as something more than its parts. As late as the 1960s, Erwin Panofsky fairly represented the pro-Renaissance diagnosis and remedy: "There is a growing tendency, not so much to revise as to eliminate the concept of the Renaissance—to contest not only its uniqueness but its very existence." To defend its distinctiveness, Panofsky used the analogy of the physiognomy (physical shape or appearance) of a human individual. The specifics of a person's life and influence can be elusive and debated, but the basic individuality cannot be denied. A large or small historical period, including the Renaissance, "may be said to possess a 'physiognomy' no less definite, though no less difficult to describe in satisfactory manner, than a human individual," he argued.[10]

There was more at issue than simply defining a historical period, however. For all the apparent liberalism of the Renaissance—communal town councils, celebration of individual achievement, and the embrace of worldly pleasures—there was also an authoritarian aspect, perhaps typified by the Renaissance strongman, or what Machiavelli euphemistically called "the Prince." With this in mind, some commentators before and after the Second World War blamed the "worldly" Renaissance for some of the major ills of the twentieth century, chiefly the rise of totalitarian regimes in Germany, Italy, and the Soviet Union. It was mainly a criticism from religious quarters, a prelude to the modern debate on the origins of "secular" humanism, and how it can unduly empower a police state of experts and bureaucrats, writ large in the social engineering of the Nazis and the communists. Amid the horrors of the twentieth century, the philosophy of Platonism was also blamed for inspiring totalitarianism. The ancient Greek musings were charged, and then indicted, with having been a handmaiden to the later philosophy of Hegelianism—a source for both Nazism and Marxism—with its sometimes brutal view of the march of history under powerful men and states.

At a time when public theology was quite acceptable in the English-speaking world—from the 1930s to the 1950s—a number of Protestant, Roman Catholic, and Greek Orthodox thinkers were forced to look for the causes of modern tribulations, and this led them to assert that Renaissance

humanism had gone awry. The focus on human powers had forgotten a history of spiritual wisdom, these theologians said, leading to a modern "crisis of faith" and a "crisis of the West."[11] Whereas the Jewish intellectuals among the prewar Warburgians in Hamburg had believed that Renaissance humanism provided a tolerant and cosmopolitan culture, from an alternative Christian point of view, the Renaissance and its twin, the Enlightenment, had been seedbeds of human hubris. Gone to their extreme, these early modern visions of human utopia, based on a presumed human genius and power, had in the twentieth century borne season after season of bad fruit: the First World War, the Great Depression, the Second World War, the Holocaust, and finally the mass systems of the Soviet Union and China.

A representative voice of the new criticism was the American theologian Reinhold Niebuhr, a liberal Protestant whose analysis contained both reason and prophetic judgment. The Renaissance was, in fact, "the chief source of toleration in modern history," Niebuhr said. Nevertheless, it was also "the real cradle of that very unchristian concept in reality: the autonomous individual." Taking that further, "the mistake of the Renaissance was to overestimate the freedom and power of man in history."[12]

For many of these religious voices, the alternative was a return to some kind of time-tested tradition. In Catholicism, this was the revival of the medieval synthesis of faith and reason, generally called neo-Thomism. For Protestants, it was the so-called neo-orthodox movement. Based on a doctrinal biblicism or a religious existentialism, this wing of Christianity argued that undue belief in science and political power—a kind of modern original sin—had dispelled faith; without a robust religious faith, the human conceit of tyranny had filled the vacuum.

In many ways, this modern reaction to Renaissance humanism was similar to how, in the sixteenth century, both the Protestant Reformation and the Catholic Counter-Reformation attacked the Renaissance as an errant, even godless, age—or at least one that had gone the way of Greek paganism, not the way of the Hebrew fathers whose faith was not philosophical but was based on revelation from Mount Sinai and the prophets. Now in the twentieth century, even as the Hellenizing liberalization of Christian theology remained, it was the Hebraic side—with its prophetic

voice of warning—that seemed to again rise up against a humanism—and a humanity—gone too secular.[13]

A prophetic voice would also rise against Platonism in ways never heard before. It was a secular and libertarian warning, though it came in almost biblical proportions. This was the voice of Karl Popper, a man fleeing from Nazism as he meanwhile mounted an attack on all forms of racial identity and irrational religion. Popper was a brilliant Viennese philosopher of science, an exceedingly assimilated Jew, and a close friend of the art historian Ernst Gombrich. Faulting every jot and tittle of Plato's metaphysics, Popper reserved his greatest damnation for Plato's politics, at least as found in his *Republic* and *Laws*. The *Republic* proposes the rise of philosopher kings. For Popper, these were history's dictators. They accounted for various "dark ages with their Platonizing authorities." Their acolytes promoted the "Platonizing worship of the state," all of which "links Platonism with modern totalitarianism."[14] Popper's two-part manifesto, *The Open Society and Its Enemies*, scored many points for the cause of rationalism and liberty, but it did begin to sound like Plato had caused every misfortune in history.[15]

As a free-market thinker, Popper felt that the Renaissance had done what it could to end medieval authoritarianism. But academics on the secular left, typically Marxist, were not so sanguine. The Italian Renaissance gave birth to capitalism, among other things, and this made even Renaissance painters a potential target of criticism. They painted not only for the capitalists, in fact, but mostly for opulent courts and self-aggrandizing tyrants. The Marxist criticism had a contemporary bite as well: the royal classes of the past had typically owned all the great antique art in Europe, and in the twentieth century it was still the upper class that bought and sold that artistic legacy. Perhaps Piero was tarred on occasion by the same brush, but it never seems to have been significant.[16] As to be expected, the latest tar-and-feathering of the old masters would begin to take place in the ebullient 1960s. It was a rite of initiation for artists and critics who sought a left-wing credential, and it was easy enough to do, since the great painters of the past had typically worked for right-wing aristocrats. People change, however, and it was not atypical for young radicals, now grown old, to have second thoughts and to admit their admiration of the skill and beauty of works by the old masters.[17] This warming to artistic tradition

on the political left would add to the broader popularity of Piero, for he is sometimes spoken of as a "cult" hero among members of the Western counterculture *du jour*.

In the postwar era, however, the praise showered on Piero came from the mainstream of society for very traditional reasons: nostalgia for better times in Western Christian culture. In 1951, the British novelist Anthony Bertram, a writer of illustrated monographs on famous artists, editorialized on what Piero meant for the crisis of the West: "Piero was a Christian, a mathematician, and an artist. It is the balance in him, his integritas, his wholeness and his holiness, which makes him so peculiarly attractive to us; a steady light above our dark turbulence, a certain star, knowing his way with such assurance."[18] Elsewhere, Piero was simply heralded as a magnificent painter, a lost treasure of culture. "Hitherto considered minor," he was now "elevated to the ranks of the greatest," said France's first postwar cultural minister, André Malraux.[19] It was this sudden interest in Piero that had surprised the art historian Bernard Berenson, prompting him to present his "ineloquent in art" thesis to explain the enduring fascination with Piero.

Although Piero was largely unknown in the United States, the American debate on the identity of the Renaissance began picking up steam during the interwar years. It was clear to American historians that, despite Burckhardt's thesis on the seminal importance of the Italian Renaissance, there may have been many renaissances in European history. These included the Carolingian age of Charlemagne's libraries, the early medieval ferment in philosophy, architecture, and science, and finally the "medieval synthesis" that Aquinas produced between Christianity and Aristotle. In Marvin Becker's field of medieval studies, there remained a strong sentiment that the Middle Ages was the most significant rebirth in Western culture.

Naturally, then, when the American Council of Learned Societies was presented with the idea of creating a Renaissance subgroup, it galvanized partisans for and against. In 1937, that American academic umbrella organization opened the Renaissance discussion by debating Burckhardt's seventy-year-old thesis, but no action was taken. Only after the Second World War did the boom in higher education give birth to something like a Renaissance specialization. First came the fledgling *Renaissance News* periodical. A growing interest finally justified the creation, in 1952, of the

Renaissance Society of America.[20] This was about the time that Becker and others had headed for Florence to dig through its archives.

On these foundations, the new wave of Piero research developed something like a geographical origin. In the case of James Banker, it was the University of Michigan, for that is where Marvin Becker (after teaching at the University of Rochester) would establish himself; there, Becker would inspire many young Americans to study the Renaissance. A geographical locus in England, in turn, seemed to arise from the Warburg/Courtauld alliance in London, and these two institutions became natural springboards for anyone in pursuit of Piero. Such was the case in the 1980s with another aficionado of the Renaissance, the young scholar and future art dealer Frank Dabell. Once he had enrolled at the Courtauld for graduate studies, Dabell put Piero firmly in his sights. In time, Banker and Dabell would spend a good deal of time in the archives of Italy.

Down the road of his studies, Banker became a professor of history at the University of North Carolina. From there, he directed his social history approach at the late medieval period, especially its religious and communal culture. This is what led him to make Sansepolcro, an emblematic town of the Quattrocento, a lifelong case study. In England, meanwhile, Dabell had been casting about for a dissertation topic. The new trend in Renaissance studies was to investigate the patrons as much as the artists. Hence, by the 1980s, Dabell was traveling to Florence, Arezzo, and Rome in search of more information about Piero's patrons for the Arezzo frescos.

When Banker and Dabell began these pursuits, the accumulation of information on Piero had essentially stalled. What was known derived still from Pacioli, Vasari, Gaetano Milanesi, and Piero's modern relative Evelyn Franceschi Marini, an Englishwoman who, by marriage into the Francesca line, had access to sundry family archives. If Banker and Dabell stood on the shoulders of proverbial giants in Piero studies, it would have been the expansive work of Roberto Longhi, perhaps Kenneth Clark's exemplary biography, and finally a 1971 work by the Italian art historian Eugenio Battisti. Patiently, Battisti and a fellow archivist had collected the citations, and some content, of all known documents related to Piero in a two-volume *Piero della Francesca*.[21]

For all this good work, the data on Piero remained inconclusive, and yet an image of him had been set in stone: he was a Florentine apprentice. This claim had never been made by Pacioli or Vasari. It arose nevertheless as the edifice of Piero studies. With a new set of data presented by Banker and Dabell, however, the edifice would begin to crumble.

During their research in Italy, Banker and Dabell were occasionally greeted by scaffolding over Piero's frescos. The science of conservation and restoration had taken off in the postwar years, and Piero's works would benefit from a good deal of this, despite the perennial debate over the appropriateness of manhandling antique artworks. Wars, fires, and floods had destroyed a good deal of early Renaissance art, and it is likely that the bulk of Piero's work had been destroyed by such causes in the first century after his death. His Quattrocento works often were torn down or plastered over by new tenants of palaces or churches.

Those that survive may surprise first-time viewers, who will suddenly realize the scarred antiquity of Piero's oeuvre (despite the beautiful color photographs in books). At such a moment of visual disappointment, viewers may want to recall the wisdom of the art collector John Charles Robinson in his late-nineteenth-century comment on one of Piero's paintings: "It was a venerable relic, and it possessed in certain respects special interest and importance, and the only thing to be done with it was to leave it untouched, inasmuch as the particular interest which still attached to it would be completely destroyed by any attempt to 'restore'—in other words, to 'repaint'—the picture."[22] Nonetheless, repainted Piero was, and fortunately most such modern conservation efforts have been praised as authentic and successful.

Before such restoration is even possible, the paintings must have actually survived, of course. During the Second World War, it was a small miracle that more Renaissance art was not destroyed when the Allied bombing and shelling came to the Italian peninsula. The Milan church that housed Leonardo's *Last Supper*, for example, was left in ruins but incredibly the fresco inside was untouched (even though it, too, is now considered to be

only about 20 percent of the original paint applied by Leonardo, the rest coming from restorers over the centuries).[23] South of Milan, the war nearly erased Piero from the heart of Sansepolcro as well.

By August 1944, the Allied forces had taken Rome and were pushing the German Tenth Army back past a line between Florence and Rimini. British units spearheaded the charge up the Apennines and central Tiber Valley toward Sansepolcro. At some point, Captain Anthony Clarke of the British Royal Horse Artillery was ordered to bombard Sansepolcro to soften up any German resistance. Earlier, in the spring, the Allies had been able to capture Rome by winning the battle of Monte Cassino, which required the utter destruction, by bombing, of the ancient Benedictine monastery, serving then as the German holdout and high observation point.

Captain Clarke may have been thinking of the tragedy of such destruction of history when the name Sansepolcro suddenly triggered a memory. Years earlier, he had read the travel essay by the English author Aldous Huxley that said Sansepolcro held "the best picture in the world." Huxley was marveling at the *Resurrection*, the fresco that continued to decorate the Sansepolcro city hall. Risking reprimand, Clarke ordered the battery of cannon to fall silent. His commander radioed him to begin firing again, but Clarke stalled for time. He looked through his binoculars and said he could not see any German targets to aim at, and fortunately, their retreat was soon confirmed. Clarke may have received a mild scolding for his hesitancy, but for that he would take an equally small position in art history. Sansepolcro's iconic Renaissance bell tower, or campanile, would be destroyed during the war, but not its most revered civic painting. One day, a street in suburban Sansepolcro was named after Clarke. He became the "man who saved the *Resurrection*."[24]

Much of the art of the Renaissance has also been in need of saving, and that had been the quiet and piecemeal activity, over the centuries, of owners and dealers who wanted Renaissance works to look their best. This was the world of art conservation, which has grown increasingly sophisticated with the tools of chemistry, materials science, and infrared and x-ray technology. Remarkably, the new technology can flawlessly lift entire fresco surfaces from the ancient plaster and put them on a backing of steel or fabric.[25] While such high-technology techniques suggest a hands-off approach, there

is really no escaping the essence of conservation, which means a certain amount of cleaning, a topic of continued controversy. Cleaning has often proven to bring a painting back as close to the original as possible, but also sometimes to ruin it, and thus the controversy continues. After a cleaning there may be "touches," a euphemism for new paint. All of these steps have proven inescapable, it seems. It has been estimated that nearly all known Renaissance tempera panels have areas that are repainted, and this would include works by Piero, both on panels and in fresco.

In memory, only one of Piero's surviving works had reached the precipice of destruction by means other than war, and that was the Misericordia Altarpiece in Sansepolcro. During a fire sometime before the seventeenth century, the flames licked at its panels, but it was duly touched up and put in a gaudy baroque frame. Then it was separated into pieces for a century, finally reunited at the turn of the twentieth century, a full altarpiece put on display at the former Palazzo Comunale, or city hall, in Sansepolcro.

Perhaps the two most notorious cases of restoration work on Piero's legacy would be his *Resurrection* fresco and his panel painting, done at the end of his life, the *Nativity*. If the *Resurrection* fresco had received some cleaning over its early lifetime, it was given the shock treatment in the eighteenth century: the fresco was whitewashed over. Thanks to its durability as true fresco, it could be cleaned and restored, although the frame of Corinthian columns that Piero had painted around it has been much trimmed away. Similarly, the fate of Piero's *Nativity* has been much debated. Was it a finished painting, or did Piero stop before he was done? Many areas seemed to be sketchy or poorly done. No strings exist on the lutes. Although this question is not absolutely resolved—even though it is logical to think that Piero finished the work—it is clear that the *Nativity* had suffered a good deal of over-cleaning, burnishing off the original paint. Here and there, amateur restorers tried to repaint what was lost.

It has always been tempting to fix up Piero's smaller works as well. When Piero did an altarpiece, with its central paintings, he also produced many of the side panels. These were separated off as individual artifacts over time. They exchanged hands between collectors and art dealers and, just as certain, underwent enhancing restoration. Such was the case with the small but brightly elegant *Crucifixion* panel in the Saint Augustine Altarpiece in

Sansepolcro. Mercifully, though, the painting retains its original colors and composition, if not every original stroke by Piero's hand, having been "restored several times" by connoisseurs and collectors.[26]

Beginning in the early 1950s, Piero's work began to benefit from the careful attention of the newest technologies. His *Senigallia Madonna* was cleaned, which included the removal of paint added by earlier attempts to "repair" the old picture. The *Flagellation* panel also received a beneficent cleaning, and, in the case of such complex works, more details could be seen. In Rimini in the 1950s, the fresco *Sigismondo Malatesta before Saint Sigismondo* also was cleaned. From behind many centuries of dirty patina, the original Piero was revealed. For the first time to the modern eye, it featured a remarkable amount of subtle decoration and color, from the robes on the human figures to ornate lines in the simulated architecture.

Piero's Perugia polyptych—the Saint Anthony Altarpiece, with its odd pointed steeple—was also gone over in the 1950s. The debate here had been whether it had been all one composition at its creation, or had later interlopers patched its odd shape together from different broken altarpieces? While Vasari had commented on the beauty of the taller-than-usual Perugia polyptych, it was not so glowing to later eyes. One mid-nineteenth-century account said its parts were "so ruined and greatly repainted, that they look more like copies than originals by Piero."[27] Owner-devotion to the old work never flagged and it, too, was given a new life by a series of professional restorations. Its dismantling in the 1990s would seem to resolve the running dispute: it was in fact a single construction, and if the top looked odd, that was simply because someone had cut it into a point, trimming off some of Piero's original composition in his famous portrayal, bristling with perspective, of the Annunciation.

In England, the *Baptism*—perhaps Piero's first major work—was cleaned, analyzed, and touched up in 1966. The same was done in 1968 with Piero's early *St. Jerome* (now in Berlin), revealing a more authentic reading of his early landscape style. In these two paintings, Piero's panorama of Tuscan geography was seen more plainly, describable as browns of baked earth contrasted to summer greens. Also, it was now clear that in the *Baptism*, Piero had changed some aspects of its composition as he went along. In time, more Piero works received such analysis.

As the five-hundredth anniversary of Piero's death approached in 1992, the decade before and after bracketed a period of concentrated restoration projects. Piero had become a national treasure. So it was that the Italian government cleaned his popular standalone fresco *Madonna del Parto*, a small monument in the city of Monterchi. Of all such cleaning projects, the two most storied would be the long, drawn-out restoration of the Arezzo frescos, begun in the 1980s, and the restoration of Piero's large oil-painted altarpiece picturing Federico da Montefeltro, completed in the 1990s.

When Napoleon's art collectors found the Montefeltro altarpiece, it was generally thought to have been done by a minor painter. It had impressed enough, though, to merit shipping to Napoleon's Milan art museum, the Brera. Seeing the altarpiece in the mid-twentieth century, when it was determined to be by Piero's hand, even so admiring a writer as Kenneth Clark felt it was evidence of Piero's decline: the aging artist had apparently lost interest in painting. However, what Clark had seen was a dull, grime-covered work. A cleaning and touchup in the 1990s brought back an oil painting with the richness of a glossy color photograph. The conservation team also discovered that the right side of the panel had been trimmed and the bottom plank removed. Another mystery solved. The altarpiece had always seemed off-kilter, and the missing pieces explained why. Originally, Piero had painted it in perfect symmetry and perspective.

The Arezzo frescos, by their enormous scale, suffered the fate of any large old church with sinking walls and cracking plaster. A few centuries after Piero painted the walls, supportive iron bars were inserted between them. This naturally interrupted or damaged some of the fresco surfaces. Once the Arezzo frescos reached a dangerous state of affairs, they had their first major restoration. This came in 1858. They were restored again by a different expert, with a different effect, in 1915.

Presently the Piero quincentenary—1992—appeared on the horizon and, thanks to the philanthropy of Italian bankers, the Arezzo frescos would receive their fullest restoration. The work began in the mid-1980s, but by one account, the "huge restoration project unfolded very slowly, Italian-style," missing the goal of a 1992 opening. It was completed instead in 2000.[28] Reportedly the care and sophistication of the restoration work, though dogged by technical difficulties, was more complicated than even

the Sistine Chapel restoration that was taking place around the same time in Rome. The Arezzo work revealed basic knowledge of how Piero proceeded with such techniques as sinopia, pouncing with cartoons, and painting highlights and glazes. It was seen that his smaller fresco, *Dream of Constantine*, was composed of ten separate patches of plaster, each laid up on a different day of work. Everywhere, thanks to the original true fresco and some of Piero's durable oils, details not seen before began to appear in many of the fresco cameos.

Archival research on Piero would also bear fruit with just enough new detail to alter the typical story of his life. This resulted from the combined efforts of Banker, the American social historian, and Dabell, the British art connoisseur. When they began their searches for Piero in the 1980s, they knew that the facts lay somewhere in Italy. The most likely and most available source would be the accounting books and notarial contracts either in the State Archive in Florence; in what remained in Sansepolcro; or in what may even have come into the possession of the Vatican during the years when Piero's town was under papal jurisdiction. This put Banker in a situation of frequent travel between the Florence archives and Sansepolcro, a winding seventy-five-mile drive to the southeast.

Though coming of age in England, Dabell had been born on the Continent and lived in Italy in his youth.[29] When he attended Oxford University, it was natural to play his strengths and study modern languages. For graduate school, Dabell followed his family's long interest in fine arts by attending the Courtauld Institute, and that meant finding a research topic that had not yet been done. At first he probed into the early Renaissance painter Masolino da Panicale (1383–1447), who had worked alongside Masaccio, the Florentine pioneer of the new naturalism. On a trip to New York in 1981, though, Dabell discovered that somebody else was already working on that topic. So he switched to Piero and, in agreement with his Courtauld adviser, began to pursue more deeply the story of Piero's patrons in Arezzo. On the way, quite naturally, Dabell checked in at the State Archives in Florence, and it was here that his and Banker's paths crossed.

By the 1980s, the State Archives in Florence was a hive of archival research. For Piero studies, the bible of research was the two-volume collection of available documents, compiled in 1971 by Eugenio Battisti. In all such historical projects, two prongs of work are necessary. One is to verify previous sources, such as even in the Battisti volumes, which in the first edition, for example, had many typographical errors in the very precise citations. The second prong is to slog through archival records that have seemingly been untouched in the modern context, what Dabell calls the "needle in a haystack" approach. "We look for that piece of gold in the mud, and you have to go through an awful lot of mud to get to it."

At this time, Banker's early rounds of research—published piecemeal in journals—were about to appear in a major academic work on medieval society. In Banker's academic era, the majority of case studies on the Renaissance seemed to focus on almighty Florence, one of Europe's largest cities in the late medieval and early modern period. Florence seemed an endless quarry for new studies of its leading merchants, families, political figures, and artists. Bucking that trend, Banker followed a new orientation in his field: to study smaller hamlets. It was an approach that also tried to reconstruct a social history of ordinary people in their time. Banker had chosen Sansepolcro for this kind of case study, and the first summary of his findings, published in 1988, was poignantly titled *Death in the Community: Memorialization and Confraternities in an Italian Commune (Sansepolcro) in the Late Middle Ages.*[30]

By this time, Banker and Dabell were beginning to work on dates related to Piero. Banker was in the lead on this. Foremost, he was able to constrain the possible dates of Piero's birth and early life, presenting the strongest case yet for a birthdate of 1412. He also identified painting commissions that gave plausible evidence that Piero's first major work had been the *Baptism of Christ*, and that it was painted for a church named for John the Baptist. All this was pointed to by records in Sansepolcro and in the State Archive.

From a different angle, Dabell pursued the Piero of Arezzo fame. As the fall of 1983 turned to the winter of 1984, Dabell wanted to find a new source of Sansepolcro documents, so he headed for Rome. He knew of at least one good historical reason that data on Piero might be there. Before the Battle of Anghiari in 1440, Sansepolcro had been in the Papal States.

That meant that documents from the town might well be part of the national archives in Rome, not just the State Archives in Florence. In Rome, the Vatican archives had already yielded some important information on Piero in the twentieth century, but now Dabell asked, What about Rome's state archives? "Things get scattered all over the place," he said. As luck would have it, the state archives did have some old Sansepolcro municipal records, and within these were some old papal payment documents. After a few days of skimming the Sansepolcro material, Dabell came upon such a papal entry, which fairly jumped off the page: an August 31, 1431 notation of a papal treasurer. The treasurer paid Antonio Anghiari and Piero's father (presumably on behalf of Piero) for painting and installing celebratory flags for events in Sansepolcro.[31]

Much as Gaetano Milanesi in the 1850s had turned a page in a Florence archive to find that Piero had been in that city in 1439, Dabell had opened the Rome ledger to a date for Piero's first known payment as an artisan. It placed him alongside Antonio, a master painter. The early career of Piero finally was revealed. "There was an arrow next to it, as if somebody has been here before," Dabell said of the notation. "So the panic sets in." No one had, however, recorded this document in the annals of art history, so Dabell had something new. When he took it to textual experts, they ruled it an authentic entry made in Sansepolcro centuries before. Banker would later remark on the importance of Dabell's discovery: "Up until 1984 nothing certain was known of Piero della Francesca's activity before his [1439] work in the choir of S. Egidio, the hospital church of S. Maria Nuova, Florence."[32]

After all this dust settled, the wider world of Piero scholarship seemed oblivious to the new, potentially revolutionary, findings, even when published. "My discovery and those by Jim Banker were routinely ignored," Dabell said. Banker was looking for hard biographical dates, and Dabell was dedicated to a commonsense approach to Piero's style when so many others wanted to find deep iconographical meanings and mathematical mysteries. Dabell knew that stylistic changes in paintings could reveal the chronology of a painter's life. Beyond that stipulation, however, stylistic interpretations still had to yield to documentary facts, both art-historical and sociological. "My interest was art history, Jim Banker's was [social] history," Dabell said. "Finally, you have the paper trail. That's what it was

about." And that is where he and Banker altered the way that Piero della Francesca's biography can be viewed.

The resistance to their findings showed how much tradition and habit can determine the basic narrative of a Renaissance painter. Part of that habit is always the enduring awe toward Florence. It was natural to believe that Piero must have learned at the knee of Florentines. To say otherwise, according to one Piero scholar, "is to say virtually that Piero sprang from the Umbrian soil with his philosophy almost formed."[33] And yet a new picture of Piero's nurturing, non-Florentine soil was being presented. Banker, too, had entered the field learning that Piero had been a teenage apprentice in Florence in 1439, "making him a child of Florentine painting."[34] To the contrary, though, Piero does seem to have blossomed on his own terms. He rose as a regional painter who picked up observations wherever he could, whether it was through wide travels or study. By the best evidence, he honed some early skills with Antonio, learned more with Domenico Veneziano, and then imbibed from the splendid work of the Flemish, all of this putting him on his own unique path.

Dabell has argued for another needed change, since the habit in Renaissance art history has often been to find a date and presume a person was at that location for a long, substantial, and formative period. Yet it was never quite so in Quattrocento Italy. Painters moved around quite a bit. "You could go from one place to another in a day," Dabell said. "They traveled an enormous amount." Dates in documents can, unfortunately, become almost meaningless, even as they are necessary pointers when history offers a blank.

At the dawn of the twenty-first century, Banker was impelled to follow one more paper trail that seemed irresistible—the suspicion that Piero had copied an entire manuscript of Archimedes. Scholars of Archimedean manuscripts in the Middle Ages had already noticed that Piero cited the ancient Greek scientist with some precision, especially in his final treatise, *Five Regular Solids*. European scholars had also solidified the important role of Piero's relative Francesco da Borgo as an architect, bookkeeper, scribe, and manuscript collector in papal circles in mid-Quattrocento Rome.[35] Adding to this, Banker's own work on the history of Sansepolcrans, including Francesco, convinced him that Francesco had introduced

Piero to a rare Vatican copy of Archimedes during Piero's trip to the Eternal City. All that was needed was a link between these findings and a suspiciously well-illustrated copy of Archimedes that now sat in the Biblioteca Riccardiana in Florence—suspicious because so few people had as good a handle on Archimedes in the fifteenth century as Piero did, and because its exquisite diagrams, accurate and numerous, required a skill such as Piero's to be so well executed. At some point, Banker began spending time in the Biblioteca Riccardiana at the heart of old Florence, only several blocks from the cathedral that bore Brunelleschi's great dome and the baptistery that boasted his bronze doors and was the subject of his perspective drawings.

Managed by a literary society that dated back to the time of Gaetano Milanesi, the Biblioteca Riccardiana is now located in the famous Medici Palace (now also called Riccardi for a later owner). The Archimedean manuscript in question had been among its prize holdings for centuries, along with original works (called "autographs") by Pliny, Petrarch, Boccaccio, Alberti, Ficino, Pico della Mirandola, Savonarola, and Machiavelli. The Archimedes manuscript (a typical compendium of his seven short works) had been bound in various ways over the generations, and its covers still showed traces of the gold trim once applied by an obviously princely owner.

Yet the prized manuscript mentioned no title or author. This is what Banker noticed with trepidation when he began to hunker down over the work in the Biblioteca Riccardiana reading room with its black-and-white chessboard floor and curved ceilings festooned with colorful baroque frescos framed in ornate gold moldings. Suspecting that it might be a Piero—since the diagrams were so meticulous—Banker began looking for all the telltale marks of his handwriting. Thankfully, these came through even in Piero's transcription of Latin: the zig-zag "e," angular "a," peculiar "et," and "g" with a large circular tail.[36] Relying on the judgment of an expert in antique Italian scripts, Banker finally declared in print (2005) that the anonymous manuscript was actually a work by Piero della Francesca. This conclusion was enthusiastically supported (and duly publicized) by the Biblioteca Riccardiana, which has since made the entire fifteenth-century text available in digital form on the Internet.[37]

Why Piero carried out such a laborious project remains unclear. It could have been as a personal possession or for an unknown patron, such

as the Montefeltro in Urbino. Either way, a generation before Leonardo da Vinci, Piero had become perhaps the first workshop artisan to breach the wall of the humanities, heretofore guarded jealously by the elite Latinists and humanists of the university culture.

As ancient manuscript interpretations go, Banker's case for Piero is extremely compelling, yet not unassailable (since, finally, the Riccardiana item has no dates or names). With the bragging rights of a sea explorer who has found land, Banker naturally emphasized the extraordinary implications. Copies of Archimedean manuscripts would have been rare in Piero's time. There were perhaps only five or six, Banker says, and therefore "Piero was probably the only person in the fifteenth century to hold in his hands three of these manuscripts of Archimedes" (two owned by Francesco da Borgo and one of his own making).[38]

Despite such marvelous new ways to see Piero in his time, the discrepancies over dating and the timeline of Piero's life continue into the twenty-first century. The proliferation of subtle and specialized connections—and four hundred years of misnomers—still present a challenge to presenting a clear story.

Nevertheless, there has always been good reason to celebrate Piero, and another opportunity arrived in 1992, the five-hundredth anniversary of his death. It was to be a year of great summation of all that was known—to date—about his life. Only one such celebration had been possible before, and that was because the date of Piero's death had not been known until 1875. In that year the townsfolk of Sansepolcro had recovered a "book of the dead" from the fifteenth century. It spoke of Piero as a "famous painter" and gave the exact day of his demise: October 12, 1492. A plaque with this information was soon affixed to his historic home. The first centenary of his life was celebrated in 1892. At that time, the dispersed pieces of the Misericordia Altarpiece were reassembled in Sansepolcro.

With 1992 on the horizon, something like a national and international commemoration became the order of the day. Significantly, it would also include projects to restore Piero's most famous works. It was not easy to compete with Christopher Columbus in 1992. The five-hundredth year of

the Genoese explorer's voyage was celebrated from Italy to the United States. The Year of Piero was no mean celebration either, it would turn out. It was coordinated, as much as possible in fractious Italy, by a National Committee for the Fifth Centenary (*quinto centenario*) of the Death of Piero della Francesca. Its fifty-one members included Italy's national and local cultural leaders, representatives of the economic development department at UNESCO, and a host of Renaissance scholars.[39]

In addition to promoting international tourism in Italy and various Piero "itineraries," the Piero projects of the year included many that were small, brief moments to commemorate. The largest activity of all was doubtless the fifteen-year restoration of the Arezzo frescos. This guaranteed that some part of the frescos would be covered by scaffolding before, during, and after the Piero celebratory year. In 2000, when the final restoration was unveiled, the steep, walled old town of Arezzo was thronged, its narrow streets hosting more than just the city's monthly antiques fair.

For generations already, the "Piero Trail" and "Piero Pilgrimage" had waxed and waned, as self-guided explorers or those signed up with tourist packages took a Piero itinerary, which typically began in Florence or Bologna in the north, visiting the core Piero territory of Arezzo, Monterchi, and Sansepolcro, and often adding branches to Perugia, Urbino, and Rimini on the coast. The final 2000 unveiling of the Arezzo restoration was a great shot in the arm for this spirit of Renaissance wanderlust. A reported fifty thousand people made reservations to visit the Arezzo church over that first summer. "The 'Piero Pilgrimage' was given a new lease on life," one chronicler said.[40] Several books were written on Piero by art historians, and the two-volume collection of Quattrocento documents related to his life—compiled by Eugenio Battisti—was corrected and updated.

The national committee also helped organize Piero exhibits in four cities where he had lived or worked: Sansepolcro, Florence, Urbino, and Monterchi, his mother's home town.[41] The arrangements were not simple. Piero's work had been dispersed throughout the world, though the vast majority was still in Italy. Some of the favorite paintings were in the midst of restorations, making it difficult to ship them around for display. Various owners of the works, meanwhile, were reluctant to loan them out

for transport to other exhibit locations, presumably due to the perils of transporting delicate antiques. Some of Piero's works did hit the road, however. Outside the city of Monterchi, the pregnant *Madonna del Parto* was gone from what has been considered her original location in a rural chapel. She was temporarily moved to the Monterchi city museum, where the restoration process was part of a 1992 public exhibit. Not only was this restoration work on the *Madonna del Parto* a perennial controversy for some in tradition-minded Italy, but the debate also continued on whether to move the beloved Piero artwork permanently from the outskirts into town.

The museum directors in Urbino wished that the owners of various Piero works had been willing to lend them for an exhibit, but to no avail. The Montefeltro altarpiece stayed in Milan the entire year. At least, the recently restored Malatesta fresco—which had been removed from the wall and adhered to a permanent canvas support—was carried to the rocky precipice of Urbino to be shown with Piero's *Flagellation*, his *St. Jerome* from Venice, the *Senigallia Madonna*, and parts of the Saint Augustine Altarpiece (which Piero had painted for Sansepolcro, but whose parts had been scattered to the winds). All of these were exhibited at Urbino's Ducal Palace, where visitors could walk in the stone hallways that Piero himself had once navigated.

While the Sansepolcro exhibit boasted a hometown hero, the city was limited to augmenting its few Piero originals with examples of other regional art that had been created before, contemporary with, and after Piero. The Uffizi Gallery in Florence took the prize, according to critics, by mounting an exhibit on "A School for Piero," suggesting again that Florence had provided his training in "light, color and perspective."[42] Only a few paintings by Piero were available to show along with other color-and-light painters who worked in Florence. The supreme example of this style was Domenico Veneziano, the one painter who has a documented relationship to Piero—though it still is uncertain whether he and Piero worked together mostly in Florence or outside the city.

Several academic conferences on Piero and his time were held in Italy. For the English-speaking world, the high point was a two-day consortium in Washington, D.C., sponsored by the National Gallery of Art.[43] In addition to the delivery of eighteen scholarly papers and the unveiling of a new

computer program to analyze fresco-cycle arrangements such as at Arezzo, the two Piero sleuths—James Banker and Frank Dabell—presented once again their new findings that dated Piero earlier than generally thought. At a roundtable event, they argued that it was urgent to compile such new information in an easily accessible place. The old data on Piero, much of it erroneous, still seemed to dominate popular and scholarly treatments of his life.[44]

The conference had been held in December, and in the next month—January 1993—Banker published his first article on documentary evidence that suggests that Piero was born in 1412 and that his *Baptism* could have been painted as early as 1438.[45] A decade later, in 2004, Banker was still at the task of separating the wheat from the chaff. "The extraordinary number of publications on Piero della Francesca presents scholars with the difficult problem of mastering the literature on this painter," he said. "Added to the problem is that in the past decade previously unedited documents have surfaced that require a rethinking of interpretations that have long been thought to be secure."[46] Indeed, in homage to Eugenio Battisti's compilation efforts four decades earlier (*Piero della Francesca*, 1971, updated in 1992), Banker was bringing to completion a new compendium, to be published in Italy, of all available documents and sources related to the life and times of Piero, including much that was new. A somewhat new Piero, it seems, was being put on the record.

New milestones on the life of Piero continued to come and go, such as the 2012 thousandth anniversary of the founding of Sansepolcro, which now deems Piero its most famous native son. The next year, the Frick Collection in New York City, which is the largest owner of Piero works in the United States (owning four of the now-separated panels from the Saint Augustine Altarpiece that Piero had painted in Sansepolcro), held the first-ever exhibit on "Piero in America." At this event, a number of emerging Piero-and-the-Renaissance scholars acknowledged that the exhibition's new image of Piero—as a self-made artist and mathematician—was a "tribute" to James Banker's long-suffering research.[47]

For all the rethinking of the historical Piero, it has long been evident that he was a man of deep personal interests. These ranged from art and

religion to "science" and Platonism. Such themes are perennial, and they allow us to rethink Piero's legacy from a contemporary point of view. What do art, religion, and science tell us about Piero today, and whither the influence of Renaissance Platonism in the modern world?

Epilogue

A s travel books and tour packages attest, the regions of central Italy that were Piero's home ground—Tuscany and Umbria—retain much of their flavor from the past. The summer light still explains the bleached colors that Piero often used in his works. As ever, the steep hills and winding roads chart the miles that Piero must have traveled. Standing in the streets of the walled old town of Sansepolcro, you can imagine the time in 1431 when Piero saw his painted candle in a religious parade; or the day in 1859 when the British art buyer John Charles Robinson showed up at the cathedral to take Piero's *Baptism* across the Atlantic.

After several centuries, there also remains in the Western world a strong residue of Platonist tradition, both Christian and secular, which during the Renaissance had offered a means to integrate art, religion, and science. Throughout this story, we have imagined that it was also a belief system that helped Piero harmonize his own aesthetic, spiritual, and intellectual experiences. An argument may also be made that even today, Platonism offers a plausible way to understand the nature and limits of human perceptions of the world, both sensible and intelligible.

How is this so?

At the most fundamental level, Platonism tells us that the world and experience are made up of essences and particulars, transcendental realities and material things. The mind and the physical senses endeavor to penetrate

these, but within limits. In turn, these limits allow a tentativeness in human knowledge, and thus enough ambiguity to avoid whatever ultimate conflicts may arise between the vying claims of art, religion, and science.

The usefulness of this outlook is manifold. Perhaps most important, it allows us to retain an aesthetic and spiritual aspect of perception in a scientific age. Some quarters of science will claim that such experiences are strictly produced by matter in motion, nothing more. However, the broad swath of humanity surely sees the need to balance science with the world's spiritual traditions, and the broad Platonist outlook on reality offers a kind of middle path to achieve this. It recognizes scientific progress, but also the provisional nature of scientific knowledge. It holds out the possibility that behind nature lies a transcendental reality, something with a quality of universal meaning, yet not necessarily with a doctrinal or ideological specificity. When Einstein asked whether the universe is, quite simply, friendly toward us or not, he was alluding to a Platonist kind of choice, even a religious choice.

Depending on one's "friendly" point of view, the transcendent realities of Platonism can be taken to mean the rationality, or mathematical nature, of the universe, or taken to mean the mind of God. In Piero we can find both, it seems. On one front, Piero's paintings convey a sense that universal beauty, religious belief, and science can coexist on relatively friendly terms. In a second line of attack, his work with mathematics foreshadows the modern world's reliance on numbers and our continuing suspicion that somehow—and for some transcendental reason—the universe is rational. The universe is here for our minds to understand within the great Platonist limits of the sensible and intelligible powers of human perception.

The Platonist legacy of the Renaissance has also perpetuated the healthy debate on the nature and origin of beauty. It has produced our modern fascination, moreover, with the concepts of human imagination, intuition, and insight. From where do these intangible qualities come? How does an insight arise? Having evolved out of Platonism, the continuing belief in intuition as a non-material quality in human life and human achievement suggests that there is something about the mind that is greater than its parts. Even scientists, drawing the line at religion, nevertheless speak of

the physical brain as producing "emergent" properties that seem to have a nature of their own.

Platonism since the Renaissance has proved relevant to art. It has allowed the belief that finite human ideas can participate in some kind of higher Ideas in the universe. Even for science, this notion of a transcendent order that makes contact with the human mind is one way to explain why the world is as intelligible as it seems to be. Otherwise, how could the mind know, or discover, the secrets of nature or produce the highest forms of creative beauty?

The seemingly scientific, or "positivist," approach to art history has been extremely productive, giving us the unadorned facts and sloughing away the hearsay and falsehoods. Nevertheless, not all the facts are available, and even they can be interpreted in a variety of ways. Once the sensible facts of a painting have had their say, it is something intelligible about the painting that finally inspires the viewer. Art historians have always seemed to know this, and it has created the urge to produce interpretations of art, what Plato might call "opinions," and yet which require both intuition and insight. This is the motive behind connoisseurship and especially iconology, the attempt at a "deep" interpretation of art's reality. Beyond iconology, the idealist tradition of intuition also defends the belief that art can have something to do with religion or spiritual experience.

The modern world has been rich with debates on the nature of things, and, in general, Platonism has been the bulwark for metaphysical idealism, a chief Western alternative in the age-old debate with materialism, now called scientism or scientific positivism. Neuroscience is only the latest science to join positivism's debate with metaphysical idealism. From time immemorial, psychology has tried to explain, or "explain away," religion. This continues with neuroscience, which has expanded its territory now to include explaining (or explaining away) the biological experiences of the pleasures of art.

As the feeling of beauty is being reduced to neurons, Platonism offers an alternative (or an add-on) that retains a transcendental element. Both neuroscience and Platonism recognize that the mind seeks constants and essences.[1] Whereas positivist science will say that these are byproducts of the brain alone—a phantasm generated by one hundred billion nerve cells

and their one thousand trillion connections—Platonism adds the other plausible possibility: essences exist in some transcendental way, perhaps in the mathematical rationality of the universe, or perhaps in the thoughts of a Creator.

The modern fields of developmental and cognitive psychology have explained why the human need for essences will not go away. From childhood, humans believe in a basic nature to things in the world. The child's mind innately produces types and associations.[2] It also attributes powers to inanimate things, as if a tree, a storm, or an animal is a person like them. Adults don't easily give up this orientation, and in culture that is the foundation for religion. This all springs from what some psychologists have said about human beings from childhood to adulthood: we are "intuitive dualists" and "intuitive essentialists."[3] Our physical brains, and our coming of age with five senses, persuade us that there are transcendent things (like minds) and there are essences (constant ideals and types). To destroy these intuitions will take years of rigid Epicurean education. Even then, the avowed positivist or atheist will speak of a faux transcendence, a sense of awe, wonder, or the numinous.[4]

Whatever the true case about the origin of essences, we know that they are central to human perception. Humanity will always feel that there is "something more." Even as the best scientists have told us, there is no way to prove or disprove such claims. Platonism takes the broadest approach. The modern world has recognized the limits to human knowledge (as derived from the physical senses), and this fits well with Platonism. In a very modern way, Plato had said the senses and human opinion are natural steps to try to understand the world. These steps can aim for a final truth about the nature of things. Those heights, however, will always be higher than our human reach.

The life and work of Piero della Francesca remind us of this Platonist legacy since the Italian Renaissance, and they do so in five ways. First is Piero's use of mathematics. It set him apart during the early Renaissance but also foreshadowed the future in science. Some would say that his mathematics

is what has made Piero so interesting to the modern world. Others have argued that he pioneered a new kind of mathematical literature, and thus was an early link in the chain of Western science. The social historian James R. Banker is only the latest to make this case for Piero's scientific contribution. After Piero applied mathematics to geometry, "It was just another step to say that this numerical geometry expressed the underlying structure of nature," which is one definition of the Scientific Revolution.[5]

For Piero, the great truths and certainties of mathematics and geometry were found not only in Archimedes and Euclid, but also in his Christian tradition, which combined the Bible and the Platonist outlook. In the Hebrew account, God "ordered all things in measure and number and weight," and in Plato's *Timaeus* the things in the world are "perfected and harmonized in due proportion" by "the ratios of their numbers, motions, and other properties."[6] That geometrical quality is an essence to Piero's paintings. Our response to a painting by Piero may indeed arise in part from the biology of our brain enjoying the constancy of geometry. From a Christian or Platonist point of view, it may also arise from an experience of something transcendent.

A second feature of Piero is this reminder about the role that science can play in the world of art. His challenge was to render linear perspective, apply mathematics to geometry, and identify perfect geometrical shapes. He did all this on the presumption that the mind had a true way of seeing the world. Today, that question of perception has shifted to psychology and neuroscience.[7] Natural science grapples relentlessly with how nature produces such human experiences, and, just as with the phenomenon of wave-particle light, the answer may remain elusive.[8] To some degree, neuroscience may explain why material images can have such a powerful effect on the mind, generating pleasure. One such mental thrill is the "counterintuitive" experience, which cognitive psychology has shown to play a role in religious perception.[9] Piero's works may project that counterintuitive effect on perception: he presents the world in an idealized form, contrary to normal experience.

Third, Piero was a painter of religious topics. This may embarrass some modernists, but it nevertheless reminds a secular age that people will always be interested in theological beliefs, or at least in the mystery behind them.

The erudite agnostic Aldous Huxley, taking the Grand Tour of Italy, once stood before Piero's *Resurrection* fresco in Sansepolcro and called it "the best painting in the world."[10] Huxley was not espousing Christian doctrine, nor was he being a connoisseur who compared different techniques or iconographies in Renaissance art. "[Piero] is majestic without being at all strained, theatrical or hysterical," Huxley said.[11] In the stark honesty of Piero's work, Huxley found a compelling story of the existential circumstances of human life. A thousand times more people enjoy Piero exactly because of the religious sentiments in his paintings.

The debate about the nature of beauty has countless examples, but Piero has presented us with one of the more classical cases. This is a fourth point: Piero painted in a time when there was a belief in metaphysical Beauty. It had divine, human, and material sources. By contrast, modern theories have attributed beauty to Darwinian survival, sexual advantage, marketplace competition, or satiation of an appetite. Nevertheless, the nagging idea of universal Beauty will not go away. In his writings about judgment of beauty, Immanuel Kant had made the distinction between the merely pleasurable and something that evokes a unique and intense response. Still today, the exclamation "It's beautiful!" seems reserved for what is special. As one modern philosopher of art has argued, the "merely agreeable" is quite different from a beauty that is a "notable pleasure," that "excites reflection and thought."[12]

At such moments, some people may include the idea of God or a higher realm as an explanation of why "things" participate in this special quality. On the other hand, the experience of beauty could simply be the chemistry of how the visual cortex and the brain's memory function interact. Either way, people are likely to always be transfixed, even for a moment, in the presence of something beautiful. Piero's art has had this effect on some viewers, and perhaps most. Being part of the Renaissance legacy, he reminds the modern world that the belief in metaphysical Beauty remains at issue.

Piero has left behind one final legacy: the story of his life itself. This is simply a matter of historical biography, and its existence seems so plain—as with the well-thumbed biographies of Julius Caesar, Marco Polo, Abraham Lincoln, or Queen Victoria on library shelves—that it would need no explanation. Human beings are forever interested in stories, narratives, and the

power of knowing the origin of things: in biography, in history, in natural science, or in the authentic work of art. Humans find an essence behind biographical realities. That essence is why people put great value on objects related to great or famous people. Authentic art is only one example, but it is a particularly keen example. A forger can make a painting that looks exactly like Piero's, but it will never have the same value, either spiritually or financially. Biography is yet another illustration of how essences give value to things that do not satiate appetites—like food or sex do—and yet are great sources of pleasure.

There are few trends in the modern world that have not been traced to the Italian Renaissance, for better or for worse. These range from individualism, hedonism, skepticism, and secularism to scientism, utopianism, new-ageism, and the Renaissance celebration of fame, wealth, and glory. The turn to artistic realism also was inaugurated in that fertile period. The number of streams of Renaissance thought may be too many to count, but, in all, they can be divided into two major ideas that have rivaled each other since the dawn of Western precepts in ancient Greece.

One is ancient materialism and Epicureanism. The other is Platonism, the first metaphysical system of thought. Although Platonism was eventually infused in Christian thought, with its Hebraic origins, the Renaissance elaborated this element even further. The Renaissance also gave Platonism a place in the new scientific thought. This was through mathematics and a more flexible outlook on the structure of the cosmos. The Platonist subculture of an artist such as Piero and a scientist such as Galileo created a fruitful environment for new solutions to the old problems of reconciling the roles of art, religion, and science in the human perception of the world.

Today, there are experts who recognize the Platonic solutions to many anomalies of knowledge. The British mathematician, physicist, and philosopher of science Alfred North Whitehead famously said that all of Western philosophy "consists of a series of footnotes to Plato."[13] In this, Whitehead was writing for a somewhat specialized audience. Even so, perhaps a majority of the general public in the Western world has adopted the

Platonic solution without knowing of such a legacy. Even the common man, if required to choose a position, is caught in the great philosophical debate that has traditionally been called the choice between philosophical Realism and philosophical Idealism: is Nature all there is, or is there something transcendent beyond Nature?[14]

At this level of reflection, the Platonist outlook has been called a kind of middle path, a form of intellectual modesty and moderation.[15] It has also proved remarkably useful to the modern world. The founding principles of the United States are one example. It is true that Thomas Jefferson admired the Greek Realists with their materialism and their atoms.[16] The Sage of Monticello was particularly drawn to the Epicurean strain of Renaissance thought, and some interpreters have found this reflected in the Declaration of Independence's insistence on the "pursuit of happiness."[17] At another level, the American founders also believed in eternal ideals. These came from "Nature's God," as they put it.[18] We might as well say that they were Platonists, and this more than Epicureans.

Since the times of Piero, Platonism has offered a pathway through the great debates over art, religion, and science. It is a path filled with the pitfalls of dialectical thinking and the limits Platonism puts on ultimate human knowledge. Being of this nature, the Platonist outlook requires a kind of "faith" in the first principles of both religion and science. In the arts it requires a willing belief that we are responding to some kind of universal intuitions about beauty; in science it has been a faith in the rationality of the universe. The very definitions of art, religion, and science will therefore remain imprecise (as they indubitably have remained), not always sharing the same methodology of investigation, but frequently overlapping as forms of human perception. For example, the debate on defining "art" has become so problematic that the topic has shifted to the *value* of art: what is it good for in satisfying and nurturing the human mind? According to Platonism and neuroscience, art speaks to the brain's search for constants and essences.[19]

By putting Piero della Francesca at the fountainhead of these great issues since the Renaissance, this book has engaged in an imaginative and constructive process. Yet this is what the life of a fascinating individual can do, especially in the context of a fascinating time, the Italian Renaissance.

This also is one way to flesh out that great and much-contested claim by the Swiss historian Jacob Burckhardt, that the Italian Renaissance was a turning point, a period that "must be called the leader of modern ages."[20] Piero reminds us of that possibility. This is Piero's light. Like his paintings, the Renaissance and the wisdom of Platonism suggest a kind of imperfect, yet hopeful, earthly salvation. They remind us, as do the Renaissance paintings of a *sacra conversazione*, that we still are having a "sacred conversation" on what may lie beyond.

Acknowledgments

A s I began this project, I came upon a comment by the scholar of
Piero and late medieval Italian culture James R. Banker: "The
extraordinary number of publications on Piero della Francesca presents
scholars with the difficult problem of mastering the literature on this
painter." How true this is, especially for a writer who does not know
Italian (or Latin). I was equally horrified by the pithy comment of art
scholar Caroline Elam: "The bibliography on Piero is now gigantic." If this
were not enough, one could argue that it is absurd to even try to write a
book on Piero without being able to read in Italian the basic compilation
of all documents related to him, Eugenio Battisti's *Piero della Francesca*
(Florence, 1971, 1992), which I could indeed peruse, but certainly could
not read in full comprehension.

I am therefore indebted to tireless Piero researchers who have presented
overviews and detailed studies of Piero in English. I have essentially built
this book on Banker's *The Culture of San Sepolcro* (2003)—with its early-
dating thesis—and then shaped it under the guidance of Piero volumes
by Roberto Longhi, Marilyn Aronberg Lavin, Bruce Cole, Kenneth Clark,
John Pope-Hennessy, Carlo Ginzburg, Creighton Gilbert, Philip Hendy,
Nathan Silver, and many others. In early 2013, the Frick Collection in New
York City held an exhibition, "Piero della Francesca in America," published
a catalog, and sponsored four scholarly lectures. My book has benefited

greatly from these public programs, especially by way of updating the most recent scholarship among connoisseurs and experts.

For art, science, and mathematics, I have relied a great deal on the work of Martin Kemp, Margaret Daly Davis, Judith V. Field, and Mark Peterson; and when it comes to the debate on optics and perspective in Renaissance art, the number of contributors, too, is "extraordinary," in particular Samuel Y. Edgerton, John White, James Elkins, B. A. R. Carter, David C. Lindberg, and others. James Banker looked over some of my draft material, and Frank Dabell was particularly helpful in granting a long overseas telephone interview. I would also like to thank Marina Laguzzi of the State Archive in Florence; Silke Reuther, biographer of Ernst Harzen; Pergiacomo Petrioli, biographer of Gaetano Milanesi; and art historian Philip Jacks for replies to my inquiries.

Following my journalist's instinct, I really began this project by requesting an interview with a Renaissance expert, Bruce Cole, to gain some perspective on the field. As early versions of the manuscript were minimally coherent, I sent samples to generous academic reviewers. My mixing of philosophy with art history—and my search for a simple theme to expand on Piero's meaning beyond art history—were met with a healthy dose of skepticism, but did elicit exceedingly helpful remarks. For these I would like to thank Kerr Houston, John T. Paoletti, John Hendrix, and Mark Peterson.

The views taken in this book, or any errors in thinking, are meanwhile entirely my own. My appreciation goes also to Alban and Mary Mullaj for some Italian translation, and to the helpful staffs at the University of Maryland libraries, the Library of Congress, the Catholic University of America Mullen Library, the Getty Research Institute Library, and the Sterling and Francine Clark Art Institute. Thanks also to my agent Laurie Abkemeier, copy editor Phil Gaskill, designer Maria Fernandez, and my editor at Pegasus Books, Jessica Case.

Illustration Credits

The dating of Piero's life and work varies widely, as do some preferred titles. The dates and names given below come from copyright holders, and may vary from dates or names found in the text of this book. For summary lists of dating options see Marilyn Aronberg Lavin, ed., *Piero della Francesca and His Legacy* (Washington, D.C. and New Haven: National Gallery of Art/Yale University Press, 1995), 14-16; and James R. Banker, *Piero Della Francesca: Artist and Man* (New York: Oxford University Press, 2014).

1. Piero della Francesca (c. 1420-1492). The Baptism of Christ, 1450s. Egg on poplar, 167 x 116 cm. Bought, 1861 (NG665). National Gallery, London, Great Britain © National Gallery, London/Art Resource, NY.

2. Piero della Francesca (c. 1420-1492). The Madonna della Misericordia Altarpiece. Pinacoteca Comunale, Sansepolcro, Italy. Photo Credit: Scala/Art Resource, NY.

3. Piero della Francesca (1410/20-92). The Flagellation of Christ. Palazzo Ducale, Urbino. Photo Credit: Alfredo Dagli Orti/The Art Archive at Art Resource, NY.

4. Piero della Francesca (c. 1420-1492). Resurrection. Christ steps from the tomb while the guards sleep, around 1458. Pinacoteca Comunale, Sansepolcro, Italy. Photo Credit: Erich Lessing/Art Resource, NY.

5. Piero della Francesca (c. 1420-1492). The Legend of the True Cross. ca. 1440-45. Fresco cycle, post-restoration. S. Francesco, Arezzo, Italy. Photo Credit: Nicolo Orsi Battaglini/Art Resource, NY.

6. [Detail] Piero della Francesca (c. 1420-1492). Legend of the True Cross: Adoration of the Sacred Piece of Wood and Meeting between Solomon and the Queen of Sheba. Ca. 1450-1465. Post-restoration. S. Francesco, Arezzo, Italy. Photo Credit: Scala/Ministero per i Beni e le Attività culturali/Art Resource, NY.

7. [Detail] Piero della Francesca (c. 1420-1492). Finding of the Three Crosses and the Verification of the True Cross. From the Legend of the True Cross. Fresco.

Post-restoration. S. Francesco, Arezzo, Italy. Photo Credit: Scala/Ministero per i Beni e le Attività culturali/Art Resource, NY.

8. [Detail] Piero della Francesca (c. 1420-1492). Legend of the True Cross: Battle of Constantine and Maxentius. Ca. 1450-1465. Post-restoration. S. Francesco, Arezzo, Italy. Photo Credit: Scala/Ministero per i Beni e le Attività culturali/Art Resource, NY.

9. Piero della Francesca (c. 1420-1492). Saint Anthony Polyptych. Ca. 1470. Oil and tempera on panel, 338 cm x 230 cm (133 in x 91 in). Galleria Nazionale dell'Umbria, Perugia, Italy. Photo Credit: Scala/Ministero per i Beni e le Attività culturali/Art Resource, NY.

10. [Detail of Battista] Piero della Francesca (c. 1420-1492). Portrait of Federico da Montefeltro, Duke of Urbino, and Battista Sforza. Ca. 1465. Tempera on wood. Uffizi, Florence, Italy. Photo Credit: Nicolo Orsi Battaglini/Art Resource, NY.

11. [Detail of Federico] Piero della Francesca (c. 1420-1492). Portrait of Federico da Montefeltro, Duke of Urbino, and Battista Sforza. Ca. 1465. Tempera on wood. Uffizi, Florence, Italy. Photo Credit: Nicolo Orsi Battaglini/Art Resource, NY.

12. Piero della Francesca (c. 1420-1492). The Madonna del parto (Virgin with two angels). Ca. 1460. Fresco, 260 x 203 cm. Post-restoration. Cappella del Cimitero, Monterchi, Italy. Photo Credit: Scala/Art Resource, NY.

13. Piero della Francesca (c. 1420-1492). Sacra Conversazione: Madonna and Child with Federico da Montefeltro. Pinacoteca di Brera, Milan, Italy. Photo Credit: Nimatallah / Art Resource, NY.

14. Puvis de Chavannes, Pierre (1824-1898). Summer (L'Eté), 1873. Oil on canvas, 305 x 507 cm. RF1986-20. Photo: Jean Schormans. Musee d'Orsay, Paris, France. © RMN-Grand Palais/Art Resource, NY.

15. Seurat, Georges. A Sunday afternoon on the Island of the Grande Jatte. 1884, 1884-86. Oil on canvas, 81 3/4 x 121¼ in. (207.5 x 308.1 cm). Helen Birch Bartlett Memorial Collection, 1926.224. Art Institute, Chicago, IL, U.S.A. Photo Credit: Erich Lessing/Art Resource, NY.

16. Piero della Francesca (c. 1420-1492). Detail. Finding of the Three Crosses and the Verification of the True Cross. From the Legend of the True Cross. Fresco. Post-restoration. S. Francesco, Arezzo, Italy. Photo Credit: Scala/Ministero per i Beni e le Attività culturali/Art Resource, NY.

17. Cézanne, Paul (1839-1906). Gardanne. 1885-86. Oil on canvas, 31½ x 25¼ in. (80 x 64.1 cm). Gift of Dr. and Mrs. Franz H. Hirschland, 1957 (57.181). © The Metropolitan Museum of Art. Image source: Art Resource, NY.

18. Piero della Francesca (c. 1420-1492). De prospectiva pingendi: page with perspective drawing of a corinthian capital. Folio 57. Biblioteca Palatina, Parma, Italy. Photo Credit: Scala / Art Resource, NY.

Notes

ABBREVIATIONS

css James R. Banker, *The Culture of San Sepolcro During the Youth of Piero della Francesca* (Ann Arbor: University of Michigan Press, 2003).

PDF Roberto Longhi, *Piero della Francesca*, ed. and trans. David Tabbat (Riverdale-on-Hudson, N.Y.: Stanley Moss-Sheep Meadow Book, 2002).

PDFSA Marisa Dalai Emiliani e Valter Curzi, eds., *Piero della Francesca tra arte e scienza: atti del convegno internazionale di studi, Arezzo, 8-11 ottobre 1992, Sansepolcro, 12 ottobre* (Venezia: Marsilio, 1996).

PFL Marilyn Aronberg Lavin, ed., *Piero della Francesca and His Legacy* (Washington, D.C. and New Haven: National Gallery of Art/Yale University Press, 1995).

PREFACE

1. Morris Kline, *Mathematical Thought from Ancient to Modern Times* (New York: Oxford University Press, 1972), 233.

2. Umberto Eco, *Art and Beauty in the Middle Ages*, trans. Hugh Bredin (New Haven, CT: Yale University Press, 2002 [1959]), 16.

3. It should be noted, however, that none of Piero's surviving written works mention the name Plato or Platonism, but rather approach that tradition in the form of Greek mathematics and geometry. The eight manuscripts Piero worked on are his original three written texts (*Abacus Treatise, On Perspective,* and *Five Regular Bodies*), four copies of *On Perspective* that he also made, and finally a copy he produced by his own hand of the works of Archimedes. See the forthcoming James R. Banker, *Piero Della Francesca: Artist and Man* (New York: Oxford University Press, 2014).

4. See Plato's *Republic*, book vi, parts 507-510. Similarly, Plato makes this statement in *Timaeus*: "One kind of being is the form which is always the same, ... invisible and imperceptible by any sense, and of which the contemplation

is granted to intelligence only. And there is another nature . . . perceived by sense, created, always in motion, becoming in place and again vanishing out of place, which is apprehended by opinion jointly with sense."

5. In this book, I will present the case that both Platonism and neuroscience arrive at the conclusion that the human mind seeks constants and essences. For this argument, I have drawn upon the psychological idea of "essences" found in two representative authors and their key works: Semir Zeki, *Inner Vision: An Exploration of Art and the Brain* (New York: Oxford University Press, 1999); and Paul Bloom, *Descartes's Baby: How Child Development Explains What Makes Us Human* (New York: Basic Books, 2004), and his *How Pleasure Works* (New York: Norton, 2010). Zeki, a neuroscientist, summarizes brain research and perceptions of essences and constancy in art. Bloom, an experimental psychologist, introduces the concepts of "natural born dualism" and "natural born essentialism" in the human mind. The persistence of dualism and essentialism in human mental life continues to be a mainstream topic of research, but these two authors provide concise summaries. Of course, both Zeki and Bloom deny the supernatural reality of Platonist essences, an idea that this book, for the sake of argument, leaves as an open question. Admittedly, my approach in this book limits the debate on human perception to what happens inside the brain-mind-soul, a so-called "Western approach," and I acknowledge that there is an entirely opposite approach (perhaps a so-called Buddhist, "process," or postmodern approach) that says an individual's perception is the product primarily of dynamic activity and relations *external* to the brain. For a recent presentation of that emphasis see Alva Noë, *Out of Our Heads: Why You Are Not Your Brain, and Other Lessons from the Biology of Consciousness* (New York: Hill and Wang, 2010).

6. See Wallace K. Ferguson, *The Renaissance in Historical Thought: Five Centuries of Interpretation* (Boston: Houghton Mifflin, 1948); and Denys Hay, ed., *The Renaissance Debate* (New York: Holt, Rinehart and Winston, 1965). It has been said that, by the 1960s, the topic of "the Renaissance period" had become so contested and over-analyzed that no more summary books appeared; scholars turned instead to narrow, specialized case studies in Italy's "early modern period."

7. Jacob Burckhardt, *The Civilization of the Renaissance in Italy* (New York: Modern Library, 2002 [1860]), 11.

8. Ibid., 385.

9. See David Carrier, "Piero della Francesca and His Interpreters: Is There Progress in History?" *History and Theory* 26 (May 1987): 150-165.

10. John Pope-Hennessy, "The Mystery of a Master: The Enigma of Piero," book review, *New Republic*, March 31, 1986, 40. A typical list of hard dates on Piero's life amounts to about thirty, and yet most bypass the real signposts: his personal life, travels, places of residence, when he did his paintings, and who exactly were his patrons, fellow painters, or assistants.

11. Marilyn Aronberg Lavin, "Piero the Painter Blended Geometry with Religious Art," *Smithsonian*, December 1992, 123.

12. James R. Banker, "The Altarpiece of the Confraternity of Santa Maria della Misericordia in Borgo Sansepolcro," in Lavin, *PFL*, 23.

13. The early dating approach to Piero hinges on three matters: a birthdate in 1412, his working with Antonio d'Anghiari as early as 1431, and his beginning

to paint the *Baptism of Christ* in 1438. These determinations are the work of two scholars, James R. Banker and Frank Dabell, to whom I am indebted. However, all speculations about the life of Piero that I make in this book are my own and do not suggest that Banker or Dabell agree with my portrayals. For the "early" approach findings, see Banker, *CSS*, 226-36; 253-56; James R. Banker, "Piero della Francesca as Assistant to Antonio d'Anghiari in the 1430s: Some Unpublished Documents," *Burlington Magazine* 135 (1993): 16-21.

PROLOGUE

1. There is no English-language biography of Milanesi. His later career is covered in Piergiacomo Petrioli, *Gaetano Milanesi: Erudizione e Storia Dell'Arte in Italia e Nell'Ottocento* (Siena: Accademia senese degli Intronati, 2004). Nor did Milanesi keep a memoir of his various discoveries. I have reconstructed his finding of the 1439 document based on published accounts and e-mail interviews with Marina Laguzzi of the Archivi Degli Ospedali e Conventi, Archivio di Stato, Firenze, and with Silke Reuther, biographer of Ernst Harzen (to whom Milanesi first conveyed his discovery).

2. Petrarch, quoted in James Bruce Ross and Mary Martin McLaughlin, eds., *The Portable Renaissance Reader* (New York: Penguin Books, 1977), 121.

3. Quoted in English in Piero Bianconi, *All the Paintings of Piero Della Francesca*, trans. Paul Colacicchi (New York: Hawthorn, 1962), 11. In Italian see Eugenio Battisti, *Piero della Francesca*, vol. 2 (Milan: Istituto editoriale italiano, 1971), 219.

4. Before the discovery of this 1439 date for use in scholarship, the writings of Luca Pacioli and Giorgio Vasari had stated various facts, while one document dating Piero exactly was discovered in 1822 in Urbino, placing him in that city in 1468. As Longhi said: "In 1822 there appear the first authentic documents concerning the artist: the ones published by PUNGILEONI." See Longhi, *PDF*, 220. Nevertheless, for defining Piero as a Renaissance painter, and providing the earliest date, the 1439 discovery is considered the first modern-day turning point.

5. Florence dealer William Spence, letter to his parents in England, March 2, 1854, quoted in John Fleming, "Art Dealing in the Risorgimento II," *Burlington Magazine* 121 (August 1979): 498.

6. John Charles Robinson, "Pictures by Piero della Francesca," *The Times* (London), June 15, 1874, 12.

7. John Charles Robinson to Henry Cole, May 13, 1859, quoted in Fleming, "Art Dealing in the Risorgimento II," 507.

8. John Charles Robinson, *Italian Sculpture of the Middle Ages and Period of the Revival of Art* (London: Chapman and Hall, 1862), xiii, 94.

9. Robinson, "Pictures by Piero della Francesca," 12.

10. Quoted in Marilyn Aronberg Lavin, *Piero della Francesca's Baptism of Christ* (New Haven, CT: Yale University Press, 1981), 166.

11. Nathan Silver, *Piero della Francesca in America: From Sansepolcro to the East Coast* (New York: The Frick Collection, 2013), 117-21. This painting, titled *Virgin and Child Enthroned with Four Angels*, was purchased in Florence in 1837 by Lord Walter Trevelyan and held privately.

12. John Charles Robinson to Henry Cole, May 13, 1859, quoted in Fleming, "Art Dealing in the Risorgimento II," 507.

13. Ibid., 508.

14. Richard Redgrave to Henry Cole, October 29, 1860, quoted in Fleming, "Art Dealing in the Risorgimento II," 507. Redgrave wrote from Florence, and Robinson was traveling with him at the time.

15. Noted in Luciano Cheles, "Piero della Francesca in Nineteenth-Century Britain," *Italianist* no. 14 (1994): 244. The queen bought the work in 1853.

16. Francis Haskell, *Rediscoveries in Art: Some Aspects of Taste, Fashion and Collecting in England and France* (Ithaca, NY: Cornell University Press, 1976), 85 n.75. The first comment on Robinson is Haskell's summary. The second is from an official report on Robinson's 1867 dismissal from the South Kensington Museum (which would evolve into the Victoria and Albert Museum).

17. For a summary of the mid-century Piero revival, as modest as it was—being contained among a fairly elite group of collectors and artists—see Cheles, "Piero della Francesca in Nineteenth-Century Britain," 218-19, 248-49.

CHAPTER I

1. Banker, *CSS*, 190-91.

2. On skill and geometry see Michael Baxandall, *Painting and Experience in Fifteenth-Century Italy* (Oxford: Oxford University Press, 1972), 14-16, 86-102.

3. For more on such revivals during the Italian Renaissance see Timothy Verdon and John Henderson, eds., *Christianity and the Renaissance: Image and Religious Imagination in the Quattrocento* (Syracuse, NY: Syracuse University Press, 1990).

4. See Michael Baxandall, *Words for Pictures: Seven Papers on Renaissance Art and Criticism* (New Haven, CT: Yale University Press, 2003), 134.

5. Ghiberti, quoted in Robert Goldwater and Marco Treves, eds., *Artists on Art from the XIV to the XX Century* (New York: Pantheon, 1972), 30.

6. Quoted from Ernst Cassirer, Paul Oskar Kristeller, and John Herman Randall, Jr., *The Renaissance Philosophy of Man* (Chicago: University of Chicago Press, 1948), 4. For the papal bureaucracy see Peter Partner, *The Pope's Men: The Papal Civil Service in the Renaissance* (Oxford: Clarendon Press, 1990).

7. Pius II, quoted in James Bruce Ross and Mary Martin McLaughlin, eds., *The Portable Renaissance Reader* (New York: Penguin Books, 1977), 75.

8. See C. C. Bayley, *War and Society in Renaissance Florence: The De Militia of Leonardo Bruni* (Toronto: University of Toronto Press, 1961). The serious wartime bloodletting in Italy began with the French invasion with "modern" weaponry in 1494. See M. E. Mallett and J. R. Hale, *The Military Organisation of a Renaissance State: Venice c. 1400 to 1617* (Cambridge: Cambridge University Press, 1984), 1-4.

9. See Samuel Y. Edgerton, *The Heritage of Giotto's Geometry: Art and Science on the Eve of the Scientific Revolution* (Ithaca, NY: Cornell University Press, 1991), 47-76; and John White, *The Birth and Rebirth of Pictorial Space* (Cambridge, MA: Harvard University Press, 1987 [1957]), 23-52.

10. There is some dispute on Piero's education. See Paul F. Grendler, "What Piero Learned at School: Fifteenth-Century Vernacular Education," in Lavin, *PFL*, 161-74; and Banker, *CSS*, 57-92, who disputes Grendler (pp. 87-88). I have followed Banker.

11. Menso Folkerts, "Piero della Francesca and Euclid," in Emiliani, *PDFSA*, 293.

12. Ibid., 294. Piero cites Companus in his *Five Regular Solids*. This was still the age of manuscripts when it came to Euclid, for the first printed book version of Euclid's *Elements* in Italian came in 1543.

13. For the story of Piero's interest in Archimedes see James R. Banker, "A Manuscript of the Works of Archimedes in the Hand of Piero della Francesca," *Burlington Magazine* 147 (March 2005): 165-69. See a fuller treatment in the forthcoming James R. Banker, *Piero Della Francesca: Artist and Man* (New York: Oxford University Press, 2014). See also a full discussion of Piero and Archimedes in Marshall Clagett, *Archimedes in the Middle Ages*, vol. 3 (Philadelphia: American Philosophical Society, 1978), 383-415.

14. Pythagoras, quoted by the Greek Neoplatonist philosopher Iamblichus of Chalcis in *Life of Pythagoras*, c. 300 BCE.

15. Quoted in Edith Hamilton and Huntington Cairns, eds., *The Collected Dialogues of Plato, Including the Letters* (New York: Pantheon Books, 1961), 1171. Most of Plato's mathematical allusions appear in *Timaeus*, his dialogue on the natural world.

16. The Pythagorean theorem states: In any right-angle triangle, the sum of the squares of the two legs (a and b) on the right angle is equal to the square of the hypotenuse, or third leg (c). As to its validity, the Pythagorean theorem would in time number up to ninety types of proof, perhaps the most-proved theorem in geometry. Although it is stated as finding squared shapes along the triangle's sides, its ability to determine the length of the hypotenuse provided a simple way for surveyors to measure land, as Piero would have seen in his own day.

17. See Stephen Gaukroger, *The Emergence of a Scientific Culture: Science and the Shaping of Modernity, 1210-1685* (New York: Oxford University Press, 2006), 96-97; David C. Lindberg, *Roger Bacon and the Origins of Perspectiva in the Middle Ages* (Oxford: Clarendon Press, 1996), lxvii-lxviii; and Edgerton, *The Heritage of Giotto's Geometry*, 47-48.

18. Banker, *CSS*, 135-36, 146-48.

19. Cennino d' Andrea Cennini, *The Craftsman's Handbook* (*Il Libro Dell'Arte*), trans. Daniel V. Thompson (New York: Dover, 1960), 3.

20. Keith Christiansen, *Gentile da Fabriano* (Ithaca, NY: Cornell University Press, 1982).

21. Vitruvius Pollio, *The Ten Books on Architecture*, trans. Morris Hicky Morgan (New York: Dover, 1960), 198.

22. Cennini, *The Craftsman's Handbook*, 3.

23. Banker, *CSS*, 179.

24. For Antonio's biography and an account of Piero's work with him see Banker, *CSS*, 173-201.

25. Ibid., 174.

26. Ibid., 195.

27. Nathan Silver, *Piero della Francesca in America: From Sansepolcro to the East Coast* (New York: The Frick Collection, 2013), 60; Nathan Silver, "Piero della Francesca: From Borgo San Sepolcro to the East Coast," lecture, The Frick Collection, New York City, May 18, 2013. Silver points out that in Piero's lifetime the old-style multi-panel polyptych would give way to the single large panel, making the altarpiece a kind of window or stage rather than flat icon.

28. Quoted in Wladyslaw Tatarkiewicz, "The Great Theory of Beauty and its Decline," *Journal of Aesthetics and Art Criticism* 31 (1972): 168. For a much

lengthier survey see Umberto Eco, *Art and Beauty in the Middle Ages*, trans. Hugh Bredin (New Haven, CT: Yale University Press, 2002 [1959]).

29. Aquinas, quoted in Ekbert Faas, *The Genealogy of Aesthetics* (Cambridge: Cambridge University Press, 2002), 72.

30. For a history of the philosophical literature available on art, theology, and beauty see Eco, *Art and Beauty in the Middle Ages*. Most of these written materials would have survived only in monasteries, some universities, and the private libraries of princes or popes. Despite the rich variety, Eco notes that: "Despite the fact that they connected the artistic with the aesthetic, the Medievals had only a scant understanding of the *specifically* artistic. They lacked a theory of the fine arts. They had no conception of art in the modern sense, as the construction of objects whose primary function is to be enjoyed aesthetically, and which have the high status that this entails" (p. 97).

31. Piero, quoted from his *On Perspective* in Baxandall, *Words for Pictures*, 152. The Italian is in Piero della Francesca, *De prospectiva pingendi*, ed. G. Nicco Fasola (Florence, 1942), 98.

32. Denys Hay, *The Italian Renaissance in Its Historical Background* (Cambridge: Cambridge University Press, 1961), 48.

33. Quoted in Bruce R. Cole, *The Renaissance Artist at Work: From Pisano to Titian* (Boulder, CO: Westview Press, 1983), 52.

34. Rucellai, quoted in Baxandall, *Painting and Experience in Fifteenth-Century Italy*, 2.

CHAPTER 2

1. Banker, *CSS*, 197.

2. Bruni, quoted in James Hankins, *Plato in the Italian Renaissance*, vol. 1 (New York: E. J. Brill, 1990), 50.

3. The dukes of Burgundy had domains that included central France and the Netherlands, and it was the French and early Flemish artists in these territories from whom the dukes commissioned works of art. French realism also arose from the maturing of French manuscript illumination. In Italy, too, Fra Angelico first learned his realism as a manuscript illuminator, then moved on to frescos and panel paintings.

4. Timothy Verdon and John Henderson, eds., *Christianity and the Renaissance: Image and Religious Imagination in the Quattrocento* (Syracuse, NY: Syracuse University Press, 1990), 52, 64-65.

5. Traversari, quoted in Dennis F. Lackner, "The Camaldolese Academy: Ambrogio Traversari, Marsilio Ficino and the Christian Platonic Tradition," in *Marsilio Ficino: His Theology, His Philosophy, His Legacy*, ed. Michael J. B. Allen and Valery Rees (Boston: Brill, 2002), 19.

6. See Franco Borsi, *Leon Battista Alberti*, trans. Rudolf G. Carpanini (New York: Harper and Row, 1977); and Franco Borsi, ed. *Leon Battista Alberti: The Complete Works*, trans. Rudolf G. Carpanini (New York: Electa/Rizzoli, 1989).

7. Leon Battista Alberti, *On Painting*, trans. Cecil Grayson (New York: Penguin Books, 2004), 60.

8. Banker, *CSS*, 224.

9. For all we know, the Franciscans may have asked Piero to finish Antonio's failed altarpiece, though Piero did not do so. The Franciscans' ultimate solution was to recruit the reputable Sienese painter Sassetta. The Franciscans

contracted with him in September 1437. Starting from scratch, Sassetta's workshop in Siena built a new structure and he began to paint its sixty panels. It became a famous work by Sassetta in Sansepolcro.

10. Banker, *CSS*, 234-42.

11. Pliny the Younger, *The Complete Letters*, trans. P. G. Walsh (New York: Oxford University Press, 2006), 114.

12. For the history of Piero's workshops in Sansepolcro see James R. Banker, "The Second 'Casa di Piero della Francesca' and Hypotheses on Piero's Studio and his Role as Builder in Borgo San Sepolcro," in *Mosaics of Friendship: Studies in Art and History for Eve Borsook*, ed. Ornella F. Osti (Firenze, Centro Di, 1999), 151-53.

13. The question of whether Piero ever met Alberti is not resolved by any surviving documents. The most likely place, however, does seem to be Florence. Both Piero and Alberti were in Ferrara, Rimini, Urbino, and Rome in a similar nexus of years, but specific dates available suggest that they may have missed each other completely. There is no record of whether Piero read Alberti's *On Painting* early in his career, when, indeed, there were surely only a few handwritten manuscripts around. For the possible influence of Alberti on Piero see Borsi, *Leon Battista Alberti*, 298-99.

14. The late-Roman statesman, writer, Christian Platonist, and mathematician Boethius coined the Latin term *perspectiva* as a translation of the Greek term "optics."

15. Kim Williams, Lionell March, and Stephen R. Wassell, eds., *The Mathematical Works of Leon Battista Alberti* (Basel: Birkhäuser, 2010), 153 n.2.

16. See David C. Lindberg, *Roger Bacon and the Origins of Perspectiva in the Middle Ages* (Oxford: Clarendon Press, 1996); David C. Lindberg, *Theories of Vision from Al-Kindi to Kepler* (Chicago: University of Chicago Press, 1976), 116-21; and David C. Lindberg, ed. and trans., *John Pecham and the Science of Optics: Perspectiva Communis* (Madison: University of Wisconsin Press, 1970). Like the Franciscan Pecham, Witelo was a Platonist. His book, simply titled *Perspectiva*, had a section on Platonist metaphysics.

17. On religion and sermons related to Renaissance optics see Samuel Y. Edgerton, *The Mirror, the Window, and the Telescope: How Renaissance Linear Perspective Changed Our Vision of the Universe* (Ithaca, NY: Cornell University Press, 2009), 30-38; and Michael Baxandall, *Painting and Experience in Fifteenth-Century Italy* (Oxford: Oxford University Press, 1972), 40-55. For the way light changed from a spiritual to a material concept in early Renaissance painting see Paul Hills, *The Light of Early Italian Painting* (New Haven, CT: Yale University Press, 1987).

18. Quoted in Edgerton, *The Mirror, the Window, and the Telescope*, 39. See also Creighton Gilbert, "The Archbishop on the Painters of Florence, 1450," *Art Bulletin* 41 (1959): 75-87. In the early 1400s, Antonino Pierozzi was prior of San Marco Church, where he supervised Fra Angelico's painting of devotional murals. He became archbishop of Florence in 1446. Franciscan preachers could draw upon the new "Franciscan optics," which was distinctly Platonic. Sermonizing Dominicans, whose spiritual guide was Thomas Aquinas, could employ the Aristotelian idea of "species" of each existence being conveyed to the eye. For Christians, this included the spiritual species of divine things. With this in mind, some early Renaissance painters added little gold dots to show where species—like a divine

visual ray—were conveyed from God or angels to human figures, such as the Virgin Mary.

19. Edgerton, *The Mirror, the Window, and the Telescope*, 39. As an artisan, Brunelleschi became familiar with Euclid's geometry. He also learned the way Roman builders used a "plan and elevation" drawing system, and he had seen how mirrors were helpful in drawing or copying geometrical objects (by visually flattening them). There may have been earlier developments than Brunelleschi, as in the work of the Florentine mathematician Paolo Toscanelli (1397-1482), a leader of the humanists, who had summarized medieval optics in an early treatise titled *Della prospettiva*. See Hubert Damisch, *The Origin of Perspective*, trans. John Goodman (Cambridge, MA: MIT Press, 1995), 71. Damisch suggests that Brunelleschi might have figured out perspective by trial and error and only later learned geometry from Toscanelli, perhaps in Padua.

20. Antonio di Tuccio Manetti, *The Life of Brunelleschi*, ed. Howard Saalman, trans. Catherine Enggass (University Park: Pennsylvania State University Press, 1970), 42 (English), 43 (Italian).

21. As the Manetti account goes, Brunelleschi showed his painting to friends in a particular way that made the story so memorable. Already in his day, the humanists in Rome and Florence were entertaining themselves with devices such as peep-hole-boxes or the pin-hole camera obscura, which casts an upside-down image on the back of a darkened box. Now, Brunelleschi showed them a different device, as it were, for viewing his painting of the Baptistery. He directed them, from the backside of the painted panel, to look with one eye through a small hole, and thus see the front of the painted panel in an adjacent mirror. The double effect—the one-eye viewpoint and the shimmering of a mirror—reportedly created a remarkable visual sensation of depth.

22. Manetti, *The Life of Brunelleschi*, 42.

23. Stephen R. Wassell, "Commentary on *Elements of Painting*," in *The Mathematical Works of Leon Battista Alberti*, 153. In *On Painting*, Alberti does mention the term "centric point," but "distance point" is a term invented later.

24. Alberti, *On Painting*, 65.

25. Leonardo da Vinci, *Notebooks*, ed. and trans. Thereza Wells (New York: Oxford University Press, 2008), 113.

26. Alberti, *On Painting*, 41.

27. Joseph Gill, *The Council of Florence* (Cambridge: Cambridge University Press, 1961), 92-93.

28. Traversari, quoted in Ibid., 118.

29. Quoted in English in Piero Bianconi, *All the Paintings of Piero Della Francesca*, trans. Paul Colacicchi (New York: Hawthorn, 1962), 11. In Italian see Eugenio Battisti, *Piero della Francesca*, vol. 2 (Milan: Istituto editoriale italiano, 1971), 219.

30. Domenico, quoted in Helmut Wohl, *The Paintings of Domenico Veneziano: A Study of Florentine Art of the Early Renaissance* (New York: New York University Press, 1980), 15. Domenico's payments for the Sant' Egidio frescos were doled out between September 1439 and 1445.

31. This simple word, "with," illustrates the dilemma for art historians interpreting Piero's life. Though Piero was "with" Domenico on the day he showed up for a payment, for example, it does not prove that Piero actually worked

with him on any frescos. The convention, however, has been to presume that he did; and from that small citation has been built the much larger case that Piero did his apprenticeship in Florence, was a young assistant to Domenico Veneziano, and roamed Florence extensively.

32. Wohl suggests that Domenico most likely was born in Venice in 1410, which is close to the 1412 date for Piero's birth (adopted in this book). For Domenico's career and influence on Piero, I have followed Wohl's reassessment. See Wohl, *The Paintings of Domenico Veneziano*, 20-21.

33. Alberti, *On Painting*, 61.

34. Augustine, *Concerning the City of God Against the Pagans*, ed. John O'Meara, trans. Henry Bettenson (London: Penguin Books, 1984), 304. Petrarch, quoted in Ernst Cassirer, *The Individual and the Cosmos in Renaissance Philosophy*, trans. Mario Domandi (Oxford: Basil Blackwell, 1963), 15. He cites Petrarch's *Triumphs*, chapter three.

35. See Jonathan Harris, *The End of Byzantium* (New Haven, CT: Yale University Press, 2011), Jonathan Harris, *Greek Emigres in the West, 1400-1520* (Camberley: Porphyrogenitus, 1995), and his Internet essay, "Byzantines in Renaissance Italy" at: (http:www.the-orb.net/encyclop/late/laterbyz/harris-ren.html); Katerina Ierodiakonou, ed., *Byzantine Philosophy and Its Ancient Sources* (New York: Clarendon, 2002), 1-30; John Monfasani, *Byzantine Scholars in Renaissance Italy: Cardinal Bessarion and Other Emigres* (London: Ashgate/Variorum, 1995); and N. G. Wilson, *From Byzantium to Italy: Greek Studies in the Italian Renaissance* (Baltimore: Johns Hopkins University Press, 1992).

36. I will emphasize again the "speculative" nature of this account of Piero, the *Baptism*, and his journey to Florence. At minimum, there is good circumstantial evidence to date the commissioning of the painting to 1438 (see Banker, *CSS*, 226-36, 253-56), after which Piero traveled to Florence. The only enigma is the stovepipe hat that Piero paints on one of the men in the background of the *Baptism*, which, according to scholarly opinion, he could not have painted unless he had seen the Greek Orthodox costumes at the Council of Florence. My solution is to have Piero travel during the period, see the costumes, and then complete the painting. In art history, this has been called a "hypothesis," which, in a strict science, means an idea that can be tested in various ways to determine its truth or falsity. Unfortunately, no tests are possible with art-historical topics that lack data. Judgments often arise from the sheer instincts of the expert or connoisseur. In the end, most hypotheses about Piero are simply speculation. So, herewith, I have felt free to offer my speculative scenario on what Piero might have done in the years 1438 and 1439.

37. See Piero's method in Marilyn Aronberg Lavin, *Piero della Francesca's Baptism of Christ* (New Haven, CT: Yale University Press, 1981), 168-70; and Roberto Bellucci and Cecilia Frosinini, "Piero Della Francesca's Process: Panel Painting Technique," in *Contributions to the Dublin Congress, 7-11 September 1998: Painting Techniques: History, Materials and Studio Practice*, ed. Ashok Roy and Perry Smith (London: International Institute for Conservation of Historic and Artistic Works, 1998), 92. Modern research has shown that Piero changed the positioning of the angels, for example.

38. See Richard Cocke, "Piero della Francesca and the Development of Italian Landscape Painting," *Burlington Magazine* 122 (September 1980): 626-28, 631.

39. Euclid combines a pentagon, triangle, and circle in book 4, proposition 16 of *Elements*. For a full and elaborate interpretation see B. A. R. Carter, "A Mathematical Interpretation of Piero della Francesca's *Baptism of Christ*," appendix I, in Lavin, *Piero della Francesca's Baptism of Christ*, 149-63.

40. See John Shearman, "Refraction, and Reflection," in Lavin, *PFL*, 213-20. On this optical problem faced by Piero in the *Baptism* see also Michael Baxandall, *Patterns of Intention: On the Historical Explanation of Pictures* (New Haven, CT: Yale University Press, 1985), 128; and Martin Kemp, "New Light on Old Theories: Piero's Studies of the Transmission of Light," in Emiliani, *PDFSA*, 40-42.

41. Banker, *CSS*, 164.

CHAPTER 3

1. Quoted in Marilyn Aronberg Lavin, *Piero della Francesca* (New York: Phaidon, 2002), 30.

2. See Diane Cole Ahl, "The Misericordia Polyptych: Reflections on Spiritual and Visual Culture in Sansepolcro," in *The Cambridge Companion to Piero della Francesca*, ed. Jeryldene M. Wood (New York: Cambridge University Press, 2002), 14-29; and James R. Banker, "The Altarpiece of the Confraternity of Santa Maria della Misericordia in Borgo Sansepolcro," in Lavin, *PFL*, 21-35.

3. Contract quoted in David S. Chambers, ed., *Patrons and Artists in the Italian Renaissance* (Columbia, SC: University of South Carolina Press, 1971), 52-53. The requirement to check the work for ten years suggests that Piero was trying some new techniques, such as oil.

4. Quoted in Creighton Gilbert, *Change in Piero della Francesca* (Locust Valley, NY: J. J. Augustin, 1968), 17. Piero was not unusual in his trouble managing commissions, as was seen in the case of Antonio Anghiari. Piero may have shirked the Misericordia job because the Pichi heirs were late in payment, turning Piero's interests to other projects in other towns. In his career, it does not seem that Piero ever failed to deliver. But his modus operandi—and perhaps his reputation—was to take on too many projects, which led to delays. These great lapses in his projects have undermined attempts to track him, but they also leave open many speculative possibilities on his travels and activities.

5. Banker, "The Altarpiece of the Confraternity of Santa Maria della Misericordia," 26, 27.

6. Ibid., 27. On the two stages see also Roberto Bellucci and Cecilia Frosinini, "Piero Della Francesca's Process: Panel Painting Technique," in *Contributions to the Dublin Congress, 7-11 September 1998: Painting Techniques: History, Materials and Studio Practice*, ed. Ashok Roy and Perry Smith (London: International Institute for Conservation of Historic and Artistic Works, 1998), 91. These scholars suggest that Piero was experimenting with oil paint by the time he finished the Misericordia, showing an "inexpert" use of oil that caused the painting to wrinkle and crack over time. This inexpert use of oil is similar to the fate of Leonardo da Vinci's *Last Supper* fresco, in which his experimental mixing of oil and tempera doomed much of the painting to flake away.

7. Banker, "The Altarpiece of the Confraternity of Santa Maria della Misericordia," 22-23. More exactly, the altarpiece measures 8 feet 9 inches tall and 10 feet 5 inches wide, or 273 cm by 323 cm.

8. Giorgio Vasari, *Lives of the Most Excellent Painters, Sculptors, and Architects*, vol. 1, trans. Gaston du C. de Vere (New York: Abrams, 1979), 472. For new evidence of Piero in Ancona see Nathan Silver, *Piero della Francesca in America: From Sansepolcro to the East Coast* (New York: The Frick Collection, 2013), 45 n.70. Meanwhile, Piero is documented as being in Sansepolcro on just two occasions between 1438 and 1449.

9. See Carlo Ginzburg, *The Enigma of Piero: Piero della Francesca*, new edition, trans. Martin Ryle and Kate Soper (London: Verso, 2002 [1985]), 23-24, 27, 45.

10. Denys Hay, *The Italian Renaissance in Its Historical Background* (Cambridge: Cambridge University Press, 1961), 155-57, 164.

11. On "architectural humanism" see André Chastel, *The Flowering of the Italian Renaissance*, trans. Jonathan Griffin (New York: Odyssey Press, 1965), 41-44.

12. Scholars note that while Vasari's *Lives* says that Piero worked for Borso Este, he more likely had arrived in Ferrara to work for Lionello Este just before Borso rose to power.

13. Filippo Pedrocco, *The Art of Venice: From its Origins to 1797* (New York: Riverside/Scala, 2002), 41.

14. On Venice see Longhi, *PDF*, 86, 100; and Aldolfo Venturi, *Piero Della Francesca* (Firenze: Presso Giorgio and Piero Alinari, 1922), 67.

15. Antonio Averlino Filarete, *Treatise on Architecture*, vol. 1, ed. John R. Spencer (New Haven, CT: Yale University Press, 1965), 116. Filarete was an architect and goldsmith from Florence. He designed his ideal city based on Plato's *Laws*.

16. The following scholars have all argued for Piero's influence on northern Italy: Luigi Lanzi, Joseph A. Crowe and Giovanni Battista Cavalcaselle, Roberto Longhi, Aldolfo Venturi, Kenneth Clark, and André Chastel. See Joseph A. Crowe and Giovanni Battista Cavalcaselle, *A New History of Painting in Italy: From the II to the XVI Century, The Florentine, Umbrian, and Sienese Schools of the XV Century*, vol. 3 (London: J. M. Dent, 1909 [1864]), 19; Longhi, *PDF*, 81-82, 86, 100, 140; Venturi, *Piero Della Francesca*, 67; Kenneth Clark, *Piero della Francesca* (London: Phaidon, 1951), 11, 14 (Clark speaks of Piero's "Ferrarese and North Italian followers"); and Chastel, *The Studios and Styles of the Renaissance, 1460-1500* (London: Thames and Hudson, 1966), 189-92.

17. Jill Dunkerton et al., *Giotto to Dürer: Early Renaissance Painting in the National Gallery* (New Haven, CT: Yale University Press; London: National Gallery Publications, 1991), 197.

18. Bellucci and Frosinini, "Piero Della Francesca's Process," 92. These scholars suggest that a 1458 legal document in which Piero left his estate in the hands of his brother Marco suggested, as in such documents of the time, that he had taken a risky journey abroad—perhaps to the Netherlands to see how oil painting was done. Others argue that the 1458 docment covered Piero on his overland journey to paint in Rome.

19. Dunkerton, *Giotto to Dürer*, 198. Piero's use of oil has been inferred from the way his paintings, including the Misericordia Altarpiece, wrinkled and cracked over the centuries.

20. The transmission of perspective from Italy to the north has been much debated since Erwin Panofsky argued for the distinction between Italian "mathematical" perspective and northern "empirical" approaches, culminating in the methods of Albrecht Dürer. See Erwin Panofsky, *Perspective as Symbolic Form*, trans. Christopher S. Wood (New York: Zone Books, 1991), 59, 62-63, further discussed in James Elkins, *The Poetics of Perspective* (Ithaca,

NY: Cornell University Press, 1994), 88. In opposition to the Panofsky thesis, Kim Veltman has argued that Piero, as a representative Italian, would have developed both a theoretical and a practical method, and both of these were likely to have been transmitted north to people such as Dürer. See Kim Veltman, "Piero della Francesca and the Two Methods of Renaissance Perspective," in Emiliani, *PDFSA*, 407-19.

21. For a summary of these achievements see Martin Kemp, "New Light on Old Theories: Piero's Studies of the Transmission of Light," in Emiliani, *PDFSA*, 33-45.

22. For Alberti's Platonism see John Hendrix, *Platonic Architectonics: Platonic Philosophies and the Visual Arts* (New York: Peter Lang, 2004), 97-148.

23. Leon Battista Alberti, *On Painting*, trans. Cecil Grayson (New York: Penguin Books, 2004), 64, 65.

24. Alberti, quoted in Philip Hendy, *Piero della Francesca and the Early Renaissance* (New York: Macmillan, 1968), 62.

25. Alberti, *On Painting*, 75.

26. Christine Smith, "Piero's Painted Architecture: Analysis of His Vocabulary," in Lavin, *PFL*, 249.

27. Ibid., 248.

28. Marilyn Aronberg Lavin, *Piero della Francesca* (New York: Phaidon, 2002), 54-55.

29. Alberti, quoted in Maria Grazia Pernis and Laurie Schneider Adams, *Federico da Montefeltro & Sigismondo Malatesta: The Eagle and the Elephant* (New York: P. Lang, 1996), 59.

30. Quoted in Lavin, *Piero della Francesca*, 75.

31. Ibid., 64.

32. Quoted in Mary Philadelphia Merrifield, *The Art of Fresco Painting as Practised by the Old Italian and Spanish Masters* (London: Charles Gilpin, 1846), 113.

33. It has been argued that Piero's two methods for perspective are the basis for his latter-day work, *On Perspective*, illustrating how he put it into practice many years before he wrote it down as an instructional theory. This two-part application of perspective would also apply to his much larger fresco project in Arezzo. See Veltman, "Piero della Francesca and the Two Methods of Renaissance Perspective," 418.

34. The idea that Piero used "a little oil" to paint the green leaves on the trees in the *Baptism* comes from analysis of the painting by its owners at the National Gallery, and presumes a much later date for the *Baptism* than this book's hypothesis of 1438-39. See Dunkerton, *Giotto to Dürer*, 198.

35. Piero's other portrait of Sigismondo, done in tempera and oil and measuring just shy of 18 x 14 inches on a panel, has been disputed as original. Roberto Longhi made the definitive assessment of authenticity and dated it to 1450, the time of the Rimini fresco. It was purchased by the Louvre in 1978, the one authenticated Piero painting in that museum (although reputed Pieros had been purchased before).

36. Quoted in Judith V. Field, *Piero Della Francesca: A Mathematician's Art* (New Haven, CT: Yale University Press, 2005), 30.

37. Ibid., 17, 19.

38. Piero offers no hint of his philosophical views about numbers, so this comes only by inference. For some suggestions see Hendrix, *Platonic Architectonics*, 149-73.

39. Quoted in Field, *Piero Della Francesca: A Mathematician's Art*, 17.

40. There is no way to date the *Abacus Treatise*. Some scholars date it late, close to Piero's last two treatises, while others suggest it was an earlier project, isolated from his later work. Either way, the presumed original is in the Laurentian Library in Florence, a handwritten manuscript of 170 small octavo leaves.

41. Lyle Massey, ed., *The Treatise on Perspective: Published and Unpublished* (Washington, D.C., and New Haven, CT: National Gallery of Art/Yale University Press, 2003).

42. Euclid, quoted in *Euclid's Elements: All Thirteen Books Complete in One Volume*, ed. Dana Densmore, trans. Thomas L. Heath (Santa Fe, NM: Green Lion Press, 2002), 367.

43. Piero cites Euclid twelve times in the *Abacus Treatise*, eleven times in *On Perspective*, and fifty-two times in *Five Regular Solids*. He refers to Euclid's *Optics* four times solely in *On Perspective*. For this count see Menso Folkerts, "Piero della Francesca and Euclid," in Emiliani, *PDFSA*, 300.

44. Marshall Clagett, *Archimedes in the Middle Ages*, vol. 3 (Philadelphia: American Philosophical Society, 1978), 385. Clagett and others note that Piero was probably repeating what he had seen in medieval commentaries, not directly from a text of Archimedes. He may have come in contact with such a direct Archimedan text in Rome in 1458-59, well after he began writing the *Abacus Treatise*.

45. Mark A. Peterson, "The Geometry of Piero della Francesca," *The Mathematical Intelligencer* 19 (Summer 1997): 33-37.

46. Quoted in J. V. Field, "Piero della Francesca's Mathematics," in *The Cambridge Companion to Piero della Francesca*, ed. Jeryldene M. Wood (New York: Cambridge University Press, 2002), 154.

47. Ibid., 155.

48. For the "two cultures" bridged by Piero and Leonardo see James R. Banker, "Three Geniuses and a Franciscan Friar," lecture, The Frick Collection, New York City, March 20, 2013.

49. Piero, quoted in Field, *Piero Della Francesca: A Mathematician's Art*, 30.

50. Plato introduces two kinds of "means," or ratios, in *Timaeus*, the first being the so-called golden ratio, or "mean and extreme ratio" as phrased by Euclid. Plato said: "There were two kinds of means, the one exceeding and exceeded by equal parts of its extremes, the other being that kind of mean which exceeds and is exceeded by an equal number." See Edith Hamilton and Huntington Cairns, eds., *The Collected Dialogues of Plato, Including the Letters* (New York: Pantheon Books, 1961), 1165. Later, Kepler said: "Geometry harbors two great treasures: One is the Pythagorean theorem, and the other is the golden ratio. The first we compare with a heap of gold, and the second we simply call a priceless jewel." Quoted in Alfred S. Posamentier and Ingmar Lehmann, *The Glorious Golden Ratio* (Amherst, NY: Prometheus Books, 2011), 12.

51. As an irrational fraction, the ratio has been called *phi* and is the basis of a numerical pattern discovered by Leonardo of Pisa called, after his name, the "Fibonacci sequence." Here, as the numbers are added together in the sequence—0, 1, 1, 2, 3, 5, 8, 13, 21, and so on—and when the larger number is divided by its predecessor, the ratio is roughly 1 to 1.6.

52. There are at least sixteen different ways that the ratio has been derived from geometrical forms. See Posamentier and Lehmann, *The Glorious Golden Ratio*, 16-38. For all the implications of the golden ratio see Scott

Olsen, *The Golden Section: Nature's Greatest Secret* (New York: Walker, 2006); and Mario Livio, *The Golden Ratio, The Story of Phi, the World's Most Astonishing Number* (New York: Broadway Books, 2002). Enthusiasts and skeptics continue to debate whether the ratio exists in ancient man-made marvels such as the pyramids, famous paintings, and, for example, the waistline ratio of Leonardo da Vinci's ideal, spread-eagle *Vitruvian Man* (late 1480s).

53. See Judith V. Field, "Rediscovering the Archimedean Polyhedra: Piero della Francesca, Luca Pacioli, Leonardo da Vinci, Albrecht Dürer, Danielle Barbaro, and Johannes Kepler," *Archive for History of Exact Sciences* 50 (September 1997): 241-289.

54. On Piero's use of the golden ratio to solve problems with the polyhedra see James R. Banker, "Three Geniuses and a Franciscan Friar," lecture, The Frick Collection, New York City, March 20, 2013.

55. Margaret Daly Davis, "Piero's Treatises: The Mathematics of Form," in *The Cambridge Companion to Piero della Francesca*, 136.

56. For a summary of various treatments of the *Flagellation* see Carlo Ginzburg, *The Enigma of Piero: Piero della Francesca*, 48-101, 116-28; Marilyn Aronberg Lavin, *Piero della Francesca: The Flagellation* (New York: Viking Press, 1972); Creighton Gilbert, "Piero della Francesca's Flagellation: The Figures in the Foreground," *Art Bulletin* 53 (March 1971): 41-51; Ernst H. Gombrich, "The Repentance of Judas in Piero della Francesca's 'Flagellation of Christ,'" *Journal of the Warburg and Courtauld Institutes* 22 (January-June 1959), 172; and Rudolf Wittkower and B. A. R. Carter, "The Perspective of Piero della Francesca's Flagellation," *Journal of the Warburg and Courtauld Institutes* 16 (1953): 292-302.

57. For a Montefeltro biography see Maria Grazia Pernis and Laurie Schneider Adams, *Federico da Montefeltro & Sigismondo Malatesta: The Eagle and the Elephant* (New York: Peter Lang, 1996), 13-25.

58. Lavin proposes a theory that the court official who commissioned the *Flagellation* was Ottaviano Ubaldini della Carda, who sought consolation from his son's death by the plague. See Lavin, *Piero della Francesca*, 107.

59. For one analysis of mathematics in this work see Wittkower and Carter, "The Perspective of Piero della Francesca's Flagellation," 292-302.

60. The measurement is given in Lavin, *Piero della Francesca*, 101.

61. See John White, *The Birth and Rebirth of Pictorial Space* (Cambridge, MA: Harvard University Press, 1987 [1957]), 194-95.

62. Lavin, *Piero della Francesca*, 96. By local tradition, for example, Piero's painting was about the assassination of Oddantonio.

63. The Jerome interpretation is the unique contribution of John Pope-Hennessy, *The Piero della Francesca Trail* (London: Thames and Hudson, 1991), 17.

64. Jerome, quoted in *Ancient Christian Writers: Letters of St. Jerome*, vol. 1, trans. Charles Christopher Mierow (New York: Paulist Press, 1963), 165-66.

65. See Wladyslaw Tatarkiewicz, "The Great Theory of Beauty and its Decline," *Journal of Aesthetics and Art Criticism* 31 (1972): 165-80.

66. Pseudo-Dionysius, quoted in Berys Gaut and Dominic Mciver Lopes, eds., *The Routledge Companion to Aesthetics* (London: Routledge, 2000), 28.

67. Aquinas, quoted in Gaut and Lopes, eds., *The Routledge Companion to Aesthetics*, 34. It comes from *Summa Theologiae*, I, 39, 8.

68. Leon Battista Alberti, *On the Art of Building in Ten Books*, trans. Joseph Rykwert, Neil Leach, and Robert Tavernor (Cambridge, MA: MIT Press, 1988), 302.

69. Leonardo on color in Martin Kemp, *The Science of Art: Optical Themes in Western Art from Brunelleschi to Seurat* (New Haven, CT: Yale University Press, 1990), 266-69.

70. Valla, quoted in Michael Baxandall, *Painting and Experience in Fifteenth-Century Italy* (Oxford: Oxford University Press, 1972), 85.

71. Alberti, *On Painting*, 82.

72. The optimal luminosity of Leonardo's painting has been studied by John Shearman, cited in Margaret Livingston, *Vision and Art: The Biology of Seeing* (New York: Abrams, 2002), 115. For luminosity in general, see Livingston, 109-122, especially "Luminance Over the Centuries" (115).

73. The two Piero paintings that show a strong chiaroscuro are *Vision of Constantine* in Arezzo and the predella panel *Stigmatization of Saint Francis* in the Perugia polyptych (Saint Anthony Altarpiece). Piero may have influenced other painters in the movement toward extremes in chiaroscuro, as seen finally in Caravaggio and Rembrandt. It has been speculated that a Piero fresco in the Vatican Palace had used dramatic dark and light since, once Raphael had erased it for his own work, Raphael painted *Liberation of Saint Peter* in a highly chiaroscuro contrast of dark and light.

74. As ever, the dating on the *Resurrection* is in dispute (scholars have dated the painting in a thirty-year range from 1442 to 1474). The agreed-upon benchmark is the 1441 political takeover of Sansepolcro by Florence. After that, the use of civic buildings changed. In 1442, Florence abolished the Sansepolcro town council and instituted a governing "Captain" over a weaker town assembly. However, the citizens continued to improve the main civic building, the Palazzo dei Conservatori, and may have envisioned Piero's painting as decorating its entrance hall. Either way, a more generous Florence in 1459 decided that "it is convenient to give and concede the said building to the commune," in effect giving Sansepolcro back its municipal hall. Piero's painting may have adorned it well before this time, however, but on the building's return, the painting surely became a stronger local symbol of independence. Quoted in Michael Baxandall, "Piero della Francesca's The Resurrection of Christ," in Michael Baxandall, *Words for Pictures: Seven Papers on Renaissance Art and Criticism* (New Haven, CT: Yale University Press, 2003), 133.

75. See Baxandall, "Piero della Francesca's The Resurrection of Christ," 130 n.18. If there was a political reason behind Piero turning to Siena for arististic models, not Florence, it may have been the fact that rapacious Florence had by now taken over every independent city in Tuscany except Siena, which was a symbol of resistence to Florence, the "wolf of Tuscany."

76. Ibid., 150 n.45.

77. See Laurie Schneider, "The Iconography of Piero della Francesca's Frescos Illustrating the Legend of the True Cross in the Church of San Francesco in Arezzo," *Art Quarterly* 32 (1969): 24. She cites how modern iconographers have taken Piero's barren tree to be symbolic of the Adam-Christ (old-new) dichotomy, and makes the same argument herself. More recently, it has been argued that the green paint simply has fallen off.

CHAPTER 4

1. See Angiola Maria Romanini, *Assisi: The Frescoes in the Basilica of St. Francis* (New York : Rizzoli, 1998); Elvio Lunghi, *Basilica of St Francis at Assisi: The Frescoes by Giotto, his Precursors and Followers*, trans. Christopher Evans

(London: Thames and Hudson, 1996); and Leonetto Tintori and Millard Meiss, *The Painting of the Life of St. Francis in Assisi, with Notes on the Arena Chapel* (New York: New York University Press, 1962).

2. The true-cross story has survived in three other known frescos: by Agnolo Gaddi in the choir of Santa Croce Church, Florence, at the end of the fourteenth century; by Cenni di Francesco in 1410 at San Francesco Church in Volterra; and in sinopia by Masolino in the St. Helena chapel, Santo Stefano, Empoli. See Laurie Schneider, "The Iconography of Piero della Francesca's Frescos Illustrating the Legend of the True Cross in the Church of San Francesco in Arezzo," *Art Quarterly* 32 (1969): 23-48.

3. For the story of the Bacci family see Carlo Ginzburg, *The Enigma of Piero: Piero della Francesca*, new edition, trans. Martin Ryle and Kate Soper (London: Verso, 2002 [1985]), 27-31. A Bacci was in the papal Curia and the family had ties to the humanists in Florence. According to Vasari, Piero used the portraits of Luigi Bacci together with "Carlo and others of his brothers and many Aretines" in the scene where the victors prepare to behead the evil Chosroes. Giorgio Vasari, *Lives of the Most Excellent Painters, Sculptors, and Architects*, vol. 1, trans. Gaston du C. de Vere (New York: Abrams, 1979), 474.

4. In this sentence, I quote from the old version of Jacobus de Voragine, *The Golden Legend; or, Lives of the saints, as Englished by William Caxton* (London: J. M. Dent, 1900). For a more concise modern translation see Jacobus de Voragine, *The Golden Legend: Readings on the Saints*, trans. William Granger Ryan (Princeton, NJ: Princeton University Press, 2012).

5. John Pope-Hennessy, *The Piero della Francesca Trail* (London: Thames and Hudson, 1991), 48.

6. For a contrast between neoclassical stillness and Impressionist movement see Margaret Livingston, *Vision and Art: The Biology of Seeing* (New York: Abrams, 2002), 74-76.

7. David Talbot offers these three summaries in Longhi, *PDF*, 111-12.

8. Kenneth Clark, *Piero della Francesca* (London: Phaidon, 1951), 28. To be precise, Clark says the first side, the left wall, is "much cooler, dominated by grey and white, green and blue; the [right] wall, although still light, is warmer, with much pink, lilac and grape purple to set off the blue and white."

9. Ginzburg, *The Enigma of Piero*. Ginzburg hypothesizes the influence of the Bacci family and other church leaders in changing the frescos.

10. Augustine, *Concerning the City of God Against the Pagans*, ed. John O'Meara, trans. Henry Bettenson (London: Penguin Books, 1984), 304.

11. Contract quoted in Philip Hendy, *Piero della Francesca and the Early Renaissance* (New York: Macmillan, 1968), 120.

12. Roberto Bellucci and Cecilia Frosinini, "Piero Della Francesca's Process: Panel Painting Technique," in *Contributions to the Dublin Congress, 7-11 September 1998: Painting Techniques: History, Materials and Studio Practice*, ed. Ashok Roy and Perry Smith (London: International Institute for Conservation of Historic and Artistic Works, 1998), 91.

13. Bert W. Meijer, "Piero and the North," in Lavin, *PFL*, 144, 156 n.22.

14. For this theory see Bellucci and Frosinini, "Piero Della Francesca's Process," 89-90.

15. For a full review of the circumstance around the commission of the Saint Augustine Altarpiece, related events in Piero's life, and the fate of the altarpiece, see the exhibition essays in Nathan Silver, *Piero della Francesca*

in America: From Sansepolcro to the East Coast (New York: The Frick Collection, 2013).

16. Vasari, *Lives*, vol. 1, 472.

17. On the migration of the Saint Augustine Altarpiece elements to the United States see Silver, *Piero della Francesca in America*. In England, Charles Eastlake acquired the *Michael the Archangel* in Milan. The painting bore the forged signature of Mantegna, but Eastlake suspected three other artists, including Fra Carnavalle. After the work passed to the National Gallery in 1867, it went under a "School of Della Francesca" label until it was declared a Piero in 1901.

18. For the Saint Anthony Altarpiece see Piero Bianconi, *All the Paintings of Piero Della Francesca*, trans. Paul Colacicchi (New York: Hawthorn, 1962), 61-63; and Marilyn Aronberg Lavin, *Piero della Francesca* (New York: Phaidon, 2002), 200-220.

19. Millard Meiss, "*Ovum Struthionis*: Symbol and Allusion in Piero della Francesca's Montefeltro Altarpiece," in *Studies in Art and Literature for Belle da Costa Green* (Princeton, NJ: Princeton University Press, 1954), 99.

20. Cited in James D. Proctor, ed., *Science, Religion, and the Human Experience* (New York: Oxford University Press, 2005), 40. Famously, Kenneth Clark, in writing on Piero, said he only belatedly "realized that Virgin is *behind* the first column." Kenneth Clark, *Piero della Francesca*, second rev. edition (London: Phaidon, 1969), 66. This is perhaps another case of Piero's "spatial games" noted herein, chapter 6 n.27.

CHAPTER 5

1. Pope Pius II was elected on August 19, 1458. Some Piero scholars, including James R. Banker, believe Piero had traveled to Rome once sometime earlier, making this his second visit. By the same token, some Piero scholars believe he was in Florence twice; but, as with Rome, the evidence is at best circumstantial (that is, Piero traveled a great deal).

2. See Carlo Ginzburg, *The Enigma of Piero: Piero della Francesca*, new edition, trans. Martin Ryle and Kate Soper (London: Verso, 2002 [1985]), 23-24, 27, 45.

3. Pius II, *Reject Aeneas, Accept Pius: Selected Letters of Aeneas Sylvius Piccolomini (Pope Pius II)*, ed. Thomas M. Izbicki, Philip D. W. Krey, and Gerald Christianson (Washington, D.C.: Catholic University of America Press, 2006), 396.

4. See Marshall Clagett, *Archimedes in the Middle Ages*, vol. 3 (Philadelphia: American Philosophical Society, 1978), 321.

5. James R. Banker, "A Manuscript of the Works of Archimedes in the Hand of Piero della Francesca," *Burlington Magazine* 147 (March 2005): 165. It is Banker's conclusion that Piero's handwritten copy is an unnamed manuscript now in the Biblioteca Riccardiana in Florence. In this complex detective story of Archimedean manuscripts, Banker meanwhile states two hypotheses of how Francesco's manuscripts ultimately showed up in the ducal library in Urbino: either a pope sent them there, or Piero carried them there; Banker sides with the second interpretation.

6. For these and more see James Hankins, *Plato in the Italian Renaissance*, vol. 1 (New York: E. J. Brill, 1990), 3-26; and John Monfasani, "Platonic Paganism in the Fifteenth Century," in *Reconsidering the Renaissance*, ed. M.

A. di Cesare (Binghamton, NY: Center for Medieval and Early Renaissance Studies, 1992), 45-61.

7. For concise biographies see Dermot Moran, "Nicholas of Cusa and Modern Philosophy," in *The Cambridge Companion to Renaissance Philosophy* (Cambridge: Cambridge University Press, 2008), 173-92; Dermot Moran, "Nicholas of Cusa (1401-1464): Platonism at the Dawn of Modernity," in *Platonism at the Origins of Modernity*, ed. Douglas Hedley and Sarah Hutton (Dordrecht, the Netherlands: Springer, 2008), 9-29; and Jasper Hopkins, "Nicholas of Cusa," *Dictionary of the Middle Ages*, vol. 9, ed. Joseph Strayer (New York: Charles Scribner's Sons, 1987), 122-25.

8. See Arthur O. Lovejoy, *The Great Chain of Being* (New York: Harper, 1960 [1936]). Lovejoy emphasizes that the Neoplatonist tradition—mystical, scientific, and mathematical—had the central idea of "plenitude," which means the optimal degree of existing things and divine creativity in all the spaces of the cosmos.

9. See Thomas Whittaker, *The Neo-Platonists: A Study in the History of Hellenism* (Cambridge: Cambridge University, 1918). The chief Christian Neoplatonist (besides, modestly, Augustine and Boethius) was Dionysius the Areopagite, believed to be a Syrian monk in the patristic period. See Sarah Coakley and Charles M. Stang, eds., *Re-thinking Dionysius the Areopagite* (Malden, MA: Wiley-Blackwell, 2009).

10. For an English translation of *On Learned Ignorance* see Nicholas of Cusa, *De docta ignorantia*, second edition., ed. and trans. Jasper Hopkins (Minneapolis: Arthur J. Banning Press, 1985).

11. Cusa, *De docta ignorantia*, 69. Kant had rebelled against European rationalism, which purported to prove God, the soul, and much else, and said the mind cannot know the "thing in itself" (ultimate reality), but instead the mind has categories (such as time and space, for example) that organize the flux of physical perceptions.

12. Ibid., 54, 50.

13. Ibid., 61, 52; Cusanus's *De conjecturis* (conjecture) and *De beryllo* quoted in *The Cambridge Companion to Renaissance Philosophy*, 184. In defining conjectures, Cusanus said "Man is the creator of conceptual beings and of artificial forms that are only likenesses of his intellect, even as God's creatures are likenesses of the divine intellect" (184). See Moran, *Cambridge Companion*, 179, on Cusanus's use of conjecture toward mathematics.

14. For a history of how the Platonist and Christian belief that Ideas in the transcendent realm evolved into a belief in the power or divinity of ideas in the human imagination see Erwin Panofsky, *Idea: A Concept in Art Theory* (New York: Harper and Row, 1975 [1968, English] [1924]), and Umberto Eco, *Art and Beauty in the Middle Ages*, trans. Hugh Bredin (New Haven, CT: Yale University Press, 2002 [1959]). See also herein chapter 9, n.36.

15. The idea of God's "immediate" relationship to all things was also a feature of nominalism, a system attributed to the English Franciscan thinker William of Ockham (c. 1285-1349). However, Ockham did not question the Aristotelian structure of the universe, so his nominalism, while opening the door to empirical science, arguably did not provide the opening for astronomical science that was provided by Cusanus.

16. Cusa, *De docta ignorantia*, 114.

17. At the dawn of the Scientific Revolution, shortly before 1600, Cusanus's writings benefited Bruno, Galileo, and Descartes. Bruno "read and admired" him and called him "divine Cusanus." Galileo had Cusanus's texts, and his contemporary, René Descartes, spoke of "Cardinal Cusanus" in regard to infinity. See Hilary Gatti, *Giordano Bruno and Renaissance Science* (Ithaca, NY: Cornell University Press, 1999): 118-119. On Descartes see Moran, "Nicholas of Cusa (1401-1464)," 11. Fundamentally, Bruno, Galileo, and Descartes jettisoned the Aristotelian and stepladder universe for one in flux and movement, with various qualities of the finite and infinite.

18. Cusanus's agenda was also to bring the thinking of the ancients under a divine providence that heretofore had only included the founding of the Christian church. This made him a modern prophet of natural religion, the idea that there is a common transcendent human experience upon which particular religions build precepts. There is "the One who seems to be sought in the various rites and various fashions," Cusanus said. "In the multiplicity of rites, there is only one religion." From Nicholas of Cusa, *De pace fidei*, quoted in Ernst Cassirer, *The Individual and the Cosmos in Renaissance Philosophy*, trans. Mario Domandi (Oxford: Basil Blackwell, 1963), 29. His vision of tolerance among religions, based on a theory of knowledge, received mixed reviews across modern history. At the least, his idea of an indeterminate world required that the center of reality be found in each being, a kind of humanist ennobling of the individual.

19. The most dedicated anti-Platonist critics of Bessarion and Cusanus, respectively, were George of Trebizond in Rome and John Wenck in Germany.

20. For Alberti and Cusanus see Il Kim, "Nicholas of Cusa and the Theological Foundations of Disegno," paper delivered at the College Art Association, New York City, February 15, 2013; and Il Kim, "Nicholas of Cusa, Leon Battista Alberti, and the Cult of Light in Fifteenth-Century Italian Renaissance Architecture," doctoral dissertation, Columbia University, 2010. For Alberti's Platonism see also John Hendrix, *Platonic Architectonics: Platonic Philosophies and the Visual Arts* (New York: Peter Lang, 2004), 97-148.

21. See Geoffrey Smedley, "Reason and Analogy. A Reading of the Diagrams: Piero della Francesca, Plato, Ptolemy, and Others," in Emiliani, *PDFSA*, 385-405. Smedley emphasizes that as a draftsman, Piero was aware of the intelligible and the sensible, using practical mathematics but also following the deeper analogy of number and proportion found in Plato's *Timaeus*.

22. On Piero in Rome see Giorgio Vasari, *Lives of the Most Excellent Painters, Sculptors, and Architects*, vol. 1, trans. Gaston du C. de Vere (New York: Knopf, 1996, 1979), 471. At best the *Lives* vaguely cites Piero's projects in both the biography of Piero and Raphael's biography as well. It is now believed that Raphael may have painted his dramatic chiaroscuro *Liberation of St. Peter* fresco over the original Piero.

23. Quoted in Kenneth Clark, *Piero della Francesca* (London: Phaidon, 1951), 37. See also Vasari, *Lives*, vol. 1, 471.

24. Piero's lasting influence on painting styles in Rome was first proposed by the Italian art historian Roberto Longhi in the first quarter of the twentieth century. As in so much art-historical interpretation, the evidence is purely stylistic, for there are no documents showing such a transmission of style. The young Raphael may have indeed seen Piero's work before Rome (in Urbino or Arezzo, for example) and then seen his Roman frescos later. If Luca Signorelli

was in fact Piero's student (a contested issue), Raphael (as well as Michelangelo) might also have been influenced by Signorelli's work. Art historians are eager to trace such "influences" but disagree widely on such stylistic interpretations.

25. Ginzburg, *The Enigma of Piero*, 45.
26. Lyle Massey, ed., *The Treatise on Perspective: Published and Unpublished* (Washington, D.C., and New Haven, CT: National Gallery of Art/Yale University Press, 2003).
27. James R. Banker, "Three Geniuses and a Franciscan Friar," lecture, The Frick Collection, New York City, March 20, 2013. Banker has itemized examples of how Piero intervened in each manuscript copy differently. In a manuscript now located in Parma, Piero wrote in vernacular with over a hundred diagrams. In the manuscript in the Ambrosiana Library, Milan, he added corrections to the Latin text of *On Perspective*, including drawing all the diagrams. In another Latin version, now in Bordeaux, France, Piero made Latin corrections in the margins.
28. Piero's *On Perspective* (*De prospectiva*), quoted in Judith V. Field, "A Mathematician's Art," in Lavin, *PFL*, 185, 187.
29. Ibid., 188.
30. Ibid., 184.
31. *On Perspective*, quoted in Kim Veltman, "Piero della Francesca and the Two Methods of Renaissance Perspective," in Emiliani, *PDFSA*, 410.
32. Ibid., 409.
33. Ibid., 411.
34. Ibid.
35. For a summary of the two methods, and the continuing historical debate on the rise and application of perspective, see Ibid., 407-19. As Veltman says, "Five hundred years after Piero's death we are only beginning to recognize the complexity of the new methods which he helped to articulate" (p. 418).
36. Some mathematicians have interpreted the diagram and Piero's intent as a successful, even ingenious, proof. Less impressed, the critics have brushed it off as one more Renaissance attempt, akin to alchemy and astrology, to find secret harmonies. Commending Piero are Mark A. Peterson, *Galileo's Muse: Renaissance Mathematics and the Arts* (Cambridge, MA: Harvard University Press, 2011), 109-12, and J. V. Field, "A Mathematician's Art," in Lavin, *PFL*, 185. Questioning Piero's proof is James Elkins, *The Poetics of Perspective* (Ithaca, NY: Cornell University Press, 1994), 104-108.
37. In making the ninety-degree claim, Piero may have been referring to Pecham's work on perspective. See also Dejan Todorovic, "The Effect of the Observer Vantage Point on Perceived Distortions in Linear Perspective Images," *Perception and Psychophysics* 71 (January 2009), 183ff. Todorovic says: "In the 15th century, the painter-geometer Piero della Francesca studied the conditions under which such effects are manifested (Field, 1986), and *the problem is still under investigation*" (emphasis added).
38. *On Perspective* (*De prospective*), quoted in Michael Baxandall, *Words for Pictures: Seven Papers on Renaissance Art and Criticism* (New Haven, CT: Yale University Press, 2003), 152. The Italian is in Piero della Francesca, *De prospectiva pingendi*, ed. G. Nicco Fasola (Florence, 1942), 98. This is Piero's only comment on the nature of the biological eye and optics, and in it he seems to adopt the antiquated, and incorrect, theory dating from Plato and

Galen that the "force" of vision extends from the eye (extromission theory) and does not enter the eye from outside (intromission theory).

39. See Kim H. Veltman, *Leonardo da Vinci and the Visual Dimensions of Science and Art* (Munich: Deutscher Künstlerverlag, 1986). He surveys Leonardo's experiments with this perspective effect in about a dozen geometrical sketches. On Leonardo and binocular vision see Leonard da Vinci, *A Treatise on Painting*, trans. John Francis Rigaud (Amherst, NY: Prometheus Books, 2002), 257-58; and Judith V. Field, "A Mathematician's Art," in Lavin, *PFL*, 184.

40. Giorgio Vasari, *Lives of the Most Excellent Painters, Sculptors, and Architects*, vol. 2, trans. Gaston du C. de Vere (New York: Knopf, 1996, 1979), 736.

41. For anatomy during the Renaissance see John William Shirley and F. David Hoeniger, eds., *Science and the Arts in the Renaissance* (Washington, D.C.: Folger, 1985), 103-109; and Katharine Park, "The Criminal and the Saintly Body: Autopsy and Dissection in Renaissance Italy," *Renaissance Quarterly* 47 (Spring 1994): 1-33.

42. Marilyn Aronberg Lavin, *Piero della Francesca* (New York: Phaidon, 2002), 275-76. Lavin sees the coral pendant on the Christ child as representing the human trachea and bronchial tubes, suggesting that Piero knew internal anatomy, perhaps from "public autopsies."

43. Marsilio Ficino, *Platonic Theology*, vol. 6, ed. James Hankins, trans. Michael J. B. Allen (Cambridge, MA: Harvard University Press, 2006), 3.

44. Stephen Gaukroger, *The Emergence of a Scientific Culture: Science and the Shaping of Modernity, 1210-1685* (New York: Oxford University Press, 2006), 87-101; and Edward A. Gosselin, "The 'Lord God's' Sun in Pico and Newton," in *Renaissance Society and Culture*, ed. Ronald G. Musto and John Monfasani (New York: Italica Press, 1991), 51-58. See herein chapter 7, n.29.

45. Piero's *On Perspective (De prospectiva)*, quoted in Veltman, "Piero della Francesca and the Two Methods of Renaissance Perspective," 411.

46. Pius, quoted from his *Commentarii*, V, in Maria Grazia Pernis and Laurie Schneider Adams, *Federico da Montefeltro & Sigismondo Malatesta: The Eagle and the Elephant* (New York: P. Lang, 1996), 27. See Cusanus's role, p. 33.

47. Clark, *Piero Della Francesca*, 30.

CHAPTER 6

1. Bruce R. Cole, *Italian Art, 1250-1550: The Relation of Renaissance Art to Life and Society* (New York: Harper and Row, 1987), 61. On the plague and Renaissance art see Millard Meiss, *Painting in Florence and Siena After the Black Death* (Princeton, NJ: Princeton University Press, 1951).

2. See Philip Hendy, *Piero della Francesca and the Early Renaissance* (New York: Macmillan, 1968), 119.

3. Piero Bianconi, *All the Paintings of Piero Della Francesca*, trans. Paul Colacicchi (New York: Hawthorn, 1962), 26, 61.

4. Kenneth Clark, *Piero della Francesca* (London: Phaidon, 1951), 47-48. Clark sees anticipation of Vermeer in the *Senigallia Madonna*.

5. On Piero's 1469 presence in Urbino see Luigi Pungileoni, *Elogio Storico di Giovanni Santi* (Urbino: V. Guerrini, 1822), 12, 75, as cited in Longhi, *PDF*, 184.

6. Giorgio Vasari, *Lives of the Most Excellent Painters, Sculptors, and Architects*, vol. 2, trans. Gaston du C. de Vere (New York: Abrams, 1979), 878. Giovanni Santi, a court artist with a workshop in Urbino, between 1484-1487 wrote a

thirty-two-part "rhymed chronicle," *Cronica Rimata*, providing a good deal of historical detail about the Montefeltro court. He presented it to Guidobaldo, son of Duke Federico Montefeltro, in 1492.

7. Quoted in Longhi, *PDF*, 184, from Pungileoni, *Elogio Storico di Giovanni Santi*, 12, 75. In the record, on April 8, 1469, the Confraternity of Corpus Domini refused to reimburse Giovanni Santi, who had advanced money "for the expenses of Maestro Piero dal Borgo" for the trip to Urbino.

8. See Pernis and Adams, *Federico da Montefeltro & Sigismondo Malatesta*, xiii-xiv.

9. John Shearman, "Refraction, and Reflection," in Lavin, *PFL*, 216.

10. Richard Cocke, "Piero della Francesca and the Development of Italian Landscape Painting," *Burlington Magazine* 122 (September 1980), 631.

11. Quoted in Bruce R. Cole, *Piero della Francesca: Tradition and Innovation in Renaissance Art* (New York: Harper and Row, 1991), 135, 137.

12. Marcello Simonetta, *The Montefeltro Conspiracy: A Renaissance Mystery Decoded* (New York: Doubleday, 2008).

13. Millard Meiss, "*Ovum Struthionis*: Symbol and Allusion in Piero della Francesca's Montefeltro Altarpiece," in *Studies in Art and Literature for Belle da Costa Green* (Princeton, NJ: Princeton University Press, 1954), 93.

14. The two-year time period on the Montefeltro altarpiece is suggested in Meiss, "*Ovum Struthionis*," 101. He argues that it was begun after the death of Federico's wife (July 1472) and completed before Federico received international honors (fall 1474), because those honors don't appear as symbols in the painting.

15. Quoted in Julia Mary Cartwright Ady, ed., *Baldassare Castiglione: The Perfect Courtier*, vol. 1 (New York: E. P. Dutton, 1908 [1528]), 52.

16. Donato di Angelo Bramante (c. 1444-1514) was a painter and architect of the High Renaissance who specialized in perspective illusion. It has been theorized variously that, hailing from Urbino, he either studied directly under Piero, simply saw Piero's work in Arezzo and elsewhere, or studied with Piero's follower Melozzo da Forli. See "Bramante," *Oxford Companion to Art*, ed. Harold Osborne (New York: Oxford University Press, 1970), 154-55.

17. The full preface letter to *Five Regular Solids* is translated in Judith V. Field, *Piero Della Francesca: A Mathematician's Art* (New Haven, CT: Yale University Press, 2005), 350-51.

18. James R. Banker, "Three Geniuses and a Franciscan Friar," lecture, The Frick Collection, New York City, March 20, 2013. Banker says that at least eight physical copies of Piero's works were produced in Latin under Piero's supervision, done after Piero composed his three originals in the vernacular. Hypothetically, a fourth manuscript supervised by Piero was his own copying, Latin to Latin, of the works of Archimedes.

19. James R. Banker, "A Manuscript of the Works of Archimedes in the Hand of Piero della Francesca," *Burlington Magazine* 147 (March 2005): 165-69.

20. As a geometer, Archimedes wrote treatises on planes, spirals, and the measurements of circles, spheres, and cylinders. As an engineer, he discovered principles for the pulley, fulcrum, lever, screw, and bodies floating in water.

21. *Five Regular Solids* quoted in Marshall Clagett, *Archimedes in the Middle Ages*, vol. 3 (Philadelphia: American Philosophical Society, 1978), 395.

22. Quoted in Field, *Piero Della Francesca: A Mathematician's Art*, 351.

23. Banker, "Three Geniuses and a Franciscan Friar."

24. See Banker, "A Manuscript of the Works of Archimedes in the Hand of Piero della Francesca," 165-69. See also Banker, "Three Geniuses and a Franciscan Friar."

25. Alberti, quoted in Philip Hendy, *Piero della Francesca and the Early Renaissance* (New York: Macmillan, 1968), 62.

26. See Giorgio Vasari, *Lives of the Most Excellent Painters, Sculptors, and Architects*, vol. 1, trans. Gaston du C. de Vere (New York: Abrams, 1979), 304. For an analysis of Vasari and space, see James Elkins, *The Poetics of Perspective* (Ithaca, NY: Cornell University Press, 1994), 53-58.

27. Thomas Martone, "Spatial Games in the Art of Piero della Francesca and Jan Van Eyk," in Emiliani, *PDFSA*, 95, 100.

28. For comments on the submerged-feet illusion see John Shearman, "The Logic and Realism of Piero della Francesca," in *Festschrift for Ulrich Middledord* (Berlin, 1968), 180-83; and Millard Meiss, *The Painter's Choice: Problems in the Interpretation of Renaissance Art* (New York: Harper and Row, 1976), 13.

29. Piero's *On Perspective*, quoted in Martone, "Spatial Games in the Art of Piero della Francesca and Jan Van Eyk," 96.

30. See "Proportion," *Oxford Companion to Art*, ed. Harold Osborne (New York: Oxford University Press, 1970), 930-36.

31. The empirical study of brain responses to proportion began with the German psychologist Gustav Flechner (1801-1887), who gathered information on people's visual responses to various objects and shapes. This approach continues under the field of neuroaesthetics, although its ability to find innate human preferences for specific proportions has been questioned by critics as either too narrow or impossible to determine in controlled experiments. Meanwhile, cognitive science presumes that the brain has evolved to recognize certain constants—symmetry, distance, faces, sexual attractiveness, etc.—as the basis for effective human survival. Brain studies have shown that the prefrontal cortex of the brain experiences higher blood flow when humans and rhesus monkeys evaluate proportions in number, lengths, and sizes. Similarly, blood flow increases in parts of the visual cortex when viewing symmetrical patterns. However, neuroscience has barely moved toward the study of how the brain judges proportion at the level of firing neurons.

32. For general summaries of symmetry in nature, mathematics, brain science, and human culture see Marcus de Sautoy, *Symmetry: A Journey into the Patterns of Nature* (New York: Harper, 2008); and Magdolna Hargittai and István Hargittai, *Visual Symmetry* (Hackensack, NJ: World Scientific, 2009). The technical study of the brain's perception of symmetry is characterized by the following paper, which found increased blood flow of a particular area of the visual cortex in humans (and less so in non-human primates) when presented with symmetrical patterns: Yuka Sasaki, et al., "Symmetry Activates Extrastriate Visual Cortex in Human and Nonhuman Primates," *Proceedings of the National Academy of Sciences*, 102 (2005): 3159-3163.

33. Cicero, quoted in Denys Hay, *The Italian Renaissance in Its Historical Background* (Cambridge: Cambridge University Press, 1961), 126.

34. On the Hellenization of Renaissance Christianity see Roland H. Bainton, "Man, God, and the Church in the Age of the Renaissance," in *The Renaissance*, ed. Wallace K. Ferguson (New York: Harper and Row, 1962 [1953]), 87-96.

35. See Giovanni Pico della Mirandola, "The Dignity of Man," in *The Portable Renaissance Reader*, ed. James Bruce Ross and Mary Martin McLaughlin (New York: Penguin Books, 1977), 476-79. For a helpful interpretation of Mirandola see Bainton, "Man, God, and the Church in the Age of the Renaissance," 82-83.

36. See "Hercules," in Silver, *Piero della Francesca in America*, 123-27.

37. Ibid., 124.

38. Piero may have no longer received commissions, or he may not have been interested in those that came to him, perhaps with some exceptions. Such an exception may have been a painting attributed to Piero between 1460 and 1470 titled *Virgin and Child Enthroned with Four Angels*, apparently for a private home. A disciple of Piero may have worked on this painting. It has the distinction of being the first Piero purchased in Italy and brought to England (1837). Now it resides in the Sterling and Francine Clark Art Institute, Williamstown, Massachusetts. See Nathan Silver, *Piero della Francesca in America: From Sansepolcro to the East Coast* (New York: The Frick Collection, 2013), 117-21.

39. For the Saint Anthony Altarpiece in Perugia, Marco received the final payment for his brother on June 21, 1468, suggesting again how slowly Piero could work (or how slowly patrons paid their debts).

40. Roberto Bellucci and Cecilia Frosinini, "Piero Della Francesca's Process: Panel Painting Technique," in *Contributions to the Dublin Congress, 7-11 September 1998: Painting Techniques: History, Materials and Studio Practice*, ed. Ashok Roy and Perry Smith (London: International Institute for Conservation of Historic and Artistic Works, 1998), 92.

41. James R. Banker, "The Second 'Casa di Piero della Francesca' and Hypotheses on Piero's Studio and his Role as Builder in Borgo San Sepolcro," in *Mosaics of Friendship: Studies in Art and History for Eve Borsook*, ed. Ornella F. Osti (Firenze, Centro Di, 1999), 147-57.

42. Quoted in Marilyn Aronberg Lavin, *Piero della Francesca* (New York: Phaidon, 2002), 287; Hendy, *Piero della Francesca and the Early Renaissance*, 20; and Longhi, *PDF*, 187.

43. Pacioli's *De divina proportione*, quoted in Bianconi, *All the Paintings of Piero Della Francesca*, 74.

CHAPTER 7

1. Francesco Guicciardini, *The History of Italy*, trans. Sidney Alexander (Princeton, NJ: Princeton University Press, 1984 [c. 1540]), 32.

2. Savanarola, quoted in J. H. Plumb, *The Italian Renaissance* (Boston: Houghton Mifflin, 1961), 220.

3. Karel van Mander's 1604 *Schilder-boeck* drew its information on Italian artists from Giorgio Vasari's *Lives of the Artists* (1550, 1568), which included a biography of Piero. See Bert W. Meijer, "Piero and the North," in Lavin, *PFL*, 154.

4. For Pacioli's biography see R. Emmett Taylor, *No Royal Road: Luca Pacioli and His Times* (Chapel Hill, NC: University of North Carolina Press, 1942).

5. Pacioli's *Summa de Arithmetica*, quoted in James Dennistoun, *Memoirs of the Dukes of Urbino, Illustrating the Arms, Arts, and Literature of Italy, 1440-1630*, vol. 2 (New York: John Lane, 1909 [1852]), 204.

6. Pacioli's *De divina proportione*, quoted in Piero Bianconi, *All the Paintings of Piero Della Francesca*, trans. Paul Colacicchi (New York: Hawthorn, 1962), 74.

7. The plagiarism charge against Pacioli has been at issue since Vasari first leveled it in his *Lives of the Artists*, written in the mid-sixteenth century. For modern interpreters, the issue has become remarkably complex due to the difficulties in finding and interpreting ancient manuscripts written by Piero and by Pacioli, the precise comparison of which—and this in the historical context of who actually produced the manuscripts and when—has been required to prove the case one way or another. On the whole, however, it does not look good for Pacioli, at least in regard to copying Piero's *Five Regular Solids* (since Pacioli seems to match up less precisely with Piero's *Abacus Treatise*). Suffice it to say, however, that there are two views. First, Pacioli is guilty: he simply plagiarized from Piero's two works, failing to give him credit. Second, Pacioli is innocent for a variety of reasons. For a start, it has been argued, Piero had already copied other sources, and indeed, by one interpretation, he may even have copied from Pacioli. Furthermore, the very idea of plagiarism did not exist in the sixteenth century. Many works were willy-nilly compilations of other manuscripts, mostly without attribution and credit. This was especially so with the rise of book publishing: publishers stitched together whatever they could find to sell books. Meanwhile, it is not perfectly clear who actually wrote the treatises now attributed to Pacioli; it could have been his students, or it may have been publishers who patched together his volumes and put his name on the book; his name would improve sales. If this is the case, Pacioli could not have plagiarized. In contemporary writings, for the general pro-Piero view see James R. Banker, *Piero Della Francesca: Artist and Man* (New York: Oxford University Press, 2014). For a pro-Pacioli view see Pacioli's modern biographer, R. Emmett Taylor, *No Royal Road: Luca Pacioli and His Times* (Chapel Hill: University of North Carolina Press, 1942), especially his chapter "The Charge of Plagiarism" (352-55). Taylor said it was untenable that Pacioli would turn to Piero to learn mathematics, since Pacioli already had mastered the same topics by the time of Piero's old age: "Piero was no great mathematician. In view of these facts does it seem likely that Pacioli took the work of Piero?" (344). For another defense of Pacioli also see S. A. Jayawardene, "'The Trattato d'abaco' of Piero della Francesca," in *Cultural Aspects of the Italian Renaissance: Essays in Honour of Paul Oskar Kristeller*, ed. C. Clough (Manchester, England: Manchester University Press, 1976), 29-43.

8. Leonardo da Vinci, *Notebooks*, ed. and trans. Thereza Wells (New York: Oxford University Press, 2008), 332.

9. In his lifetime, Leonardo never produced a formal "treatise" on anything. Rather, he left behind some twenty thousand unorganized pages, loose and in notebooks, of writings and drawings. Later editors organized these, for example, into his so-called "treatise on painting," which included various notes on perspective.

10. James R. Banker, "Three Geniuses and a Franciscan Friar," lecture, The Frick Collection, New York City, March 20, 2013. I borrow from Banker's theme of the two cultures and how Piero and Leonardo bridged them.

11. Giorgio Vasari, *Lives of the Most Excellent Painters, Sculptors, and Architects*, vol. 1, trans. Gaston du C. de Vere (New York: Abrams, 1979), 471.

12. Ibid., vol. 2, 773.

13. Ibid., vol. 1, 475.

14. Ibid., vol. 1, 470.

15. Ibid. For a discussion of Vasari's charge of plagiarism against Pacioli see herein chapter 7, n.7.
16. Vasari, *Lives*, vol. 1, 304.
17. Ibid., vol. 1, 475.
18. Dürer, quoted in Martin Kemp, *The Science of Art: Optical Themes in Western Art from Brunelleschi to Seurat* (New Haven, CT: Yale University Press, 1990), 55.
19. Albrecht Dürer, *The Painter's Manual*, trans. Walter L. Strauss (New York: Abaris, 1977 [1525]), 28.
20. Barbaro, quoted in James Elkins, *The Poetics of Perspective* (Ithaca, NY: Cornell University Press, 1994), 174.
21. The Quadraturisti buildings are diverse in their shapes, but the scenes are spookily absent of human beings. In this movement, one such painter credited Piero, writing in 1585 of him as the "never-sufficiently-praised... greatest geometrist of his time." Quadraturisti, quoted in Longhi, *PDF*, 214.
22. The nine parts of Barbaro's work typified an expanding curriculum of study that combined optics, math, and perspective. Part one was about "principles" and "fundamentals," in which he looks at the history and theory in general. Part two concerns basic methods, drawing upon Piero. Parts three to nine are on solids, scenography, a "secret" shortcut method, maps, light and color (and shadows, which Piero never covered), the human body, and finally perspective devices. For a summary of Barbaro's *Pratica della perspettiva* see both Elkins, *The Poetics of Perspective*, 90-96, and Thomas Frangenberg, "Piero della Francesca's *De Propsectiva Pingendi* in the Sixteenth Century," in Emiliani, PDFAS, 428-35. Barbaro's comment on Plato in Martin Kemp, "Piero and the Idiots: The Early Fortuna of His Theories of Perspective," in Lavin, *PFL*, 207.
23. Barbaro, quoted in Kemp, "Piero and the Idiots," 205.
24. For this interpretation of Vasari and Dürer see Erwin Panofsky, *Idea: A Concept in Art Theory* (New York: Harper and Row, 1975 [1968, English] [1924]), 6-68, 121-26. Panofsky quotes Vasari thusly: "Design is nothing but a visual expression and clarification of that concept which one has in the intellect, and that which one imagines in the mind and builds up in the idea" (62).
25. Dürer, quoted in Panofsky, *Idea: A Concept in Art Theory*, 124.
26. Historians disagree on the origins of science, especially its origins in the philosophy and religious thought of the medieval world. Those who see Renaissance art playing a role directly, or in parallel, include the science historian Alistair C. Crombie, the art historian Samuel Y. Edgerton, and cultural historians Leonardo Olschki and Eugenio Garin. Crombie said, for example, that Renaissance art and science are "exemplary products of the same intellectual culture." See Alistair C. Crombie, "Science and the Arts in the Renaissance: The Search for Truth and Certainty, Old and New," in *Science and the Arts in the Renaissance*, ed. John William Shirley and F. David Hoeniger (Washington, D.C.: Folger, 1985), 15-16. See also Leonardo Olschki, *Geschichte der neusprachlichen wissenschaftlichen Literatur*, vol. 1 (Leipzig, Florence: Leo S. Olschki, 1919); and Leonardo Olschki, *The Genius of Italy* (New York: Oxford University Press, 1949).
27. On science and quantification see Samuel Y. Edgerton, *The Heritage of Giotto's Geometry: Art and Science on the Eve of the Scientific Revolution* (Ithaca, NY: Cornell University Press, 1991); and Alfred W. Crosby, *The Measure of*

Reality: Quantification and Western Society, 1250-1600 (Cambridge: Cambridge University Press, 1997).

28. The concept of "rationalization" of visual space was introduced in William Mills Ivins, *On the Rationalization of Sight* (New York: Da Capo, 1973 [1938]).

29. Marsilio Ficino, *The Book of the Sun (De Sole)*, excerpted in *Marsilio Ficino: Western Esoteric Masters Series*, ed. Angela Voss (Berkeley, CA: North Atlantic Books, 2006), 205, 213. Unlike Cusanus, Ficino never voiced the Copernican/ Galilean view of the Earth moving. Nevertheless, Ficino's *Book of the Sun*, a companion to his *Book of Light (De lumine*, both around 1491-92) repeated Plato's assertions about the primacy of the Sun: "Plato twice refers to the dual constitution of the Sun in the *Timaeus*, first placing it amongst the planets as their companion, secondly presenting it as divine, with a light miraculous beyond all things and with a regal authority." For the role of the Sun in the new astronomy see also Edward A. Gosselin, "The 'Lord God's' Sun in Pico and Newton," in *Renaissance Society and Culture*, ed. Ronald G. Musto and John Monfasani (New York: Italica Press, 1991), 51-58. Gosselin says that the "Solar Age" began with Ficino's discourses on light, *De lumine* and *De sole*, and ended with Newton's Sun theology and gravitational theory. Historian Eugenio Garin has called this collective approach from 1480 to 1700 "solar literature" (Gosselin, 52).

As the early proponent of a Sun-centered world, Copernicus had embraced the Platonic solar emphasis. He had studied in Italy, the great school of Padua, and in his lifetime had read both Cusanus and (probably) Ficino. He read Plato and cited him to justify the making of astronomical calendars to help order society. Noting that the ancients spoke of the sun as the "visible god," Copernicus expounded on why the deity would put the Sun at the center of things: "For who would place this lamp of a very beautiful temple in another or better place than this wherefrom it can illuminate everything at the same time? . . . And so the sun, as if resting on a kingly throne, governs the family of stars which wheel around." See Nicholas Copernicus, *On the Revolutions of Heavenly Spheres* (Amherst, NY: Prometheus Books, 1995 [1453]), 24-26.

30. Ficino, quoted in John Hendrix, *Platonic Architectonics: Platonic Philosophies and the Visual Arts* (New York: Peter Lang, 2004), 143.

31. Ficino, quoted in *All Things Natural: Ficino on Plato's* Timaeus, ed. Arthur Farndell (London: Shepherd-Walwyn, 2010), 93.

32. For the importance of Platonism in changing scientific concepts see James Hankins, "Galileo, Ficino and Renaissance Platonism," in *Humanism and Early Modern Philosophy*, ed. Jill Kraye and M. W.F. Stone (London: Routledge, 2000), 209-37.

33. Kepler, quoted in Edgerton, *The Heritage of Giotto's Geometry*, 20.

34. Despite this difference in temperament, it has been documented that Galileo was influenced by Kepler's argument for a Sun-centered universe in his most visionary, Platonist, and "least scientific" book, *Prodromus* (1596). See Stillman Drake, "Galileo's 'Platonic Cosmology' and Kepler's *Prodromus*," *Journal of the History of Astronomy* 4 (1973): 175. As contemporaries, Galileo and Kepler communicated over the *Prodromus*, which had both astronomical calculations and vivid speculations useful to Galileo. What Galileo found most useful in *Prodromus* was Kepler's suggesting—contrary to Aristotle and supported by Plato—that the universe combined rectilinear (straight) and curved motion, allowing the two to be combined in mathematical equations.

35. Quoted in "Aristotle," in *Encyclopedia of Catholicism*, ed. Richard P. McBrien (New York: Harper Collins, 1995), 94.

36. For the kind of elaborate perspective books and experiments produced after Dürer see Kemp, *The Science of Art*, 62-162; and James Elkins, *The Poetics of Perspective* (Ithaca, NY: Cornell University Press, 1994), 145-80.

37. For Kepler and the Platonic solids see Judith V. Field, "Rediscovering the Archimedean Polyhedra: Piero della Francesca, Luca Pacioli, Leonardo da Vinci, Albrecht Dürer, Daniele Barbaro, and Johannes Kepler," *Archive for History of Exact Sciences* 50 (September 1997): 241-89. Kepler quoted, 273.

38. Galileo used several non-scientific sources to argue for his world system. For his preference for perfect circles over Kepler's elliptical orbits see Erwin Panofsky, "Galileo as a Critic of the Arts: Aesthetic Attitude and Scientific Thought," *Isis* 47 (1956): 3-15; and Gerald Holton, *Thematic Origins of Scientific Thought* (Cambridge, MA: Harvard University Press, 1973), 434. Galileo also used the Bible to argue for his science when necessary, citing theologians who pointed to the Bible statement that God "shakes the earth out of its place" (Job 9:6) and quoting Plato and his interpreters. On Galileo citing theologians see David C. Lindberg and Ronald L. Numbers, *God and Nature: Historical Essays on the Encounter Between Christianity and Science* (Berkeley, CA: University of California Press, 1986), 98-103.

39. Galileo's two major works, which cite Plato for a new theory of motion, adopted the dialogue style begun by Plato's writings. In his *Concerning the Two Chief World Systems* (1632), Galileo's mouthpiece is Salviati, who says: "[L]et us suppose God to have created the planet Jupiter, for example, upon which He had determined to confer such-and-such a velocity, to be kept perpetually uniform forever after. We may say with Plato that at the beginning He gave it a straight and accelerated motion; and later, when it had arrived at that degree of velocity, converted its straight motion into circular motion whose speed thereafter was naturally uniform." In the dialogue of *Two New Sciences*, his mouthpiece Sagredo congratulates Galileo himself for finding such true scientific principles hidden in Plato's poetry: "The conception is truly worthy of Plato, and is to be the more esteemed to the extent that its foundations, of which Plato remained silent, but which were discovered by our Author [Galileo] in removing their poetical mask or semblance, show it in the guise of a true story." Both are quoted in Hankins, "Galileo, Ficino and Renaissance Platonism," 209, 210.

40. Quoted in David C. Lindberg, *Theories of Vision from Al-Kindi to Kepler* (Chicago: University of Chicago Press, 1976), 176.

41. Kepler, quoted in Lindberg, *Theories of Vision*, 200. As modern optics would later discover, the cornea area of the eye focuses two thirds of the light, while the lens—which changes shape under muscle control—produces the final one third of a precisely focused ray of light.

42. Kepler, quoted in Lindberg, *Theories of Vision*, 203.

43. Newton, quoted in Kemp, *The Science of Art*, 285.

44. Newton, quoted in Margaret Livingston, *Vision and Art: The Biology of Seeing* (New York: Abrams, 2002), 14.

45. Newton, quoted in Kemp, *The Science of Art*, 286.

46. Anthony Ashley Cooper, 3rd Earl of Shaftesbury, *Characteristicks of Men, Manners, Opinions, Times*, vol. 1 (Oxford: Clarendon Press, 1999 [1709]), 77-78.

47. Ibid., 106-108.
48. Locke, quoted in Victor Nuovo, "Reflections on Locke's Platonism," in *Platonism at the Origins of Modernity*, ed. Douglas Hedley and Sarah Hutton (Dordrecht, the Netherlands: Springer, 2008), 209.
49. Winckelmann, quoted in Udo Kultermann, *The History of Art History* (New York: Abaris, 1993), 53.
50. Ibid.
51. Goethe, quoted in Kultermann, *The History of Art History*, 56.
52. Winckelmann, quoted in Kultermann, *The History of Art History*, 39. The German title of his work is *Geschichte der Kunst des Altertums*.
53. Luigi Lanzi, *The History of Painting in Italy*, trans. Thomas Roscoe, vol. 1 (London: Henry G. Bohn, 1847 [1795]), 26, 15.
54. Ibid., vol. 1, 15, 338, 339, 340.
55. Ibid., vol. 1, 339.
56. Ibid., vol. 2, 467.
57. Ibid., vol. 3, 188. He said the other "foreign" painter who influenced Ferrara was Francesco Squarcione, who had a noted painting academy in Padua.
58. Ibid., vol. 1, 11.
59. Ibid., vol. 1, 23.

CHAPTER 8

1. Quoted in Marilyn Aronberg Lavin, *Piero della Francesca's Baptism of Christ* (New Haven, CT: Yale University Press, 1981), 165. In Sansepolcro, the Sassetta altarpiece of 1444, which had substituted for Antonio's failed commission, had been apparently segmented into parts and carried off. One of its parts made the journey all the way to the Louvre, where it, too, remains down to the present.
2. See C. P. Brand, *Italy and the English Romantics: The Italianate Fashion in Early Nineteenth-Century England* (Cambridge: Cambridge University Press, 1957); and J. R. Hale, *England and the Italian Renaissance: The Growth of Interest in its History and Art* (London: Faber and Faber, 1954). Before the Protestant break with the papacy, England had warm enough ties to the principalities of Italy, especially over trade and banking, and to include the generations around Piero. Before Piero was born, English poet Geoffery Chaucer's visit to the Italy of Dante—this was around 1373—had inspired a new form of English literature. As Piero came of age, the Florentines had honored the English mercenary John Hawkwood by putting his great equestrian portrait in their cathedral. In Piero's last years with the House of Montefeltro, the king of England awarded the duke of Urbino the Order of the Garter.
3. The English writer Joseph Addison, after his Grand Tour, commented that the Alpine precipices "fill the mind with an agreeable kind of horror." See Joseph Addison, *Remarks on Several Parts of Italy, etc.: In the Years 1701, 1702, 1703*, second edition (London: J. Tonson, 1718), 350.
4. Luigi Pungileoni made this discovery, reported in his tract *Elogio Storico di Giovanni Santi* (Urbino: V. Guerrini, 1822).
5. See Margaret Daly Davis, *Piero della Francesca's Mathematical Treatises: The "Trattato d'abaco" and "Libellus de quinque corporibus regularibus"* (Ravenna: Longo, 1977), 100. She notes: "A close reading of the commentaries to Vasari's vita of Piero shows that around 1832 . . . there were manuscripts by Piero in the possession of the Franceschi Marini in Sansepolcro."

6. Giacomo Mancini, *Istruzione Storica-Pittorica* (Perugia: Baduel, 1832), 340-41. In this book, Mancini appends letters written during his art-appreciation travels, and the "third letter" dated 1828 touches on Piero.

7. M. Valery, *Historical, Literary, and Artistical Travels in Italy*, trans. C. E. Clifton (Paris: Baudry's European Library, 1839 [1931, French]), 638.

8. Johann David Passavant, *Raphael of Urbino and His Father Giovanni Santi* (London: Macmillan, 1872 [1839, German]).

9. In Padua, the master painter Francesco Squarcione (c. 1397-1468) had a school that trained such painters as Mantegna, who was a skilled perspectivist. Squarcione believed the painter was a humanist, so he rejected the term "bottega" and called his school a "studium." Some German historians believed Piero studied under Squarcione.

10. For the names of all the enthusiasts see Luciano Cheles, "Piero della Francesca in Nineteenth-Century Britain," *Italianist* no. 14 (1994): 219. See also herein, chapter 8 n.34.

11. See David Robertson, *Sir Charles Eastlake and the Victorian Art World* (Princeton, NJ: Princeton University Press, 1978).

12. Eastlake, quoted in Cheles, "Piero della Francesca in Nineteenth-Century Britain," 224.

13. Eastlake, quoted in Robertson, *Sir Charles Eastlake and the Victorian Art World*, 19.

14. Johann Wolfgang von Goethe, *Theory of Colors*, notes by Charles Lock Eastlake (Cambridge, MA: MIT Press, 1970 [London: John Murray, 1840]). The German title is *Zur Farbenhehre*.

15. *Lives of the most Eminent Painters, Sculptors and architects: translated from the Italian of Giorgio Vasari, with notes and illustrations chiefly selected from various commentators by Mrs. Jonathan Forster, 5 vols + 1 supplement edited by J.P. Richter* (London: Henry G. Bohn, 1850-55, and 1885). Piero is in volume 2.

16. Ranke, quoted in Edward Hallett Carr, *What is History?* (New York: Knopf, 1962), 113.

17. Eastlake, quoted in Franz Kugler, *Hand-Book of the History of Painting: From the Age of Constantine the Great to the Present Time*, vol. 1, ed. C. L. Eastlake (London: John Murray, 1941), 138.

18. James Dennistoun, *Memoirs of the Dukes of Urbino, Illustrating the Arms, Arts, and Literature of Italy, 1440-1630*, vol. 1 (New York: John Lane, 1909 [1852]), xxix, 201; and Dennistoun, *Memoirs of the Dukes of Urbino*, vol. 2, 201.

19. Lindsay, quoted in Cheles, "Piero della Francesca in Nineteenth-Century Britain," 228. Lindsay would write *Sketches of the History of Christian Art* (1847).

20. Dennistoun, *Memoirs of the Dukes of Urbino*, vol. 2, 207.

21. Piero, quoted in Dennistoun, *Memoirs of the Dukes of Urbino*, vol. 2, 205-206.

22. Ibid., vol. 2, 209. Dennistoun's erroneous comments included that Piero had painted "ideal city" panels and that he had written an anonymous perspective treatise found in the Urbino library. Having seen a copy of Pacioli's *Summa de Arithmetica*, with its praise for Piero as the "prince of modern painting," Dennistoun also disputed Vasari's claim that the Franciscan friar had plagiarized the painter, saying Pacioli was no "literary pirate." Quoted in Dennistoun, *Memoirs of the Dukes of Urbino*, vol. 2, 204. For a discussion of Vasari's charge of plagiarism against Pacioli see herein chapter 7, n.7.

23. Jennifer Meagher, "The Pre-Raphaelites," in Heilbrunn Timeline of Art History (New York: The Metropolitan Museum of Art, 2000–). (http:www. metmuseum.org/toah/hd/praf/hd_praf.htm) (October 2004).

24. See Cheles, "Piero della Francesca in Nineteenth-Century Britain," 247-48. William Michael Rossetti's article on early Renaissance art was in the ninth edition of the Encyclopedia Britannica (1875) and was repeated in editions up through 1910. He praised the Arezzo frescos but said "Piero's earlier style was energetic but unrefined, and to the last he lacked selectness of form and feature. The types of visages are peculiar, and the costumes . . . singular." See Cheles, 248.

25. Florence dealer William Spence, letter to his parents in England, March 2, 1854, quoted in John Fleming, "Art Dealing in the Risorgimento II," Burlington Magazine 121 (August 1979): 498.

26. Elizabeth Eastlake, quoted in Hale, England and the Italian Renaissance, 157 (emphasis added).

27. Lady Trevelyan, quoted in Nathan Silver, Piero della Francesca in America: From Sansepolcro to the East Coast (New York: The Frick Collection, 2013), 120 n.1.

28. Government reports and directives, quoted in Hale, England and the Italian Renaissance, 158, 40.

29. Graham and Dennistoun, quoted in Hale, England and the Italian Renaissance, 161.

30. Eastlake, quoted in Hale, England and the Italian Renaissance, 162.

31. See Giorgio Vasari, Le vite de' piu eccellenti pittori, scultori, e architetti, vol. 4, ed. Vincenzo Fortunato Marchese, Carlo Pini, Carlo Milanesi, and Gaetano Milanesi (Florence: F. Le Monnier, 1848), 13-24.

32. Ernst Harzen, "Über den Maler Pietro degli Franceschi und seinen vermeintlichen Plagiarius den Franziskanermönch Luca Pacioli," Archiv für die zeichenden Künste (Leipzig, 1856): 231-244. In the article, Harzen questioned whether Pacioli really plagiarized Piero since Pacioli could have known about regular solids by other sources, and indeed, Piero may have copied from Pacioli. For a discussion of the charge of plagiarism against Pacioli see herein chapter 7, n.7. On Milanesi, see his second edition of Vasari's Lives (now the standard): Giorgio Vasari, Vite de' più eccellenti pittori, scultori, ed. architettori, vol. 2, ed. Gaetano Milanesi (Florence: Sansoni, 1878-85), 487-501. As an update, Milanesi's notes cite the 1439 presence of Piero in Florence and the recent discoveries of his 1487 will, written "in sound mind," and the official recording of his death, which surfaced with a book of the dead in Sansepolcro. Milanesi's second edition also updated a range of dates discovered for Piero's commissions or payments (such as in 1445, 1454, 1469, and 1478), cited more documents from Franceschi Marini heirs of Piero, drew upon the opinions of Passavant, Crowe, and Cavalcaselle, located Piero's nativity painting in "Mr. [Alexander] Barker's" collection in England, and cited two new cases of Piero's manuscripts being found.

33. See Austin Henry Layard, "Publications of the Arundel Society," Quarterly Review 104 (1858): 277-325. After establishing his fame for the Near East discoveries, Layard joined up with the Arundel Society, founded in London in 1848 to publish facsimiles of historic works of art for public edification. Layard joined in 1852 and, taken by the new interest in frescos and aware of their deterioration at locations in Italy, helped organize a series of

copies—drawings and etchings—of such works, including by Piero. In his 1858 article about the series, Layard praised Piero as holding "first place of order of genius" among the fresco painters. Quoted in Cheles, "Piero della Francesca in Nineteenth-Century Britain," 230. Historians attribute this affection to the association Layard drew between the stoic friezes of Assyrian and Egyptian art and the similar effect Piero produced in Arezzo.

34. The Marini-Francesci family booklet is cited in Longhi, *PDF*, 223, 280. It was produced as a wedding present, published as F. Gherardi-Dragomannin, *Vita da Pietro della Francesca by Vasari*, with notes (Florence, 1835); Giacomo Mancini, *Istruzione Storica-Pittorica* (Perugia: Baduel, 1832), 340-41.

35. Eastlake, quoted in Nicholas Penny, "Piero della Francesca in the National Gallery," in *Piero interpretato: copie, giudizi e musealizzazione di Piero della Francesca*, ed. Cecilia Prete e Ranieri Varese (Ancona: Il Lavoro editoriale, 1998), 188.

36. Quoted in Marilyn Aronberg Lavin, *Piero della Francesca's Baptism of Christ* (New Haven, CT: Yale University Press, 1981), 167.

37. Cheles, "Piero della Francesca in Nineteenth-Century Britain," 241-44; on the Louvre see Caroline Elam, *Roger Fry and the Re-Evaluation of Piero della Francesca* (New York: Art Museum Press, 2004), 33.

38. J. C. Robinson, "To the Editors of The Times," *The Times* (London), June 9, 1874, 7.

39. See Penny, "Piero della Francesca in the National Gallery," 185-89.

40. Eastlake, quoted in Robertson, *Sir Charles Eastlake and the Victorian Art World*, 195. See also Cheles, "Piero della Francesca in Nineteenth-Century Britain," 238.

41. Immanuel Kant, *Prolegomena to any Future Metaphysics*, rev. edition (Cambridge: Cambridge University Press, 2004), 10.

42. Immanuel Kant, *Critique of Judgment*, trans. J. H. Bernard (New York: Hafner Press/Macmillan Publishing, 1951), 45.

43. Kant, quoted in Gerald R. Cragg, *The Church and the Age of Reason, 1648-1789* (New York: Penguin, 1970), 252.

44. Classical definitions of beauty have included Dionysius's divine Beauty, Aquinas's perfection, Alberti's proportion, Shaftesbury's unity of parts, and Winckelmann's "noble simplicity and quiet grandeur." All of these have roots in Platonism's idea of universal forms. See for example Jeffrey Morrison, *Winckelmann and the Notion of Aesthetic Education* (New York: Oxford University Press, 1996), 217 n.17. Morrison cites both Winckelmann and Goethe's interest in Platonism and neo-Platonism in developing their objective ideals of art.

45. Kant, *Critique of Judgment*, 52. See J. H. Bernard's "Introduction," xxxiii, for how several commentators, from Edward Caird to Johann Wolfgang von Goethe, have noted this contradiction in Kant.

46. Umberto Eco, *Art and Beauty in the Middle Ages*, trans. Hugh Bredin (New Haven, CT: Yale University Press, 2002 [1959]), 108.

47. At this point, it is worth summarizing Erwin Panofsky's study on how the Platonist "Idea" became modern "intuition" in art. See Erwin Panofsky, *Idea: A Concept in Art Theory* (New York: Harper and Row, 1975 [1968, English] [1924]). Plato proposed that eternal Ideas are beyond nature, so at best the artist can use skill to only approximate ultimate Beauty. The later Greco-Roman classical world eschewed Plato's negative view of the artist and praised

artistic craft. Thus, the Idea of Plato was now put into nature, which artists could imitate by skill. At the start of the medieval period, Neoplatonism combined the two previous eras: it said that transcendent Ideas and Beauty could be materialized in art, thus keeping the artist's stature and also allowing art to retain a divine quality. During the early Renaissance, figures such as Alberti, while working within the Platonist tradition of mathematics, otherwise were positive toward art expressing the classical ideal of imitating nature (with no transcendent Idea necessary). The later Renaissance, however, departed again from Alberti by combining theology with Platonism to reintroduce the divine element of Idea back into art.

At this juncture, what Panofsky calls "art theory" began to face serious contradictions. Western culture wanted to keep three opposing priorities: the eternal Idea, human invention, and nature. Gradually, beginning with the early baroque (around the time of Vasari's *Lives of the Artists* in 1568), and then peaking in neoclassicism, the artist was given the power to tap into the Idea, as if divinely connected. In this, the artist could represent ideal forms, improving even on nature. Neoclassical art formalized this idea: a painting that conveyed nature "purified" by the mind was Beauty incarnate. However, an alternative solution would begin to win the day, which Panofsky traced to Albrecht Dürer: this emerged in modern thought as the idea of intuition (typical of Immanuel Kant's formulation). In short, the Idea and nature were, as Plato suggested, forever separate, but the human mind in a mysterious kind of way is a link between the two. Artists therefore often express this conjunction.

In Panofsky's scenario, I will argue, Piero della Francesca was prescient of the revival of the Platonist Idea by his use and knowledge of mathematics and his Christian Platonism, which he learned from his religious and intellectual environment.

48. Kant, *Critique of Judgment*, 150-64.

49. See Clive Bell, *Art* (New York: Capricorn Books, 1958 [1914]), 17. He said "significant form" is "the quality that distinguishes works of art from all other classes of objects."

50. In Kant's discussion of art, imagination, and genius, he says that true art, using the material of nature, is "worked up into something different which surpasses nature" and achieves a "completeness of which there is no example in nature." Moreover, the imagination is the source of "*aesthetical ideas*"; also the "*movement* of the mind" is the source of feeling the "sublime" when seeing nature. See Kant, *Critique of Judgment*, 157-58, 85, 89.

51. Bell, *Art*, 17.

52. On Eastlake's aesthetic see Cheles, "Piero della Francesca in Nineteenth-Century Britain," 225.

53. Eastlake, quoted in Robertson, *Sir Charles Eastlake and the Victorian Art World*, 195.

54. Jules Michelet, *Renaissance et réforme: Historie de France au seiziéme siécle*, ed. Claude Mettra (Paris: Robert Laffont, 1982).

55. See Giovanni Pico della Mirandola, "The Dignity of Man," in *The Portable Renaissance Reader*, ed. James Bruce Ross and Mary Martin McLaughlin (New York: Penguin Books, 1977), 476-79. For a helpful interpretation of Mirandola see Roland H. Bainton, "Man, God, and the Church in the Age of the Renaissance," *The Renaissance*, ed. Wallace K. Ferguson (New York: Harper and Row, 1962 [1953]), 82-83.

56. Jacob Burckhardt, *The Cicerone: An Art Guide to Painting in Italy for the Use of Travelers and Students*, trans. A. H. Clough (New York: Scribner's Sons, 1908 [1855]), 69.

57. Helene Wieruszowski, "Jacob Burckhardt (1818-1897) and Vespasiano da Bisticci (1422-1498)," in *Philosophy and Humanism: Renaissance Essays in Honor of Paul Oskar Kristeller*, ed. Edward P. Mahoney (New York: Columbia University Press, 1976), 387-405; and Udo Kultermann, *The History of Art History* (New York: Abaris, 1993), 95-102.

58. Jacob Burckhardt, *The Civilization of the Renaissance in Italy* (New York: Modern Library, 2002 [1860]), 385.

59. Joseph A. Crowe and Giovanni Battista Cavalcaselle, *A New History of Painting in Italy: The Florentine, Umbrian, and Sienese Schools of the XV Century*, vol. 3 (London: J. M. Dent, 1909 [1864]), 5.

60. Ibid., 2.

61. Ibid., 8.

CHAPTER 9

1. Pacioli's *Summa de Arithmetica* (1494) called Piero the "prince of modern painting," quoted in James Dennistoun, *Memoirs of the Dukes of Urbino, Illustrating the Arms, Arts, and Literature of Italy, 1440-1630*, vol. 2 (New York: John Lane, 1909 [1852]), 204; and Giorgio Vasari, *Lives of the Most Excellent Painters, Sculptors, and Architects*, vol. 1, trans. Gaston du C. de Vere, intro. Kenneth Clark (New York: Abrams, 1979), 474.

2. Caroline Elam, *Roger Fry and the Re-Evaluation of Piero della Francesca* (New York: Art Museum Press, 2004), 36.

3. For Piero's influence on Puvis see Serge Lemoine, ed., *Toward Modern Art* (New York: Rizzoli, 2002), 223; and B. Biagetti, "Puvis de Chavannes," *Arte Cristiana* 5 (May 15, 1917): 130-40. Lemoine, director of the Musee d'Orsay, is quoted on the book cover saying that "modern art does not descend, as is commonly thought, from Manet and Impressionism, but from . . . the French painter Pierre Puvis de Chavannes."

4. Blanc, quoted in Albert Boime, "Seurat and Piero della Francesca," in *Seurat in Perspective*, ed. Norma Broude (Englewood Cliffs, NJ: Prentice-Hall, 1978), 158.

5. Ibid., 159 n.27. Boime gives the sizes and dates of the Arezzo copies.

6. Blanc, quoted in Ibid., 160.

7. Ibid., 155-56. For more on various ties between Piero, Puvis, Blanc, Seurat, and modern art see Daniel Catton Rich, *Seurat and the Evolution of "La Grande Jatte"* (New York: Greenwood Press, 1969 [1935]), 47-48; Robert L. Herbert, "Seurat and Puvis de Chavannes," *Yale University Art Gallery Bulletin*, 25 (October 1959): 23-29; William Innes Homer, *Seurat and the Science of Painting*, 17; and Lionello Venturi, "Piero della Francesca-Seurat-Gris," in Broude, *Seurat in Perspective*, 105-110. Venturi says that, of eighteenth century painters, Seurat "bears most resemblance to Piero" (108), and that "it was not Seurat who sent art-lovers flocking to Arezzo. It was Cubism" (109).

8. The evidence of Piero's influence on Cézanne is circumstantial. By the time in 1873 that the two copies of Piero's Arezzo frescos were displayed in the chapel of the École des Beaux Arts, Cézanne had been in Paris as a painter for more than a decade. He recalled his rejection twice to study at the École des Beaux Arts, but he attended exhibits there and was a fastidious observer of classic

art at museums: he registered as a copyist at the Louvre in 1863 and 1868. He said "The Louvre is the book from which we learn to read." While saying he never looked much at Renaissance "primitives" at the Louvre—Cimabue, Uccello, and Fra Angelico—that was because of their lack of solidity, which, by contrast, he must have found in Piero's buildings, landscape, and figures. His Piero-like landscape *View of Gardanne* (c. 1886) was done around the time he moved back to the family estate he inherited in Aix-en-Provence, though he visited Paris frequently. In short, he had at least thirteen years in Paris when he could have regularly viewed the Piero copies. Cézanne, quoted in Alex Danchev, *Cézanne: A Life* (New York: Pantheon, 2012), 9, 101, 140.

9. See Cézanne's "Letters to Emile Bernard," which were published in *Mercure de France* on October 1 and 15, 1907, at the same time as his Salon d' Automne retrospective.

10. See the boldest such statement of this Piero-Cézanne linkage to Cubism (". . . this very composition by Cézanne inspired the first true Cubist landscapes . . .") in Marilyn Aronberg Lavin, "Piero the Painter Blended Geometry with Religious Art," *Smithsonian*, December 1992, 126.

11. See Elam, *Roger Fry and the Re-Evaluation of Piero della Francesca*, 9. In making these connections, Fry was an "unrecognized player" in the Piero revival, Elam persuasively argues.

12. Quoted in Ibid., 22.

13. Quoted in Ibid., 38.

14. Quoted in Ibid., 24-25.

15. Quoted in Ibid., 27, 33.

16. Fry, quoted in Frances Spalding, *Roger Fry: Art and Life* (Berkeley, CA: University of California Press, 1980), 118.

17. Fry, quoted from 1910 and 1911 in Roger Fry, *Transformations* (London: Chatto and Windus, 1926), 191; and Roger Fry, *A Roger Fry Reader*, ed. Christopher Reed (Chicago: University of Chicago Press, 1996), 91.

18. Quoted in Elam, *Roger Fry and the Re-Evaluation of Piero della Francesca*, 46.

19. For examples of early-twentieth-century discoveries about Piero see Longhi, *PDF*, 236-51.

20. Quoted in Kenneth Clark, *Piero della Francesca* (London: Phaidon, 1951), 37.

21. Mancini's discovery of the will draft is cited in Longhi, *PDF*, 187.

22. On Mancini see Margaret Daly Davis, *Piero della Francesca's Mathematical Treatises: The "Trattato d'abaco" and "Libellus de quinque corporibus regularibus"* (Ravenna: Longo, 1977), 22. In particular, Mancini found the Piero original in the Biblioteca Laurenziana in Florence, where it had ended up after being part of the manuscript collection of Lord Ashburnham in London, who had earlier bought much of the collection from Guglielmo Libri, the Italian mathematical historian and manuscript collector.

23. See James R. Banker, "A Manuscript of the Works of Archimedes in the Hand of Piero della Francesca," *Burlington Magazine* 147 (March 2005): 165 n.2.

24. See Ernst Harzen, "Über den Maler Pietro degli Franceschi und seinen vermeintlichen Plagiarius den Franziskanermönch Luca Pacioli," *Archiv für die zeichenden Künste* (Leipzig, 1856): 231-244; on Jordan see Davis, *Piero della Francesca's Mathematical Treatises*, 99.

25. See Florian Cajori, book review, *The American Mathematical Monthly* 23 (January-December 1916), 384, which cites G. Pittarelli in Atti del IV. Congresso dei mathematici, tom, III, Roma, 1909. For a discussion of the charge

of plagiarism against Pacioli, or pro-Pacioli commentators who questioned Piero's ability at mathematics, see herein chapter 7, n.7.

26. The following list of Piero originals and their modern published book forms is provided by Davis, *Piero della Francesca's Mathematical Treatises*, 1: *Trattato d'abaco* (Florence, Biblioteca Medicea Laurenziana, MS. Ashb. 280/359-291); *Libellus de quinque corporibus regularibus* (Rome, Biblioteca Vaticana, MS. Vat.Urb.lat. 632); and *De prospectiva pingendi* (Parma, Biblioteca Palatina, MS. 1576, in Italian; Milan, Biblioteca Ambrosiana, Cod. Ambr. C. 307, in Latin). Their modern published forms are: *Trattato d'abaco*, ed. G. Arrighi (Pisa, 1970); *L'opera "De corporibus regularibus" di Pietro Franceschi detto della Francesca usurpata da Fra Luca Pacioli*, ed. G. Mancini (Rome, 1916); *De prospectiva pingendi*, ed. C. Winterberg (Strassburg, 1899); *De prospectiva pingendi*, ed. G. Nicco Fasola, 2 vols. (Florence, 1942).

27. Piero, quoted in his preface letter to *Five Regular Solids* as translated in Judith V. Field, *Piero Della Francesca: A Mathematician's Art* (New Haven, CT: Yale University Press, 2005), 350-55. See also Mark A. Peterson, "The Geometry of Piero della Francesca," *The Mathematical Intelligencer* 19 (Summer 1997): 33-37.

28. Leonardo Olschki, *Geschichte der neusprachlichen wissenschaftlichen Literatur* vol. 1 (Leipzig/Florence: Leo S. Olschki, 1919); and Leonardo Olschki, *The Genius of Italy* (New York: Oxford University Press, 1949).

29. American writers who significantly unveiled Piero included W. G. Waters in his *Piero della Francesca* (1901), which presented forty black-and-white plates of Piero's work, and Egerton Williams in his travel guide, *The Hill Towns of Italy* (1904).

30. For this account see Nathan Silver, *Piero della Francesca in America: From Sansepolcro to the East Coast* (New York: The Frick Collection, 2013), 20-22. One work went to Rockefeller in 1929 for $375,000 and another to the Frick Collection in 1936 for $400,000.

31. Bernard Berenson, *The Central Italian Painters of the Renaissance*, second edition (New York: G. P. Putnam's Sons, 1909 [1897, Italian]), iii.

32. Ibid., 16, 69.

33. Ibid., 69, 70, 71, 72.

34. Bernard Berenson, *Piero della Francesca, or the Ineloquent in Art* (New York: Macmillan, 1954 [1950]), 5, 6, 7 (italics in original).

35. Adolfo Venturi, *Storia Dell' Arte Italiana*, vol. 7 (Nendeln, Liechtenstein: Kraus Reprint Ltd., 1967 [1911, Milan]), 432-486.

36. Roberto Longhi, "Piero Francesca and the Development of Venetian Painting," *L'Arte* (1914): 198-221, 241-56.

37. Longhi, *PDF*, 244.

38. German critic, quoted in Longhi, *PDF*, 245.

39. Aldofo Venturi, *Piero Della Francesca* (Firezne: Presso Giorgio and Piero Alinari, 1922), 67.

40. Longhi, *PDF*, 245.

41. Ibid., 256.

42. Ibid., 245.

43. Ibid., 244-45, 44.

44. Ibid., 144.

45. André Lohte, *La Nouvelle Revue Française* (January 1930), quoted in Longhi, *PDF*, 256. Longhi notes that the Lohte article "exhumed" an earlier one by

art historian Leon Rosenthal, director of the Musée des Beaux-Arts in Lyon, who had claimed to find the golden ratio in the *Death of Adam* lunette of the Arezzo frescos.

46. For example, Frank Jewett Mather, *A History of Italian Painting* (New York: H. Holt and Co., 1923) associated Piero with Manet; Albert Barnes, *The Art in Painting* (New York: Harcourt, Brace and Co., 1937), linked Piero to Puvis, Picasso, and others.

47. Longhi, *PDF*, 272. At the end of his career, Longhi still was trying to clear the air on the Cubism issue and is worth quoting from the 1962 edition of his book: "The names which do turn up in my book, and most forcefully, are those of Cézanne and Seurat" (267). The era of Seurat and Cézanne had been "hermetically sealed off" from the Cubist and abstract era (272). Longhi's most important assertion is that "Seurat's 'Synthetism' was derived from Piero, by way of his more than probable acquaintance" with copies of the Arezzo frescos (262).

48. Longhi, *PDF*, 272.

49. Berenson, *Piero della Francesca, or the Ineloquent in Art*, 25.

50. Heinrich Wölfflin, *The Principles of Art History: The Problem of the Development of Style in Later Art*, trans. M. D. Hottinger (New York: Dover, 1950 [1932, 1915]), 237, 11, 13, 277. In the categories of beholding, artists of various periods swung between opposing styles: linear or painterly, clarity or complexity, flatness or depth, multiplicity or unity, closed or open form (14-16).

51. Croce, quoted in Udo Kultermann, *The History of Art History* (New York: Abaris, 1993), 176; Wölfflin, *The Principles of Art History*, 230. For the contrast between Wölfflin and Croce see Kultermann, *The History of Art History*, 176.

52. See Benedetto Croce, *Aesthetic: As Science of Expression and General Linguistic*, trans. Douglas Ainslie (New York: Farrar, Straus, and Giroux, 1970), 8-15; and Croce, quoted in Angelo A. de Gennaro, *The Philosophy of Benedetto Croce* (New York: Greenwood Press, 1968), 39.

53. The facing-off of metaphysical idealism with positivism in the late nineteenth and early twentieth centuries has been a common theme in intellectual histories. This has been the case especially in histories that explain the idealist resurgences seen in five areas: in figures such as Henri Bergson and Croce; in idealist and religious reactions to materialist Darwinism and Marxism; in the return of Hegelian vitalism in science; in natural philosophy; and in the re-emergence of transcendentalism with the neo-Kantians.

54. Kultermann, *The History of Art History*, 176.

55. See E. H. Gombrich, *Aby Warburg: An Intellectual Biography* (London: Phaidon, 1986), and E. H. Gombrich, "Aby Warburg: His Aims and Methods: An Anniversary Lecture," *Journal of the Warburg and Courtauld Institutes* 62 (1999): 268-282.

56. Warburg's Rome lecture, quoted in Gombrich, "Aby Warburg: His Aims and Methods," 275.

57. A. Warburg, "Piero Della Francescas Constantinschlacht in der Aquarellkopie des Johann Anton Ramboux," in Aldolfo Venturi, *L'Italia e l'arte straniera: atti del X Congresso Internazionale di Storia dell'Arte in Roma* (1912), Roma 1922. In this paper, Warburg cites the details available in the watercolor copies of the Arezzo fresco by Ramboux. This Warburg paper was republished in 1922 along with reproductions of Ramboux's work.

58. Cassirer, quoted from dedication page, Ernst Cassirer, *The Individual and the Cosmos in Renaissance Philosophy*, trans. Mario Domandi (Oxford: Basil Blackwell, 1963).

59. Ibid., viii, 15, 10.

60. Edward Skidelsky, *Ernst Cassirer: The Last Philosopher of Culture* (Princeton, NJ: Princeton University Press, 2008), 60.

61. For Cassirer's interest in Einstein see Ibid., 81-82.

62. For a biography of Panofsky see Michael Ann Holly, *Panofsky and the Foundations of Art History* (Ithaca, NY: Cornell University Press, 1984).

63. Ibid., 23.

64. Erwin Panofsky, *Perspective as Symbolic Form*, trans. Christopher S. Wood (New York: Zone Books, 1991 [1925]), 41, 68.

65. Erwin Panofsky, *Studies in Iconology: Humanistic Themes in the Art of the Renaissance* (New York: Harper and Row, 1962 [1939]), 14, 8.

66. William Hood, "The State of Research in Italian Renaissance Art," *Art Bulletin* 69 (June 1987): 174-86. Hood surveys several directions in modern research, but sees the main split between empirical "social history" and the iconological approach of Panofsky. He appeals for a return to an older speculative approach with unifying themes, not just mounds of disparate empirical data. See his conclusion, 185-86.

67. Kenneth Clark, *Piero della Francesca* (London: Phaidon, 1951). Clark makes no fewer than twenty-five references to "beauty" in Piero's work.

68. Ibid., 40.

69. Ernst H. Gombrich, "The Literature of Art: Piero della Francesca," book review, *Burlington Magazine* 94 (June 1952), 177-78.

70. Kenneth Clark, "Stories of Art," *New York Review of Books*, November 24, 1977, 36.

71. Wölfflin's terminology was influential in twentieth-century art history with words such as "schema," the "eye," "modes of vision," and other references to physical and visual psychology. Gombrich naturally uses many of the same terms in his own theories. However, Gombrich, mirroring his friend Karl Popper, rejected Hegelianism root and branch, eventually calling all such "ready-made paradigms" (by Hegel, Wölfflin, Panofsky, or others) as unhealthy for discussing art. He instead argued for a "pluralism" in approaches. See Ernst Gombrich, "A Plea for Pluralism," *American Art Journal* 3 (Spring 1971): 83-87.

72. Gombrich, "The Literature of Art: Piero della Francesca," 178.

73. Ibid., 177-78.

74. Clark, "Stories of Art," 38.

75. E. H. Gombrich, *The Story of Art* (New York: Phaidon, 1966 [1950]), 190.

76. The most recent work on the Darwinian origins of art is Denis Dutton, *The Art Instinct: Beauty, Pleasure, and Human Evolution* (New York: Bloomsbury, 2008). He adopts the sociobiological (or cognitive-psychology) approach. In this late-twentieth-century debate, evolutionists such as Stephen Jay Gould, however, argued that art is simply an accidental byproduct that did not relate to adaptation for survival. The third approach, also included in Dutton, is to see art related primarily to sexual selection: females looking for fit males (who display colorful skills) for reproductive survival.

77. For his "schema and correction" and "mental sets," see Ernst Gombrich, *Art and Illusion*, second edition (Princeton, NJ: Princeton University Press, 1961

[1960]), 60-62, 313. For his "logic of fashion," see Ernst Gombrich, "The Logic of Vanity Fair: Alternatives to Historicism in the Study of Fashions, Style, and Taste," in E. H. Gombrich, *Ideals and Idols: Essays on Values in History and in Art* (London: Phaidon, 1979), 60-92.

78. For this view on Gombrich see John Onians, "Gombrich," in John Onians, *Neuroarthistory: From Aristotle and Pliny to Baxandall and Zeki* (New Haven, CT: Yale University Press, 2007), 159-77.

79. Ibid., 161-63.

80. Ernst Gombrich, "From the Revival of Letters to the Reform of the Arts: Niccoló Niccoli and Filippo Brunelleschi," *Essays in the History of Art Presented to Rudolf Wittkower*, vol. 2, ed. Douglas Fraser, Howard Hibbard, and Milton J. Lewine (London: Phaidon, 1967), 80.

81. Gombrich, *Art and Illusion*, 101; and E. H. Gombrich, *The Sense of Order: A Study in the Psychology of Decorative Arts* (Ithaca, NY: Cornell University Press, 1979), 12, 114.

82. Quoted in E. H. Gombrich, *A Lifelong Interest: Conversations on Art and Science with Didier Eribon* (London: Thames and Hudson, 1993), 133.

83. In the twentieth century, most of the "modernist" alternatives were applied by Protestantism, since the papacy officially condemned "modernism" at the turn of the twentieth century. In general, however, modernist Christianity everywhere tried to revise Bible interpretation and historic doctrines based on the findings of science (such as cosmology, human origins, and Darwinian evolution). With the rise of totalitarianism, moreover, Protestantism especially turned to revelation, existentialism, psychology—and even an argument for "secular Christianity"—as ways to retain the relevance of religion in a world of new intellectual political forces. While both Protestants and Catholics frequently turned to revivals of past traditions, now updated, even the Catholics drew upon modernist resources such as Kant and existentialism to explain faith in the modern world. See the leading Catholic theologian Karl Rahner's "transcendental Thomism," for example.

84. For Tillich's collected essays on art and theology, see Paul Tillich, *On Art and Architecture*, ed. John Dillenberger (New York: Crossroads, 1987).

85. Although scientists tend not to call themselves transcendentalists, many have rejected the old scientific conceit—now called scientism as well as positivism—that scientists are supremely rational, disinterested, and accurate finders of truth. Instead, a new generation of scientists (and sociologists of science) concedes that science can be as irrational (even as mystical) as any human enterprise, influenced by personal, cultural, and political biases; the main difference being that science must use rigorous methodologies to test its claims about reality to verify their truth as a "theory" (which is tentatively "true" until proven inadequate by new theories and testing). For an even-handed cultural approach to science, and how not only "facts" but "themes" shape its findings, see Gerald Holton, *Thematic Origins of Scientific Thought: Kepler to Einstein* (Cambridge, MA: Harvard University Press, 1973).

86. Plato, quoted in *The Collected Dialogues of Plato, Including the Letters*, ed. Edith Hamilton and Huntington Cairns (New York: Pantheon Books, 1961), 1178.

87. Rudolf Wittkower and B. A. R. Carter, "The Perspective of Piero della Francesca's Flagellation," *Journal of the Warburg and Courtauld Institutes* 16 (1953): 295.

88. Bruce Cole, "Piero della Francesca: The Flagellation by Marilyn Aronberg Lavin," book review, The *Burlington Magazine* 115 (November 1973): 749-50. Lavin has perhaps written the largest number of English-language books and journal articles on the art of Piero. The books include her general overview and work on the *Baptism of Christ* and *The Flagellation*. Her art-historian husband, Irving Lavin, in turn, was a close associate of Erwin Panofsky; thus, iconology was a prevailing interest in the Lavins' academic studies.

89. John Wilton-Ely, "The Fortunes of Piero della Francesca in Britain and the United States of America," in Emiliani, *PDFSA*, 562-63. Wilton-Ely notes that the last significant English-language articles proposing empirical dates for Piero's works came in 1941 in journal articles by Creighton Gilbert on the Montefeltro diptych and by Millard Meiss on the Saint Augustine Altarpiece. After that, iconographical interpretations prevailed, "since firm dates and biographical documentation in Piero's career remain comparatively scant."

90. Creighton Gilbert, *Change in Piero della Francesca* (Locust Valley, NY: J. J. Augustin, 1968).

91. For advocacy of "theory" in Renaissance historiography see James Elkins and Robert Williams, eds., *Renaissance Theory* (New York: Routledge, 2008). This book includes a survey of the "interpretative strategies" taken in academic publications on art history from the 1930s to 2000; the dominant spikes since the 1970s and 1980s, in order of intensity, are feminism, psychoanalysis, semiotics, and the Lacanian "gaze" approach. See p. viii.

92. Laurie Schneider, "The Iconography of Piero della Francesca's Frescos Illustrating the Legend of the True Cross in the Church of San Francesco in Arezzo," *Art Quarterly* 32 (1969): 23-48; and Laurie Schneider Adams, *Art and Psychoanalysis* (New York: Harper Collins, 1993), 107-14, 230-31.

93. Quoted in Longhi, *PDF*, 187.

94. Hubert Damisch, *A Childhood Memory by Piero della Francesca*, trans. John Goodman (Palo Alto, CA: Stanford University Press, 2007).

95. Carlo Ginzburg, *The Enigma of Piero: Piero della Francesca*, new edition, trans. Martin Ryle and Kate Soper (London: Verso, 2002 [1985]).

96. John Pope-Hennessy, "The Mystery of a Master: The Enigma of Piero," book review, *New Republic*, March 31, 1986, 40.

97. Cole, "Piero della Francesca: The Flagellation by Marilyn Aronberg Lavin," 749-50.

98. Longhi, *PDF*, 253.

CHAPTER 10

1. Piero, quoted from his *On Perspective*, in Michael Baxandall, *Words for Pictures*, 152. The Italian is in Piero della Francesca, *De prospectiva pingendi*, ed. G. Nicco Fasola (Florence, 1942), 98.

2. Piero's *On Perspective*, quoted in Judith V. Field, *Piero Della Francesca: A Mathematician's Art* (New Haven, CT: Yale University Press, 2005), 130.

3. Johann Wolfgang von Goethe, *Theory of Colors*, notes by Charles Lock Eastlake (Cambridge, MA: MIT Press, 1970 [London: John Murray, 1840]). See also Dennis L. Sepper, *Goethe Contra Newton: Polemics and the Project for a New Science of Color* (New York: Cambridge University Press, 1988). The famous Newton-Goethe debate has often been taken as the first sign of the split between the humanities and the natural sciences, which widened after the era of Hermann von Helmholtz, who also engaged the debate with Goethe.

4. Hermann von Helmholtz, "An Autobiographical Sketch," *Selected Writings of Hermann von Helmholtz*, ed. Russell Kahl (Middletown, CT: Wesleyan University Press, 1971), 472.

5. For the Renaissance tools see Hermann von Helmholtz, "The Relation of Optics to Painting [1871]," *Selected Writings*, 299-306. These include linear perspective and shadow, and space and form created by magnitude or how one object obscures another. There is also the effect of atmosphere on distant colors, which artists simulate by using "aerial perspective." The artist also can deliver to the eye the effect of the brightest sunlight by a contrast of painted colors, when in fact the luminosity of the Sun is infinitely more than white paint.

6. For example, the system sees a red apple as red all the time, even though the eye can interpret red by a few possible combinations: by a direct red wave, by a contrast with another color wave, or by the momentary fatigue of nerve cells.

7. Hermann von Helmholtz, "Recent Progress of the Theory of Vision," *Selected Writings*, 175-77. Helmholtz clarified that each of the three had subtle features: 1) Hue puts a color in one of the seven or so categories of the light spectrum; 2) Intensity is the purity of color. In paint, it is a color with no mixture of light or dark, and in the visual spectrum, it is the more precise wavelength for the pure color; 3) Brightness is also called luminosity, which, as it turns out, is a measure of dark or light relative only to the eye (and not to an electronic device, for example).

8. Hermann von Helmholtz, "Goethe's Anticipation of Subsequent Scientific Ideas [1892]," *Selected Writings*, 487.

9. Helmholtz, "The Relation of Optics to Painting [1871]," *Selected Writings*, 313, 323. In the generation after Helmholtz, the art historian Heinrich Wölfflin (1864-1945), seeking a scientific basis for art interpretation, emphasized the role of the physical, biological "eye" in perceiving stylistic changes in paintings.

10. Linda Dalrymple Henderson, *The Fourth Dimension and Non-Euclidean Geometry in Modern Art* (Princeton, NJ: Princeton University Press, 1983), 70.

11. Some of the Cubists, for example, were attentive to the late-nineteenth-century revival of interest in Leonardo da Vinci as a geometer, and to the Renaissance concept of the "golden section," with its roots in Pythagorean and Platonist mysticism. It would turn out, however, that the golden ratio—a proportion of 1 to 1.6—has never been found in a Renaissance painting or one that was done by the Cubists. This would have required, for example, to put those exact proportions into a painted composition, and no such precise dimensions were really pursued, it seems. It was long believed that Leonardo used the golden section, but research has looked in vain. (See Ross King, *Leonardo and the Last Supper* [New York: Walker and Company, 2012], 170-74.) Either way, the Cubists were attracted by the idea, as illustrated by their use of the term "golden section." When the term "Cubism" was getting worn out in popular and media usage, the Parisian Cubists named their famous 1912 exhibition Section d'Or, the Golden Section, a synonym for the golden ratio as an alternative.

12. For a history of the science of light and its relationship to psychology and religion see Arthur Zajonc, *Catching the Light: The Entwined History of Light and Mind* (New York: Bantam, 1993).

13. There are a few models for how the brain produces "mind." The prevailing scientific one today is the computer "parallel processing" model. Related to this—and adopted by both scientists and some theologians—is the idea that "mind" is a higher "emergent property" of the brain's unfathomable physical complexity. Thirdly, in the tradition of dualism, the mind is something independent of the brain, or working in parallel with it. This kind of dualism originated in the Platonist and Christian idea of soul and, modernly, in René Descartes's "thinking substance." Dualism has had modern advocates in such people as the Nobelist neuroscientist John Eccles, but it primarily is a theological argument that questions how human identity is maintained if all brain cells are replaced several times in a lifetime, or that acknowledges the testimony of people's transcendent experiences. See Owen Flanagan, *The Problem of the Soul* (New York: Basic Books, 2002); Ric Machuga, *In Defense of the Soul* (Grand Rapids, MI: Brazos Press, 2002); and Warren S. Brown, Nancey Murphy, H. Newton Malony, eds., *Whatever Happened to the Soul? Scientific and Theological Portraits of Human Nature* (Minneapolis, MN: Fortress Press, 1998).

14. For an overview of the anatomical and hierarchical system of the "visual pathway" see David Hubel, *Eye, Brain, Vision* (New York: Scientific American Library, 1988), 26-28.

15. Francis Collins, director of the National Institutes of Health, speaking on the PBS "Newshour," February 20, 2013: He said there are one hundred billion neurons and each one has about ten thousand connections. "That means there's something like one thousand trillion connections inside your brain."

16. Hubel, *Eye, Brain, Vision*, 3. Hubel notes that the clear anatomy of visual nerves and their arrival at the visual cortex in the back of the head have made vision easier to study: "The visual cortex is perhaps the best-understood part of the brain today and is certainly the best-known part of the cerebral cortex."

17. The scientist who first formalized the color-opponent theory was Ewald Hering (1834-1918), who built upon the earlier intuitions of Aristotle and Goethe. In 1874, Hering contested the tricolor mixing theory and instead proposed that the visual brain had a three-"opponent" system: red versus green, yellow versus blue, and black versus white. This not only explained the origin of color, but also features of color blindness; some people can see red but not green; blue but not yellow. What Hering lacked was experimental or physiological evidence. Nevertheless, these two rival theories now dominated optics. The longstanding tricolor theory would hold the field, favored by physicists, knowledgeable as they are about tricolor experiments with light and color wheels. By contrast, the new field of psychology became supportive of Hering's oppositional theory. Eventually, the two theories have been tentatively reconciled (as nerve cells were shown to be able to inhibit, or oppose, each other, as well as mix primary colors). On Hering see Hubel, *Eye, Brain, Vision*, 172-74.

18. Margaret Livingston, *Vision and Art: The Biology of Seeing* (New York: Abrams, 2002), 86.

19. Semir Zeki, *Inner Vision: An Exploration of Art and the Brain* (New York: Oxford University Press, 1999), 61.

20. Livingston, *Vision and Art*, 50-52, 64-65.

21. Ibid., 64-65.

22. Hubel, *Eye, Brain, Vision*, 86.

23. Ficino, quoted from his *De amore* in John Hendrix, *Platonic Architectonics: Platonic Philosophies and the Visual Arts* (New York: Peter Lang, 2004), 143.

24. Several philosophers of the mind have explained why there is an ultimate barrier to science's locating and explaining human consciousness, including Thomas Nagel, John R. Searle, and Colin McGinn. They were famously called the "new mysterians" by the more optimistic materialist philosopher Owen Flanagan in his *Science of the Mind* (Cambridge, MA: MIT Press, 1991), 313. Flanagan said: "The old mysterians were dualists [like Plato]. . . . The new mysterians are naturalists" [like all materialists].

25. Helmholtz, "Recent Progress of the Theory of Vision," 213.

26. For a summary of why and how the brain and visual arts seek constants and essences see Zeki, *Inner Vision*, 1-12. For the psychology of essences see Paul Bloom, *How Pleasure Works* (New York: Norton, 2010), 8-24, 205-17.

27. My overlapping of Platonism and neuroscience (that is, arguing that both say essentially the same thing, but disagree on the material v. transcendental nature of the universe), may seem implausible to neuroscience. However, it is neuroscience itself that constantly targets Plato as its enemy, keeping Plato very much in the game. The critics of Platonist dualism of mind and body say that the essences Plato talked about are not "out there," but have now been found in brain functions: modules and cells. I am simply continuing to contrast these two historic rivals, supposing that the natural v. transcendental question about reality remains open, even in an "age of science." For the consistent rejection of "Platonism" in favor of neuroscience, see the writings of neuroscientist Semir Zeki (*Inner Vision*) and art historian John Onians (*Neuroarthistory*). Meanwhile, one critic of neuroscience, the philosopher Alva Noë (*Out of Our Heads*), says that both Platonist idealism (by way of Descartes) and neuroscience share the identical problem of seeking reality inside the head, whereas the postmodernist view congenial to Noë's school of thinking says that human thought and perception, and indeed personal identity, are "socially constructed" by external factors ranging from power structures to friendships and language.

28. Gilbert Ryle, *The Concept of Mind* (Chicago: University of Chicago Press, 2000 [1949]), 15-16.

29. Zeki, *Inner Vision*, 22; John Onians, *Neuroarthistory: From Aristotle and Pliny to Baxandall and Zeki* (New Haven, CT: Yale University Press, 2007), 183, 187. Zeki hypothesizes that, in neurological terms, "Great art can thus be defined . . . as that which comes closest to showing as many facets of the reality, rather than the appearance, as possible and thus satisfying the brain in its search for many essentials." Onians cites the concept that compelling art stimulates the brain's "proper perception" and thus produces pleasure.

30. For a summary of biological theories on contemplative beauty and "disinterested" pleasure see Jennifer Anne McMahon, "Beauty," *The Routledge Companion to Aesthetics*, ed. Berys Gaut and Dominic McIver Lopes (London: Routledge, 2001), 227-238. This basic experience of mental pleasure obviously goes beyond art, but in all cases has similar contemplative and disinterested features as well as an aspect of perceiving essences: this happens with enjoyment of stories, discoveries of principles, or seeing a puzzle solved (and thus, for example, the pleasure of beauty is found in mathematics and scientific answers). For all of this broader interpretation of beauty see Bloom, *How Pleasure Works*, 227-238.

31. For counterintuitive theories of religion see Pascal Boyer, *Religion Explained* (New York: Basic Books, 2001), and Todd Tremlin, *Minds and Gods: The Cognitive Foundations of Religion* (New York: Oxford University Press, 2006).

32. For the ability of the brain to change, repair itself, and "rewire" damaged areas see Norman Doidge, *The Brain That Changes Itself* (New York: Viking, 2007); and Jeffrey M. Schwartz and Sharon Begley, *The Mind and the Brain: Neuroplasticity and the Power of Mental Force* (New York: Regan Books, 2003). The new research relates to the repair of lost brain faculties and the apparent ability of "mind," separate from the brain's machine-like biology, to alter brain patterns. The plasticity, however, does not suggest that the basic cognitive powers or limits of the physical brain can be altered. In the new fields of "neuroaesthetics" and "neuroarthistory," it is presumed that the plasticity causes changes in art appreciation and perception. This remains to be tested: it would require comparative brain scans, for example, of people over a few generations in different countries and cultures to see how new neurological growth in the brain (that is, new patterns of neuron connections) are stimulated by culture and thus cause entirely new kinds of physical perceptions. Current science shows that attitudes, such as "positive thinking," can indeed heal the brain, or that impairment of hearing, sight, or phobias can be altered by daily practice—but these are different sorts of changes from experiencing a high level of "notable pleasure" from beautiful art. Interestingly, the leading medieval commentator on optics, Erasmus Witelo, noted how art perception has both constancy (he was a Platonist) and variety: "Each person," said Witelo, "makes his own estimate of beauty according to his own custom." Quoted in Umberto Eco, *Art and Beauty in the Middle Ages*, trans. Hugh Bredin (New Haven, CT: Yale University Press, 2002 [1959]), 69. As seen in Witelo, Platonism acknowledges constancy and change.

33. Suzanne Nalbantian, "Neuroaesthetics: Neuroscientific Theory and Illustration from the Arts," *Interdisciplinary Science Reviews* 33 (December 2008): 357-68. As Nalbantian notes, neuroaesthetics received its formal definition in 2002: "The scientific study of the neural bases for the contemplation and creation of a work of art."

34. Michael Baxandall, *Painting and Experience in Fifteenth-Century Italy* (Oxford: Oxford University Press, 1972).

35. Quoted in Michael Baxandall, "Fixation and Distraction," in *Sight and Insight: Essays on Art and Culture in Honour of E. H. Gombrich*, ed. John Onians (London: Phaidon, 1994), 413.

36. For a classic statement on the biological objectivity of visual linear perspective see James T. Gibson, "Perspective and Perception," *Daedalus* 89 (Winter 1960): 216-27.

37. Zeki, *Inner Vision*, 22-29.

38. Livingston, *Vision and Art*, 71-73.

39. Zeki, *Inner Vision*, 205-208.

40. On Impressionism and Cubism see Livingston, *Vision and Art*, 74-76, 125-33, 153-60, 77.

41. Ibid., 115. See John Shearman's study of Leonardo's luminescence cited here.

42. Michael Baxandall, *Words for Pictures: Seven Papers on Renaissance Art and Criticism* (New Haven, CT: Yale University Press, 2003), 148. He lists Piero's psycho-visual techniques for creating depth as: 1) interposition: masking part

of a familiar object by another; 2) foreshortening: familiar object at angles to picture plane; 3) discernible recession of ground plane: "texture gradient"; 4) height in relation to a horizon: the higher, the farther; 5) reduction of the known size of an object with distance; 6) the relative diminution of similar objects with distance; 7) cast shadows in discernible relation to the casting object; 8) the modeling of volumes by shading and self-shadow; 9) degradation of distinctness of color (or reduced acuity); and 10) degradation of distinctness or color (atmosphere).

43. E. H. Gombrich, *Art and Illusion*, second edition (Princeton, NJ: Princeton University Press, 1961 [1960]), 332.

44. Thomas Martone, "Spatial Games in the Art of Piero della Francesca and Jan Van Eyck," in Emiliani, *PDFSA*, 95-109.

45. Typically, counterintutive events are anything that defies normal expectations, and thus it may be when action is frozen. On the counterintuitive and transcendent belief see Boyer, *Religion Explained*, and Tremlin, *Minds and Gods*. The sociologist Peter Berger has written on this phenomenon in Peter L. Berger, *A Rumor of Angels: Modern Society and the Rediscovery of the Supernatural* (Garden City, NY, Doubleday, 1969); and Peter L. Berger, *A Far Glory: The Quest for Faith in an Age of Credulity* (New York: Free Press, 1992).

46. Zeki, *Inner Vision*, 205-208.

47. John Pope-Hennessy, *The Piero della Francesca Trail* (London: Thames and Hudson, 1991), 69.

48. Psychology and economics have accepted the way humans establish value for various objects. Those critical of this acceptance have been Karl Marx, who called such values "fetishes," and the Marxist-leaning art theorist Walter Benjamin, who lamented that art with such an essence has an "aura" that is illusory.

CHAPTER II

1. Banker, *CSS*, v.

2. Ibid., 136.

3. James R. Banker, "Three Geniuses and a Franciscan Friar," lecture, The Frick Collection, New York City, March 20, 2013.

4. Anthony Molho, "The Italian Renaissance, Made in the USA," in *Imagined Histories: American Historians Interpret the Past*, ed. Anthony Molho and Gordon S. Wood (Princeton, NJ: Princeton University Press, 1998), 273. See Molho's entire "The Italian Renaissance" chapter (263-94) for a survey of American views of the Renaissance, especially in scholarly circles, since the nineteenth century.

5. Important compatriots of Becker in this project abroad were Gene Brucker and Donald Weinstein. See Donald Weinstein, "Introduction," Marvin Becker, *Florentine Essays: Selected Writings of Marvin Becker*, ed. James R. Banker and Carol Lansing (Ann Arbor, MI: University of Michigan Press, 2002), 1-10.

6. On the German approach and influence in the United States see Molho, "The Italian Renaissance," 271-76.

7. See Becker's recollections in "Afterword," Becker, *Florentine Essays*, 308-12. As with the United States, each postwar nation had its characteristic approach to the Renaissance. In Italy, it was studied as part of modern history up to the Italian unification in 1870. Before the war, Italian historians looked mainly

for antecedents in ancient Rome and the medieval commune—both ideals of Benito Mussolini's fascist state. When Becker had arrived in the 1950s, Italy was sharply divided between extreme parties on the left and right, and the Renaissance was of no use, it seemed, to either side. In Germany, despite its rich contributions to art history, the Reformation still dominated historical studies. See Paul F. Grendler, *Encyclopedia of the Renaissance*, vol. 5 (New York: Charles Scribner's Sons, 1999), 283-85.

8. For histories of the Warburg and Courtauld Institutes see their Web sites: ⟨http:warburg.sas.ac.uk/home/⟩ and ⟨http:www.courtauld.ac.uk/about/history.shtml⟩. For histories of the Courtauld see "About Us" at the Web site. On the Warburg-Courtauld alliance see Elizabeth McGrath, "A Short History of the Journal," at ⟨http:warburg.sas.ac.uk/publications/journal/short-history-of-the-journal/⟩.

9. Historian Carl Becker, quoted in Wallace K. Ferguson, *The Renaissance in Historical Thought: Five Centuries of Interpretation* (Boston: Houghton Mifflin, 1948), 196.

10. Erwin Panofsky, *Renaissance and Renascences in Western Art* (New York: Harper and Row, 1969), 7, 4.

11. See Herbert Weisinger, "The Attack on the Renaissance in Theology Today," *Studies in the Renaissance* 2 (1955), 176-189. Between the 1930s and 1950s, the critics of the Renaissance heritage became a *Who's Who* in theology: Emile Brunner and Karl Barth from Germany, John Ballie and Christopher Dawson from Britain, Étienne Gilson and Jacques Maritain from France, Nikolai Burdiev from Russia, and Reinhold Niebuhr and Bishop Fulton J. Sheen from America.

12. Reinhold Niebuhr, *The Nature and Destiny of Man: Human Destiny: A Christian Interpretation, 1. Human Nature, 2. Human Destiny*, one-volume edition (New York: Charles Scribner's Sons, 1964), 221, 68, 61.

13. For the Hellenism/Hebraism theme, see Roland H. Bainton, "Man, God, and the Church in the Age of the Renaissance," *The Renaissance*, ed. Wallace K. Ferguson (New York: Harper and Row, 1962 [1953]), 87-96. The Renaissance legacy in modern religion is, of course, complex (as were the theological currents of Piero's Quattrocento). For the theme of this book, it is worth noting that the three modern Christian approaches had roots in Platonist dualism and its epistemology of "intelligible" Ideas and the "sensible" world: liberal Protestantism, existentialism, and Kantian theology (adopted even by some Catholic theologians). Liberal Protestantism is perhaps the prevailing example of Platonist influence. This Protestant approach was born with the German theologian Friedrich Schliermacher (1768-1834), who had a "passion for Plato." Rather than emphasizing doctrines, Schliermacher said religion is the "feeling of absolute dependence" on something higher, an idea that emphasized intuition. Like Cusanus, he found Platonist philosophy a helpful basis on which to generalize Christian thought, a pattern that lasted for the next century and blossomed into liberal, ecumenical Protestantism. See Friedrich Schliermacher, *On Religion: Speeches to its Cultured Despisers*, ed. Richard Crouter (Cambridge: Cambridge University Press, 1996), xvii, xi-xlii; and Jacqueline Mariña, ed., *Cambridge Companion to Friedrich Schliermacher* (Cambridge: Cambridge University Press, 2005), 37.

14. Karl R. Popper, *The Open Society and Its Enemies*, vol. 2 (Princeton, NJ: Princeton University Press, 1971 [1962]), 302 n.61, 31.

15. When it came to authoritarianism, Popper overlooked the fact that the fascists and Nazis had ample sources besides Platonism. Mussolini built his ideology on the Roman Empire and the medieval Italian commune. The National Socialists in Germany drew upon pagan Nordic mythology and not a little social Darwinism. Even if Piero, some Renaissance artists, the Medici court, and the Camaldolese religious order leaned Platonist in their aesthetics and Christianity, this was hardly an invitation to totalitarianism. See Karl R. Popper, *The Open Society and its Enemies: The Spell of Plato*, vol. 1 (Princeton, NJ: Princeton University Press, 1971 [1944]. In volume 2, he argues that Aristotle's thought is "entirely dominated" by Plato's as well. Popper began writing the book in 1938 after Germany invaded Austria. In the acknowledgements, Popper thanks Ernst Gombrich for helping get the book published.

16. Regarding the idea that Piero has been endorsed by an elite art world, though presumably by no fault of his own, see Albert Boime, "Piero and the Two Cultures," in Lavin, *PFL*, 256. Boime speaks of the "elitist concern," and even the Christian antisemitism, of some admirers and advocates of Piero.

17. Two classic cases are the literary critic Susan Sontag and the painter Philip Guston, both of whom started on the radical left but later in life praised the old masters. Guston spoke of Piero as his favorite artist. Sontag, in her famous essay *Against Interpretation*, argued that a more traditional and descriptive appreciation of external art forms—in literature, but also paintings by implication—would help the modern sensibility far more than the endless, rootless, and over-intellectualized interpretation of art that had become fashionable.

18. Anthony Bertram, "Piero della Francesca and the Twentieth Century," *The Studio* (1951): 120-23.

19. Quoted in Longhi, *PDF*, 263. This first volume of André Malraux's *Museum Without Walls* was published in French in 1947.

20. Grendler, *Encyclopedia of the Renaissance*, vol. 5, 283. See also William Hood, "The State of Research in Italian Renaissance Art," *The Art Bulletin* 69 (June 1987): 174-86.

21. Eugenio Battisti, *Piero della Francesca*, 2 vols. (Milan: Istituto editoriale italiano, 1971).

22. J. C. Robinson, "To the Editors of The Times," *The Times* (London), June 9, 1874, 7.

23. Cited in Ross King, *Leonardo and the Last Supper* (New York: Walker, 2012), 274.

24. Tim Butcher, "The Man Who Saved The Resurrection," *BBC News*, December 23, 2011 (www.bbc.co.uk/news/magazine-16306893).

25. These art-restoration examples have been drawn from several sources, especially Piero Bianconi, *All the Paintings of Piero Della Francesca*, trans. Paul Colacicchi (New York: Hawthorn, 1962). For the "ingenious method," see Bruce R. Cole, *The Renaissance Artist at Work: From Pisano to Titian* (Boulder, CO: Westview Press, 1983), 93-94.

26. See "The Crucifixion," in Nathan Silver, ed., *Piero della Francesca in America: From Sansepolcro to the East Coast* (New York: The Frick Collection, 2013), 110.

27. Crowe and Cavalcaselle, quoted from 1864 in Bianconi, *All the Paintings of Piero Della Francesca*, 61.

28. See Caroline Boucher, "Restorers' Subtle Touch Brings Piero's Genius to Glorious Life," *The Observer* (London), May 7, 2000 (http:www.guardian. co.uk/travel/2000/may/07/observerescapesection); and Ralph Blumenthal, "The Restoration of Piero's Renaissance Masterwork," *New York Times*, April 6, 2000, E1. The restoration was paid for by the Banca Popolare dell'Etruria e del Lazio, which also published a compendium of articles on the entire fifteen-year project.

29. Telephone interview with Frank Dabell, August 4, 2012. All quotes are from the interview.

30. James R. Banker, *Death in The Community: Memorialization and Confraternities in an Italian Commune (Sansepolcro) in the Late Middle Ages* (Athens, GA: University of Georgia Press, 1988).

31. Frank Dabell, "Antonio d' Anghiari e gli inizi di Piero della Francesca," *Paragone* 417 (1984): 73-94.

32. James R. Banker, "Piero della Francesca as Assistant to Antonio d'Anghiari in the 1430s: Some Unpublished Documents," *Burlington Magazine*, 135 (1993): 16.

33. Philip Hendy, *Piero della Francesca and the Early Renaissance* (New York: Macmillan, 1968), 72. Hendy is protesting Longhi's early date of the *Baptism*.

34. Banker, *CSS*, 136.

35. See the two articles by this German scholar: Christopher Frommel, "Francesco del Borgo: Architekt Pius' II, und Pauls II'," *Römisches Jahrbuch für Kunstgeschichte* 20 (1983): 108-45; 21 (1984): 129-38.

36. See James R. Banker, "A Manuscript of the Works of Archimedes in the Hand of Piero della Francesca," *Burlington Magazine* 147 (March 2005): 165-69. Banker credits the antique writing expert Armando Petrucci with authenticating the traits of Piero's handwriting in the Archimedean manuscript in the Biblioteca Riccardiana in Florence.

37. See the 2007 Biblioteca Riccardiana press release, "L'Archimede autografo di Piero della Francesca," di Giovanna Lazzi: (http:www.riccardiana.firenze. sbn.it/allegati/2007-2_1.pdf). In cooperation with the World Digital Library, the Biblioteca Riccardiana has posted a digital copy of the entire Piero work at (http:www.wdl.org/en/item/10646/).

38. Banker, "Three Geniuses and a Franciscan Friar."

39. Attilio Brilli, *In Search of Piero: A Guide to the Tuscany of Piero della Francesca*, trans. D. Hodges (Milan: Electa, 1990). See front matter.

40. Marilyn Aronberg Lavin. *Piero della Francesca* (New York: Phaidon, 2002), 116.

41. Carl Brandon Strehlke, "Urbino, Monterchi, Sansepolcro and Florence: The Piero Exhibitions," *Burlington Magazine* 134 (December 1992): 821-23.

42. Ibid., 823.

43. The U.S. consortium is documented in Marilyn Aronberg Lavin, ed., *Piero della Francesca and His Legacy* (Washington, D.C., and New Haven, CT: National Gallery of Art/Yale University Press, 1995). The leading European conferences for 1992 were held in Arezzo (October 8-11) and Sansepolcro (October 12). Their many authoritative papers on Piero are documented in Marisa Dalai Emiliani e Valter Curzi, eds., *Piero della Francesca tra arte e scienza: atti del convegno internazionale di studi, Arezzo, 8-11 ottobre 1992, Sansepolcro, 12 ottobre* (Venezia: Marsilio, 1996).

44. "Introduction," in Lavin, *PDFL*, 10.

45. Banker, "Piero della Francesca as Assistant to Antonio d'Anghiari in the 1430s," 16.

46. Banker, "Contributions to the Chronology of the Life and Works of Piero della Francesca," in *Arte cristiana*, 92 (2004), 248. In this essay, Banker reviewed eight critical dates, questioning them and offering the most likely alternative interpretations.

47. Machtelt Israels, quoted in Machtelt Israels, "Piero at Home: The Art of Piero della Francesca," lecture, The Frick Collection, New York City, February 13, 2013.

EPILOGUE

1. The legitimacy of comparing Platonism and neuroscience as both viewing the brain as seeking constants and essences is argued above in chapter 10, n.27. The brain's desire for constants and essences is not in question; the debate is over the origin of that desire, material versus transcendental. Indeed, anti-Platonists frequently cite him as erroneous in the face of neuroscience. See Semir Zeki, *Inner Vision: An Exploration of Art and the Brain* (New York: Oxford University Press, 1999), and John Onians, *Neuroarthistory: From Aristotle and Pliny to Baxandall and Zeki* (New Haven, CT: Yale University Press, 2007).

2. On children and essences see Frank C. Keil, *Concepts, Kinds, and Cognitive Development* (Cambridge, MA: MIT Press, 1989); Justin L. Barrett, *Born Believers: The Science of Children's Religious Beliefs* (Free Press, 2012); and Paul Bloom, *How Pleasure Works* (New York: Norton, 2010), 14-18.

3. On intuitive dualism see Paul Bloom, *Descartes's Baby: How Child Development Explains What Makes Us Human* (New York: Basic Books, 2004). See also Henry Wellman and Carl Johnson, "Developmental Dualism: From Intuitive Understanding to Transcendental Ideas," in *Psycho-Physical Dualism Today: An Interdisciplinary Approach*, ed. Alessandro Antonietti, Antonella Corradini, and E. Jonathan Lowe (Lanham, MD: Lexington Books, 2008), 3-36.

4. This fact surfaced during the widespread debates over the "new atheism" in the first decade of the twenty-first century. When asked for alternatives to religion, the "new atheists," who often relied on brain science, cited such qualities as wonder, mystery, and the numinous. For citation of this irony, see Bloom, *How Pleasure Works*, 211-15.

5. The origins of the Scientific Revolution are much debated. In this context, Piero scholar James Banker ranks Piero as an important link on the way to Galilean science. See James R. Banker, "Three Geniuses and a Franciscan Friar," lecture, The Frick Collection, New York City, March 20, 2013.

6. Wisdom of Solomon, 11:20; Plato, *Timaeus*, in *The Collected Dialogues of Plato, Including the Letters*, ed. Edith Hamilton and Huntington Cairns (New York: Pantheon Books, 1961), 1182.

7. This emphasis on psychology and neuroscience excludes the postmodern trend that says "language" creates reality, and thus the study of our language—not our biology or psychology—will explain how we truly perceive reality. This has Platonist origins as well, as suggested by Ernst Cassirer's argument that language was a kind of "symbolic form" that existed between the human mind and reality. This debate is fearsome today between the sciences and humanities, and in this book I have set aside this great linguistic

debate, just as I have set aside debates on supernatural religion, to focus instead on science and Platonist philosophy as two dynamic solutions to modern questions.

8. Quite apart from religion, materialist scientists debate among themselves as to whether they can answer everything or whether there are limits to scientific methods. Some scientists warn against the ideology of "scientism," preferring to recognize the futility of science's aspiring to absolute knowledge. The *Merriam-Webster Dictionary* defines scientism as "an exaggerated trust in the efficacy of the methods of natural science." See also Philip Kitcher, "The Trouble with Scientism," *New Republic*, May 24, 2012; Martin Ryder, "Scientism," *Encyclopedia of Science, Technology, and Ethics* (New York: Macmillan Reference, 2005).

9. The idea of the counterintuitive experience has been tied primarily to religion, but also is suggested in visual neuroscience in cases where the brain must resolve visual experiences that do not match its perceptual needs. For the "What and Where" analysis see Margaret Livingstone, *Vision and Art: The Biology of Seeing* (New York: Abrams, 2002), 50-52, 64-65. For counterintuitive theories of religion see Pascal Boyer, *Religion Explained* (New York: Basic Books, 2001), and Todd Tremlin, *Minds and Gods: The Cognitive Foundations of Religion* (New York: Oxford University Press, 2006).

10. See Huxley's essay, "The Best Picture," in John Pope-Hennessy, *The Piero della Francesca Trail* (London: Thames and Hudson, 1991), 5-11.

11. Ibid., 7.

12. Mary Mothersill, *Beauty Restored* (Oxford: Oxford University Press, 1984), 374-75. She defines beauty as "notable pleasure," agreeing with Kant that beauty must be something beyond the "merely agreeable."

13. Alfred North Whitehead, *Process and Reality* (New York: Free Press, 1979), 39.

14. The terms Realism and Idealism have had a complex pedigree in the history of religion, philosophy, and science. The important distinction is how they are used when talking about existence (ontology) or talking about human knowing (epistemology). On the first, Idealism means the existence of a god or universal mind that causes existence, whereas Realism, in effect, means there is only matter. In regard to epistemology, Idealism argues that "mind" is superior to the physical senses in creating perception; a Realist epistemology, at the same time, simply says that the physical world is real as separate from the mind (and the mind is a material product of that real physical world). In this "knowing" debate, connecting the mind to the world "out there" is the main issue. On one extreme, there is "naïve realism"—the belief that the physical senses know the physical world precisely. On the other Idealist extreme, the world is entirely elusive (or even does not exist!) without a spiritual mind to organize its infinite flux. The debate is interminably complex. Traditional Christianity, for example, is Idealist in ontology (God exists, therefore we exist), but both Idealist and Realist in knowing: that is, God created a world independent of the human mind; yet, for humans, a mind with divine origins—typically called the soul—is necessary to know, by intuition or "spiritual" sense, the nature and origin of the real Creation.

15. For arguments supporting the moderate and reasonable nature of Platonism, see John Wild, *Plato's Modern Enemies and the Theory of Natural Law* (Chicago: University of Chicago Press, 1953); Ronald B. Levinson, *In Defense of*

Plato (Cambridge, MA: Harvard University Press, 1953); and Lawrence F. Hundersmarck, "Plato," in Ian P. McGreal, ed., *Great Thinkers of the Western World* (New York: Harper Collins, 1992), 27-28.

16. See Stephen Greenblatt, *The Swerve: How the World Became Modern* (New York: Norton, 2011), 262-63.

17. The Declaration of Independence speaks of the "pursuit of happiness," a concern raised among the philosophers of morals in the Scottish Enlightenment. Most of America's founding debate, however, was couched in terms of the "national happiness," which suggested a concern to find a basis for freedom, order, and prosperity in a society, that is, the "public good," which the founders decided to base on the balance of powers and on transcendent beliefs, such as "human rights," a "Creator," and "Nature's God." If the new American citizens were wise "philosophers," said the Calvinist and Platonist (in metaphysics) James Madison, then a balance of powers would not be necessary. However, he said, "a nation of philosophers is as little to be expected as the philosophical race of kings wished for by Plato." Quoted in Hamilton, Madison, and Jay, *The Federalist Papers*, ed. Clinton Rossiter (New York: New American Library, 1961), 315.

18. The American founders used, willy-nilly, a range of classical sources, primarily Roman, most of which had been recovered during the Renaissance. Although Thomas Jefferson was a "philosophical materialist," the other founders worked from a Christian, and therefore Platonist, framework. Otherwise, the down-to-earth Jefferson found in Plato's dialogues the "sophisms, futilities, and incomprehensibility" of a "foggy mind"; and while some founders at first cited Plato as a philosopher of "civil liberty," their actual reading of the *Republic*, taking it as a kind of utopian fantasy, turned them away from Plato's bizarre politics—though not away from the transcendentalism that Plato had endowed to Christianity. This explains the final agreement in the Declaration of Independence to base freedom in the reality of "Nature's God." The next great import of Platonism to American life came in the Transcendentalist movement in the decades before the Civil War. This religious and literary movement drew upon German philosophical Idealism (with its roots in Platonism). Abraham Lincoln was amendable to Transcendentalism, as evident, it has been argued, in his Gettysburg Address and his appeal to a transcendent good. In sum, the first few generations of American constitutional tradition were a mixture of European materialist ideology—stemming from the Epicurean Romans, Newtonian science, England's David Hume, and the French Revolution—and a broad swath of Platonism, conveyed in Christianity (primarily Reformed-Protestant and Augustinian) and German Idealism. The first significant new development in American thought would be pragmatism, characterized by the philosophers William James and Charles Sanders Peirce (around 1900), who redefined "truth" as what is useful, and yet remained Platonist in presuming a transcendent "something more," as James famously said. Still, today probably 90 percent of Americans believe in "something more," and a sizable percentage of American scientists holds transcendental beliefs. See Bernard Bailyn, *The Ideological Origins of the American Revolution* (Cambridge, MA: Harvard University Press, 1967), Jefferson on Plato quoted, 24; Hamilton, Madison, and Jay, *The Federalist Papers*, ed. Clinton Rossiter (New York: New American Library, 1961); Perry Miller, ed., *The American Transcendentalists: Their*

Prose and Poetry (Garden City, NY: Doubleday, 1957), 352-66; Gary Wills, *Lincoln at Gettysburg: The Words That Remade America* (Simon and Schuster, 1992), 102-120; and Louis Menand, *The Metaphysical Club: A Story of Ideas in America* (New York: Farrar, Straus and Giroux, 2001).

19. On the value of art see Gordon Graham, *Philosophy of the Arts: An Introduction to Aesthetics* (London: Routledge, 2000).

20. Jacob Burckhardt, *The Civilization of the Renaissance in Italy* (New York: Modern Library, 2002 [1860]), 385.

Index